eat in my kitchen

to cook, to bake, to eat, and to treat

MEIKE PETERS

PRESTEL

MUNICH · LONDON · NEW YORK

© Prestel Verlag, Munich · London ·
New York 2016
A member of Verlagsgruppe
Random House GmbH
Neumarkter Strasse 28 · 81673 Munich

In respect to links in the book, Verlagsgruppe
Random House expressly notes that no illegal
content was discernible on the linked sites at the
time the links were created. The Publisher has
no influence at all over the current and future
design, content or authorship of the linked sites.
For this reason Verlagsgruppe Random House
expressly disassociates itself from all content on
linked sites that has been altered since the link
was created and assumes no liability for such
content.

Text and photography © 2016 Meike Peters
Meet In Your Kitchen recipes © the individual
contributors

Prestel Publishing Ltd.
14-17 Wells Street
London W1T 3PD

Prestel Publishing
900 Broadway, Suite 603
New York, NY 10003

All photos taken by Meike Peters, except:
page 8 Susanne Erler
page 12 (right) Marta Greber
page 241 Yossy Arefi
page 243 (top) Dennis Williamson / Recipe from
Cynthia Barcomi, Cookies, Mosaik Verlag, 2015
page 249 (top) Nick Hopper
page 251 Molly Yeh

Library of Congress
Cataloging-in-Publication Data

Names: Peters, Meike, 1975- author.
Title: Eat in my kitchen : to cook, to bake, to eat,
and to treat / Meike
 Peters.
Description: Munich ; Berlin ; London ; New
York : Prestel, 2016.
Identifiers: LCCN 2016013498 | ISBN
9783791382005 (hardback)
Subjects: LCSH: Cooking, European. | BISAC:
COOKING / Regional & Ethnic /
 Mediterranean. | COOKING / Regional &
Ethnic / German. | COOKING /
 Regional & Ethnic / European. | LCGFT:
Cookbooks.
Classification: LCC TX723.5.A1 P48 2016 | DDC
641.594--dc23
LC record available at https://lccn.loc.
gov/2016013498

A CIP catalogue record for this book is available
from the British Library.

Editorial direction: Holly La Due
Design and layout: Jan Derevjanik
Production management:
Karen Farquhar, Luke Chase
Copyediting: Lauren Salkeld
Proofreading: Monica Parcell
Index: Ellen Sherron

Printed on the FSC-certified paper Chinese
Hoopoe FSC woodfree

Printed in China

ISBN 978-3-7913-8200-5

www.prestel.com

eat in my kitchen

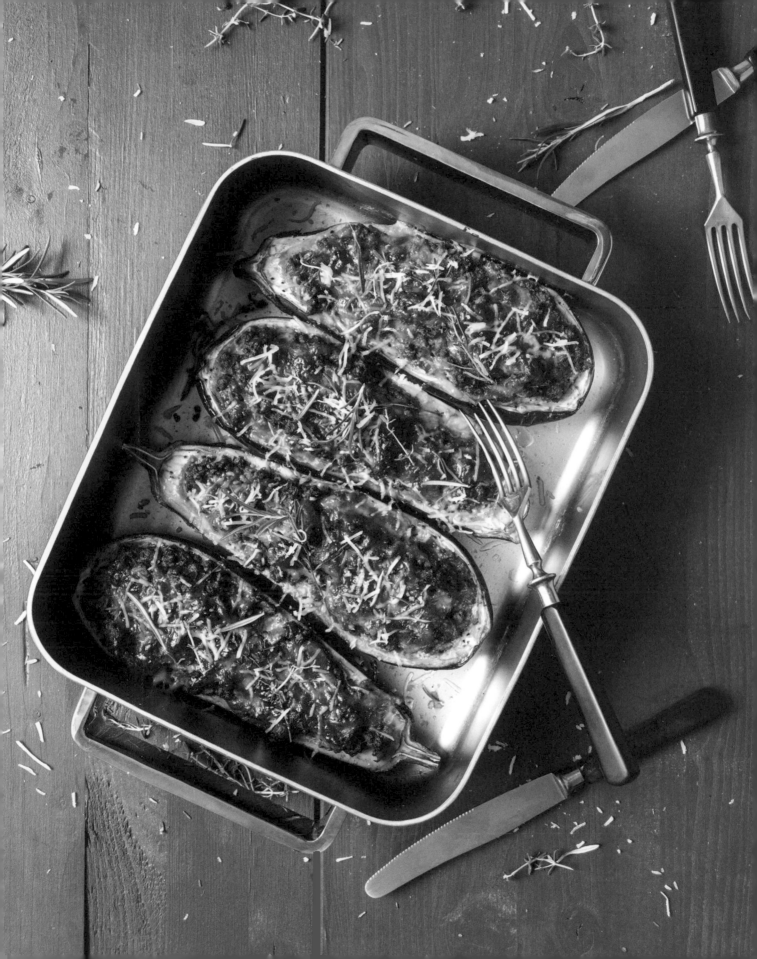

To Mama and Jamie, my two rocks.

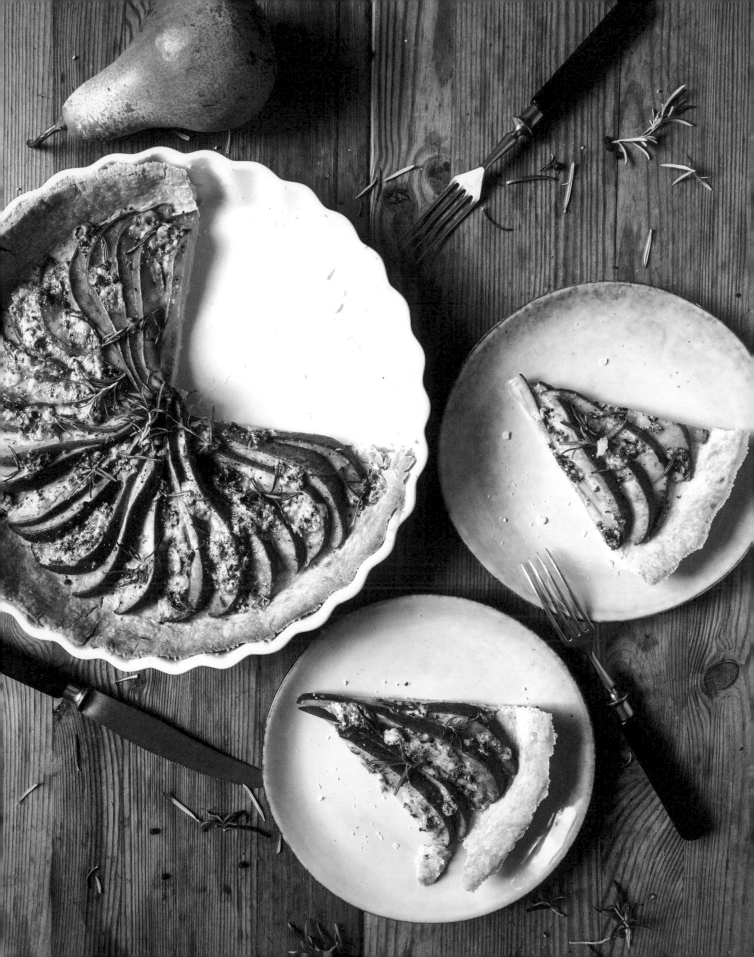

contents

introduction

My food is in my hands. Whatever I buy, whatever I cook and eat—it's all up to me. My
mother and grandmothers introduced me to the marvelous everyday pleasures of the kitchen.
I was a young child, but watching them create fantastic treats with such ease and satisfaction
impressed me and sparked my lifelong love of food. Through them I understood that it is
a sensory process that leads to an unforgettable meal. The idea for a recipe is only the start.
Before the cutting, searing, and stirring even begins, smelling and choosing fresh fruits and
vegetables at the market, or picking a nice piece of meat at the butcher or a warm loaf of bread
at the bakery is what turns a simple dish into something greater. When I sit down at the table,
on my own or with family and friends, I enjoy every single bite to the fullest. It is pure bliss
created by my own two hands. If there isn't much time, I keep it simple, with only a few
ingredients tossed together in half an hour, but I won't skip it. To cook, to bake, to eat, and to
treat is my daily feast.

My culinary education is rooted in hearty German comfort food, with strong influences
from French and Italian cuisine. It all started with my mother who is my biggest inspira-
tion in the kitchen. She's a fabulous cook, a wonderful host, and she introduced my young
taste buds to the pleasures of fine olive oil and the generous use of Mediterranean herbs and
garlic, along with France's elaborate classical dishes and Italy's simple but scrumptious pastas.
Although I grew up in western Germany, in North Rhine-Westphalia, most of the traditional
German recipes I cook originated in the South of the country. I learned to love them through
my Swabian stepfather who brought wonderful treats like Spätzle and *Maultaschen* (*see page 90*) to
our table. Our lavish family gatherings aroused an unstoppable appetite for traditional home-
made cakes, and led to my huge passion for baking, which I continue to indulge in, especially
on cozy weekends.

My kitchen journey continued when my partner came into my life, bringing with him
the culinary traditions of his Maltese mother and American father. Spending summers in
Malta, on the warm edge of Europe, sixty misty miles from Sicily, easily changes the mind,
humor, and cooking of a German girl. My Mediterranean family brought lots of love and
laughter into my life and many new recipes and habits into my kitchen. Similar to Sicily, the

cuisine of Malta has strong Arabic influences and features warming spices like cumin, coriander, and fennel, as well as the concentrated zest and juice of lemons, tangerines, and oranges, which add depth, flowery fruitiness, and tangy edge. For this reason, I use citrus in almost everything, especially when it comes from my Maltese mama's garden.

My partner's American family bestowed upon me a new love for luscious sandwiches, chunky cookies, and Sunday morning muffins. The size of my burgers also grew dramatically, but besides this, I learned to be more free and experimental and less traditional in how I think about ingredient combinations for my recipes.

This is my culinary map and I'm thankful for every single influence and experience. I combine and make use of everything I've learned—cooking, baking, and eating based on what I've seen, smelled, and tasted in the world. New ideas, trusted family classics, and culinary traditions melt into each other and turn into delicious treats to be savored at the long wooden table in our old flat on one of Berlin's wide boulevards.

The seed for my deep fascination with food was sown early—maybe it's been there from the start. An old photograph from when I was a baby—I couldn't even walk yet—shows me toothlessly licking the last pieces off a chicken bone with such persistence that it seems obvious where my passion would take me. Years later, in November 2013, I decided to write about my kitchen adventures, and share my experiences on my blog *Eat in My Kitchen*. Not knowing what it would lead to, I simply enjoyed exchanging tips and recipes with readers all over the world. Some of those readers became friends, and have been with me on this journey since the beginning. We are all connected through the universal language of food, and inspire each other with our different cultures and creations.

I love to end my day in the kitchen; it relaxes me. Listening to music, enjoying a glass of wine with some nibbles—a bit of cheese, some olives or grapes—turns the cooking experience into a greater pleasure. The meals that follow are some of my most treasured memories, and are a big part of who I am. The food we choose to create and eat, the way we set up the room where it all happens, and the importance we give it in our lives says a lot about who we are. This is what I was curious about when I started **meet in your kitchen** (*see page* 240), an interview series I do for my blog that's also included in this book. Each guest shares a personal recipe and their views and stories about food, so it offers a real and honest insight into someone's life through their kitchen.

a few notes on equipment and kitchen specifics

My own kitchen is a rather small but bright room with a large window facing an old brick wall covered in vines. Every second spent there is precious to me. I've been cutting, stirring, and kneading on my worn-out marble countertops for many years and every scratch has a story connected to a meal.

My collection of **pots and pans** has grown over the years. It's an international mélange of American cast iron skillets, French copper, and German stainless steel saucepans that were a

gift from my mother for my first kitchen, and have been with me for more than twenty years.

My **plates and cutlery** are an eclectic collection of new and old. Only my **wine glasses** are uniform. When it comes to wine, I believe that form must follow function—for the wine's sake.

The most important equipment in my kitchen is a large **chopping block** and **sharp knives**. One large knife and one small one, both with a fine blade, are essential; a simple honing steel to maintain your knives is a beneficial investment.

I work with an **electric stove** and all recipes are made in a conventional oven, unless otherwise stated as convection setting or broiler. Every oven works differently and the material and shape of a baking dish alters the way heat is transferred. Food needs your attention while it's cooking or baking. It's better to check once too often than to miss the right moment. Pricking the surface of a cake with a skewer doesn't affect its beauty, but a burnt top does; a piece of meat with a cut surface speaks for a careful cook and not for a lack of experience.

Talking about precise **amounts in a cookbook** is tricky, as the needs of two, four, or six people can vary considerably. I would describe my appetite as healthy—I don't eat like a mouse, but it's also not excessive—and this has been my guideline.

In my early cooking days, my mother taught me to trust my own taste and I pass her words on to you: Use your senses. Being brave and open-minded helps you discover what pleases your taste buds. **Recipes need adjustments** to fit your personal preferences. Vegetables and fruits have to be ripe, but a zucchini grown in America, versus in northern or southern Europe, will add a different flavor to a dish. The soil, the climate, and the variety, all make a difference, and demand your attention when it comes to cooking times and seasoning.

a few notes on ingredients

The **dairy products** and **eggs** used in my kitchen are **organic**, the **meat** is from a butcher, and the **seafood** is preferably wild. Both the meat and seafood are rinsed under cold water and dried well with paper towels. We eat meat or fish only once or twice a week, because the realities of responsible consumption change far more quickly than any regulation can dictate. A law might come into effect too late, or with too many compromises, for our environment to recover from our exploitation.

Learning about the **seasons** and following their natural rhythm with my recipe choices led to less frustrating grocery shopping and far tastier results. To know when tomatoes are sweet, peaches are juicy, and cucumbers are packed with flavor is essential, and prevents disappointment in the kitchen. The next step was leaving out artificial flavoring, additional processing, and industrial agriculture as much as possible, which helped me rediscover the original tastes as I remember them from my childhood.

Vegetables, also preferably organic, are rinsed or scrubbed, if not explicitly stated as peeled. The **weight** indicates the final amount after peeling, coring, pitting, and cutting.

Onions and garlic are peeled, unless otherwise stated. Before using garlic, make sure the bulb is fresh. If it smells a bit odd and moldy, you'll end up with this unpleasant flavor in your dish. Whether you use a press or a knife to finely chop the cloves is up to you.

Instead of buying ground powders, I like to use a **mortar and pestle** to grind or crush whole **spices**, especially black **peppercorns**, which I use to finish many of my dishes. You

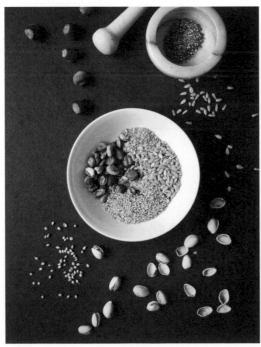

will often find both ground and coarsely crushed peppercorns in the same recipe, which is a Maltese habit I learned to appreciate. They each add unique spice and taste, so I like to layer them when I cook. When it comes to **salt**, I trust Mr. Cini from the Xwejni Salt Pans in Gozo, Malta's little sister island. He and his family harvest salt straight from the rocks (*see page 244*); the beautiful white grains are of exceptional taste and quality, and refine my cooking every day. I'm often asked about the deliciously salty flavor of my cooking and the answer is so simple: It comes from the clear blue Mediterranean Sea. I mostly use sea salt that's been finely ground with a mortar and pestle, but for oven roasting or creating a crunchy topping, I stick to the large, flaky crystals.

Although I find the thyme, sage, and rosemary from my mother's garden to be the most fragrant in the world, I do grow them, along with a selection of other **herbs**, on my window-sill. Most of the pots stay outside until Berlin's frosty winter kicks in. Basil, chervil, oregano, marjoram, tarragon, and savory all grow happily in my city garden, and beat any dried herb, which I rarely ever use.

When it comes to **citrus**, especially the zest or peel, it's essential to buy **organic** produce, and to rinse and scrub the skin well. A stiff **vegetable brush** is helpful.

Cheese is always freshly grated or sliced; pre-packed products lack aroma and taste. In general, I prefer strong, aromatic cheese for cooking. Soft chèvre is the exception; its milky sourness fits perfectly with spring greens.

I use white spelt **flour** for all of my baking recipes, both sweet and savory, though the recipes in this book call for all-purpose flour. White spelt flour weighs as much as unbleached all-purpose wheat flour **(1 cup equals 130 g / 4½ ounces)** and has almost the same qualities in taste and texture. You can use the same amount of unbleached all purpose wheat or white flour or white spelt flour for all of my recipes; I simply prefer spelt's nutritional value. For pizza dough and buns, I use fast-acting yeast and let the **yeast dough** rise in a warm environment or 100°F (35°C) oven. Letting dough rise at room temperature prolongs the process.

You will find two kinds of extra-virgin **olive oil** on my shelves: a simple one for cooking, and a finer one, with a stronger flavor, that I use for cold dressings and to make adjustments at the table. I use a basic **sunflower oil** for deep-frying, which is a rather rare event.

A thick, dark **balsamic vinegar** and a white balsamic vinegar are always at hand. The lighter one, perfect for deglazing crisp bacon or for fruity dressings, can be replaced with high-quality white wine vinegar. Classic dark balsamic is my everyday addition to vinaigrettes.

Capers and **anchovies** are preserved in salt. For **preserved lemons**, I prefer to use my recipe on page 239.

I make my own **broth** (*see page 239*) for my soups and sauces, as instant products tend to have an unpleasant artificial note. Nothing beats the pure concentrated flavor of a homemade broth, ready to add taste and depth to further creations.

salads

PERSIMMONS, MOZZARELLA, PROSCIUTTO DI PARMA, AND BASIL
WITH MAPLE VINAIGRETTE

ARUGULA, GRAPE, AND CHICKPEA SALAD WITH ORANGE BLOSSOM DRESSING

GREEN BEAN, ARTICHOKE, AND GRAPEFRUIT SALAD WITH OLIVES AND ROSEMARY

CABBAGE AND PEAR SALAD WITH BALSAMIC BACON

WARM SALAD OF SAUTÉED CARROTS, PRESERVED LEMON, AND MINT

ENDIVE AND STRAWBERRY SALAD WITH PINK PEPPERCORNS

FENNEL AND MELON CARPACCIO WITH CHERVIL

CUCUMBER, ARUGULA, AND ORANGE SALAD WITH TURMERIC AND MINT

MEDITERRANEAN POTATO AND FAVA BEAN SALAD WITH ARUGULA AND LEMON PESTO

ROASTED PEPPERS AND CHERRY TOMATOES WITH BURRATA, LEMON, AND BASIL

RADICCHIO, PEACH, AND ROASTED SHALLOT SALAD WITH BLUE CHEESE

RED CABBAGE AND POMEGRANATE SALAD WITH CANDIED WALNUTS AND ROSEMARY

ZUCCHINI, SPINACH, AND TOMATO SALAD WITH LIME VINAIGRETTE

persimmons, mozzarella, prosciutto di parma, and basil with maple vinaigrette

Whenever I spot ripe persimmons at the market—honey-sweet and plump, so soft that their golden skin can barely hold its juices—I have to buy a bunch of them. They're one of those fruits that offer a sensory experience of pure bliss, but only when they're perfectly ripe, and that's often limited to a day or two. As with avocados, mangos, and kiwis, it can be challenging to find the perfect moment to cut open a persimmon. They can be glorious and memorable, but there's always the potential for disappointment. Still, when the time is right, I only need a spoon to scoop out their syrupy sweetness.

Many, many years ago in Paris, I ate the first and also the best persimmons of my life. I bought two of them and they were so soft that they almost slipped out of my hands as I pulled off the stems. Eating those persimmons was a mess, but also a true pleasure. I might have been a little biased by the city's beauty and the fact that I was still an excitable teenager, but I'll never forget my first taste of this jelly-like fruit.

For salads, I like to tear persimmons into luscious chunks, and for one of the most sensual salads I know, I pair it with creamy bites of mozzarella di bufala and the thinnest slices of prosciutto di Parma. Finished with basil and a maple syrup vinaigrette, it's heavenly. Needless to say, this decadent salad is practically made for a romantic dinner for two.

SERVES 2 TO 4

FOR THE DRESSING

2 tablespoons olive oil

1 tablespoon white balsamic vinegar

½ teaspoon maple syrup

Fine sea salt

Ground pepper

2 very ripe and soft persimmons, peeled and torn into chunks

4½ ounces (125 g) mozzarella di bufala, drained and torn into bite-sized chunks (*double the amount for 4 servings*)

8 very thin slices prosciutto di Parma or prosciutto di San Daniele

1 small handful fresh basil leaves

A few black peppercorns, crushed with a mortar and pestle (optional)

For the dressing, whisk together the olive oil, vinegar, and maple syrup. Season to taste with salt and pepper.

Arrange the persimmons, mozzarella, and prosciutto on a large platter or individual plates. Drizzle with the dressing, sprinkle with the basil and crushed peppercorns, if desired, and serve immediately.

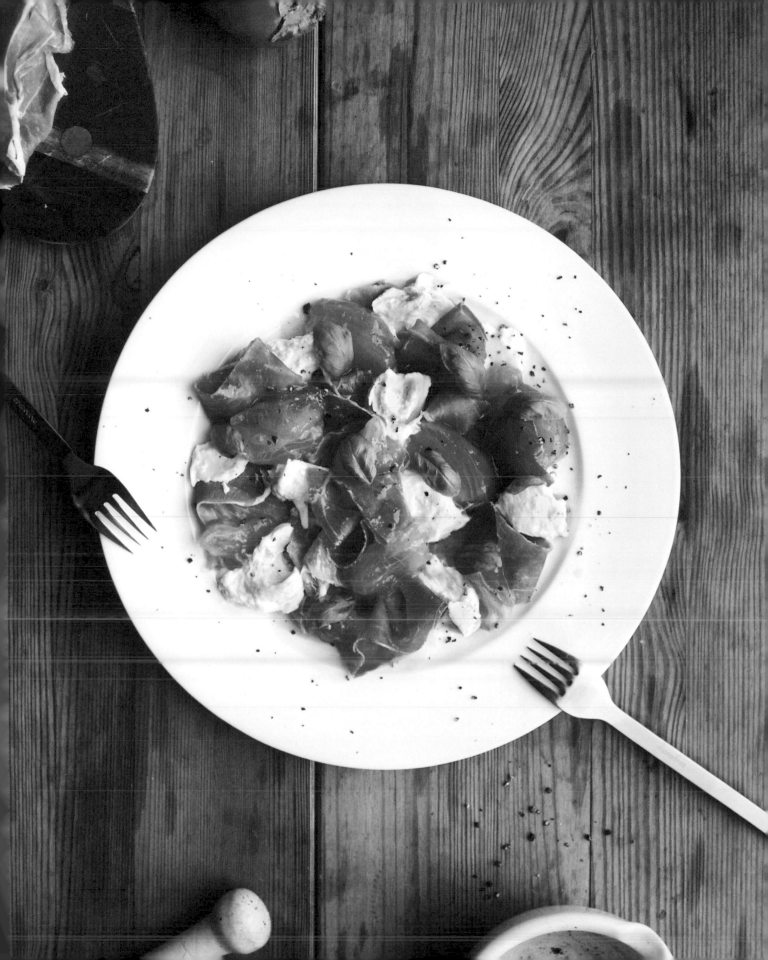

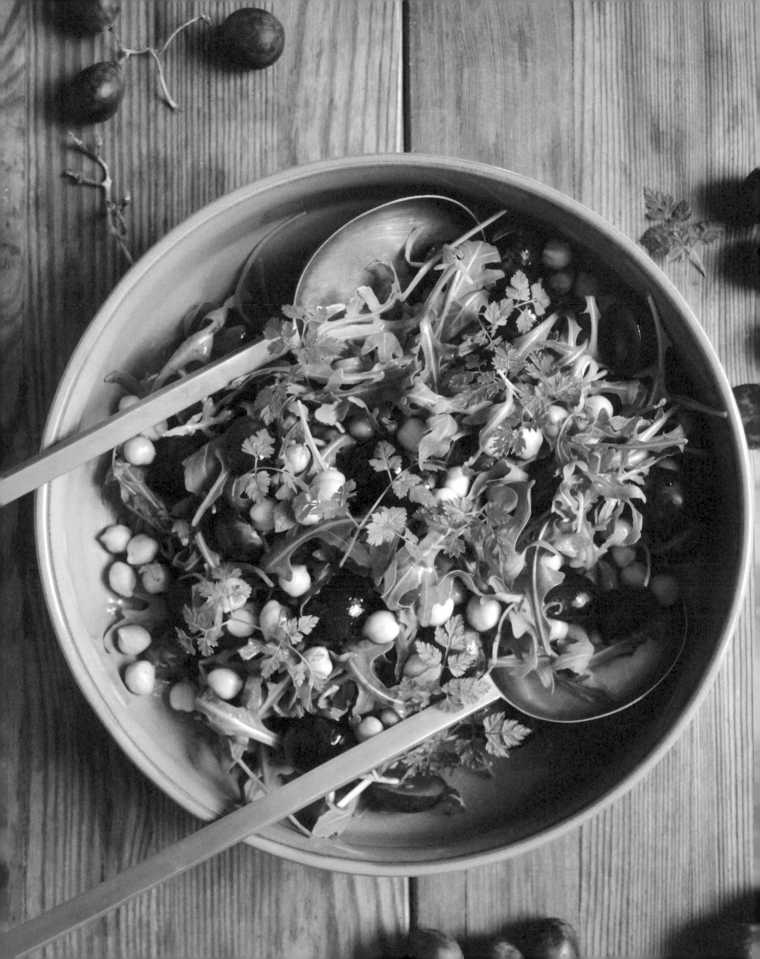

arugula, grape, and chickpea salad
with orange blossom dressing

Some of the best recipes emerge out of a spontaneous mood. The inspiration can come from a quick look in the fridge, a stroll through the farmers' market, or a chat with a friend. Within a split second, a whole dish can appear in front of my eyes and all I have to do is go to the kitchen and cook what my mind created.

This recipe arose from one of these magical moments. As I was rinsing firm arugula leaves under cold water, I felt their rough surface. Looking around, I spotted plump, dark grapes lying gracefully on a white plate. I immediately thought of chickpeas and in the next second I found myself imagining the smell of the orange blossoms in my Maltese mama's garden in Msida. My salad was born: spicy and crisp arugula, ripe grapes, velvety legumes, and a beautiful flowery dressing made of olive oil, freshly squeezed orange juice, and fragrant orange blossom water.

The taste of orange blossom water depends a lot on quality. Some products resemble soap rather than the bloomy elegance of orange blossoms. It's worth seeking out an organic brand and spending a little more money. This essential water is strong, so you won't need more than a teaspoon or two, and it's really only enjoyable if it manages to capture the natural essence of the blossoms, which is very different from any artificial flavoring.

SERVES 2 TO 4

FOR THE DRESSING

3 tablespoons olive oil

2 tablespoons freshly squeezed orange juice

2 teaspoons high-quality orange blossom water, preferably organic

Fine sea salt

Ground pepper

2 large handfuls arugula leaves

5 ounces (140 g) red grapes, preferably seedless, cut in half *(remove the seeds if necessary)*

¾ cup (140 g) drained and rinsed canned chickpeas (or ⅓ cup [60 g] dried chickpeas*)

1 small handful fresh chervil leaves

For the dressing, whisk together the olive oil, orange juice, and orange blossom water. Season to taste with salt and pepper.

Arrange the arugula, grapes, and chickpeas in a large bowl. Drizzle with the dressing, garnish with chervil, and serve immediately.

* If using dried chickpeas, soak them in cold water overnight then cook them in plenty of simmering water (without salt) for about 1 hour or until completely soft. Drain the chickpeas, quickly rinse, and let cool.

green bean, artichoke, and grapefruit salad with olives and rosemary

It's not hard to fall for green beans, cooked al dente and bursting with crunchiness. Their sweet and grassy taste makes it easy to experiment with flavors and textures. In this dish, green beans are side by side with bittersweet pink grapefruit, tender preserved artichokes, and assertively fruity Kalamata olives. A light orange dressing, refined with woody rosemary, wraps up this vibrant composition.

This salad is like a colorful antipasti platter, but instead of having different treats arranged separately on a plate, everything is tossed together to create one adventurous dish. It's crisp and soft, juicy and unctious, tart and sweet.

SERVES 2 TO 4

10 ounces (280 g) trimmed green beans

1 pink grapefruit

4 artichoke hearts, preserved in olive oil, cut into quarters

8 black olives, preferably Kalamata

FOR THE DRESSING

3 tablespoons olive oil

3 tablespoons freshly squeezed orange juice

1 heaping teaspoon finely chopped fresh rosemary

Fine sea salt

Ground pepper

FOR THE TOPPING

A few fresh rosemary needles

A few black peppercorns, crushed with a mortar and pestle

Bring a large pot of salted water to a boil and blanch the beans for 4 to 5 minutes or until al dente (the cooking time can vary depending on the freshness of the beans). Drain and quickly rinse them with cold water. Set aside. You can prepare the beans in advance and keep them covered in the fridge.

To cut the grapefruit into segments, first peel off the outer skin then cut off the white pith. Working over a bowl, hold the grapefruit in one hand and use a small, sharp knife to cut between the membranes and release the segments into the bowl.

For the dressing, whisk together the olive oil, orange juice, and rosemary. Season to taste with salt and pepper.

In a large bowl, toss together the green beans, grapefruit, artichokes, and olives. Drizzle the dressing over the salad, sprinkle with a few rosemary needles and crushed peppercorns, and serve immediately.

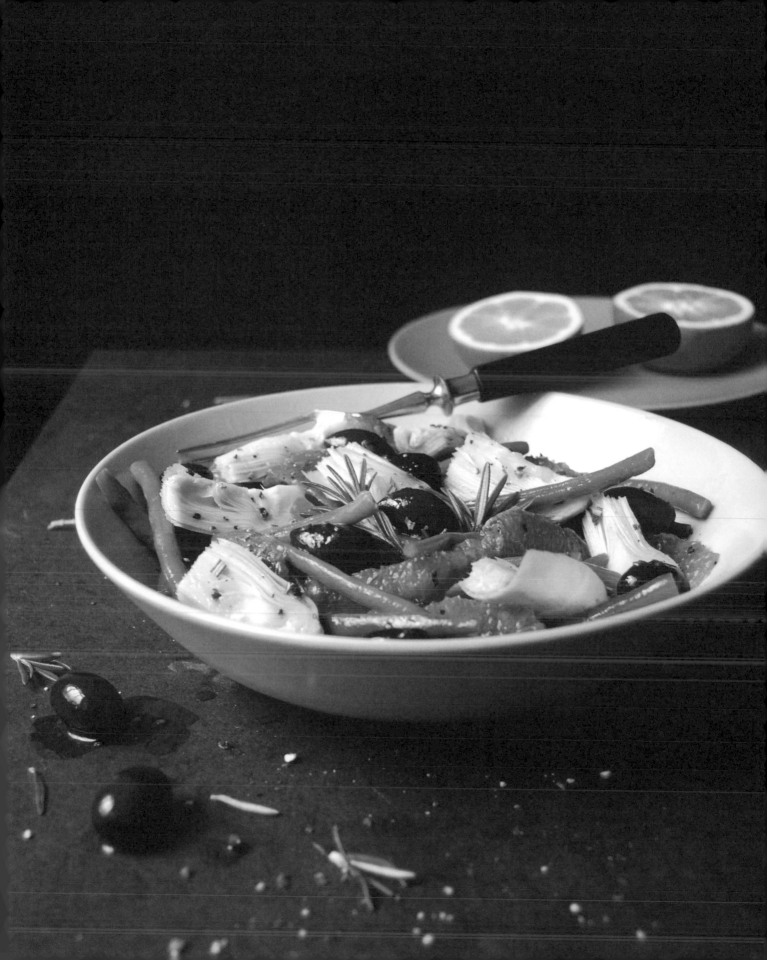

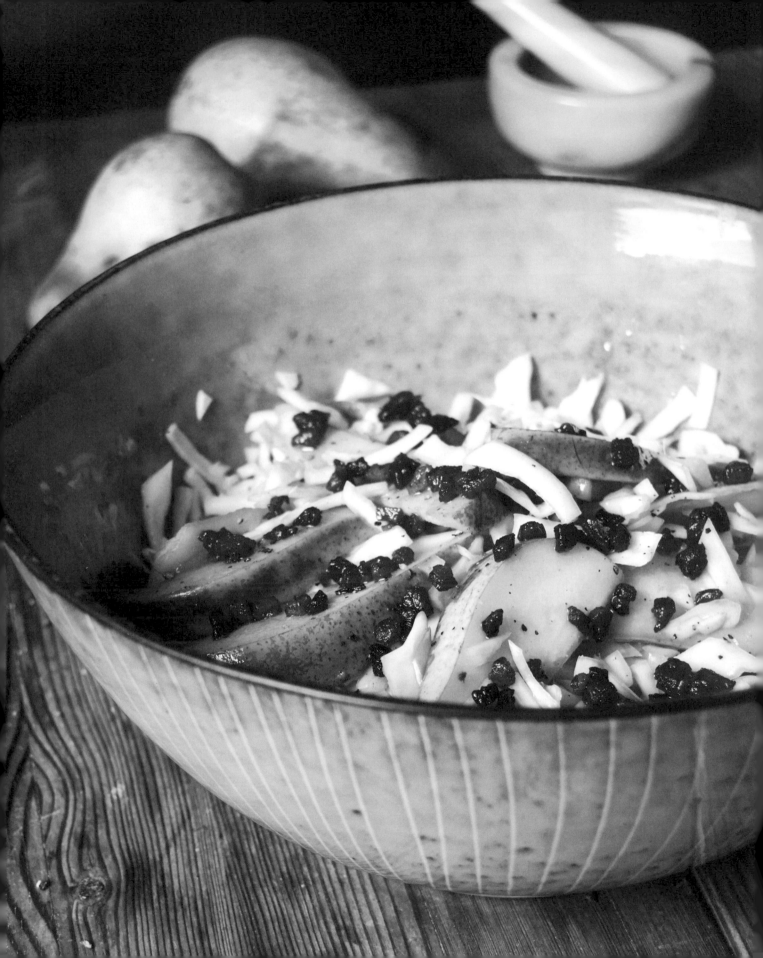

cabbage and pear salad with balsamic bacon

Each season offers plenty of tasty produce. Young, crisp greens appear in spring, then colorful, juicy vegetables and fruits store the light and warmth of summer's sun, before we move on to autumn's glowing squash and roots, and winter's cabbages. Luckily, my culinary mood tends to follow what nature bestows. It's only at the end of winter, a season that can be annoyingly long in Berlin, that a rising impatience interferes with my enjoyment in the kitchen.

At the beginning of the cold season, as the days get shorter, I indulge in hearty treats and the coziness of our home. In early November, the cabbages at the market still fill me with excitement and I'm inspired to update traditional family recipes with new ideas to create the most satisfying comfort food. There's a salad made with chopped cabbage and crunchy balsamic bacon that's popular in Bavaria and Swabia in southern Germany. My mother makes this recipe quite often; she's the one who introduced me to the genius dressing you get when the vinegar merges with the bacon juices in the pan. It has an oily smoothness and is sweet, salty, and sour. I add pear slices for the perfect contrast to the cabbage's spiciness and the salty meat.

SERVES 2 TO 4

Fine sea salt

1 pound (450 g) cored white or green cabbage, cut in half and thinly sliced

Olive oil

4 ounces (110 g) thick-cut bacon, cut into very small cubes

3 tablespoons white balsamic vinegar, plus more to taste

1 large firm pear, cored and cut into thin wedges

A few black peppercorns, crushed with a mortar and pestle

In a large bowl, sprinkle ½ teaspoon of salt over the cabbage and rub it in with your fingers for about 1 minute. Let sit for 10 to 20 minutes to soften the cabbage.

In a medium, heavy pan, heat a splash of olive oil over medium-high heat and cook the bacon for about 5 to 6 minutes or until crispy and golden brown. Deglaze the pan with the vinegar, add the pear wedges, and stir gently. Carefully pour the bacon, pear, and any sauce from the pan over the cabbage, toss gently, and season to taste with the crushed peppercorns and additional vinegar. You might have to add a little more salt depending on the bacon's saltiness. If you find the salad too dry, add a splash of olive oil. Serve immediately or let it sit for up to 1 day in the refrigerator.

warm salad of sautéed carrots, preserved lemon, and mint

I regret that I experienced the salty-sour deliciousness of Moroccan preserved lemons so late in my culinary life. My aunt Ursula introduced me to this North African delicacy when she bought a tiny jar from the gourmet section of one of our favorite Berlin food stores. Despite her excitement, the price almost made her fall over. I got absolutely hooked on them, so much so that it could have caused a noticeable gap in my bank account. Instead, I decided to try making our favorite new discovery at home. It's not easy to find the small, thin-skinned lemons used in Morocco, so I had to be a bit experimental, but with a few strategic cuts into the peel, regular lemons work just as well.

After weeks of patience, I was rewarded with stunning results. Juicy preserved lemon is quite salty, but in a very pleasant way and it's now a frequent addition to my vegetables, lamb, and even pizza—with chèvre, it's fantastic. And whenever a dish needs more than just a hint of citrus, I always turn to preserved lemon to add a strong, exotic touch. Fresh mint goes very well with it, especially when there are crunchy sautéed carrots on the plate.

This salad can be served as a side—it's delicious with the Spiced Braised Lamb Shanks (*see page 156*)—but there's something very satisfying about a single golden bowl of lemony carrots at lunch.

You can find the recipe for preserved lemons on page 239, or use a squeeze of lemon juice and a bit of zest instead.

SERVES 2

Olive oil

14 ounces (400 g) peeled carrots, thickly sliced

¼ preserved lemon, very thinly sliced (*see page 239*)

1 teaspoon liquid from the preserved lemons, plus more to taste

Flaky sea salt

Ground pepper

15 fresh mint leaves, thinly sliced

FOR THE TOPPING

2 fresh mint leaves, sliced

In a medium saucepan, heat a generous splash of olive oil over medium-low heat. Add the carrots, along with the preserved lemon and its liquid. Season with a little flaky sea salt and pepper, cover the pan, and cook for about 3 minutes or until the carrots are al dente. Stir in the mint and season to taste with flaky sea salt, pepper, and more of the liquid from the preserved lemons.

Sprinkle with additional mint, and serve warm or cold.

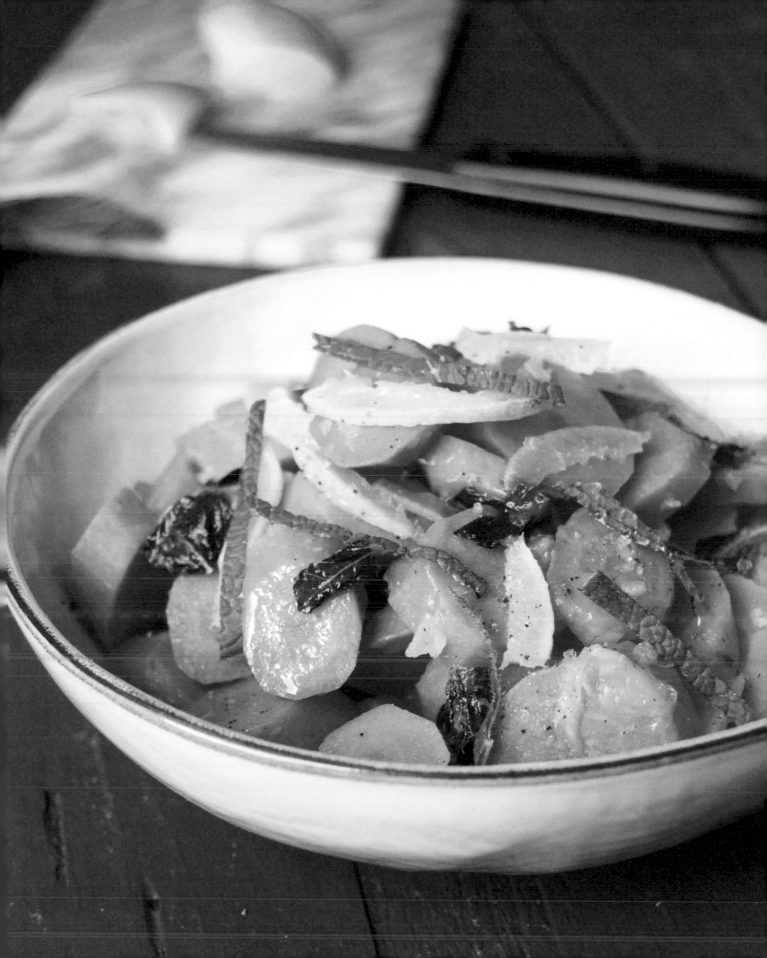

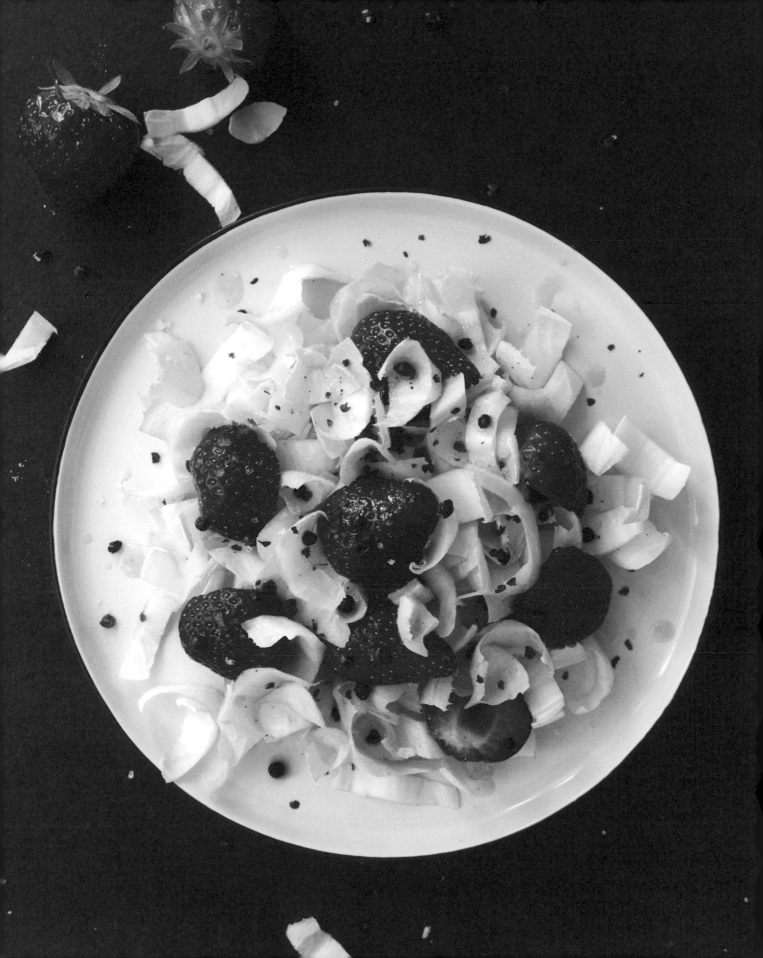

endive and strawberry salad
with pink peppercorns

Early summer welcomes a funny attraction to the streets of Berlin: Little stalls, just big enough for two people to stand in, are painted like giant strawberries and turned into miniature shops. It's not hard to guess what they offer. This is strawberry heaven packed into a fiberglass box. It's a family-run business that grows the sweetest, juiciest—simply the best—strawberries, and brings them into the city when they're at their peak. The stalls pop up all over Berlin, but if you have trouble spotting them, just look for the endless lines that form out front. Even people who normally squeeze their grocery shopping into less than ten minutes are willing to wait patiently in line to enjoy the freshest and prettiest fruit.

In the first couple weeks of this exciting event, I don't even think about mixing the berries with any other flavors. It's just about strawberries, eaten fresh out of the box. But at some point, after baskets of berries have been snacked away at breakfast, lunch, and dinner, I feel ready to let them loose in recipes. Apart from baking (*see the Strawberry and Ricotta Olive Oil Muffins on page 210 and my Strawberry–Ricotta Cheesecake on page 234*), I love to use strawberries in salads. Give them a bitter contrast, like crunchy Belgian endive and some pink peppercorns, and their sweetness sparkles even more.

I know there are great places for strawberries all over the world, and in a beautiful way, this fruit is often connected to childhood memories. Where I grew up, in the west of Germany, we used to pick and eat them straight from the fields and I could never get enough berries in my little belly. Over the years I've enjoyed their deliciousness in Malta, where strawberry season starts a couple months earlier than in northern Europe, and with great pleasure, I've indulged in piles of berries in the US, France, and Italy, but I've never seen Berlin's strawberry stalls anywhere else, which makes them special to me.

SERVES 2

FOR THE DRESSING

3 tablespoons olive oil

2 tablespoons white balsamic vinegar

Fine sea salt

Ground pepper

10 ounces (280 g) Belgian endive, cut in half and thinly sliced (about 2 to 3 endives)

10 ounces (280 g) hulled ripe strawberries, cut in half

Flaky sea salt

1 to 2 teaspoons pink peppercorns, lightly crushed with a mortar and pestle

For the dressing, whisk together the olive oil and vinegar. Season to taste with salt and pepper—only use a little salt, as the salad will be sprinkled with flaky sea salt.

Arrange the endive and strawberries on 2 plates, drizzle with the dressing, sprinkle with the flaky sea salt and crushed pink peppercorns, and serve immediately.

fennel and melon carpaccio with chervil

A few years ago, a friend of mine served a refreshing summer cocktail at a birthday party. He scooped out tiny balls of ripe Galia melon, dropped them into glasses of pastis, and that was it—done. It was so simple yet so good that it immediately earned a spot in my repertoire.

People tend to either love or hate anise-flavored spirits and I'm definitely one of the former—I'm a huge fan of this French apéritif. Sitting on a beach, watching the setting sun and sipping a glass of Ricard or Pernod with a generous splash of water and a few ice cubes, is simply perfection. The smell is mesmerizing; even my boyfriend, who doesn't like pastis at all, is always happy when I order it. The anise aroma, combined with the salty sea air, is better than any perfume. It also works in the city, where warm memories of summer come alive as soon as I open the bottle. When I came up with the recipe for this fennel and melon carpaccio, I had my friend's cocktail and the rocky beach scene in mind.

My favorite way to prepare fennel is to slice it very thinly, which makes this stringy vegetable easier to eat, while preserving its crisp texture. Fennel has a strong flavor and demands a confident partner. I often mix it with salty capers, olive oil, and freshly squeezed lemon juice, but when I can get hold of a ripe melon, I always go for this elegant salad.

SERVES 2 TO 4

FOR THE DRESSING

3 tablespoons olive oil

2 tablespoons white balsamic vinegar

Fine sea salt

Ground pepper

1 (10-ounce / 280-g) fennel bulb, cut in half lengthwise, cored, and very thinly sliced

1 small ripe Galia melon or cantaloupe, peeled, cut into quarters, and very thinly sliced

1 small handful fresh chervil leaves

For the dressing, whisk together the olive oil and vinegar. Season to taste with salt and pepper.

Arrange the fennel and melon in overlapping layers on plates then drizzle with the dressing, sprinkle with the chervil, and serve immediately.

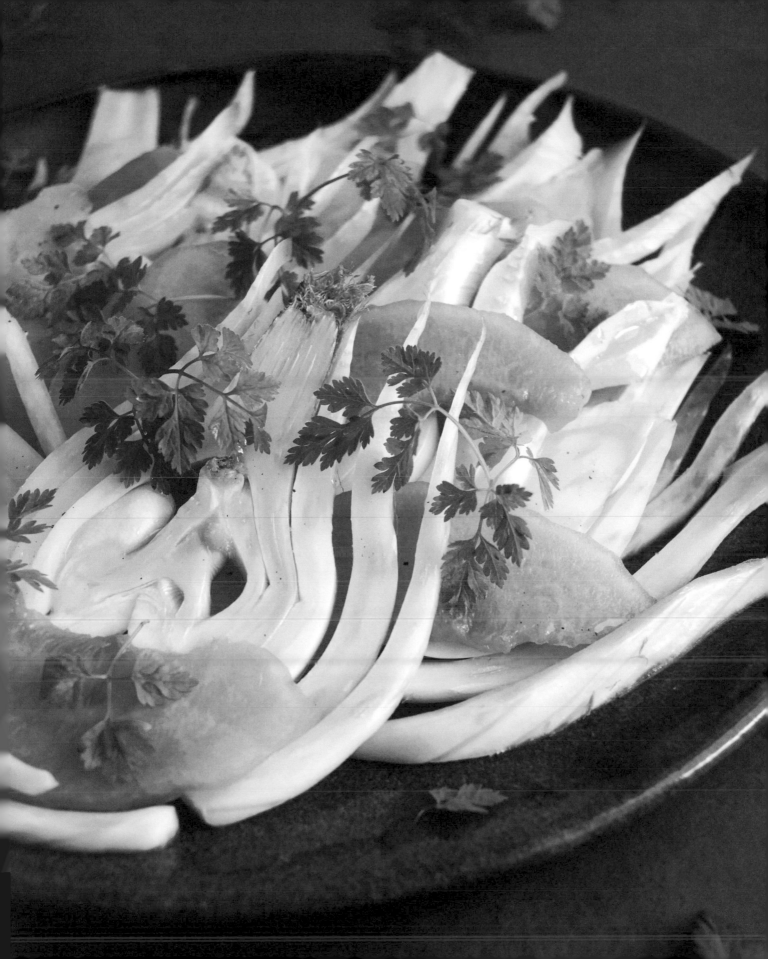

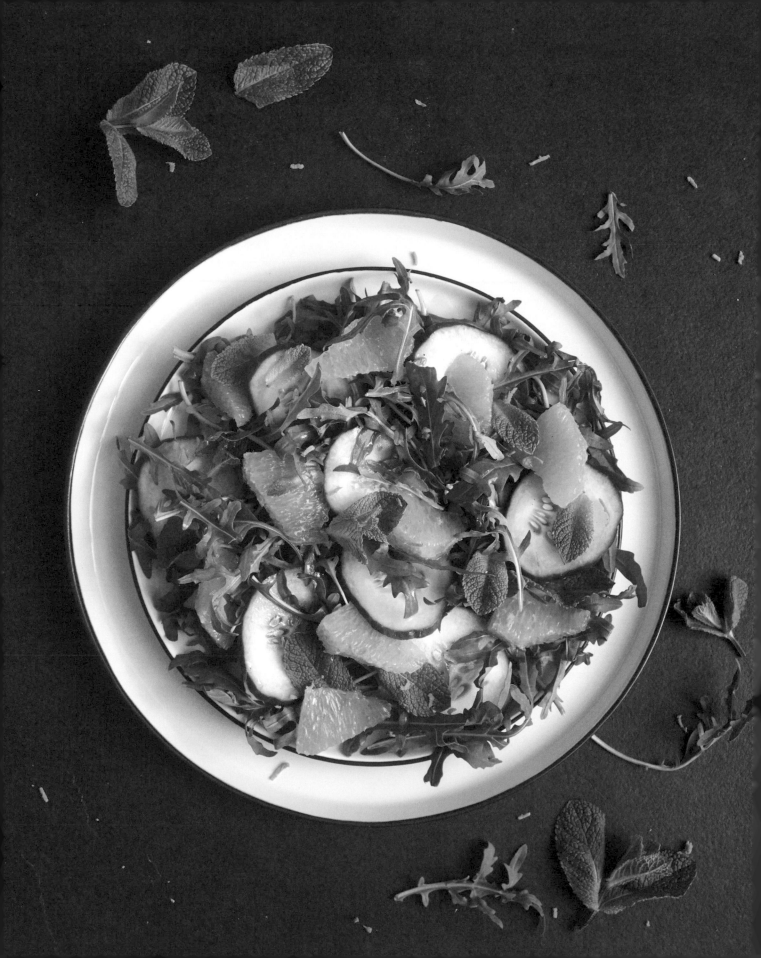

cucumber, arugula, and orange salad
with turmeric and mint

This salad combines the two culinary worlds that influence my kitchen the most: Nordic comfort food and Maltese cuisine, which is rooted in the Mediterranean but has traces of Arabic and British cooking. I'm talking about a salad that you can find in any German home, as soon as cucumbers come into season in June or July. I try my best to accept the natural rhythm of the seasons and adapt my choice of recipes, so when I spot the first cucumbers, firm and dark, and fresh from the fields, I know it's time to slice them up for fresh salads.

Tossing cucumbers in a light vinaigrette or yogurt dressing with lots of dill would be the German approach. Adding spicy arugula leaves, juicy orange, and fresh mint transforms this dish into a Mediterranean explosion of vibrant colors and flavors. The dressing is made with warming turmeric that's freshly grated and mixed with olive oil and sweet orange juice. This saffron-hued root can be hard to find at times, but you can replace it with freshly grated ginger.

SERVES 2

FOR THE DRESSING

3 tablespoons olive oil

3 tablespoons freshly squeezed orange juice

⅛ to ¼ teaspoon freshly grated turmeric (or ginger), plus more to taste

Fine sea salt

Ground pepper

1 to 1½ oranges

1 large handful arugula leaves

12 ounces (340 g) cucumber, scrubbed and very thinly sliced

1 small handful fresh mint leaves

For the dressing, whisk together the olive oil, orange juice, and turmeric. Season to taste with salt and pepper.

To cut the orange into segments, first peel off the outer skin then cut off the white pith. Hold the orange in one hand and use a small, sharp knife to cut between the membranes and release the segments.

Arrange the arugula leaves, cucumber slices, and orange segments on 2 plates. Drizzle with the dressing, sprinkle with the mint leaves and a little more grated turmeric, and serve immediately.

mediterranean potato and fava bean salad
with arugula and lemon pesto

I used to think of potato salad as easy party food. The German take, thick with mayonnaise and served with gherkins and wieners, is often quite filling to make sure no one leaves hungry. Years later, I gladly experienced a lighter variation, thanks to my stepfather, Uli, who grew up in southern Germany, in Stuttgart, and introduced my family to his grandmother Martha's recipe, a Swabian rendition in which the potatoes are sliced or grated, and mixed with fresh cucumber and a sweet and sour vinaigrette made with finely chopped onions cooked in vinegar (*see page 159*). It's basically the complete opposite of the traditional northern approach. This made me realize there was great potential to change that birthday party staple from my childhood into anything I wanted. I could even add pesto, as I do here.

When it comes to pesto, we tend to think of the classic basil version, pesto alla Genovese, but there's so much more to grind and pound: dried tomatoes, ramps, arugula, asparagus, broccoli (*see page 104*), nuts, zest, capers—I could go on endlessly. For this salad, I make two different kinds of pesto, one with spicy arugula leaves and another with lemon zest. It's a very fresh composition, perfect for a summery lunch or picnic, or for a party buffet.

SERVES 3 TO 4

FOR THE ARUGULA PESTO

3 ounces (80 g) arugula leaves

1 ounce (30 g) freshly grated young Parmesan

1 ounce (30 g) pine nuts

⅓ cup (75 ml) olive oil

Fine sea salt

FOR THE LEMON PESTO

2 tablespoons freshly grated young Parmesan

1 tablespoon olive oil

2 teaspoons freshly grated lemon zest, plus more to taste

1 teaspoon finely chopped pine nuts

21 ounces (600 g) scrubbed or peeled waxy potatoes, boiled

7 ounces (200 g) shelled and peeled fava beans (about 28 ounces [800 g] in pods)

Flaky sea salt

A few black peppercorns, crushed with a mortar and pestle

For the arugula pesto, purée the first 4 ingredients in a food processor or blender until smooth. Season to taste with salt.

For the lemon pesto, whisk together the ingredients and use the back of a spoon to press the Parmesan into the oil.

Cut the boiled potatoes into thick slices and set aside.

Bring a large pot of salted water to a boil and blanch the peeled fava beans for about 3 minutes or until al dente. Drain and quickly rinse with cold water.

Arrange the potatoes and fava beans on plates, drizzle with the arugula pesto and the lemon pesto, and season to taste with flaky sea salt and crushed peppercorns. Finish with a sprinkle of freshly grated lemon zest, if desired, and serve immediately.

If you don't use all the pesto, enjoy it with spaghetti or as a spread on dark, toasted bread.

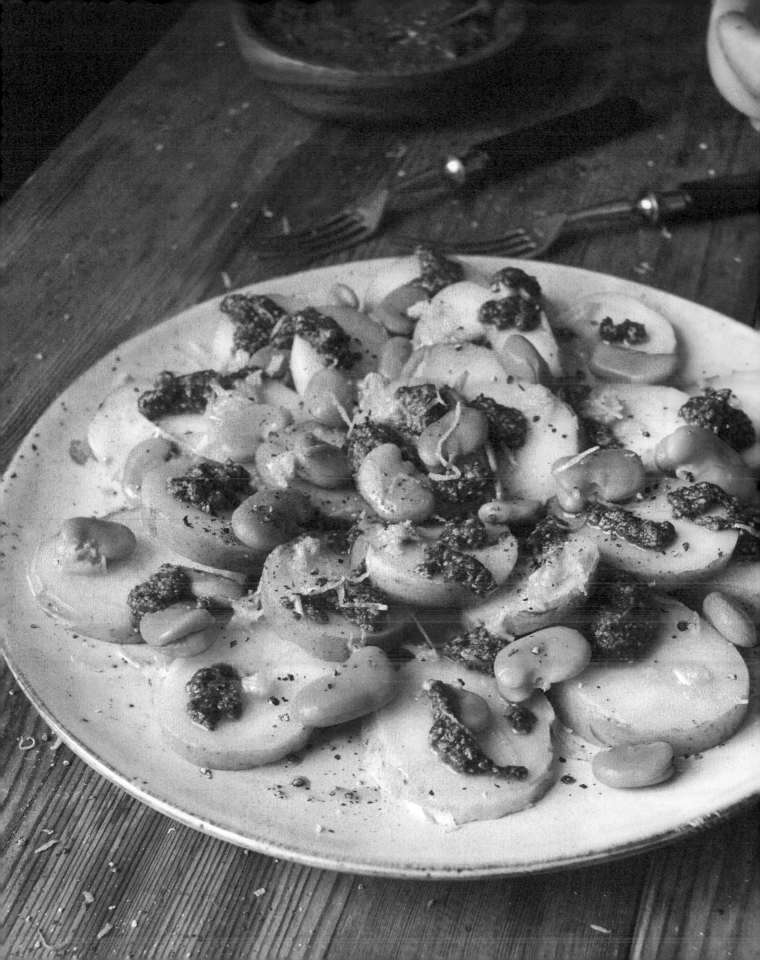

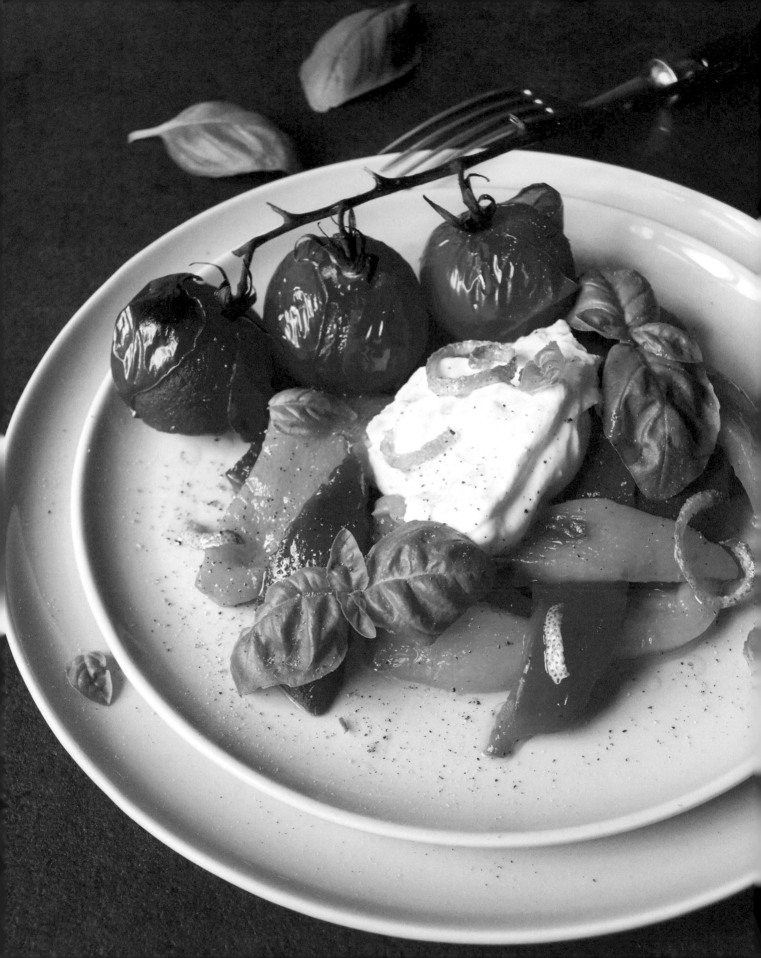

roasted peppers and cherry tomatoes
with burrata, lemon, and basil

There's a reason why insalata caprese is so popular all over the world. With its focus on just a few pure flavors, this simple combination of tomatoes, mozzarella, and basil satisfies even the most sophisticated gourmet. To enhance the salad's sweetness, and add a smoky element, I roast the tomatoes, plus a colorful mix of bell peppers, until they almost burst. I also use the heat to roast thin strips of lemon peel in olive oil, which creates a crunchy citrus topping and wonderful aromatic oil at the same time. Considering that we're already halfway to an extravagant summer lunch, I replace the mozzarella with heavenly, creamy Burrata.

SERVES 2 TO 4

4 long strips fresh lemon peel	3 bell peppers, preferably a mix of red, orange, and yellow	1 small handful fresh basil leaves
¼ cup (60 ml) olive oil		
8 cherry tomatoes, on the vine	4½ ounces (125 g) Burrata or mozzarella di bufala, drained and torn in half (double the amount for 4 servings)	Fine sea salt
		Ground pepper

Set the oven to broil (quicker method) or preheat to 425°F (220°C).

In a small broiler-proof baking dish, toss the lemon peel with the olive oil. Place the tomatoes and bell peppers in 2 separate large broiler-proof baking dishes.

Roast the lemon peel and oil for about 6 minutes or until the peel turns crisp and golden brown—mind that it doesn't get dark. Remove the dish from the oven and set aside.

Roast the tomatoes for about 12 minutes using the broil setting or 35 to 45 minutes at 425°F (220°C)—their skins should turn partly black and start to burst. Remove the tomatoes from the oven. Leave the tomatoes on the vine, but divide them into 2 to 4 portions and set aside.

Roast the bell peppers, turning them twice so they cook on 3 sides, until their skins turn partly black. The peppers need about 22 minutes using the broil setting or 30 minutes at 425°F (220°C). Remove the peppers from the oven and immediately cover them with a wet paper towel—this will make peeling easier. Let them cool for 2 minutes. Use a small, sharp knife to peel the peppers. Cut the peppers in half, scrape out and discard any seeds and fibers, and cut into strips.

Arrange the bell peppers and tomatoes on plates, and place some Burrata in the middle of each plate. Remove the lemon peel from the oil and cut it into small pieces. Drizzle the lemon oil over the salads, sprinkle with the lemon peel and basil, season to taste with salt and pepper, and serve.

radicchio, peach, and roasted shallot salad with blue cheese

Going to Malta for the first time, I had a very northern European idea of the islands and imagined a peaceful Mediterranean getaway. I expected to find lonely beaches and tranquil villages—a holiday cliché. However, I was introduced to an unknown world, so different from anything I had ever seen, heard, smelled, or tasted before. The towns and villages blend into each other to create a vivid density, a constant hustle—it's a bit like being in a beehive. I had to find my hidden spots, my personal favorites.

The stunning Fomm ir-Riħ, meaning "mouth of the wind," is one of them. On the western side of the island, this small pebble-beached bay, sunk into imposing cliffs, is only safely accessible through a small path along the cliff face that's camouflaged by the sandy white rock it's formed in. It's hidden so well that I couldn't find it on my first try. I had to take a rather long walk around the cliffs before sliding down a sandy slope and tumbling onto the beach. I must have looked quite exhausted, as a passing farmer offered me a peach that happened to be one of the juiciest and sweetest I've ever tasted. I'll never forget the pleasure of the first bite.

I wish I had that peach for this salad. The crunchy bitterness of radicchio, combined with sweet oven-roasted shallots and sharp blue cheese, fits so well with the fruit's honey-like juices.

SERVES 2 TO 4

8 shallots, peeled and cut in half lengthwise (or 4 small red onions, peeled and cut into quarters)

2 tablespoons olive oil

Flaky sea salt

Ground pepper

5 ounces (140 g) radicchio, soft leaves only, torn into pieces

4 ripe peaches, peeled and cut into 8 wedges each

2 ounces (60 g) Fourme d'Ambert, Stilton, or any crumbly blue cheese, crumbled

1 to 2 tablespoons fresh thyme leaves

FOR THE DRESSING

3 tablespoons olive oil

1 tablespoon balsamic vinegar

1 tablespoon white balsamic vinegar

1 teaspoon honey

Fine sea salt

Ground pepper

Preheat the oven to 425°F (220°C) and line a baking sheet with parchment paper.

Spread the shallots on the lined baking sheet, drizzle with the olive oil, and season to taste with flaky sea salt and pepper. Gently mix with your fingers and roast for 10 minutes. Flip the shallots over and roast for another 5 minutes or until golden brown and soft. Peel any hard or burnt layers off the shallots and set them aside. You can prepare the shallots in advance; they don't need to be warm.

For the dressing, whisk together the olive oil, both vinegars, and the honey; season to taste with salt and pepper.

Arrange the radicchio, peaches, and shallots in overlapping layers on plates, sprinkle with the crumbled cheese and thyme, drizzle with the dressing, and serve immediately.

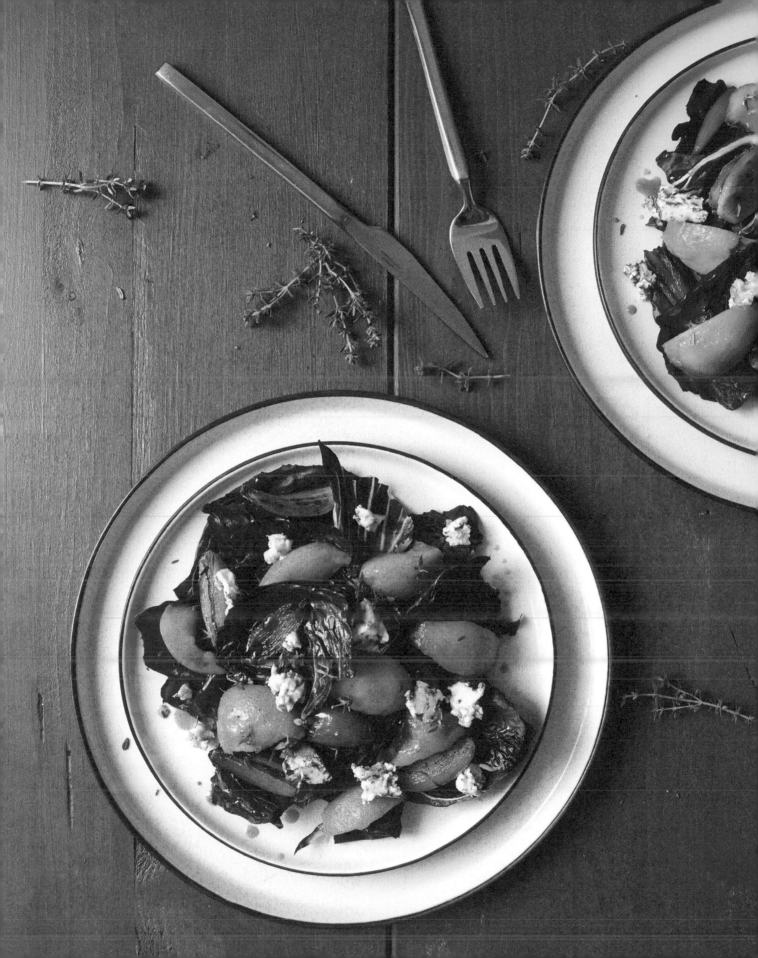

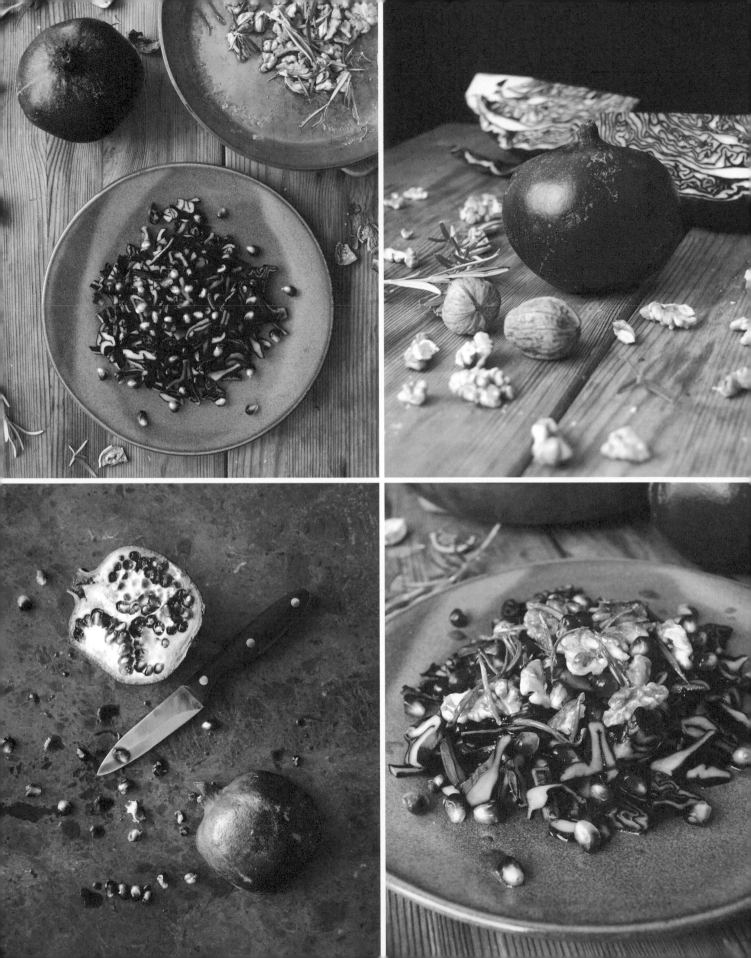

red cabbage and pomegranate salad with candied walnuts and rosemary

Crisp in texture and excitingly rich in flavor, this glowing salad is a festive beauty. Pungent cabbage combined with juicy pomegranate is delicious in its own right, but the addition of caramelized walnuts and rosemary turn this salad into a gem. Although I'm sure it would make a wonderful lunch, this dish is practically made for an elegant dinner.

You can easily prepare the salted cabbage, pomegranate, and dressing in advance, but I definitely recommend caramelizing the nuts and herbs just before serving. If you let them sit in the pan, even for a minute, you'll need a hammer to get them out. To limit stress, take a few minutes to give your full attention to the caramel. I believe I've mastered the art of multitasking, but if there's boiling sugar on the stove, my eyes and mind focus on one thing, and that's watching it carefully.

SERVES 2 TO 4

Fine sea salt

¾ pound (340 g) cored red cabbage, cut in half and thinly sliced

Seeds from ½ to 1 pomegranate

FOR THE DRESSING

3 tablespoons olive oil

1 tablespoon balsamic vinegar

1 tablespoon white balsamic vinegar

½ teaspoon honey

Fine sea salt

Ground pepper

FOR THE CARAMELIZED NUTS AND HERBS

3 tablespoons sugar

2 tablespoons water

1½ ounces (40 g) walnuts

Needles from 3 medium sprigs fresh rosemary

In a large bowl, sprinkle ⅓ teaspoon of salt over the cabbage and rub it in with your fingers for 1 minute. Let sit for 10 to 20 minutes to soften the cabbage.

For the dressing, whisk together the olive oil, both vinegars, and the honey; season to taste with salt and pepper. Taste the salted cabbage, and if you would prefer it a bit saltier, add more salt to the dressing.

Arrange the cabbage on plates, sprinkle with the pomegranate seeds, and drizzle with the dressing.

In a medium, heavy pan, heat the sugar and water over medium-high heat. Cook without stirring, until the mixture turns golden brown. Add the walnuts and rosemary and quickly stir to coat them in caramel. Take the pan off the heat and immediately use 2 forks to carefully divide the walnuts and rosemary among the salads. You have to do this quickly, while the caramel is still liquid—it becomes sticky and hard within seconds. If you can't get the nuts and herbs out of the pan, place the pan over low heat and melt the caramel again. Serve the salad immediately.

zucchini, spinach, and tomato salad with lime vinaigrette

Zucchini cut into thin tagliatelle, lightly sautéed, and folded into a pile of baby spinach is more than just a beautiful green feast for the eyes. It's the taste of summer and winter merged on a plate. The soft flesh of the jade-colored summer squash brings a distinct fruity note. It's sweet and mild, but against all odds, it can stand up to the comparatively hearty spinach. Baby spinach is not as bitter as the thicker winter leaves; it's rather tender, but you can still taste a hint of soil. Slightly earthy, the leaves are a welcome contrast to the juicy zucchini.

Colorful cherry tomatoes and toasted pine nuts hint at a late summer dish and the fresh oregano sprinkled on top makes it very clear that we're not yet into the cold season. Oregano can be replaced with milder marjoram, which is less pungent and more pleasant if you find oregano too harsh. I like both and tend to follow my mood—and the state of my plants.

The vinaigrette is light and citrusy. Using lime instead of lemon introduces a more flowery aroma, and the fruit's juice and zest, mixed with white balsamic vinegar, adds the right sour touch to round out this colorful salad.

SERVES 2 TO 4

Olive oil

7 ounces (200 g) zucchini, cut into long, very thin slices (use a mandoline or cheese slicer)

Fine sea salt

Ground pepper

1 large handful baby spinach leaves

7 ounces (200 g) ripe cherry tomatoes, cut in half

2 tablespoons toasted pine nuts

2 to 3 tablespoons fresh oregano or marjoram leaves

FOR THE DRESSING

¼ cup (60 ml) olive oil

1 tablespoon white balsamic vinegar

1½ teaspoons freshly grated lime zest

2 tablespoons freshly squeezed lime juice

Pinch of sugar

Fine sea salt

Ground pepper

In a large, heavy pan, heat a splash of olive oil over medium-high heat. Sauté the zucchini in batches: Arrange a few zucchini slices next to each other in the pan and cook for 1 minute. Flip the slices over, season to taste with salt and pepper, and cook for another 30 seconds or until soft and golden but not dark. Transfer to a plate and continue cooking the remaining slices, adding a little splash of olive oil before each batch.

Toss together the sautéed zucchini, spinach, and tomatoes on a large, deep plate.

For the dressing, whisk together the olive oil, vinegar, lime zest and juice, and the sugar. Season to taste with salt and pepper. Drizzle the dressing over the salad, garnish with the pine nuts and oregano, and serve immediately.

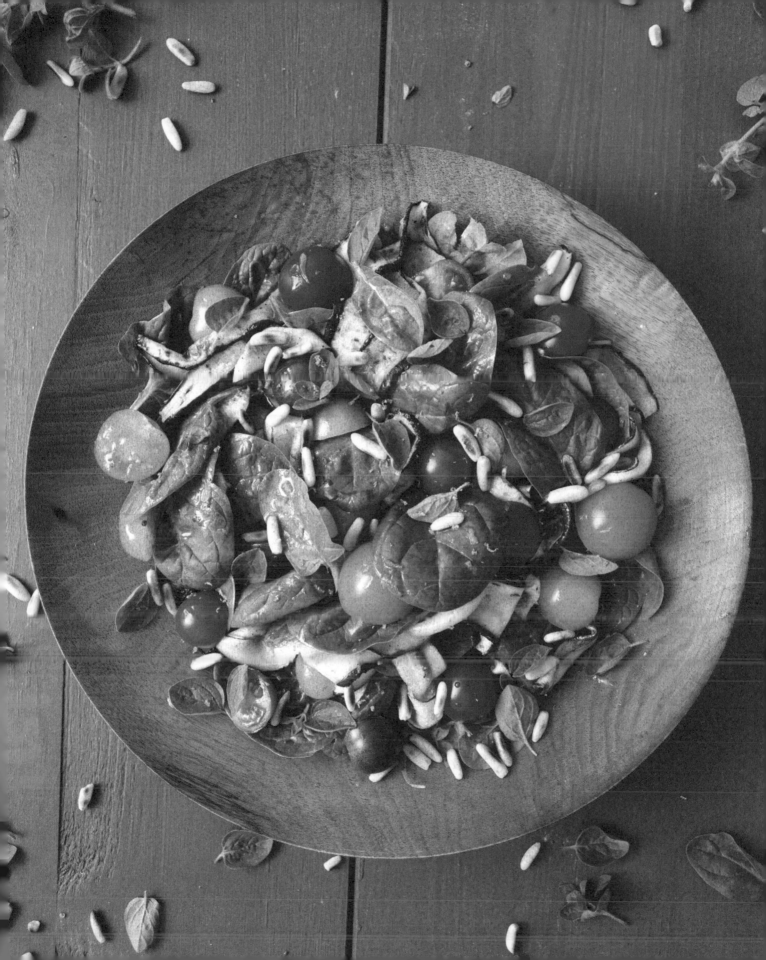

vegetables

CRISPY FRIED POTATOES WITH FENNEL

ROASTED ROOTS WITH GARLIC AND ROSEMARY MASHED BEANS

SAUTÉED SPINACH WITH ORANGE AND CARDAMOM

BELUGA LENTILS WITH POMEGRANATE AND DUKKAH

CUMIN-ROASTED SQUASH WEDGES WITH PISTACHIO-FETA DIP

WHITE ASPARAGUS WITH SORREL CRÊPES AND BOZEN SAUCE

POTATO–SAUERKRAUT LATKES WITH JUNIPER SOUR CREAM DIP

SPICY CAULIFLOWER WITH HARISSA, LEMON, AND PARSLEY YOGURT DIP

SAUTÉED ENDIVE WITH BALSAMIC BUTTER AND MARJORAM

FETA, ARTICHOKE, AND ZUCCHINI CASSEROLE WITH OLIVES AND CAPERS

MEDITERRANEAN MASHED POTATOES WITH CORIANDER OIL

ROASTED BRUSSELS SPROUTS WITH GINGER AND LEMON

crispy fried potatoes with fennel

Fennel tends to be either cherished for its licorice sweetness or passionately rejected for the very same reason. I adore it, seed to bulb. I bought my first Maltese fennel seeds from a woman at a farmers' market in Marsaxlokk, a village in southern Malta. Her *bużbież* (Maltese for "fennel seeds") comes in unspectacular plastic bags, but their fragrance is indescribably mesmerizing and addictive.

Fennel grows like weeds under the hot Mediterranean sun, its sturdy roots digging persistently into the red limestone soil of the *garigue*. This rocky ground looks a bit like a moon landscape, fissured and parched, but the soil is rich in minerals. It nurtures wild flowers and herbs, and adds a strong aroma to the vegetation, including my beloved fennel. Because of this, I started a tradition: I only buy seeds in Marsaxlokk, and visit the lady once a year to fill the jars in my kitchen.

In this recipe, I celebrate fennel with a mélange of the plant's crunchy roasted seeds, thin slices of the tender bulb, and its filigree-like fronds, all stirred into fried potatoes. I always boil the potatoes a few hours—or even a day—before I fry them, as they need to be fully dry to fry up golden and crispy.

SERVES 2 TO 3

1½ pounds (700 g) peeled waxy potatoes, boiled, drained, and dried

Olive oil

Flaky sea salt

A few black peppercorns, crushed with a mortar and pestle

1½ tablespoons high-quality fennel seeds, preferably organic

1 small fennel bulb, cut in half lengthwise, cored, and very thinly sliced

A few fennel fronds, chopped, for the topping

Let the potatoes dry and cool completely on a wire rack for several hours, then cut into thick rounds.

In a large, heavy pan, heat a generous splash of olive oil over medium-high heat. Working in batches, add 1 layer of potatoes to the pan and fry, without moving, for a few minutes or until golden brown and crisp on the bottom. Using 2 forks, carefully flip the potatoes over, 1 at a time, and continue frying for a few minutes or until golden brown and crisp on the other side. Season to taste with flaky sea salt and crushed peppercorns. Transfer to a large baking dish, cover, and keep warm. Repeat with the remaining potatoes, adding more oil if necessary.

In the same pan, heat a generous splash of olive oil over medium heat. Add the fennel seeds and toast, stirring, for about 1 minute or until light golden brown. Mind the heat—the seeds can burn within seconds and turn bitter. Transfer to a bowl and set aside.

Place the pan back over medium heat and add a little oil if necessary. Sauté the sliced fennel, stirring, for about 2 minutes or until golden and al dente. Add the potatoes and fennel seeds and continue to cook, stirring gently, for 1 to 2 minutes. Season to taste with flaky sea salt and crushed peppercorns, sprinkle with the chopped fennel fronds, and serve.

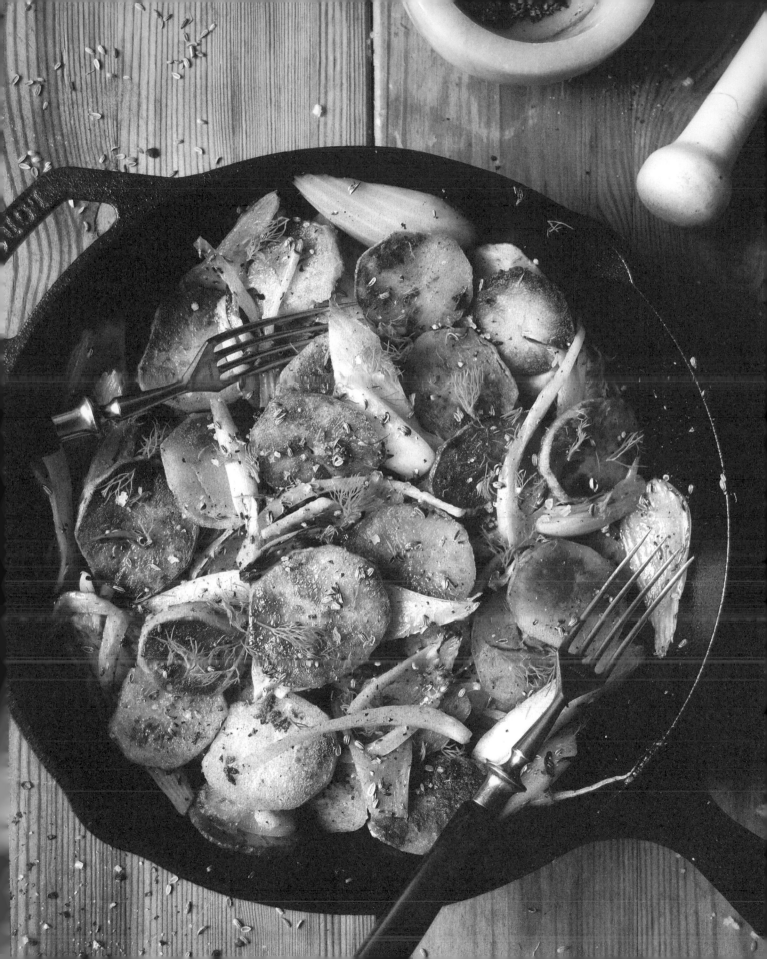

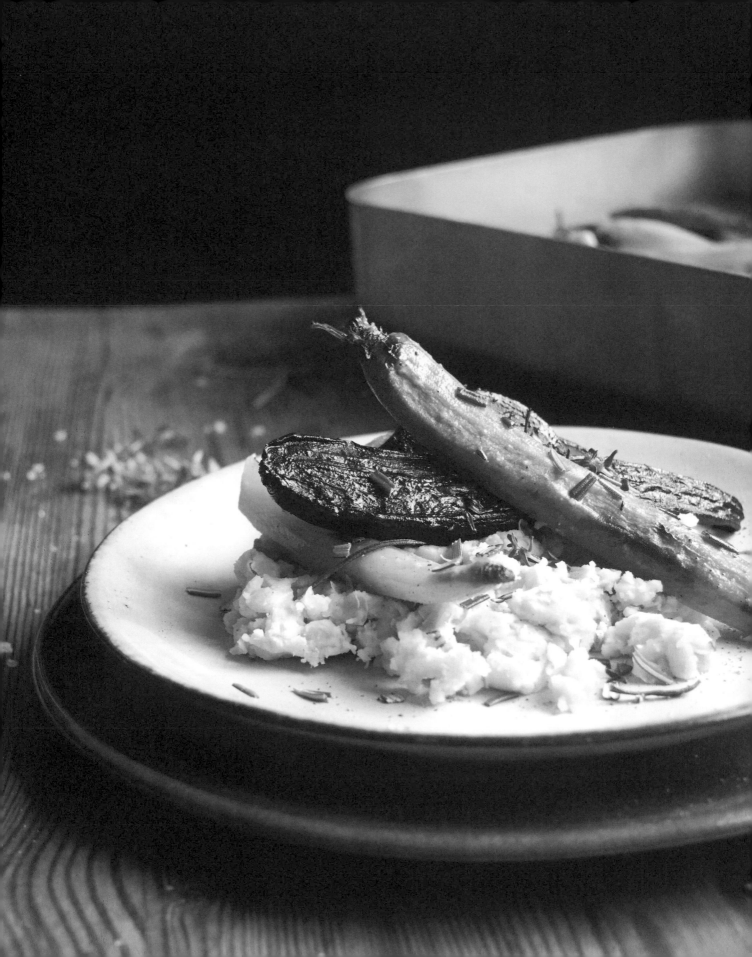

roasted roots with
garlic and rosemary mashed beans

When summer comes to an end, the colors on my plate tend to fade according to the falling temperatures outside. Screaming reds, yellows, and greens make way for the dimmed shades of autumn produce. Earthy flavors find their way back to my kitchen and with them comes the warm purple, cream, and mustard tones of roots and beans. For this autumn recipe, I roast colorful beets, carrots, and turnips tossed in olive oil, orange juice, and maple syrup to enhance their natural sweetness. Fresh rosemary and thyme add their woody aroma to this cozy dish, which is accompanied by a velvety mash of garlicky butter beans.

SERVES 4

FOR THE ROASTED ROOTS

¼ cup (60 ml) olive oil

2 tablespoons freshly squeezed orange juice

1 tablespoon maple syrup (or honey)

2 ¾ pounds (1.2 kg) peeled root vegetables, preferably a colorful mix of beets, carrots, and turnips, cut in half (for the long roots) or into wedges (for the round roots)

4 medium sprigs fresh rosemary

1 small bunch fresh thyme

Coarse sea salt

Ground pepper

FOR THE BEAN MASH

¼ cup (60 ml) olive oil

2 large cloves garlic, cut into quarters

17 ounces (480 g) drained and rinsed canned butter or cannellini beans (or about 7 ounces [200 g] dried beans*)

2 teaspoons chopped fresh rosemary, plus more to taste

Fine sea salt

Ground pepper

FOR THE TOPPING

1 to 2 tablespoons chopped fresh rosemary

Preheat the oven to 425°F (220°C).

For the roasted roots, whisk together the olive oil, orange juice, and maple syrup. Place the root vegetables in a large baking dish and coat them with the olive oil mixture. Add the rosemary and thyme and toss to combine. Season generously with coarse sea salt and pepper and roast for 20 minutes. Stir the roots and continue roasting for another 25 minutes or until golden and al dente. If you prefer the roots a little darker, turn the broiler on for the last 1 to 2 minutes. Season to taste with coarse sea salt and pepper.

For the bean mash, heat the olive oil in a medium saucepan over medium heat. Add the garlic and sauté for 1 minute or until golden—mind that it doesn't burn. Stir in the beans and rosemary, reduce the heat to medium-low, and cover the pan. Cook for 2 minutes then roughly mash the beans with a potato masher. Season to taste with salt, pepper, and additional rosemary. If the beans are too dry, add a little more olive oil.

Serve the roasted roots on top of the bean mash and sprinkle with the chopped rosemary.

* If using dried beans, soak them in cold water overnight then cook them in plenty of simmering water
 (without salt) for about 1 hour or until completely soft. Drain and quickly rinse the beans and let them cool.

sautéed spinach with orange and cardamom

Spinach should be cooked as briefly as possible, at least for my taste. Whether blanching or sautéing, as soon as the leaves begin to wilt, it's time to pull them off the heat. It only takes a few seconds to a minute to cook baby spinach and just a little longer for the larger and more robust winter leaves. If the result is too soft and soggy, without any texture, spinach loses its distinctive taste, as well as many of its essential vitamins.

In Sicilian cuisine, sweet raisins, salty anchovies, and sour balsamic vinegar are often used to complement the earthiness of spinach. I like to balance it with juicy chunks of fresh orange, plus some of the fruit's tangy zest. Cracked cardamom pods lend their fragrant aroma and give the spinach a Middle Eastern touch. On its own, this makes a scrumptious lunch, but it can also be served alongside sweeter meat dishes, such as the Riesling and Elderflower Chicken with Apricots on page 166. And besides the preparation of the orange, the recipe takes only a few minutes.

SERVES 2 TO 4

3 small oranges

Olive oil

2 small onions, finely chopped

3 cardamom pods, lightly cracked with a mortar and pestle

17 ounces (480 g) baby spinach (or regular spinach leaves), rinsed and still slightly wet

¼ cup (60 ml) freshly squeezed orange juice

Fine sea salt

Ground pepper

Ground cardamom (optional)

Zest the oranges and reserve the zest before separating the flesh into segments. To cut the oranges into segments, first peel off the outer skin then cut off the white pith. Hold 1 of the oranges in one hand over a bowl and use a small, sharp knife to cut between the membranes and release the segments, as well as any juice, into the bowl. Repeat with 2 more oranges. Separate the orange segments from the juice by pouring them through a strainer set over a bowl. Measure ¼ cup (60 ml) of orange juice, use the juice from the oranges, and top it up with additional freshly squeezed orange juice.

In a large pot, heat a splash of olive oil over medium heat. Add the onions and cardamom pods and sauté, stirring constantly, for about 3 minutes or until the onions are soft and golden but not brown. Stir in the spinach, along with 1 heaping teaspoon of the orange zest and the orange juice, then cover and cook for 1 minute or until the spinach is just wilted (regular spinach will take slightly longer). Remove the cardamom pods and season to taste with salt, pepper, and ground cardamom, if using. Gently stir in the orange segments or arrange the spinach on plates and lay the orange segments on top. Sprinkle with a little more orange zest and serve.

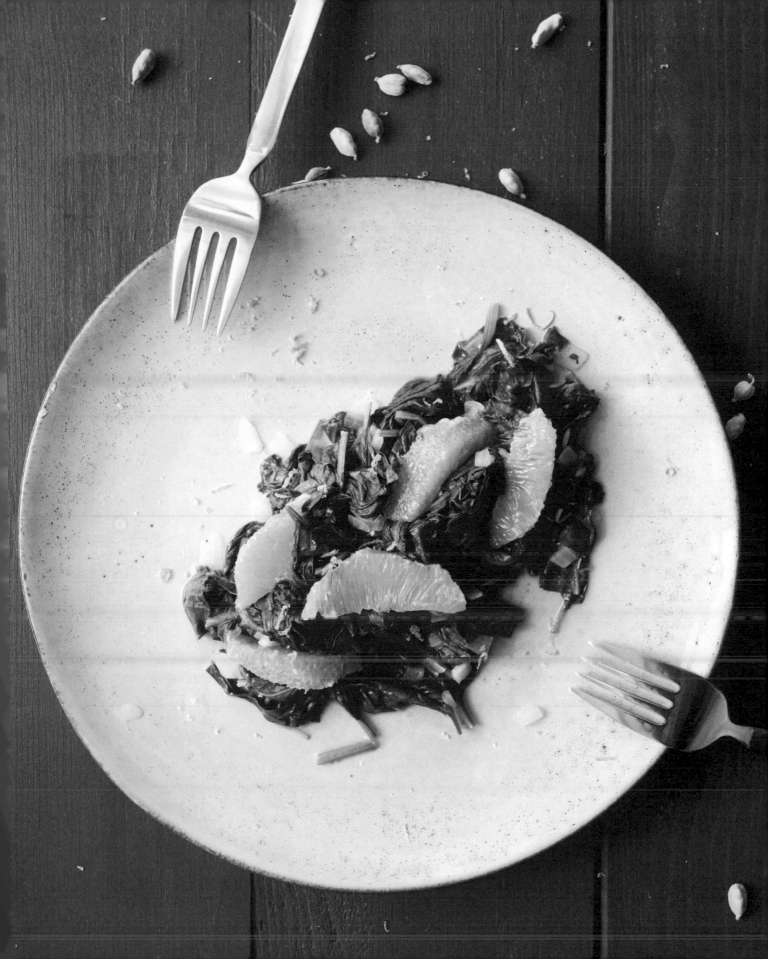

beluga lentils with pomegranate and dukkah

The image of pomegranate seeds sparkling atop black beluga lentils like giant polished rubies was so tempting that I had to give this duo a try. And it didn't let me down—the result is stunning. When something so visually beautiful tastes so irresistible, I'm a happy cook.

In all fairness, the nutty topping also plays a significant role in the success of my little experiment. Dukkah is a mixture of ground seeds, nuts, and spices, and is popular in Egyptian cuisine. I like to use hazelnuts, pistachios, and sesame and sunflower seeds with black peppercorns, cumin, fennel, and coriander seeds from my spice box. While this may seem too powerful, the different flavors balance each other out. To give the lentils enough space to develop their own fine aroma, I cook them with just a bunch of fresh thyme and a bay leaf and then add a splash of olive oil before serving. The crunchy dukkah fits perfectly with the lentils' floury nuttiness, while the pomegranate's sweet and sour juiciness freshens up the combination. There's usually a calming simplicity to be found in a bowl of legumes, but not here: This is a firework display of tastes and textures.

SERVES 3 TO 4

FOR THE DUKKAH*

1 ounce (30 g) skin-on hazelnuts

1 ounce (30 g) salted pistachios

1 ounce (30 g) white sesame seeds

1 ounce (30 g) sunflower seeds

1 teaspoon fennel seeds, crushed with a mortar and pestle

1 teaspoon coriander seeds, crushed with a mortar and pestle

½ teaspoon black peppercorns, crushed with a mortar and pestle

⅓ teaspoon coarse sea salt

¼ teaspoon ground cumin

FOR THE LENTILS

1¼ cups (280 g) lentils, preferably beluga (no soaking required)

1 small bunch fresh thyme

1 bay leaf

Olive oil

Fine sea salt

Seeds from 1 pomegranate

For the dukkah, pulse the ingredients in a food processor until crumbly—the mixture should be dry—and transfer to a bowl or an airtight jar.

For the lentils, place the lentils in a saucepan with plenty of (unsalted) water, add the thyme and bay leaf, and bring to a boil. Lower the heat and simmer for about 20 minutes or until al dente (or follow the package instructions). Remove any excess liquid with a ladle, if necessary. Remove the thyme and bay leaf and stir in a generous splash of olive oil. Season lightly with salt (the dukkah will add saltiness).

Divide the lentils between plates and sprinkle with the pomegranate seeds and 1 to 2 tablespoons of dukkah. Drizzle with olive oil and serve.

You won't need all of the dukkah for this recipe. Store leftover dukkah in an airtight container and use it in salads and soups.

cumin-roasted squash wedges
with pistachio-feta dip

Spice-roasted squash wedges have long been a favorite of mine, especially for cozy winter nights on the sofa. But I was newly inspired when I discovered Sabrina Ghayour's wonderful *Persiana* cookbook, a beautiful recipe collection strongly influenced by the Middle East. The London-based chef takes an Asian pesto and squash dish created by her friend chef Tony Singh, and makes her own variation with feta, pomegranate, and a Persian-style pesto made of pistachio, coriander, parsley, and dill. It caressed my taste buds and lifted the vegetable to new heights. Nutty, sweet, and salty—it's simply brilliant. I just had to come up with my own take on the recipe.

To make the dish simpler, I leave out the pomegranate and pesto and focus on the caramel sweetness of roasted squash, the biting sharpness of feta, and the flowery flavor of pistachios. I also add cumin to lend the dish an earthy note and a hint of warmth. Sabrina uses butternut squash in her recipe, but I sometimes replace that with Hokkaido squash, which has edible skin and needs less time in the oven.

SERVES 3 TO 4

2¼ pounds (1 kg) seeded squash with skin, preferably Hokkaido or butternut, cut into 2-inch (5 cm) wedges

¼ cup (60 ml) olive oil

1 teaspoon ground cumin

Ground pepper

Coarse sea salt

FOR THE PISTACHIO-FETA DIP

2 ounces (60 g) salted pistachios

6 ounces (170 g) feta

3 tablespoons olive oil

¼ teaspoon ground cumin, plus more to taste

FOR THE TOPPING

1 ounce (30 g) salted pistachios, roughly chopped

Preheat the oven to 400°F (200°C).

Place the squash in a baking dish. Whisk together the olive oil and cumin and season generously with pepper. Pour this over the squash and use your hands to toss and coat the squash in the oil. Sprinkle with coarse sea salt and roast for 15 minutes. Turn the squash wedges over and continue roasting until golden brown and soft when pricked with a fork—about 7 minutes for the Hokkaido squash and 15 minutes for the butternut squash.

While the squash is roasting, make the pistachio-feta dip: Pulse the pistachios in a food processor until finely ground. Add the feta, olive oil, and cumin, and purée until smooth. Season to taste with additional cumin. Transfer to a bowl, cover, and set aside.

Arrange the warm squash wedges on plates, add a generous dollop of the pistachio-feta dip, and sprinkle with the chopped pistachios. If you like, add a little more cumin to taste. If you use butternut squash, make sure to scrape out the flesh; if you go for Hokkaido, you can eat the skin.

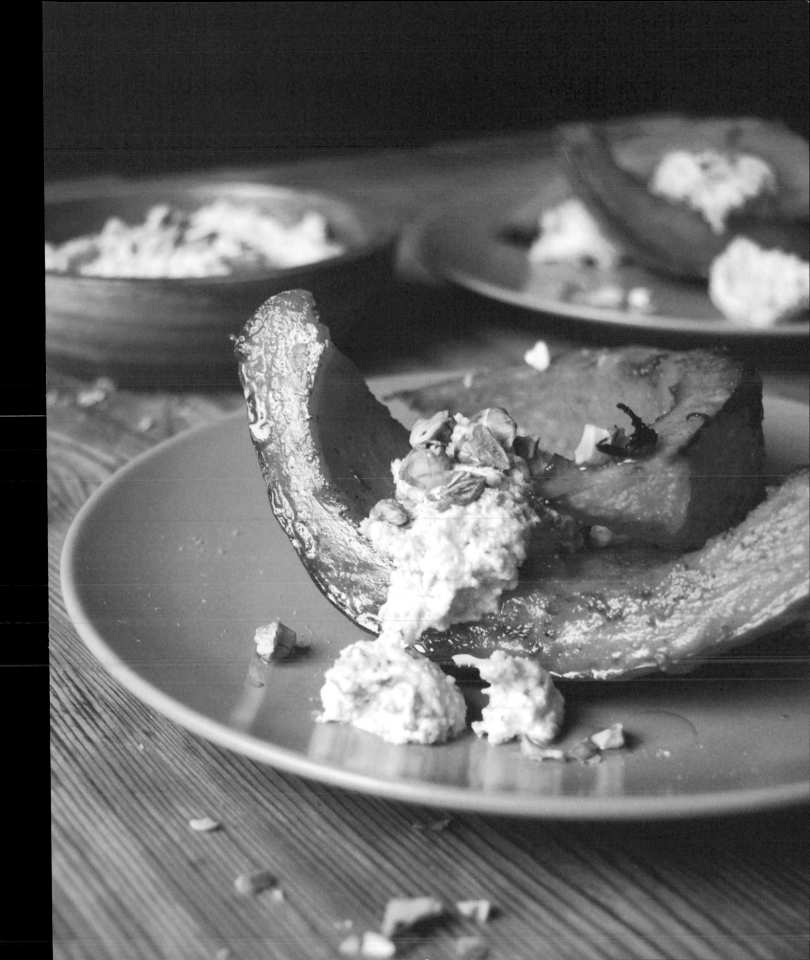

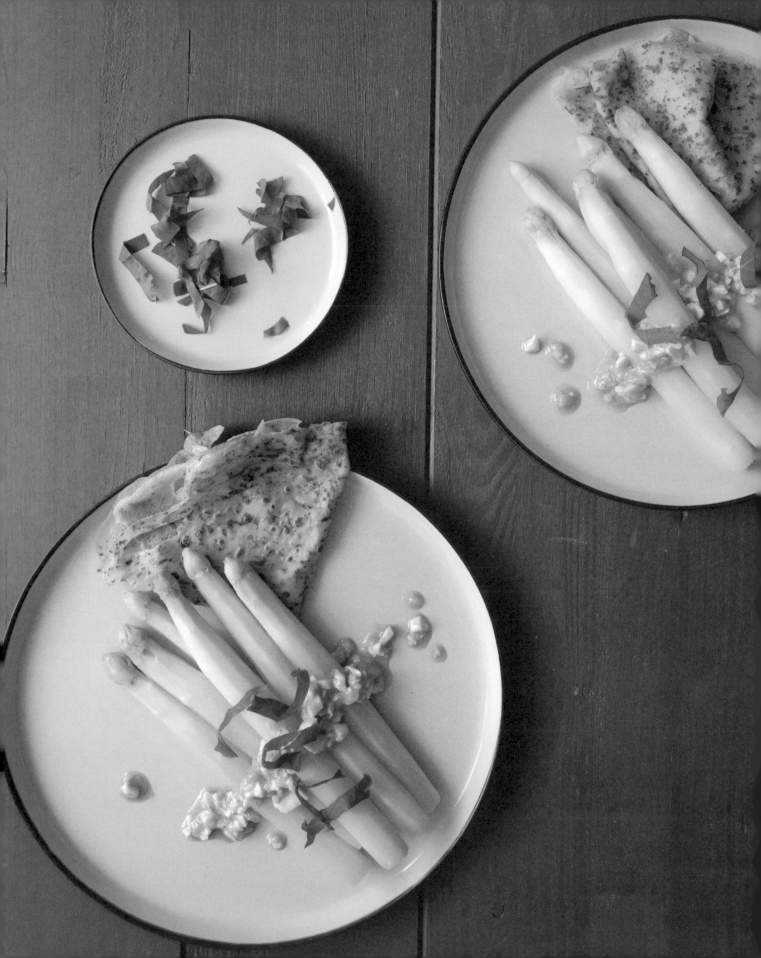

white asparagus with sorrel crêpes and bozen sauce

Thirty miles outside Berlin, is a historic town called Beelitz, famous for its thick white asparagus. The stalks are almost sweet, with just a hint of the vegetable's distinct bitterness. Years of enjoying the produce from this area made me curious to find out more about Beelitz. After a one-hour train ride, my boyfriend and I arrived at a tiny and seemingly abandoned station, the only visitors on a silent platform, overgrown with grass and low bushes. When we left the timber-framed railway building to start our bike ride, we discovered the kind of peace that is so easy to miss when you live in the city.

Beelitz is a picturesque village, with tiny houses lined along the road like toy blocks and quiet streets snaking through trees, rivers, and farms—it's the kind of scene a Berlin girl longs for. After a rocky ride through a dark pine forest, we saw a dazzling white light in the distance. We had finally found the famous asparagus fields. The stalks of white asparagus grow under a bright foil covering that reflects the beams of the late afternoon sun and sparkles like diamonds. On a clear day, when the workers come to pick the crop in early evening, their silhouettes fuse with the light of the low sun and the white foil, and it feels like you're on another planet.

White asparagus is very common in Germany and France but can be hard to find in other parts of the world. If you can only find green asparagus, there's no reason to skip this recipe, as the green stalks taste just as good with the thin sorrel crêpes and South Tyrolean *Bozen* sauce. Named after Bolzano, a town in northern Italy, this rich, tangy sauce is made with mustard, olive oil, and eggs. White asparagus is usually served with potatoes and Hollandaise or brown butter breadcrumbs, but every tradition deserves a break once in a while.

SERVES 4

FOR THE SORREL CRÊPES

1¾ cups (410 ml) whole milk

4 large eggs

2 ounces (60 g) fresh sorrel leaves, very finely cut with a knife or a food processor (or the same amount of arugula and a squeeze of lemon juice)

1½ cups (200 g) all-purpose flour, sifted

1 teaspoon fine sea salt

Unsalted butter, to cook the crêpes

FOR THE BOZEN SAUCE

2 large eggs

¼ cup (60 ml) olive oil

2 tablespoons freshly squeezed lemon juice

2 teaspoons Dijon mustard

Fine sea salt

Ground pepper

3⅓ pounds (1.5 kg) trimmed and peeled white asparagus (if you use green asparagus, just cut off the woody bottoms)

Pinch of sugar

FOR THE TOPPING

3 large fresh sorrel leaves, cut into thin strips

(continued)

For the crêpe batter, whisk together the milk and eggs in a large bowl. Add the sorrel, flour, and salt and beat with an electric mixer until smooth and well combined. Let the batter sit for about 10 minutes before you cook the crêpes.

For the sauce, place the eggs in a small saucepan and cover with cold water. Bring to a boil then lower the heat and simmer for 7 minutes. Drain the eggs and rinse them with cold water until they're just cool enough to handle. Crack the shells then peel the eggs and chop them very finely. In a medium bowl, whisk together the olive oil, lemon juice, and mustard. Stir in the chopped eggs, season to taste with salt and pepper, and set the sauce aside.

Bring a large pot of water to a boil. Add the asparagus and sugar and cook for 8 to 10 minutes or until al dente. (If using green asparagus, cook it for 3 to 4 minutes only.) Drain and keep warm.

To cook the crêpes, melt ½ teaspoon of butter in a large cast iron or nonstick skillet over medium-high heat. Pour in a ladle of the batter, tilting and turning the pan, so that the batter spreads evenly and very thinly. Cook the crêpe for about 30 to 60 seconds per side or until golden. Carefully fold the crêpe in half twice, so it forms a triangle, then transfer to a plate, and keep in a warm oven. Finish making crêpes with the remaining batter, adjusting the heat as necessary and adding a little more butter to the pan between crêpes. This makes about 12 crêpes.

Serve the asparagus with the sorrel crêpes and Bozen sauce, or roll the asparagus in the crêpes like a wrap and serve the sauce on top. Sprinkle the crêpes with the freshly cut sorrel strips and serve immediately.

potato–sauerkraut latkes
with juniper sour cream dip

When my grandmother Lisa cooked for me, I would sit in front of the window in her small kitchen and look out at her dreamy garden. Surrounded by fir trees on one side and a bed of roses on the other, the lawn in the middle was covered in daisies that bloomed under the strong branches of a huge cherry tree. It was the most perfect cherry tree I've ever seen, and had a swing that made me feel like I could touch the sky. I could sit and swing for hours, daydreaming or just waiting for lunch to be ready.

Whenever I visited this wonderful woman for a few days, she would ask me for a list of the recipes I would like to eat during my little holiday. I used to give her a long list, always far too long for my short visit, but I loved this ritual. One of these meals, an absolute highlight, was German potato latkes, called *Kartoffelpuffer* or *Reibekuchen*. Lisa fried them to perfection— crisp on the outside and juicy on the inside.

In western Germany, where I grew up, we usually eat potato pancakes with apple compote, sugar beet syrup, or, my childhood favorite, granulated sugar, but I had a new idea. I was raised on sauerkraut and it often tops the list when people think of my home country's food—apart from wurst (sausage), of course. The classic version is served with mashed potatoes and soft southern liver sausage—that might not sound appealing, but it's actually quite addictive—but why not experiment? I mix the sour fermented cabbage into grated potatoes and turn it into sauerkraut Kartoffelpuffer. It's great, especially with a juniper–scented sour cream dip on the side.

SERVES 3 TO 4

**FOR THE JUNIPER
SOUR CREAM DIP**

10 ounces (280 g) sour cream
or crème fraîche

2 to 8 large dried juniper
berries, finely chopped or
crushed with a mortar and
pestle

Fine sea salt

Ground pepper

FOR THE LATKES

1½ pounds (700 g) peeled
waxy potatoes, grated

17 ounces (480 g) drained
sauerkraut, canned or jarred

1 cup (130 g) all-purpose
flour

2 large eggs

2 teaspoons fine sea salt

Sunflower oil, for frying
the latkes

For the dip, whisk the sour cream with 2 juniper berries, adding more until you reach the desired taste. The flavor should be present but not too overpowering. Season to taste with salt and pepper.

For the latkes, squeeze as much liquid as possible out of the grated potatoes and the sauerkraut and spread each out on separate paper towels. Top with a second paper towel and press out any remaining moisture. Roughly chop the sauerkraut.

(continued)

In a large bowl, use your hands to mix together the potatoes, chopped sauerkraut, flour, eggs, and salt until well combined. Mind that the sauerkraut is well mixed in, so you don't end up with big chunks of it in the latkes. If the mixture is too moist—it should be easy to form into latkes—gradually add more flour.

Fill a large, heavy sauté pan with about ⅓ inch (7.5 mm) of sunflower oil and place over medium-high heat. Take 2 to 3 tablespoons of the potato-sauerkraut mixture into your fingers and form it into a thin, small pancake-shaped latke. Mind that the latkes have to be thin enough to get crispy when fried. (You can also add balls of the mixture directly to the hot oil and push them down with a spatula.) Repeat with the remaining latke mixture. Working in batches, fry the latkes for 1½ to 3 minutes per side or until golden brown and crisp. Lower the heat if they brown too quickly. Transfer to paper towels to drain, and repeat with the remaining latkes, adding more oil if necessary. Serve or keep the fried latkes in a warm oven until you finish the last batch. This makes about 15 latkes.

Enjoy the latkes warm with a little dollop of the juniper sour cream dip.

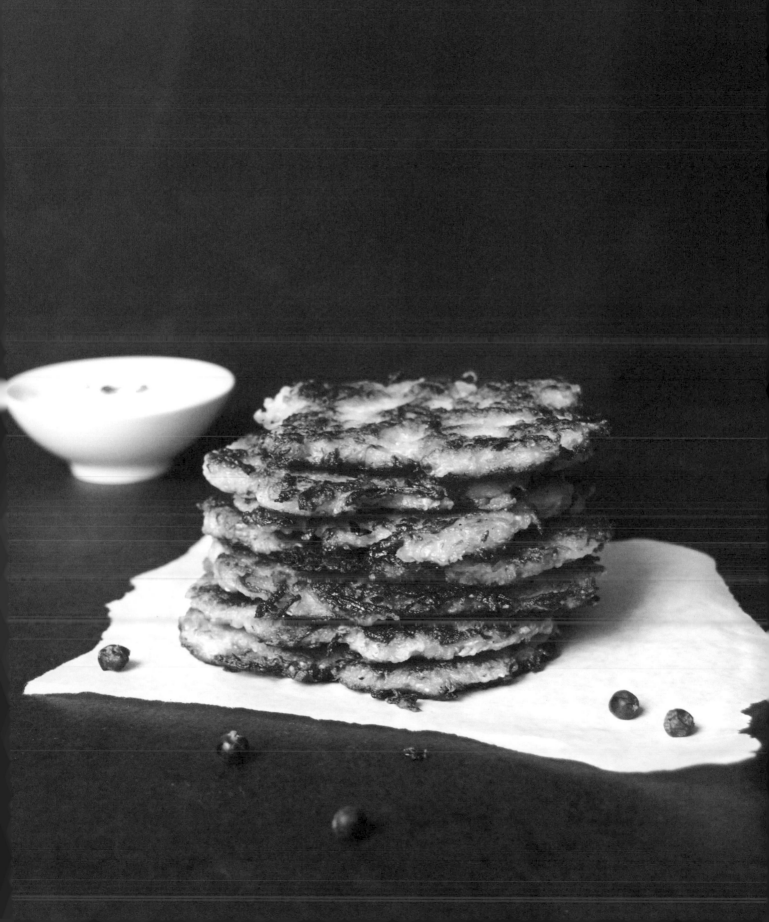

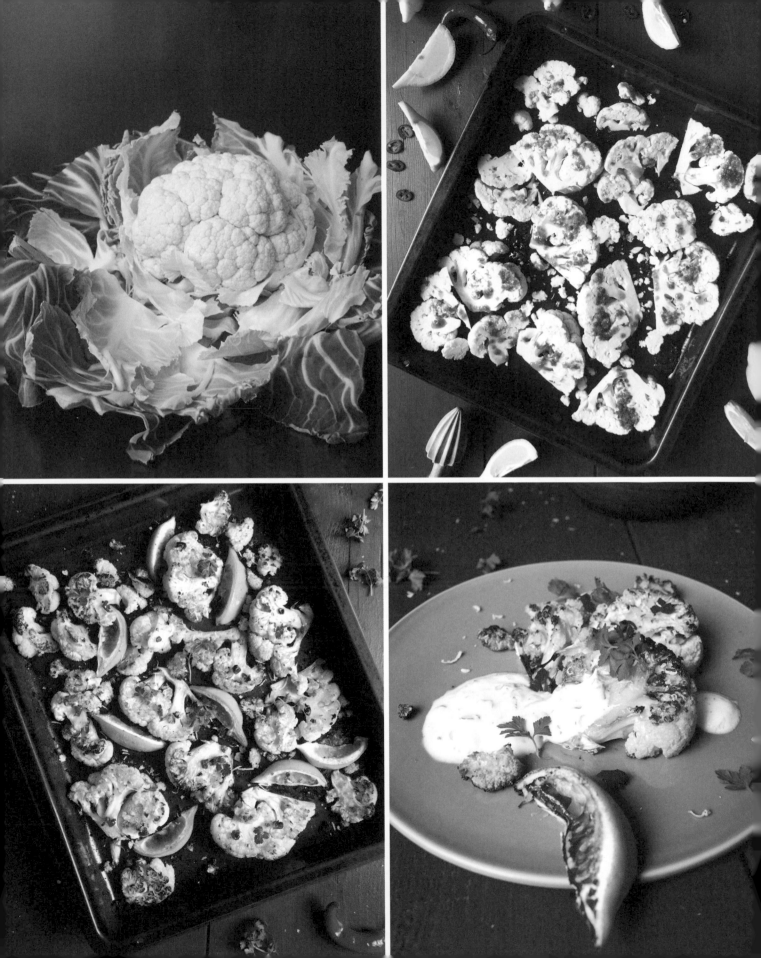

spicy cauliflower with harissa, lemon, and parsley yogurt dip

Oven roasting brings out certain qualities in vegetables that you can't achieve with any other cooking technique. The texture is crisper, while the flavor gets more concentrated and turns slightly smoky. Best of all, the kitchen is filled with the most fragrant aromas.

In my eyes, cruciferous vegetables, such as cabbage, Brussels sprouts (*see page 69*), and cauliflower, are at their best when tossed with olive oil, sprinkled with salt and pepper, and roasted in the oven. With its plainness, cauliflower can easily get lost; it needs a bit of a punch to wake up its flavor. In this recipe, sour lemon, spicy harissa, hot chile peppers, and a refreshing parsley-flecked yogurt dip help this mild-mannered vegetable display its delicious side.

These cauliflower wedges make a fantastic warm lunch, but in summer, I love to serve them as a cold salad with soft ciabatta and a glass of crisp white wine.

SERVES 2 TO 4

2¼ pounds (1 kg) cored cauliflower, cut into 1¼-inch (3 cm) wedges	Flaky sea salt	1 teaspoon freshly grated lemon zest
⅓ cup (75 ml) olive oil	Ground pepper	Fine sea salt
4 teaspoons harissa	**FOR THE PARSLEY YOGURT DIP**	Ground pepper
1 teaspoon freshly squeezed lemon juice, plus 1 large lemon, cut into 8 wedges	⅔ cup (160 g) full-fat yogurt	**FOR THE TOPPING**
1 large fresh red chile pepper, seeded and thinly sliced	2 tablespoons crème fraîche or sour cream	1 small handful flat-leaf parsley leaves
	2 heaping tablespoons roughly chopped flat-leaf parsley leaves	2 teaspoons freshly grated lemon zest

Preheat the oven to 425°F (220°C).

Spread the cauliflower wedges on a baking sheet. Whisk together the olive oil, harissa, and lemon juice. Drizzle over the cauliflower, and use your hands to gently toss and coat the cauliflower. Place the lemon wedges in between the cauliflower, sprinkle with the chile peppers, and season to taste with the flaky sea salt and pepper. Roast for about 18 minutes or until the wedges turn golden. Flip the cauliflower and lemon wedges over, add a little more flaky sea salt, and roast for about 15 minutes or until golden brown and al dente.

While the cauliflower is roasting, make the dip: Whisk together the yogurt, crème fraîche, chopped parsley, and lemon zest. Season to taste with salt and pepper.

Sprinkle the roasted cauliflower with the parsley leaves and lemon zest and season to taste with salt and pepper. Divide the cauliflower among plates and serve with the yogurt dip and the roasted lemon wedges to squeeze over the cauliflower.

sautéed endive with balsamic butter and marjoram

I embrace radicchio, endive, and grapefruit for their natural bitterness; bitter ingredients have the potential to turn simple recipes into exciting treats. As in this recipe, their compelling contrast to sweet, sour, and salty nuances opens the door to more sophisticated culinary experiences.

Golden sautéed Belgian endive with sweet balsamic butter and flowery marjoram is a challenging combination. Every single flavor is present and prominent and although each one screams for attention, together they create something greater than they could on their own.

SERVES 2 TO 4

Olive oil

3 small heads Belgian endive, cut in half lengthwise

Fine sea salt

FOR THE BALSAMIC BUTTER

2 tablespoons (30 ml) balsamic vinegar

3 tablespoons (40 g) unsalted butter, cut into small pieces

Pinch of sugar

Fine sea salt

Ground pepper

FOR THE TOPPING

About 3 tablespoons young marjoram leaves

A few black peppercorns, crushed with a mortar and pestle

In a medium, heavy pan, heat a splash of olive oil over medium-high heat and sauté the endive for 1½ to 2 minutes per side or until golden brown and al dente—it should stay firm in the middle. Take the pan off the heat and season to taste with salt.

For the balsamic butter, in a small saucepan, bring the vinegar to a boil, then reduce the heat and simmer gently for 1 minute. Take the pan off the heat and add the butter in 5 batches, letting it melt before adding more and whisking well so that the sauce can bind. Season to taste with a pinch of sugar, plus salt and pepper if desired. Don't let the butter sauce sit for too long without whisking or it will separate.

Divide the endive among plates and drizzle with the balsamic butter. Sprinkle with the marjoram and crushed peppercorns, season to taste with salt, and serve.

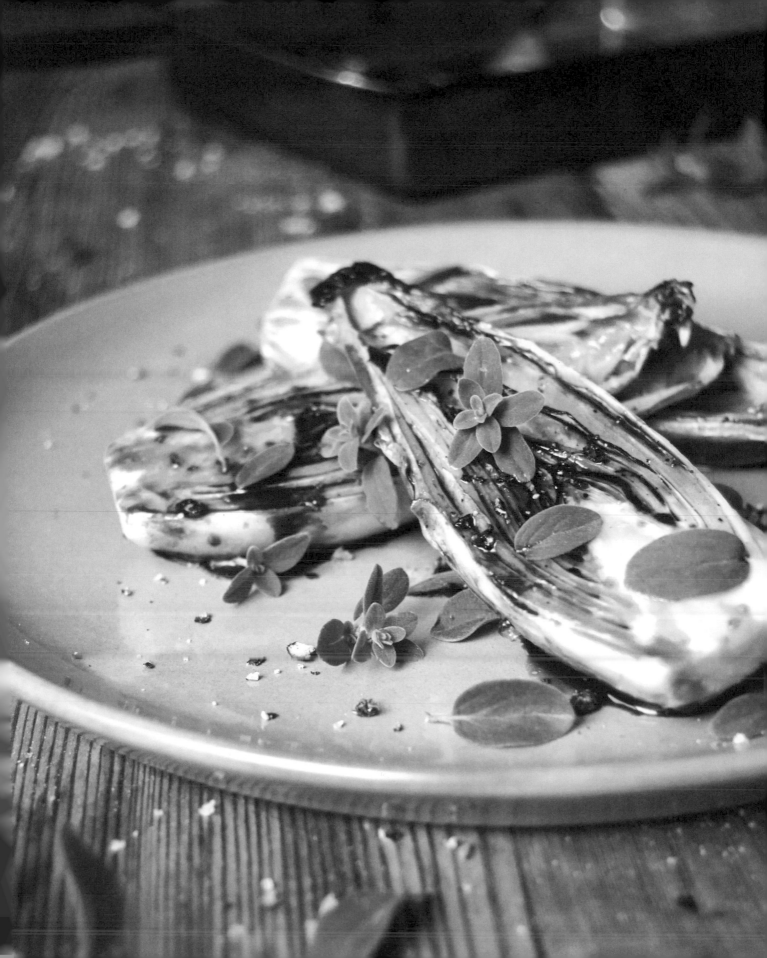

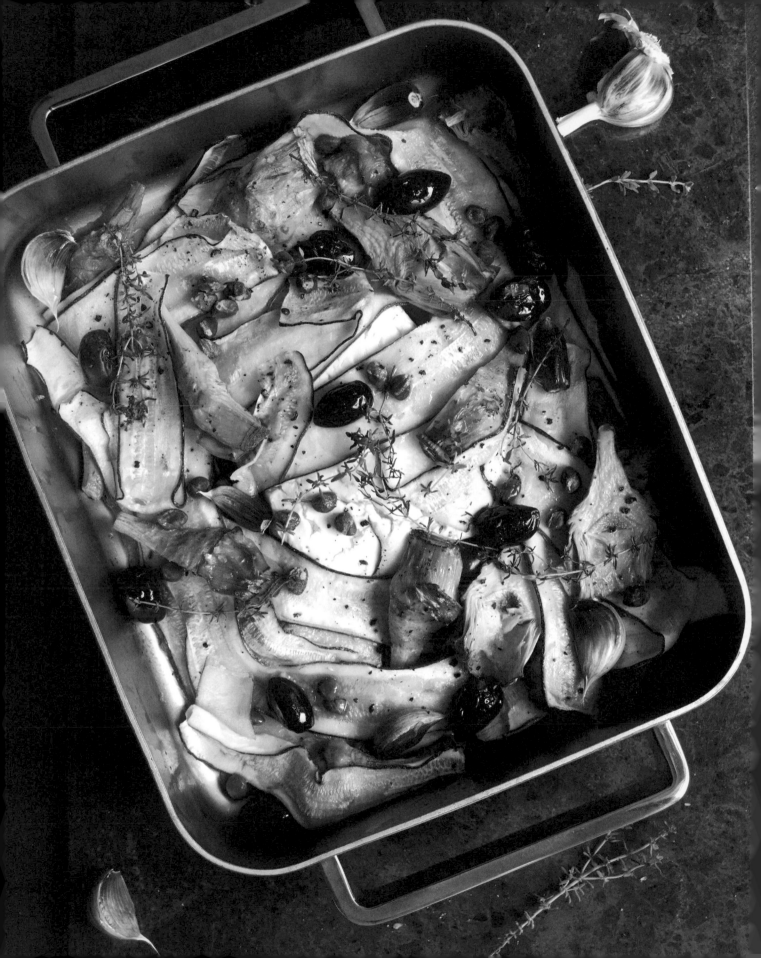

feta, artichoke, and zucchini casserole with olives and capers

A few years ago, my aunt Ursula had us over for dinner, which she and my uncle Uwe do quite often. After a long day of work and a half-hour bike ride through the city, we were happy to be welcomed with a glass of Champagne and the beautiful smell of roasting vegetables and herbs coming from the kitchen. Bike rides always make me hungry, so I couldn't resist sneaking a peek at my aunt's creation. She'd cooked a thick slice of feta under a pile of colorful Mediterranean vegetables with lots of thyme and rosemary. It instantly made my mouth water and my enthusiasm for the fragrant aroma escaping the casserole dish was as big as my appetite.

Ursula's recipe is one of the easiest and most satisfying summer dishes I know. And a big spoonful of this juicy mixture of sweet vegetables plus salty cheese, piled onto a slice of oil-slicked ciabatta, is such a pleasing prospect. My aunt used zucchini, eggplant, tomato, and bell pepper, but almost any veggie combination works. I like to add artichokes, Kalamata olives, and capers, but feel free to incorporate your own favorite ingredients.

SERVES 3 TO 4

8 small baby artichokes, fresh or preserved in oil

Olive oil

10 ounces (280 g) feta, about 1 inch thick (2.5 cm)

14 ounces (400 g) zucchini, cut into long, very thin slices *(use a mandoline or cheese slicer)*

10 large black olives, preferably Kalamata, with pits

1 small handful capers, preferably preserved in salt, rinsed well and drained

6 large cloves garlic, in their skin

8 small sprigs fresh thyme

Flaky sea salt

A few black peppercorns, crushed with a mortar and pestle

Rustic white bread, such as ciabatta, for serving

Preheat the oven to 425°F (220°C).

If the artichokes are fresh, cut off the woody part of their stems and pluck off the hard outer leaves. Trim off the top ⅓ to ¼ of the artichokes, then loosen the hairy choke with a knife and scoop it out with a spoon. Cook the artichokes in boiling salted water for 10 minutes or until tender, then rinse with cold water and drain. Cut the artichokes in half or into quarters, depending on their size.

If the artichokes are preserved in oil, cut them in half or into quarters.

Oil the bottom of a large baking dish and place the feta in the middle. Arrange the zucchini and artichokes in alternating layers on top of the cheese, then sprinkle with the olives, capers, garlic, and thyme. Drizzle the vegetables with 4 tablespoons of olive oil and season to taste with flaky sea salt and crushed peppercorns. Bake for 25 minutes or until the vegetables are tender. Serve with rustic white bread.

mediterranean mashed potatoes with coriander oil

The warm, citrusy depth of coriander infused into the smooth silkiness of good olive oil turns plain waxy potatoes into an aromatic Mediterranean mash. This is easy comfort food, with a light touch. Although it works very well as a summery side for seafood, I find it totally satisfying to sit in front of a single bowl filled with fragrant, rustic potatoes at lunchtime.

These are no ordinary mashed potatoes. It's more like a rough purée, soft but with tender golden bites. You won't need a masher or food processor. In fact, chopping the potatoes roughly with a knife to keep them chunky is essential.

Feel free to replace the coriander with a teaspoon of crushed fennel seeds. I don't have a preference. I simply put my nose to the jar and decide which aroma suits my mood.

There is one simple but very important rule to follow: the fewer ingredients you need for a recipe the more attention you have to pay to their quality. Here, that means that having the best potatoes, olive oil, coriander seeds, and sea salt is vital.

SERVES 2 TO 4

3 tablespoons high-quality olive oil, plus more to taste

2 teaspoons coriander seeds, lightly crushed with a mortar and pestle

1¼ pounds (560 g) peeled waxy potatoes

Flaky sea salt

In a small saucepan, heat the olive oil and coriander seeds over medium heat for about 2 to 3 minutes or until fragrant. Mind the heat—the seeds can burn within seconds and turn bitter. Take the pan off the heat and set aside.

In a large pot, cover the potatoes with cold salted water and bring to a boil. Cover the pot, reduce the heat, and simmer the potatoes for 15 to 20 minutes or until tender. Drain the potatoes and return them to the pot.

Warm the coriander oil over low heat for about 1 minute.

With a plain butter knife (don't use your sharpest knife) break the potatoes into chunks, while gradually adding the warm coriander oil and a little flaky sea salt until the desired taste and texture is achieved—the mash should be smooth but partly chunky. If the potatoes are too dry, add a little more olive oil. Season to taste with flaky sea salt and serve warm.

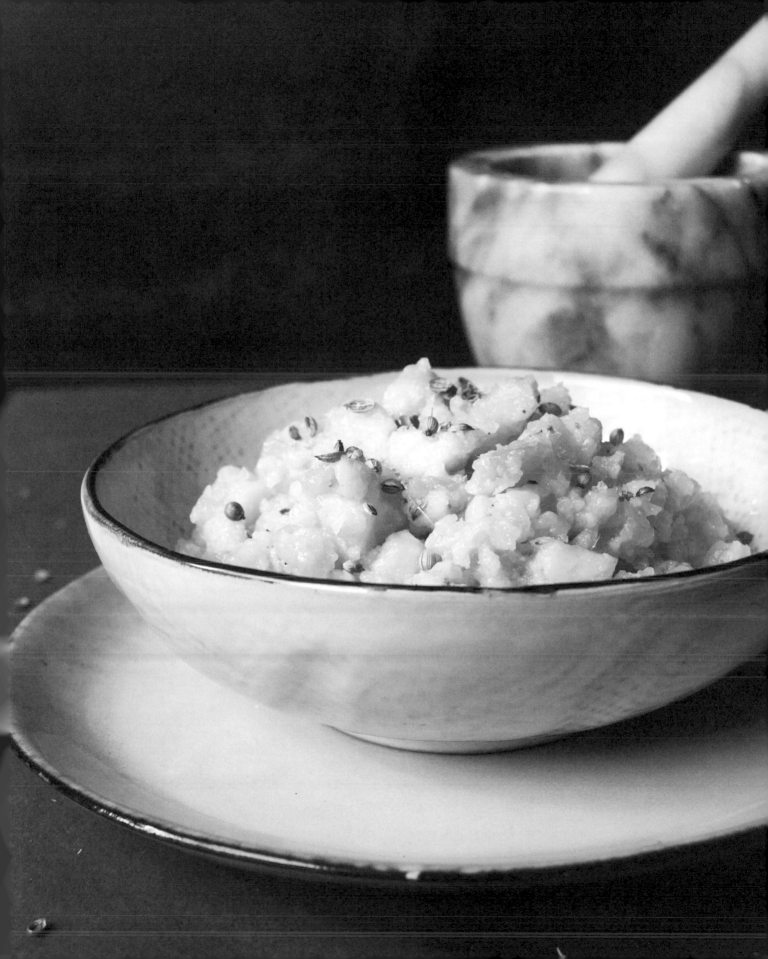

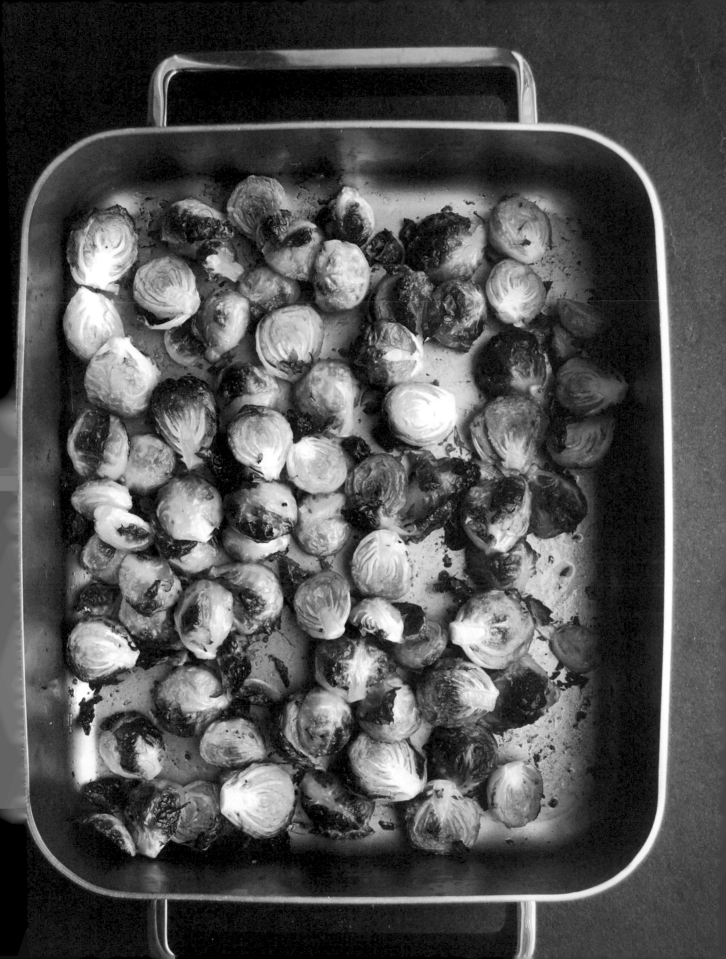

roasted brussels sprouts
with ginger and lemon

The fact that I sometimes find a bunch of withered Brussels sprouts in the far, far corner of my fridge says a lot about my relationship to these miniature cabbages. It's not that I don't enjoy Brussels sprouts once they're cooked and on my plate. They just don't excite me, so they rarely find their way into my pots and pans. But food is about learning and having an open mind. One day, a simple idea broke the cycle and changed my perspective. In the end, it wasn't the poor vegetable's fault; my preparation just had to evolve.

Roasting Brussels sprouts in a ginger- and lemon-infused oil is just what I've been waiting for. The sharpness of the root and the brightness of the citrus tame the overpowering flavor of this veggie's green leaves and take it in a fresh and completely new direction.

This recipe is as easy to prepare as it is to move a bag of Brussels sprouts from the back of the fridge to the chopping block. Once the outer leaves are removed, the mini cabbages are generously coated in the flavored oil then crisped in the oven for half an hour. Although this dish works well on its own for lunch, it's also a confident partner for poultry or pork. These Brussels sprouts would be lovely on the Thanksgiving or Christmas table, but don't wait until the holidays to make them—they're equally at home in a casual meal.

SERVES 4

1⅓ pounds (600 g) trimmed Brussels sprouts, cut in half	2 tablespoons freshly grated lemon zest	1½ tablespoons freshly grated ginger
⅓ cup (75 ml) olive oil	2 tablespoons freshly squeezed lemon juice	1 teaspoon granulated sugar
		Flaky sea salt

Preheat the oven to 425°F (220°C).

Spread the Brussels sprouts in a baking dish. Whisk together the olive oil, lemon zest, lemon juice, and ginger. Drizzle over the Brussels sprouts and use your hands to gently toss and coat the Brussels sprouts. Sprinkle with the sugar, season generously with salt, and roast for 10 minutes. Stir the Brussels sprouts then continue roasting, stirring every 5 minutes to prevent burning, for about 15 to 20 minutes or until golden brown, crisp, and al dente.

Serve as a main for lunch or as a side dish for roasts, such as the Bavarian Beer-Roasted Pork from page 163 or Slow-Roasted Duck (*see page 171*).

soups

RAMP VICHYSSOISE

PARSNIP AND SWEET POTATO SOUP WITH CARAMELIZED PLUMS
AND WHIPPED GORGONZOLA MASCARPONE

MALTESE MINESTRONE WITH SOUTH TYROLEAN CRÊPES FRITTATEN

TOMATO SOUP WITH BASIL, RICOTTA, AND CRISPY BACON

GINGER AND LEMON CAULIFLOWER SOUP

ramp vichyssoise

Before I moved to Berlin, I lived near a forest that snuggled into the dark arms of the Rhine River. The scenery was lush and dense with rich, fertile soil and every April the air filled with the strong aroma of *ramson*, the European cousin of North American ramps. Huge patches of pointy leaves covered the soggy ground, waiting to be picked, so they could add their pungency to pesto, soups, seafood, and salads. Ramps are wild and taste somewhere between onion and garlic. They're versatile and can be used like herbs (*see the Cod al Cartoccio with Ramps and Red Onion recipe on page 152*), or in place of leeks and chives.

This vichyssoise has the smoothness of the French classic, but the ramps lend it a little more finesse. This spring plant can vary in intensity, so you may have to use more or less to get the right flavor. Traditionally, vichyssoise is served cold in summer, but some people, myself included, prefer it slightly warm.

SERVES 2 TO 4

5 cups (1.2 l) water

Fine sea salt

5 ounces (140 g) ramp or ramson leaves

⅓ cup (75 ml) heavy cream

1 tablespoon freshly squeezed lemon juice

1 tablespoon unsalted butter

Olive oil

1 medium onion, finely chopped

18 ounces (510 g) peeled potatoes, cut into small cubes

Ground pepper

Nutmeg, preferably freshly grated

FOR THE TOPPING

2 large ramp leaves, cut into thin strips

4 teaspoons heavy cream

2 to 3 teaspoons freshly grated lemon zest

In a large pot, bring the water and ¼ teaspoon of salt to a boil; add the ramps and blanch for 2 minutes. Use a slotted ladle or spoon to remove the ramps (reserve the cooking water) and quickly rinse with cold water. Hold the ramps over the pot of water and squeeze out any remaining water. In a blender or food processor, purée the ramps with the cream and lemon juice until smooth; set aside.

In a second large pot, heat the butter and a splash of olive oil over medium heat. Add the onion and sauté for 2 minutes. Stir in the potatoes and cook for 1 minute. Add the water reserved from cooking the ramps and bring to a boil then lower the heat and simmer, uncovered, for 15 minutes or until the potatoes are tender. Remove from the heat, add the ramp mixture, and purée the soup in a food processor or blender, or with an immersion blender. Season to taste with salt, pepper, and nutmeg. If the soup is in a food processor or blender, return it to the pot. Bring to a boil then lower the heat and simmer, stirring constantly, for about 4 minutes or until thickened. Season to taste with salt and pepper.

Serve the vichyssoise warm or cold, sprinkled with freshly cut ramps, a few drops of heavy cream, and lemon zest.

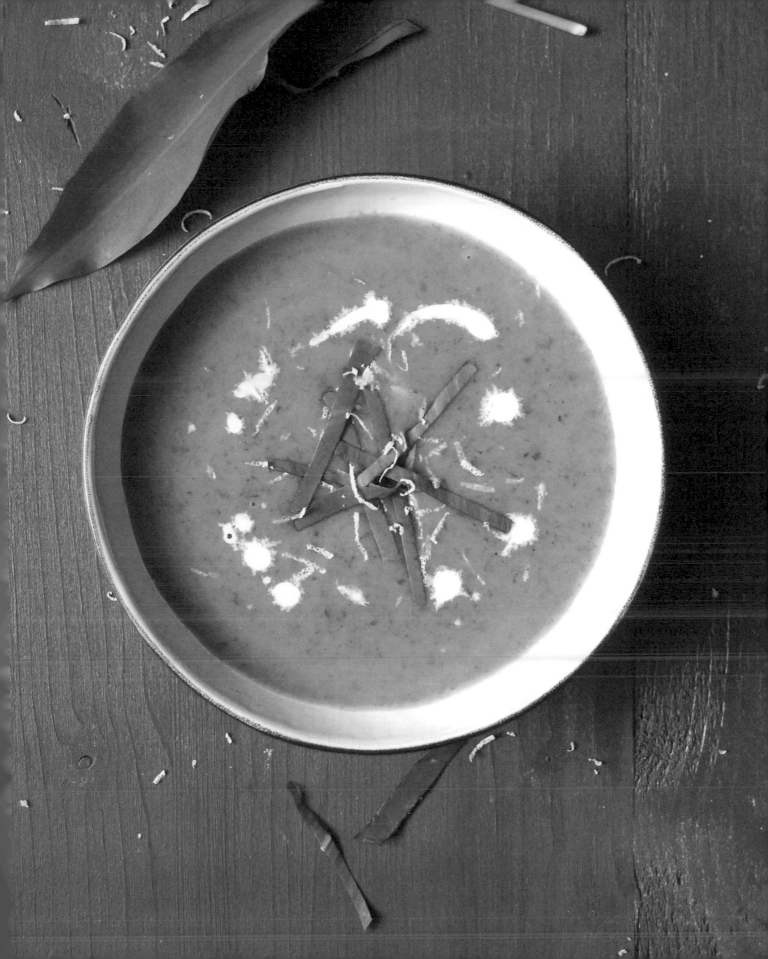

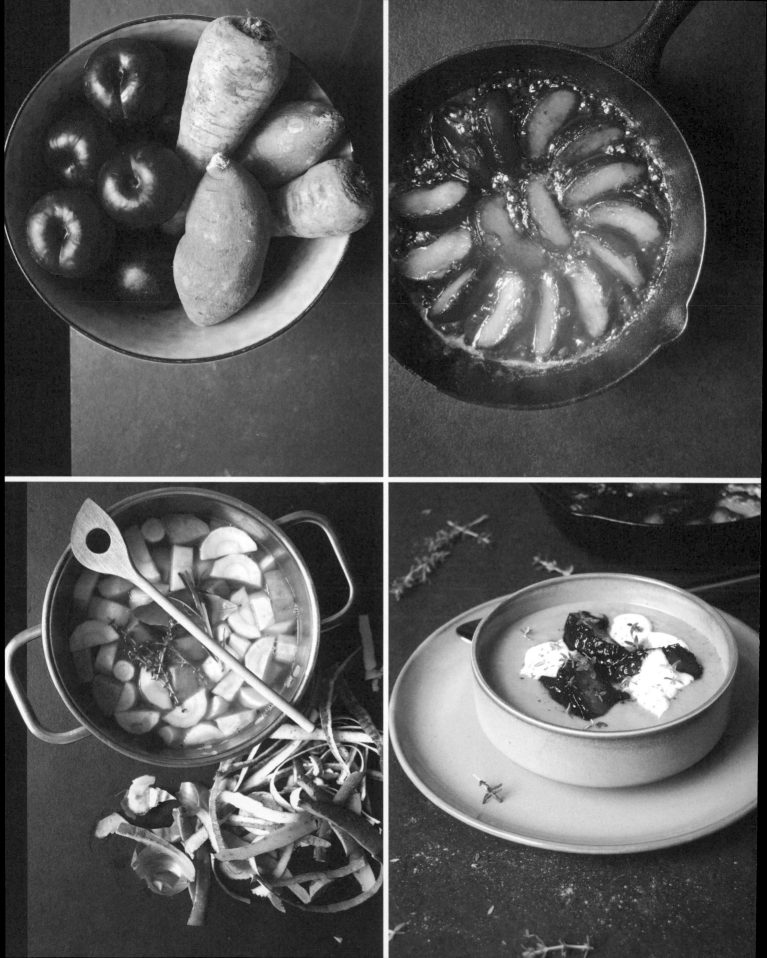

parsnip and sweet potato soup with caramelized plums and whipped gorgonzola mascarpone

The mixture of parsnips, sweet potatoes, and plums offers subtle spice and just the right amount of sweetness. This soup is thick and full of flavor, but not too heavy. Puréed vegetables cooked in broth only need a splash of cream to create smooth velvety results—sometimes I even leave it out completely. I prefer to focus on the natural taste of the produce and keep it light. However, I would never pass up a dollop of whipped Gorgonzola mascarpone, which goes so unbelievably well with the caramelized plums.

SERVES 4 TO 6

Olive oil

1 medium onion, roughly chopped

10 ounces (280 g) peeled parsnips, cut into cubes

10 ounces (280 g) peeled sweet potatoes, cut into cubes

4 ounces (110 g) pitted plums, cut into quarters

3⅓ cups (800 ml) vegetable broth, hot (see page 239)

1 bay leaf

1 medium sprig fresh rosemary

5 medium sprigs fresh thyme

Fine sea salt

Ground pepper

⅓ cup (75 ml) heavy cream

Ground cinnamon

FOR THE CARAMELIZED PLUMS

2 tablespoons unsalted butter

2 tablespoons granulated sugar

2 large plums, pitted and cut into 8 wedges each

FOR THE WHIPPED GORGONZOLA MASCARPONE

2 ounces (60 g) Gorgonzola

2 ounces (60 g) mascarpone

2 tablespoons heavy cream

FOR THE TOPPING

1 to 2 tablespoons fresh thyme leaves

Ground cinnamon

In a large pot, heat a splash of olive oil over medium heat. Add the onion and sauté for a few minutes or until soft and golden but not brown. Add the parsnip, sweet potato, and plums and sauté, stirring constantly, for 1 minute. Add the hot vegetable broth, bay leaf, rosemary, and thyme, stir, and season to taste with salt and pepper. Bring to a boil then lower the heat and simmer, uncovered, for about 20 minutes or until the parsnip and sweet potato are tender. Remove the herbs and discard. Purée the soup in a food processor or blender, or with an immersion blender. If the soup is in a food processor or blender, return it to the pot. Add half the heavy cream, adding more until you reach the desired taste and texture, stir, and season to taste with salt, pepper, and cinnamon. Cover and keep warm.

For the caramelized plums, melt the butter and sugar in a medium, heavy pan over medium-high heat. When the butter turns golden, add the plums and cook for 3 to 4 minutes or until golden and caramelized on the bottom. Turn the plums over and cook for 1 to 2 minutes or until golden on the other side. Remove from the heat and set aside.

Mash the Gorgonzola and mascarpone in a bowl with a fork. Add the heavy cream and whisk until smooth and creamy. If the mixture is too thick, gradually add more cream.

Serve the warm soup topped with whipped Gorgonzola mascarpone, caramelized plums, fresh thyme leaves, and a little cinnamon.

maltese minestrone
with south tyrolean crêpes frittaten

Two culinary worlds—Malta's light Mediterranean cuisine and South Tyrol's cozy comfort food—meet in a bowl of soup. I cook my warming minestrone the way I know it from my Maltese granny, Edith, with lots of squash, zucchini, and kohlrabi. Add a few cauliflower florets, plus carrots, celery, potatoes, and tomato and the recipe sounds like a walk through a vegetable garden. There isn't one formula for cooking good minestrone; it changes with the seasons, so let the produce at the farmers' market be your guide.

When I visit Edith in her kitchen, there's often a huge pot of this soup sitting on her 60-year-old enamel gas cooker. The family is big and there's a constant flow of children and grandchildren passing through the house, so my grandmother needs to have all kinds of convenient sweet and savory treats on hand. Edith knows that minestrone is the perfect recipe to keep her family's large appetite fed. She finishes her soup with freshly grated Parmesan, in classic Italian style, but living in Germany, where it's much colder, I prefer a soup that's a little more filling. South Tyrolean *Frittaten*—called *Flädle* in southern Germany—provides the perfect solution. These thin chive-studded crêpes are rolled into tight wraps and cut into slim strips, so they look like delicate pancake snails and turn minestrone into a hearty winter soup.

SERVES 4 TO 6

FOR THE CRÊPES FRITTATEN

½ cup (65 g) all-purpose flour, sifted

½ cup (120 ml) whole milk

1 large egg

¼ teaspoon fine sea salt

3 tablespoons finely chopped fresh chives

Unsalted butter, to cook the crêpes

FOR THE MINESTRONE

Olive oil

1 medium onion, finely chopped

2 large cloves garlic, crushed

6 ounces (170 g) cored cauliflower, cut into small florets

6 ounces (170 g) seeded and peeled butternut squash, cut into small cubes

6 ounces (170 g) zucchini, cut into small cubes

4 ounces (110 g) peeled potato, cut into small cubes

3 ounces (90 g) peeled carrot, cut into small cubes

2 ounces (60 g) peeled kohlrabi, cut into small cubes

1 celery stalk, trimmed and cut into small cubes

1 medium tomato, cut into small cubes

6½ cups (1.5 l) vegetable broth, hot *(see page 239)*

1 bay leaf

Fine sea salt

Ground pepper

2 spring onions, thinly sliced

FOR THE TOPPING

4 tablespoons finely chopped fresh chives

For the crêpe batter, combine the flour, milk, egg, and salt in a large bowl and use an electric mixer to beat until smooth and well combined. Let the batter sit for about 10 minutes before you cook the crêpes.

(continued)

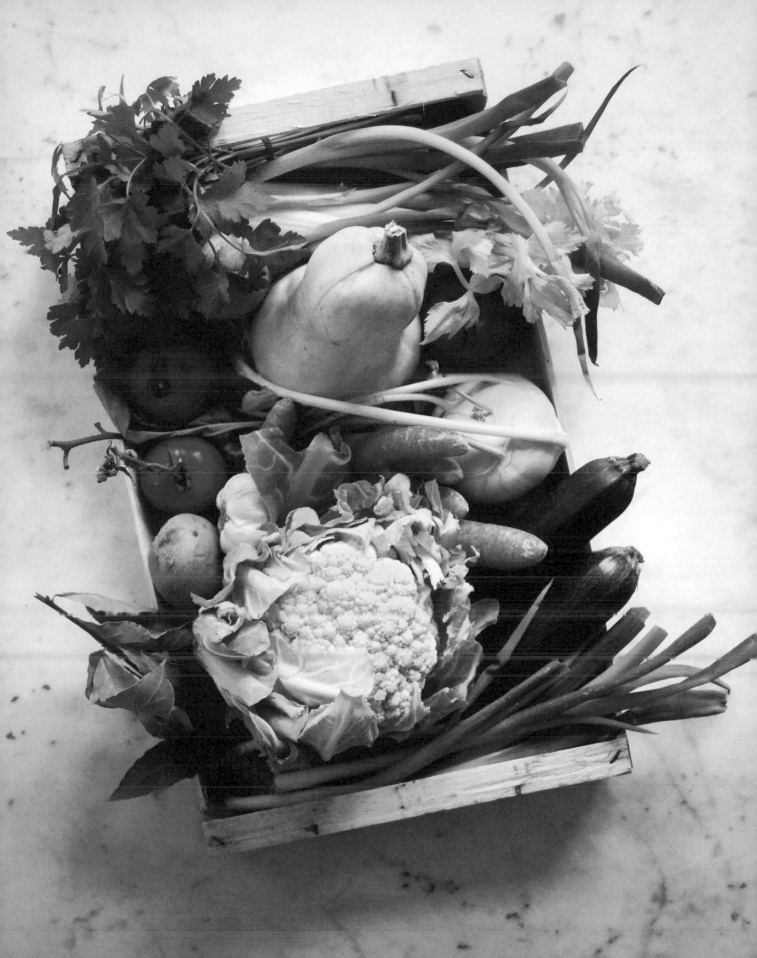

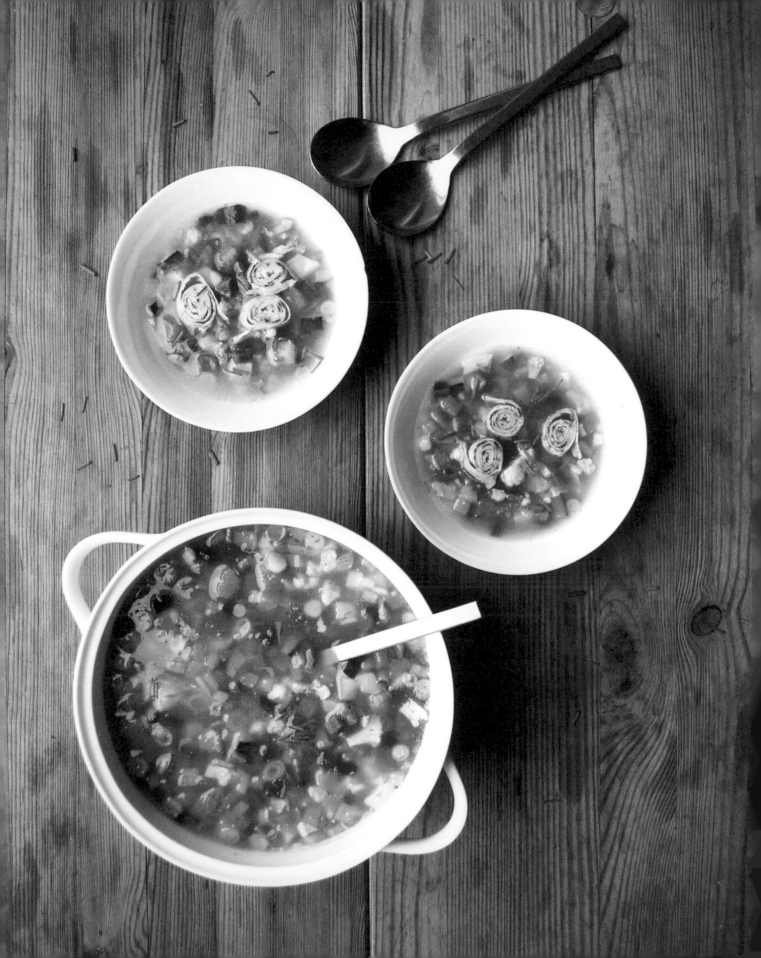

For the minestrone, heat a splash of olive oil in a large pot over medium heat. Add the onion and sauté for a few minutes or until soft and golden but not brown. Add the garlic and sauté for 1 minute or until golden. Add a little more oil and the cauliflower, squash, zucchini, potato, carrot, kohlrabi, celery, and tomato, stir, and cook for 1 to 2 minutes. Add the hot vegetable broth and the bay leaf and season to taste with salt and pepper. Bring to a boil then reduce the heat and simmer uncovered for 15 to 20 minutes or until the vegetables are tender. Cover and keep warm.

To cook the crêpes, stir the chives into the batter and melt ½ teaspoon of butter in a large cast iron or nonstick skillet over medium-high heat. Add a ladle of the batter, tilting and turning the pan, so that the batter spreads evenly and very thinly. Cook the crêpe for about 30 to 60 seconds per side or until golden. Carefully transfer the crêpe to a plate. Finish making crêpes with the remaining batter, adjusting the heat as necessary and adding a little more butter to the pan between crêpes. Once all the batter is used, roll the crêpes very tightly and use a sharp knife to carefully cut them into thin strips (snails).

Stir the spring onions into the hot soup and season to taste with salt and pepper. Divide the soup among bowls, sprinkle with the chives, and serve with the crêpes Frittaten.

tomato soup with basil, ricotta, and crispy bacon

Let ripe summer tomatoes take over your kitchen and celebrate their sweetness with this bright and fruity soup. It's so light that it can easily handle a sprinkle of crispy bacon and a dollop of fresh ricotta—the salty, smoky meat and the creamy cheese sink in perfectly.

When my counter fills with soft tomatoes that need to be enjoyed, this recipe is my favorite solution. It's rustic and easy to prepare, but there is one rule: Use the very best fruit. If your tomatoes are bland and watery, it's pointless to throw them in. For the pure taste of summer, only the tastiest and ripest tomatoes will do. From then on, the recipe is very simple, with no precooking or fiddly peeling of the fruit. The tomatoes are chopped and quickly cooked in vegetable broth, then puréed and topped with a handful of fresh basil, crispy fried bacon, and a touch of ricotta.

SERVES 2 TO 4

1 large clove garlic, preferably from a young bulb

Fine sea salt

Olive oil

2¼ pounds (1 kg) ripe tomatoes, roughly chopped

½ cup (120 ml) vegetable broth, hot *(see page 239)*, plus more to taste

1 tablespoon tomato paste

1 bay leaf

1 tablespoon balsamic vinegar, plus more to taste

Pinch of sugar

Ground pepper

1 small handful fresh basil leaves, very thinly sliced

FOR THE TOPPING

Olive oil

3 to 4 slices bacon *(use 4 slices for 4 starter portions)*

4 to 8 heaping teaspoons fresh ricotta *(use 2 teaspoons per portion)*

8 to 12 small fresh basil leaves

A few black peppercorns, crushed with a mortar and pestle

Roughly chop the garlic then sprinkle with ¼ teaspoon of salt and use the side of a large knife to press and rub the garlic and salt into a smooth paste.

In a large pot, heat a splash of olive oil over medium-high heat. Add the garlic paste and tomatoes and sauté, stirring occasionally, for 4 minutes. Add the hot vegetable broth, tomato paste, bay leaf, and vinegar and season to taste with sugar and pepper. Bring to a boil then lower the heat and simmer, uncovered, for 5 minutes. Take the soup off the heat and remove and discard the bay leaf. In a food processor or blender, or with an immersion blender, purée the soup until smooth. If it's too thick, gradually add more broth. Season to taste with salt, pepper, and vinegar and stir in the sliced basil. Cover and keep warm.

For the topping, heat a small splash of olive oil in a medium, heavy pan over medium-high heat. Add the bacon and cook for a few minutes or until crispy and golden brown. Transfer to paper towels to drain. Gently break the bacon into large pieces.

Divide the soup among bowls and top each serving with 2 teaspoons of ricotta. Sprinkle with the bacon, fresh basil leaves, and crushed peppercorns.

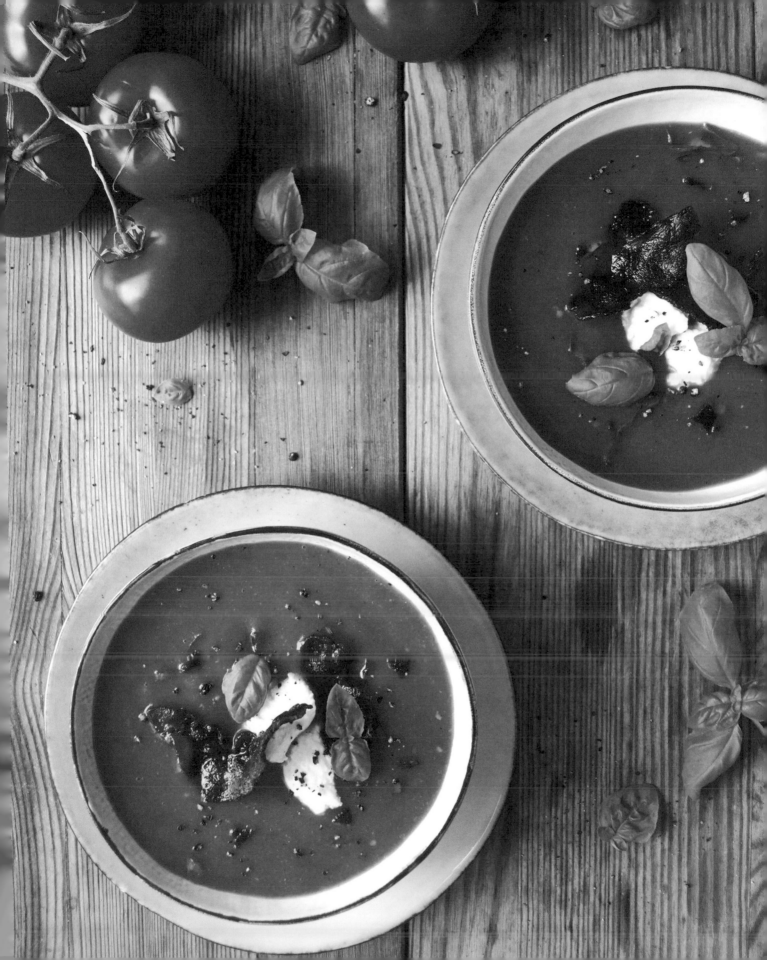

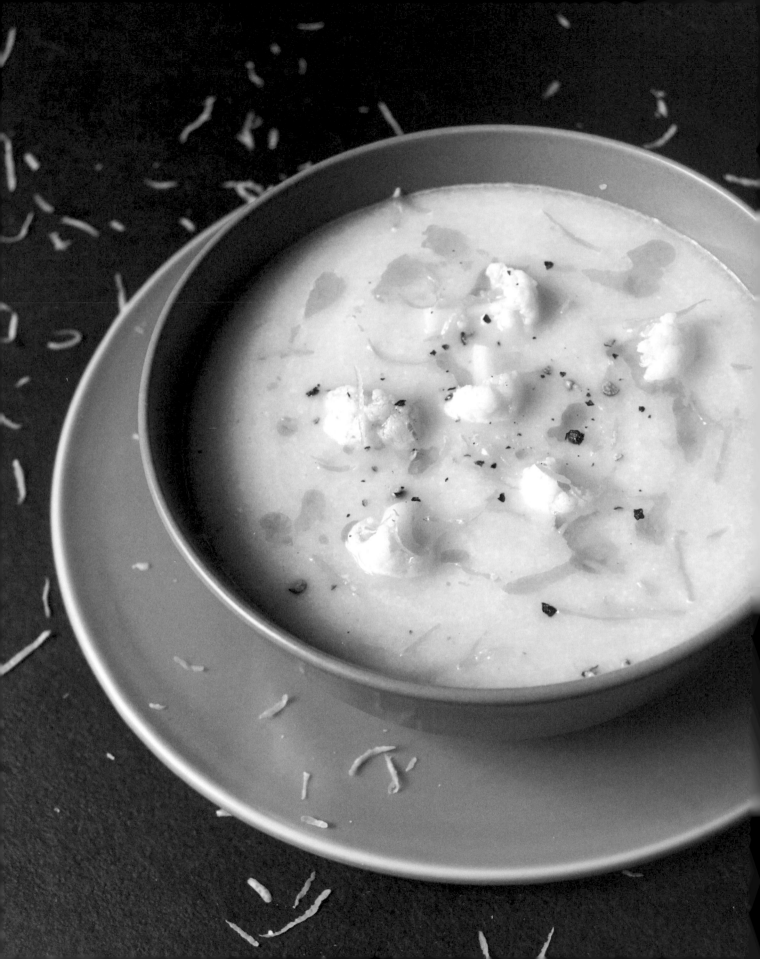

ginger and lemon cauliflower soup

This is another recipe in which the supporting ingredients—in this case, ginger and lemon—bring life to cauliflower, a vegetable that can seem plain and cabbagey but is actually rather delicate and subtly sweet. Refined with assertive ginger and lemon, cauliflower can be surprisingly light and fresh, a bit edgy but not at all intrusive.

The cauliflower, citrus, and ginger combination works so well that I use it often in my kitchen. Oven roasting adds a wonderful hint of smokiness to this trio, but turning them into soup is one of the fastest recipes in my cauliflower repertoire—it takes just 15 minutes. Naturally smooth and velvety, this soup doesn't require any butter or cream and is nearly pure vegetable.

SERVES 2 TO 4

Olive oil

1 medium onion, chopped

1 clove garlic, crushed

2 heaping teaspoons freshly grated ginger, plus more to taste

1 pound (450 g) cored cauliflower, cut into 2-inch (5 cm) florets

3⅓ cups (800 ml) vegetable broth, hot (see page 239)

1 bay leaf

4 long strips fresh lemon peel

1 tablespoon freshly squeezed lemon juice, plus more to taste

Nutmeg, preferably freshly grated

Fine sea salt

Ground pepper

FOR THE TOPPING

Freshly grated lemon zest

A few black peppercorns, crushed with a mortar and pestle

Olive oil

In a large pot, heat a splash of olive oil over medium heat. Add the onion and garlic and sauté for a few minutes or until soft and golden but not brown. Add the ginger and sauté, stirring constantly, for 1 minute or until fragrant. Add the cauliflower, hot vegetable broth, bay leaf, lemon peel, and lemon juice and stir to combine. Season to taste with nutmeg, salt, and pepper. Bring to a boil then reduce the heat, cover, and simmer for about 10 minutes or until the cauliflower is al dente. Remove the bay leaf and lemon peel and discard. Use a slotted ladle or spoon to remove about 7 ounces (200 g) of the cauliflower florets and set them aside.

Purée the remaining soup in a food processor or blender, or with an immersion blender. If the soup is in a food processor or blender, return it to the pot. Season to taste with additional ginger, lemon juice, nutmeg, salt, and pepper. Break the reserved cauliflower into bite-size pieces, if necessary, and gently stir it into the soup, or use it as a topping. Divide the soup among bowls, sprinkle with the grated lemon zest and crushed peppercorns, and drizzle with a little olive oil.

pasta

CICERI E TRIA | SPAGHETTI WITH ZUCCHINI, CHICKPEAS, CUMIN, AND ORANGE

MALTESE LEMON AND RICOTTA PASTA WITH BASIL

MAULTASCHEN | GERMAN SPINACH AND MEAT RAVIOLI

ASPARAGUS, LEEK, AND PEA LASAGNA WITH CHÈVRE AND PECORINO

WILD MUSHROOM SPAGHETTI WITH ORANGE BUTTER AND CRISPY SAGE

SPAGHETTI WITH PESTO POLPETTE AND ROASTED CHERRY TOMATOES ON THE VINE

PUMPKIN GNOCCHI WITH ROQUEFORT SAUCE

SPAGHETTI WITH BROCCOLI PESTO, SUN-DRIED TOMATOES, AND CHILE

ciceri e tria

SPAGHETTI WITH ZUCCHINI, CHICKPEAS, CUMIN, AND ORANGE

This melodically named dish translates to "chickpeas and pasta." Introduced to the southern Italian region of Puglia by the Arabs, this rustic recipe is a great example of the richness of *cucina povera*, the kind of old-fashioned frugal cooking that's found in every culture. Using local, affordable ingredients, whether from the garden, the fields, or the sea, leads to some of the world's best recipes. It proves that creativity can rise above restrictions, and can inspire genius—at the stove as much as anywhere else.

The classic recipe from Puglia is made with dried chickpeas and partially fried pasta. I love tradition, but I mostly use it for inspiration to create dishes of my own. Sautéed zucchini adds some green to my version. To save time, I replace the dried legumes with canned chickpeas, which I toss in hot cumin oil to enhance their nuttiness. There's no crunchy fried pasta in my *ciceri e tria*. Instead, I go for fresh and bright, and add basil and orange zest.

SERVES 4

12 ounces (340 g) dried spaghetti

Olive oil

1 pound (450 g) zucchini, cut into long, very thin slices (*use a mandoline or cheese slicer*)

Fine sea salt

Ground pepper

½ teaspoon ground cumin

1½ cups (280 g) drained and rinsed canned chickpeas

FOR THE TOPPING

1 small handful fresh basil leaves

2 to 4 teaspoons freshly grated orange zest

A few black peppercorns, crushed with a mortar and pestle

Bring a large pot of salted water to a boil and cook the spaghetti, according to the package instructions, until al dente. Reserve about ½ cup (120 ml) of the cooking water then drain the spaghetti and return it to the pot.

In a large, heavy pan, heat a splash of olive oil over medium-high heat. Working in batches, arrange the zucchini slices side by side in the pan. Cook for 1 minute or until golden on the bottom, then flip the zucchini over, season lightly with salt and pepper, and cook for another 30 seconds or until golden on the other side. Transfer to a plate, cover, and keep warm. Continue cooking the remaining zucchini, adding a splash of olive oil between batches.

Using the same pan, heat 3 tablespoons of olive oil over medium heat. Add the cumin and cook, stirring frequently, for 1 minute—mind that it doesn't burn. Add the chickpeas, season to taste with salt and pepper, and stir to combine. Reduce the heat to medium-low, cover, and cook for 4 minutes. Add the cooked spaghetti, along with a splash of the reserved cooking water. Season to taste with salt and gently fold in the zucchini. Divide the spaghetti among plates, sprinkle with the basil, orange zest, and crushed peppercorns, and serve immediately.

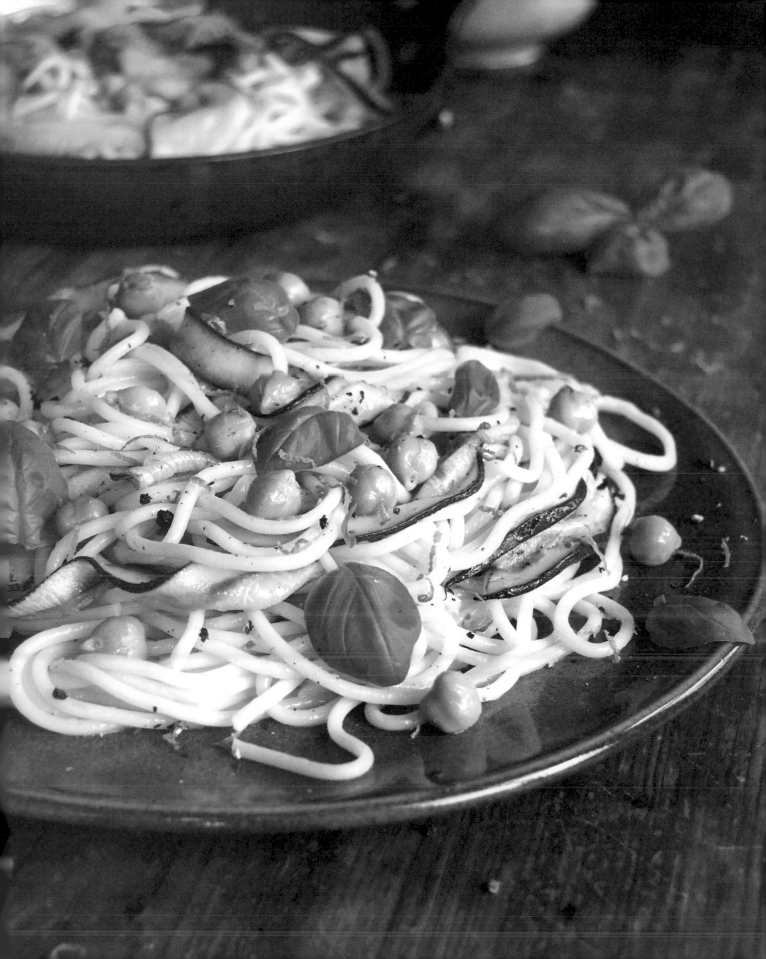

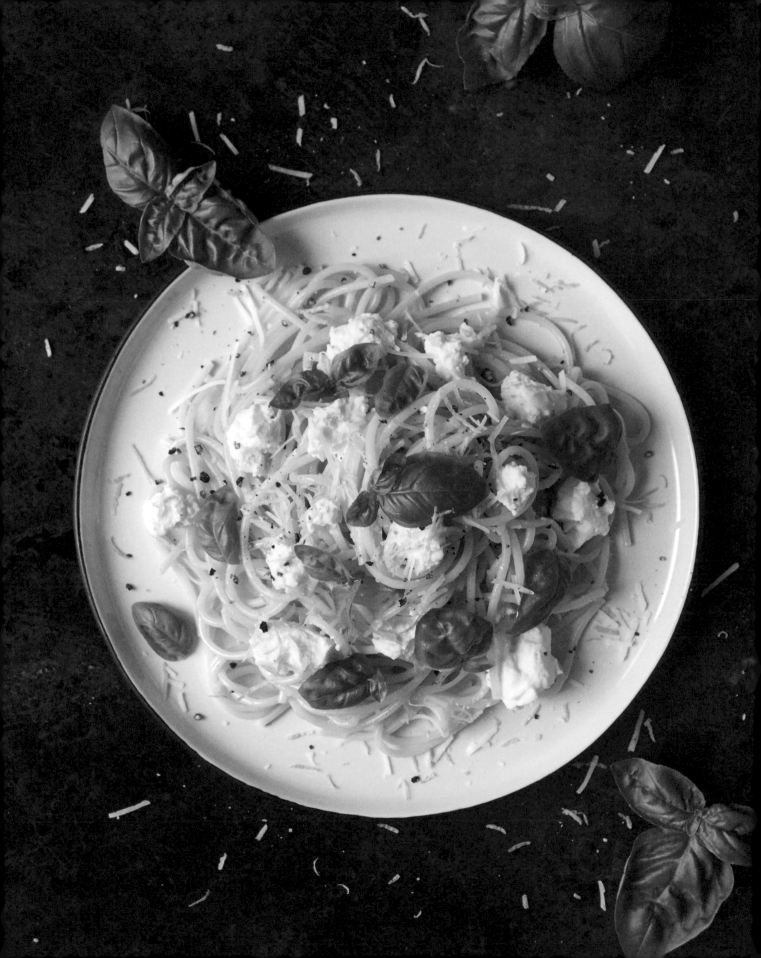

maltese lemon and ricotta pasta with basil

This recipe is like a good friend—close and always ready, day or night. When my mind is as empty as my fridge and I'm too tired to think about what to make, I grab spaghetti, a lemon, and ricotta, an essential dairy product that always has to be on hand when you live with a Maltese man. The citrus zest tames the creamy cheese with help from fresh basil and crunchy bites of crushed black pepper. This is comfort food: It keeps the weary mind at ease and gives the taste buds a feast.

I wish I could call this creation my own, but my boyfriend deserves all the credit. We came home late one night—in a silly mood and more than just a bit hungry—and went straight for the stove. Or rather he did. I sat down at the table, chatty with a glass of wine, and he threw together this little masterpiece. Made with ingredients so deeply rooted in Malta's cuisine, it's been called our "Maltese Pasta" ever since.

There's only one rule for this recipe and that's to adapt it to your own taste. It's up to the cook to decide if the final result should highlight the tangy richness of the ricotta, the pucker of the lemon, the sharpness of the peppercorns, or the basil's bright, aromatic qualities.

SERVES 2

7 ounces (200 g) dried spaghetti

Olive oil

4 to 6 heaping tablespoons fresh ricotta

Zest of 1 large lemon and a squeeze of juice (optional)

20 fresh basil leaves

Flaky sea salt

A few black peppercorns, crushed with a mortar and pestle

2 to 4 tablespoons freshly grated Parmesan

Bring a large pot of salted water to a boil and cook the spaghetti, according to the package instructions, until al dente. Drain the spaghetti and return it to the pot. Add a splash of olive oil and toss to coat. Divide the spaghetti among plates and top with generous dollops of ricotta. Sprinkle with the lemon zest and basil and season to taste with flaky sea salt and crushed peppercorns. Finish with the Parmesan and a squeeze of lemon, if using. Enjoy immediately.

maultaschen

GERMAN SPINACH AND MEAT RAVIOLI

Maultaschen are a southern German variation on ravioli and are typically filled with meat, spinach, and parsley. They're a Swabian classic, and apart from the equally delicious spaetzle (egg noodles), they're probably the region's most popular pasta. I learned to make this dish from a great man and a true master of Maultaschen, my Swabian stepfather, Uli. According to Uli, there are two traditional ways to serve Maultaschen, either in a bowl of steaming broth or fried in butter with juicy sweet onions, which is how leftovers are usually enjoyed.

This culinary masterpiece has a long and much-disputed origin story. One simple yet amusing version ties into the region's strong religious roots. Legend has it that at the Maulbronn monastery, a few crafty Cistercian monks found a sneaky way to eat meat on Fridays and during Lent. They combined minced meat with lots of greens to fill their ravioli, believing that God couldn't see the forbidden ingredient if it was hidden under pasta and vegetables. The monk's sinful trick led to the dish's crude nickname *Herrgottsbescheißerle*, meaning "God's cheater" in German.

Maultaschen are bigger than their Italian relatives, and according to Uli, the pasta should be thin and the filling generous. My version pairs beef, bacon, and sausage with tons of spinach and parsley to keep the Maultaschen light and green.

SERVES 6

FOR THE PASTA DOUGH

2⅓ cups (300 g) all-purpose flour

1½ teaspoons fine sea salt

3 large eggs

FOR THE FILLING

1 medium stale white bun or roll

10 ounces (280 g) regular spinach leaves

Olive oil

2 ounces (60 g) thick-cut bacon, cut into very small cubes

1 medium onion, finely chopped

2 cups (60 g) flat-leaf parsley leaves, finely chopped

9 ounces (250 g) ground meat (beef or a mixture)

5 ounces (140 g) coarse sausage, casings removed

2 heaping tablespoons sour cream

¼ teaspoon nutmeg, preferably freshly grated

1 teaspoon fine sea salt

A generous amount ground pepper

TO SERVE

About 6 ½ cups (1.5 l) vegetable broth (*see page 239*)

1 to 2 tablespoons unsalted butter

Olive oil

3 medium onions, cut in half and thinly sliced

1 small bunch chives, snipped

For the pasta dough, mix the ingredients together with the dough hooks of an electric mixer for 3 to 4 minutes or until well combined. Continue kneading with your hands for about 5 minutes or until smooth. Form the dough into a ball, wrap it in plastic wrap, and refrigerate for at least 1½ hours.

(continued)

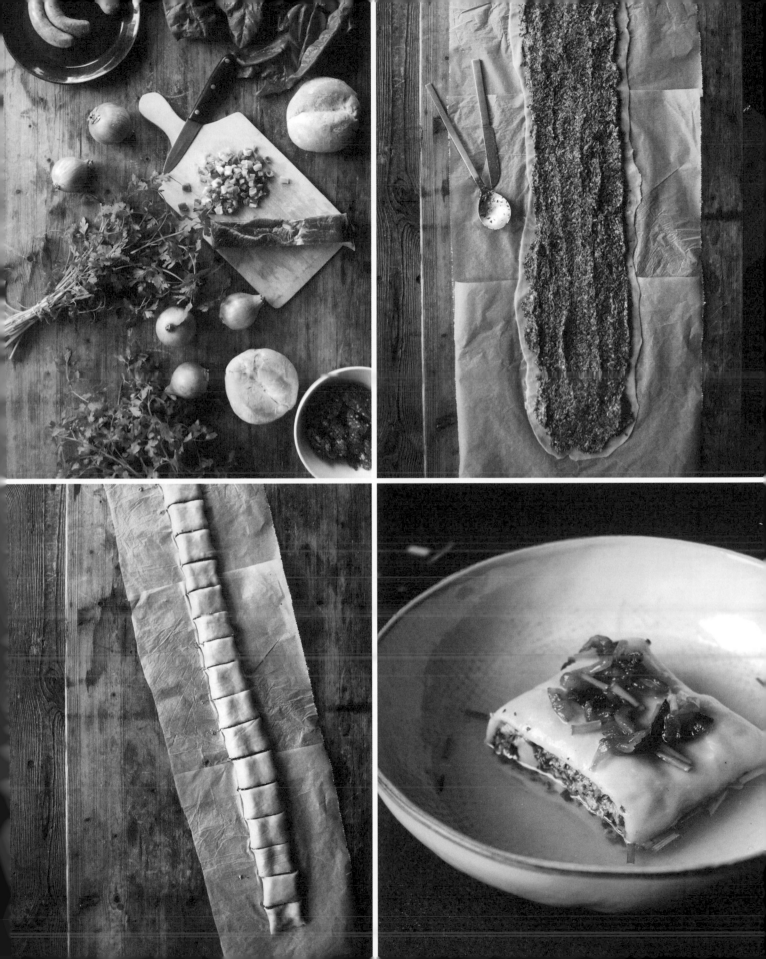

For the filling, soak the bun in warm water for 15 minutes, then squeeze out the excess water and tear it into chunks.

Bring a large pot of salted water to a boil and blanch the spinach for 1½ minutes. Drain and quickly rinse with cold water. Let the spinach cool for a few minutes, then squeeze out the excess water and finely chop the leaves. Transfer to a large bowl and set aside.

In a medium, heavy pan, heat a small splash of olive oil over medium-high heat. Add the bacon and cook for a few minutes or until crispy. Add the onion and sauté for 2 to 3 minutes or until soft and golden.

Add the bacon-onion mixture and the chunks of wet bread to the bowl of spinach, along with the parsley, ground meat, sausage, and sour cream. Season with nutmeg, salt, and pepper and mix with your hands until well combined. Cover the bowl and refrigerate while you roll out the pasta dough.

On a large table or countertop, arrange the pasta dough between 2 large sheets of plastic wrap. Use a rolling pin to roll out the dough into a thin 8 x 35-inch (20 x 90 cm) rectangle. Be patient: This can take about 20 minutes. Alternatively, use a pasta machine.

It's easier to finish the Maultaschen if the dough is on parchment paper instead of plastic wrap. Pull the top layer of plastic wrap off the dough and arrange a large sheet of parchment in its place. Carefully flip the sheet of pasta over, so that the parchment is on the bottom; pull off the plastic wrap that's on top.

Spread the filling evenly on top of the dough, leaving a ½-inch (1.25 cm) border all the way around. Use the parchment to gently roll one of the long sides up and over until the edge extends just past the middle. Gently pull the parchment away from the rolled up dough. Repeat on the other side, letting the edges of the pasta overlap generously in the middle and pulling the parchment away from the second side. Use your fingers to gently push the dough together and seal the fold. Arrange a new sheet of parchment next to the pasta roll and quickly flip the roll over and onto the clean parchment, so that the fold is on the bottom. With a sharp knife, carefully cut the pasta roll into 18 Maultaschen.

Bring a large pot of salted water to a boil (or 2 to 3 pots if you want to cook all the Maultaschen at the same time). Depending on the size of the pot, work in batches of about 6 and slip the Maultaschen into the boiling water. Cover the pot and immediately remove it from the heat. After about 12 minutes or when the Maultaschen rise to the surface, use a slotted spoon or ladle to transfer them to a rack. Repeat with the remaining Maultaschen.

While the Maultaschen cook, bring the broth in a medium saucepan to a boil and season to taste with salt and pepper. Take the saucepan off the heat, cover, and keep warm.

For the topping, in a medium skillet, heat the butter and a splash of olive oil over medium heat. Add the onions and sauté for 10 minutes or until soft and golden brown.

Serve the Maultaschen in bowls filled with a ladle of hot broth and garnished with the onions and chives.

asparagus, leek, and pea lasagna with chèvre and pecorino

This lasagna isn't as heavy as the Italian original, because instead of rich Bolognese, I use crisp green vegetables. Asparagus, leeks, and peas get to show off their sweeter side in a creamy béchamel that's refined with tangy chèvre and the fine aroma of young pecorino. It's delicious at lunchtime, cozy for dinner, and a fun treat for a summer party. Some, including my boyfriend, even like this pasta for breakfast, but that goes a bit too far for my taste.

SERVES 4 TO 6

FOR THE BÉCHAMEL SAUCE

3 cups (700 ml) whole milk

Pinch of nutmeg, preferably freshly grated

Fine sea salt

Ground pepper

2 tablespoons (30 g) unsalted butter

4 tablespoons (30 g) all-purpose flour

1 large bay leaf

FOR THE LASAGNA

Unsalted butter, for the baking dish

1¼ pounds (560 g) trimmed green asparagus

4 ounces (115 g) fresh or frozen peas

Olive oil

7 ounces (200 g) leeks (white and light green parts only), thinly sliced

About 9 ounces (250 g) no-boil lasagna noodles

6 ounces (170 g) soft chèvre, crumbled

1¼ cups (300 ml) dry white wine

2 heaping tablespoons freshly grated pecorino or Parmesan

A few black peppercorns, crushed with a mortar and pestle

FOR THE TOPPING

2 to 3 tablespoons freshly grated pecorino or Parmesan

For the béchamel sauce, combine the milk, nutmeg, and pinches of salt and pepper in a medium saucepan and bring to a boil. Immediately take the pan off the heat and set aside.

To make the roux for the béchamel, melt the butter in a separate medium saucepan over medium-high heat and as soon as it's sizzling hot, whisk in the flour. Slowly pour the hot milk mixture into the roux and whisk until smooth. Add the bay leaf and simmer on low, whisking occasionally, for 2 to 3 minutes or until the texture starts to thicken. Remove and discard the bay leaf. Season to taste with nutmeg, salt, and pepper, then cover and set aside.

Preheat the oven to 350°F (180°C) and butter a 10 x 8-inch (26 x 20 cm) baking dish (or a dish of roughly this size).

Bring a large pot of salted water to a boil and cook the asparagus for about 3 minutes or until al dente. Drain and quickly rinse with cold water. Cut the heads off and reserve (for the top layer of the lasagna) and cut the stems in half lengthwise.

Bring a small saucepan of salted water to a boil and blanch the peas for about 1 minute or until al dente, drain, and quickly rinse with cold water.

(continued)

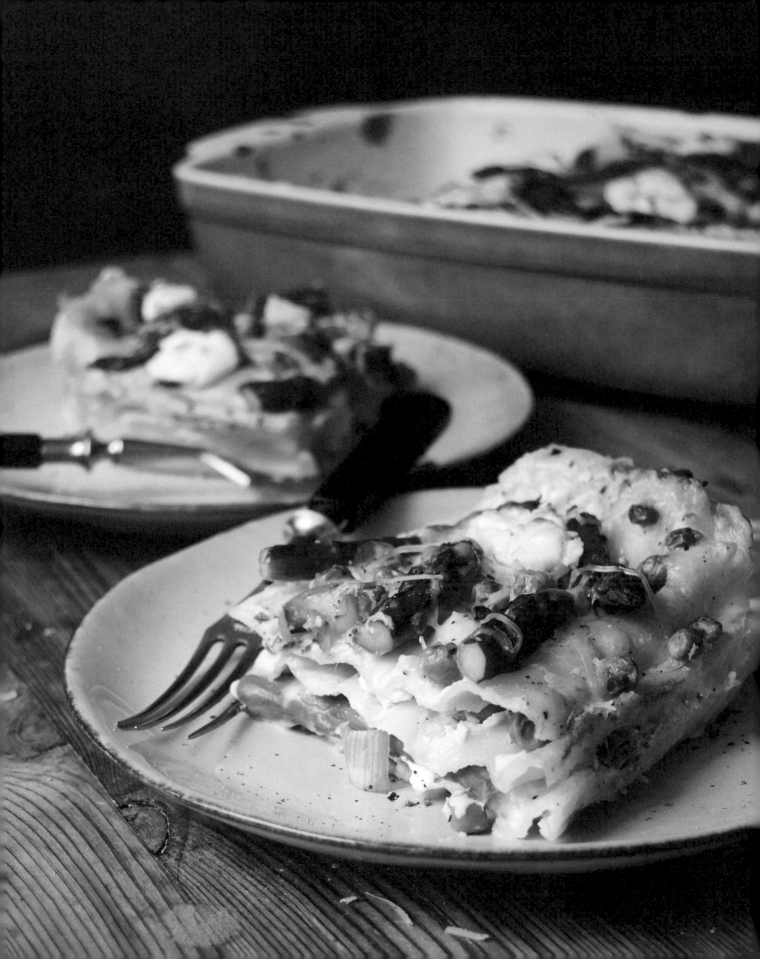

In a large, heavy pan, heat a splash of olive oil over medium heat and sauté the leeks, stirring occasionally, for a few minutes or until soft and golden brown.

Arrange a layer of pasta on the bottom of the baking dish and spread with ¼ of the béchamel. Top with ⅓ of the asparagus stems, ¼ of the peas, and ¼ of the leeks. Top with ¼ of the chèvre then pour ¼ of the wine on top. Repeat to make 3 more layers, using the asparagus heads (instead of the stems) for the final layer. Sprinkle with pecorino and crushed peppercorns and bake for 35 to 45 minutes (depending on the lasagna package instructions) or until the pasta is al dente. To brown the cheese a little, you can switch on the broiler for the last 1 to 2 minutes.

Let the lasagna sit for 5 to 10 minutes before serving. Divide it among plates and sprinkle with pecorino.

wild mushroom spaghetti
with orange butter and crispy sage

Spaghetti stirred into luscious orange butter is as smooth as velvet and makes a satisfying supper on its own—just sprinkle some crushed black peppercorns on top and you have a comforting dish without much effort. But if you add crispy fried sage and meaty wild mushrooms you can take this pasta to the next level. The tasty trilogy of porcini, chanterelles, and king oyster mushrooms adds earthy flavor and a hearty feel to this autumn-friendly meal. And it's quick: The mushrooms are best when they're cooked only briefly. They should be firm with some bite—that's what you're after.

This is the kind of pasta dish that's best eaten straight out of the pan, a culinary delight that's hard to beat.

SERVES 2

7 ounces (200 g) dried spaghetti

Unsalted butter

2 ounces (60 g) porcini mushrooms, cut into ½-inch (1.25 cm) pieces

Fine sea salt

A few black peppercorns, crushed with a mortar and pestle

4 ounces (110 g) chanterelles, cut in half lengthwise

Olive oil

4 ounces (110 g) king oyster mushrooms, cut into ½-inch (1.25 cm) pieces

15 fresh sage leaves

5 tablespoons freshly squeezed orange juice

Freshly grated zest of 1 orange

Bring a large pot of salted water to a boil and cook the spaghetti, according to the package instructions, until al dente. Drain the spaghetti and set aside.

In a large, heavy pan, heat 1 tablespoon of butter over high heat. Add the porcini mushrooms and sauté, stirring constantly, for 1 minute or until al dente and golden. Season to taste with salt and crushed peppercorns and transfer to a plate. Keep the pan over high heat and heat 1 tablespoon of butter until it starts sizzling. Add the chanterelles and sauté, stirring constantly, for 1 to 1½ minutes or until al dente. Season to taste with salt and crushed peppercorns and add to the plate with the porcinis. Keep the pan over high heat and heat another tablespoon of butter and a splash of olive oil. Add the king oyster mushrooms and sauté, stirring constantly, for 2 to 2½ minutes or until they're golden but still have some bite. Season to taste with salt and crushed peppercorns and add to the plate with the other mushrooms.

Place the pan over medium-high heat, heat 2 tablespoons of butter, and fry the sage for about 30 seconds or until crisp and golden but not dark. Transfer the sage to a plate. Add the orange juice and deglaze the pan, using a spatula to scrape any bits and pieces off the bottom. Add the pasta and mushrooms to the pan, stir to combine, and season to taste with salt, crushed peppercorns, and orange zest. Sprinkle with the crispy sage leaves and serve immediately.

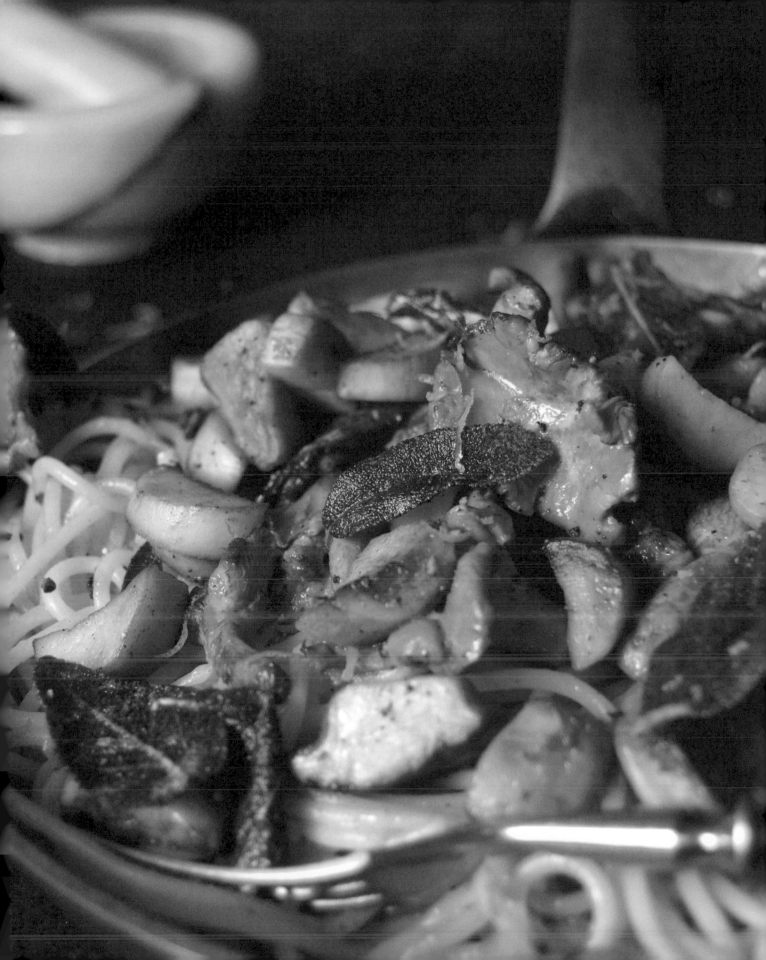

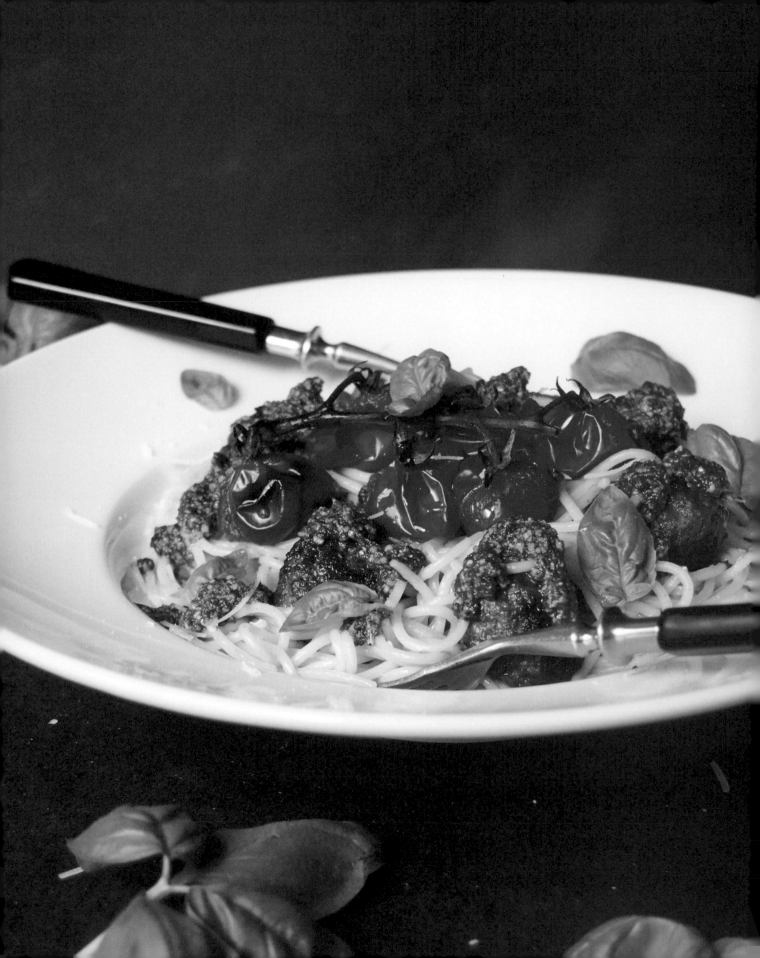

spaghetti with pesto polpette and roasted cherry tomatoes on the vine

I grew up on meatballs—juicy walnut-sized balls in a sweet-and-sour caper sauce (a Prussian dish called *Könisberger Klopse*) made by my grandmother Lisa and herb-stuffed *polpette* in my mother's kitchen. My version features pesto. The oily herb sauce gives the meatballs a succulent texture and rich aromatic flavor. I use basil, but you could easily exchange it with arugula or ramps. Most importantly, the meatballs have to be small enough to roll up into a forkful of spaghetti with a soft, roasted tomato.

SERVES 4

FOR THE PESTO

2 ounces (55 g) fresh basil leaves

1 ounce (30 g) freshly grated Parmesan

3 tablespoons pine nuts

½ cup (120 ml) olive oil

Fine sea salt

24 cherry tomatoes, on the vine

12 ounces (340 g) dried spaghetti

Olive oil

FOR THE MEATBALLS

18 ounces (510 g) ground beef

1 large egg

⅓ cup (40 g) dry breadcrumbs

1 medium onion, finely chopped

2 large cloves garlic, crushed

3 tablespoons basil pesto

1½ teaspoons fine sea salt

A generous amount ground pepper

2 tablespoons unsalted butter, to cook the meatballs

Olive oil, to cook the meatballs

FOR THE TOPPING

Freshly grated Parmesan

A few fresh basil leaves

Flaky sea salt

A few black peppercorns, crushed with a mortar and pestle

For the pesto, in a food processor or blender, purée the first 4 ingredients until smooth. Season to taste with salt and set aside.

For the tomatoes, set the oven to broil (quicker method) or preheat to 425°F (220°C).

Place the tomatoes on the vine in a baking dish and broil for 12 minutes or roast at 425°F (220°C) for 35 to 45 minutes—their skins should start to burst and turn partly black. Leaving the tomatoes on the vine, divide them into 4 portions.

For the meatballs, combine the ingredients in a large bowl and mix with your hands until well combined. Wet your hands and form the mixture into 24 1½-inch (4 cm) meatballs.

In a large, heavy pan, heat the butter and a generous splash of olive oil over medium heat. Cook the meatballs, turning occasionally, for 8 to 10 minutes or until just cooked through.

While the meatballs are cooking, bring a large pot of salted water to a boil and cook the spaghetti, according to the package instructions, until al dente. Drain the spaghetti and return it to the pot. Add a splash of olive oil and toss to coat.

Divide the spaghetti among plates. Top with the meatballs and tomatoes, drizzle with the remaining pesto, and sprinkle with Parmesan and basil. Season to taste with flaky sea salt and crushed peppercorns and serve.

pumpkin gnocchi with roquefort sauce

Gnocchi are the most tempting treat, but only if they're homemade. They make such a relaxed and cozy dinner, yet there's also something elegant about them. For years, I only used potatoes for the dough, and focused on mastering these little pasta pillows. In the process, I learned how to avoid a few common mistakes, like most importantly, to never mix the flour into warm potatoes, as this leads to gnocchi that are far too soft. You must add the butter and egg yolks right after pressing the warm potatoes through a ricer, but let this mixture completely cool before you add the flour and shape the gnocchi.

Over the years, I started introducing other vegetables to the mix. Spinach is delicious, but pumpkin, or butternut squash, is my favorite. It adds a certain sweetness, while still providing the same light fluffiness as potatoes.

When it comes to the sauce, sage leaves fried in butter until golden and crisp are quick, easy, and scrumptious. With a little more time—while the dough is cooling for example—you can make a creamy Roquefort sauce. It's so intensely flavored and has such sensual smoothness that I always find it hard to stop myself from eating every last drop.

SERVES 4 TO 6

FOR THE GNOCCHI

21 ounces (600 g) seeded and peeled squash, preferably butternut, or Hokkaido with skin, cut into 1-inch (2.5 cm) cubes

7 ounces (200 g) peeled starchy potatoes, cut into 1-inch (2.5 cm) cubes

2 tablespoons (30 g) unsalted butter

2 large egg yolks

2¼ to 4¼ cups (290 to 550 g) all-purpose flour

1 tablespoon fine sea salt

A generous amount nutmeg, preferably freshly grated

A generous amount ground pepper

FOR THE ROQUEFORT SAUCE

2 tablespoons (30 g) unsalted butter

2 small onions, finely chopped

3 cloves garlic, cut in half

1¼ cups (300 ml) dry white wine

1 cup (240 ml) whole milk

1 cup (240 ml) heavy cream

3 long sprigs flat-leaf parsley

4 whole cloves

4 juniper berries, lightly cracked with a mortar and pestle

1 large bay leaf

8 black peppercorns

4 ounces (110 g) Roquefort (or any aromatic blue cheese, such as Stilton or Fourme d'Ambert), crumbled

Fine sea salt

Ground pepper

FOR THE TOPPING

A few black peppercorns, crushed with a mortar and pestle

For the gnocchi dough, bring a large pot of salted water to a boil and cook the squash and potatoes for 15 to 18 minutes or until very soft. Use a slotted spoon or ladle to transfer them to a colander. Drain well, then use a spoon to gently push any remaining water out of the squash and potatoes; leave to dry in the colander for about 2 minutes. Press the squash and the

(continued)

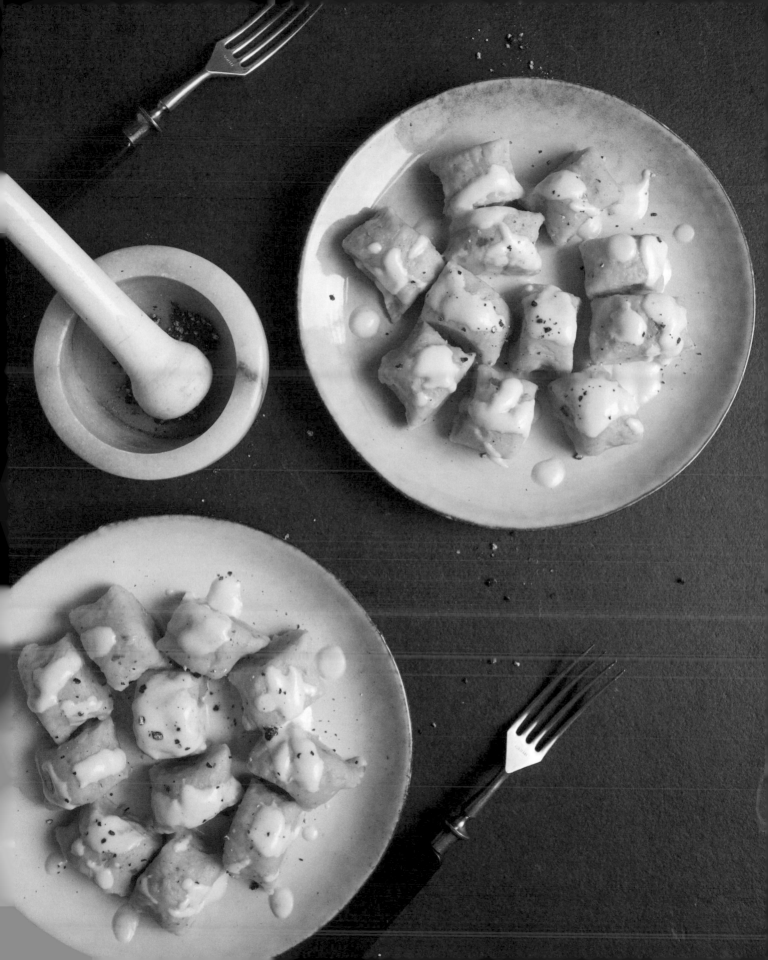

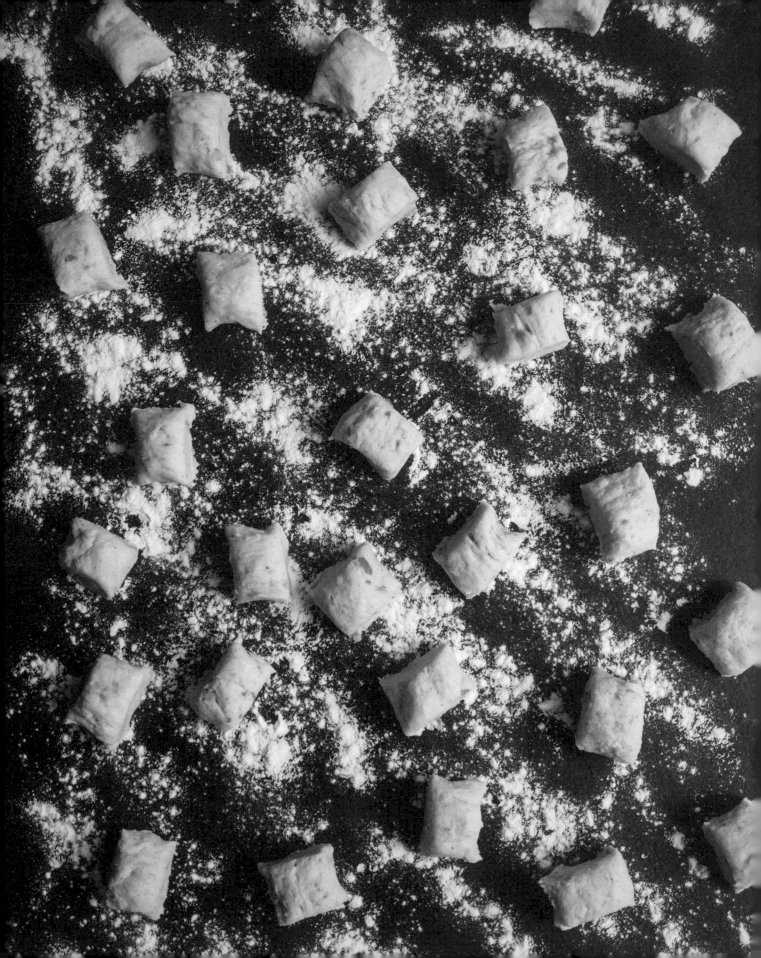

potatoes through a potato ricer into a large bowl. If there's any water in the bowl, use a spoon to remove it. Add the butter and egg yolks and stir to combine. Refrigerate for 1 to 2 hours or until completely cool.

For the Roquefort sauce, heat the butter in a medium saucepan over medium heat. Add the onions and garlic and sauté for 2 to 3 minutes or until soft and golden. Add the wine, milk, cream, parsley, cloves, juniper berries, bay leaf, and peppercorns and bring to a boil. Reduce the heat and simmer uncovered, stirring occasionally, for 10 minutes. Pour the sauce through a fine-mesh strainer into a wide pan and bring to a boil. Add the Roquefort and whisk until melted. Reduce the heat to medium and cook, stirring occasionally, for 15 to 20 minutes or until the sauce starts to thicken. Season to taste with salt and pepper. Let the sauce cool for a few minutes—it will continue to thicken—then cover and set aside.

Once the squash-potato mixture is completely cool, add 2¼ cups (290 g) of the flour, the salt, nutmeg, and pepper, and quickly stir to combine. If the mixture is too soft and not firm enough to roll into a log, gradually add more flour. It can be a little sticky. Dust your hands and a table or countertop generously with flour. Roll a quarter of the dough into a 1-inch-thick (2.5 cm) log. Cut the log into 1-inch (2.5 cm) pieces and transfer to a well-floured baking sheet. Repeat with the remaining dough.

Bring a large pot of salted water to a boil. Working in batches, add the gnocchi and simmer for 3 to 4 minutes, or until they float to the top of the water—mind that they don't stick to the bottom of the pot. Use a slotted ladle or spoon to scoop the gnocchi out of the water then quickly drain and place them in an ovenproof dish. Cover and keep them in a warm oven while you cook the rest of the gnocchi, bringing the water back to a boil between batches.

Warm the Roquefort sauce over low heat. Divide the gnocchi among plates, drizzle with the sauce, and sprinkle with crushed peppercorns.

spaghetti with broccoli pesto, sun-dried tomatoes, and chile

Come February, my culinary mood tends to hit a low point. The market offers little more than cabbages and roots, and my kitchen has seen so many soups and stews, that I've started dreaming about them. Colorful fruits and vegetables are on my mind, but unfortunately not on my plate. Eventually I lose my patience. My head starts spinning and I find myself looking for recipes with at least a hint of summer. Pasta with pesto is an excellent solution. I just ignore the cold grey outside and pretend that I'm already a few months ahead. Winter's greenhouse basil is far too weak, so pesto alla Genovese isn't really an option. Instead, I find unexpected help from broccoli. Cooked then puréed with parsley, ginger and garlic, this normally shy vegetable comes alive as a thick pesto. Sprinkling sun-dried tomatoes and fresh chile on top wipes out any lingering winter blues, and gives me that early summer feeling I crave.

SERVES 2

7 ounces (200 g) dried spaghetti

½ pound (225 g) broccoli florets

2 heaping tablespoons chopped flat-leaf parsley leaves

1 anchovy fillet, rinsed, dried, and chopped

1 large clove garlic, crushed

¼ teaspoon freshly grated ginger

1 tablespoon freshly squeezed lemon juice

1 tablespoon olive oil

Fine sea salt

Ground pepper

FOR THE TOPPING

1 sun-dried tomato, not packed in oil

1 medium fresh red chile, seeded and finely chopped

A few black peppercorns, crushed with a mortar and pestle

Bring a large pot of salted water to a boil and cook the spaghetti, according to the package instructions, until al dente.

While the spaghetti is boiling, make the topping: In a small saucepan, bring about ½ cup (120 ml) of water to a boil. Add the sun-dried tomato then reduce the heat and simmer for 2 minutes. Rinse the sun-dried tomato under cold water and pat dry with paper towels. Roughly chop and set aside.

For the pesto, bring a large pot of salted water to a boil and blanch the broccoli for about 3 minutes or until al dente. Use a slotted ladle or spoon to remove the broccoli (reserve the cooking water) and rinse under cold water. Reserve a handful of small, pretty broccoli florets.

In a food processor or blender, purée the remaining broccoli, along with 6 tablespoons of its cooking water. Add the parsley, anchovy, garlic, ginger, lemon juice, and olive oil and purée until smooth. Season to taste with salt and pepper. If the pesto is too thick, gradually add more broccoli water.

When the spaghetti is done, drain it and divide between plates. Top with the reserved broccoli florets and generous dollops of the broccoli pesto. Sprinkle with the sun-dried tomato, chile, and crushed peppercorns and serve.

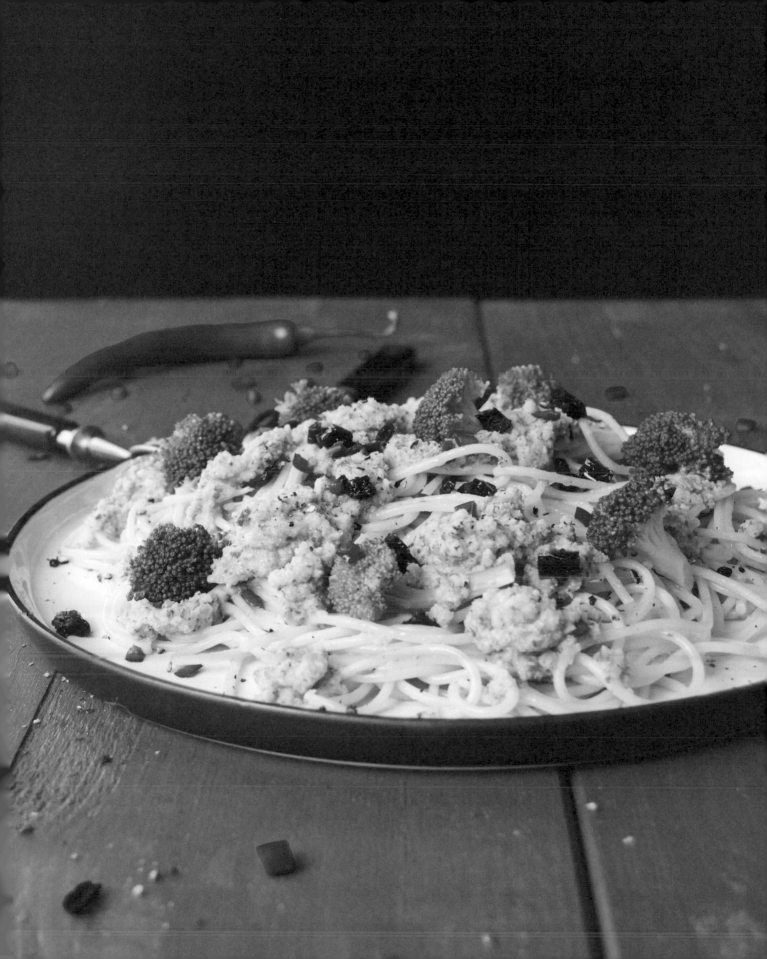

sandwiches

WILD MUSHROOM, BACON, AND GRILLED GRUYÈRE SANDWICH

PEA PESTO AND HONEY-CARAMELIZED BACON SANDWICH
WITH FRESH MARJORAM

LAMB, MOROCCAN LEMON, AND CAPER SANDWICH

ROASTED SPRING ONIONS AND RACLETTE IN CARROZZA

TAJJEB | GRILLED EGGPLANT, RICOTTA, CHICKPEA, AND POACHED EGG TARTINE

TORTA AL TESTO WITH LEMON-ROSEMARY LENTIL BURGERS
AND MOZZARELLA DI BUFALA

SAUSAGE AND BUTTER BEAN CIABATTA SANDWICH WITH ORANGE AND THYME

ROASTED SHALLOT, CARAMELIZED PLUM, AND STILTON TARTINE WITH ROSEMARY

A SWEDISH LOBSTER ROLL: CRAYFISH WITH BEET MOUSSE ON SOURDOUGH

SPICED APPLE, HAM, AND RACLETTE SANDWICH

ROASTED GARLIC AND TOMATO FOCACCIA SANDWICH WITH ROSEMARY OIL

BALSAMIC STRAWBERRY, CHÈVRE, AND PISTACHIO TARTINE

wild mushroom, bacon, and grilled gruyère sandwich

The sandwich has often been my best friend in the kitchen. There's something very satisfying about its down-to-earth simplicity and I love that it works for breakfast, lunch, and dinner. You just have to follow a few rules, starting with the right choice of bread. No matter if it's white or dark, the bread needs to be spongy to soak up any juices from the filling. There's an unlimited universe of options for what you can stuff inside your sandwich, but a well-balanced combination is the key to success. Limit yourself to just a few contrasting flavors and textures. Using too many ingredients can be distracting and you don't want to strain your taste buds.

This autumnal sandwich features salty bacon, aromatic Gruyère, and a generous sprinkle of thyme, but the real focus is on the earthy depth of the mushrooms. I'm quite picky when it comes to mushrooms, and can't stand it when they're soft and mushy. They should be tender yet firm, which is why they only see the hot pan for a minute or two.

MAKES 3 TO 4 SANDWICHES

Olive oil

6 to 8 slices bacon

10 ounces (280 g) oyster and king oyster mushrooms (or any wild mushrooms, such as porcini or chanterelles), cut in half lengthwise

A few black peppercorns, crushed with a mortar and pestle

Unsalted butter

3 to 4 rustic white buns, cut in half

4 ounces (110 g) Gruyère (or any aromatic hard cheese such as Comté or Raclette), thinly sliced

1 tablespoon fresh thyme leaves

In a large, heavy pan, heat a small splash of olive oil over medium-high heat and cook the bacon, turning occasionally, for a few minutes or until crispy and golden brown. Take the bacon out of the pan, leaving the fat behind, and set aside.

Return the pan to medium-high heat. It's best to cook each type of mushroom separately, as cooking times vary. Sauté the mushrooms in the bacon fat, stirring occasionally, for 1 to 2 minutes or until golden—they should still have some bite. Season to taste with crushed peppercorns. Remove the mushrooms from the pan, cover, and keep warm. Repeat with the other varieties of mushrooms, adding a little butter to the pan if it gets dry.

Set the oven to broil (quicker method) or preheat to 500°F (260°C).

Lay the bacon on the bottoms of the buns and cover with about ¾ of the Gruyère slices. Put the sandwiches under the broiler, or roast at 500°F (260°C), for a few minutes or until the cheese just starts to melt. Divide the mushrooms among the sandwiches and sprinkle with the thyme and crushed peppercorns. Break up the remaining Gruyère and divide it among the sandwiches. Place the tops of the buns over the cheese and enjoy immediately.

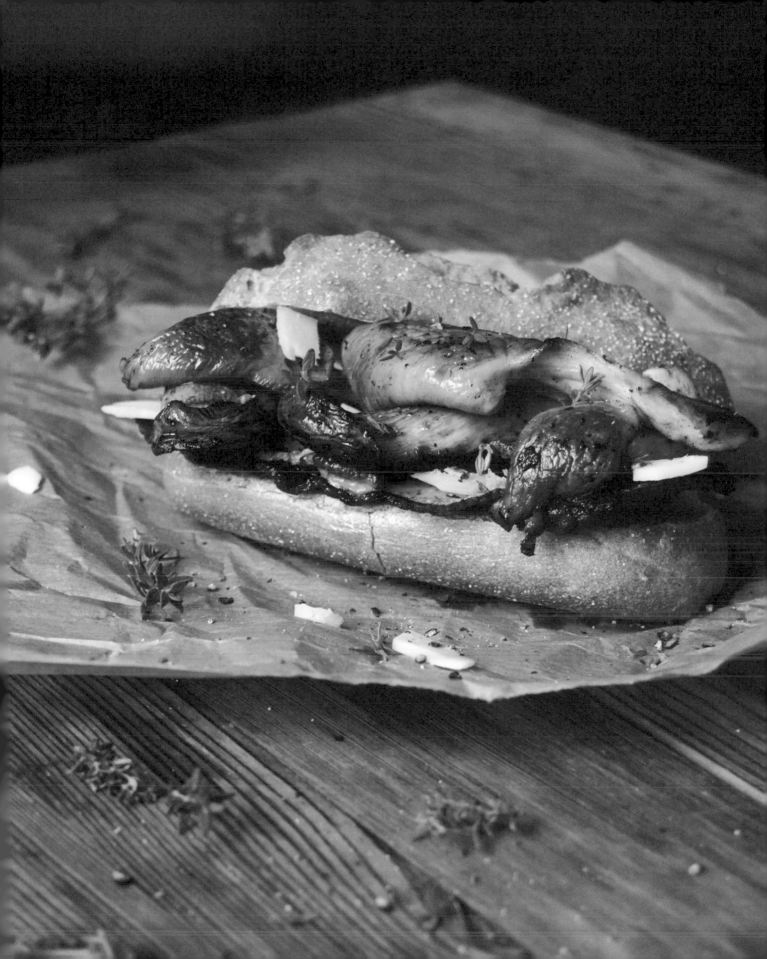

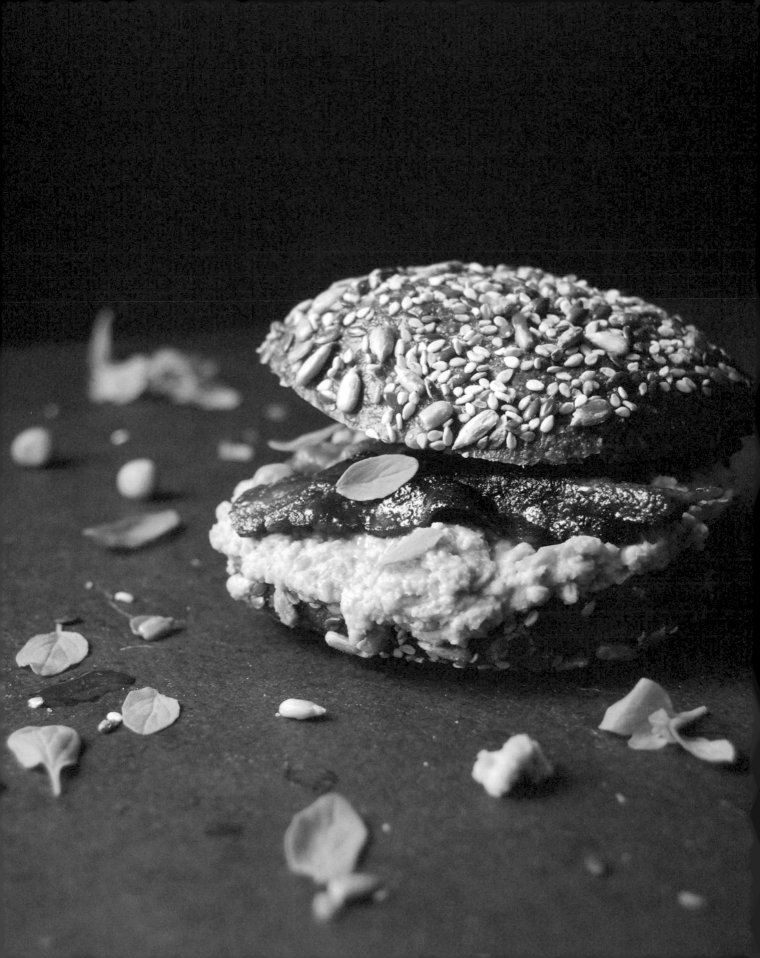

pea pesto and honey-caramelized bacon sandwich with fresh marjoram

There is only one frozen vegetable in my kitchen: sweet peas. This is partly due to the fact that peas have such a short season, but it's mainly because I like to eat them all year round. I always keep a bag in a corner of my freezer, just in case one of my salad, pasta, or curry recipes needs a hint of their grassy green sweetness. Using peas to make pesto was a late but very pleasant discovery. You could call it a purée though that doesn't sound as nice and wouldn't do this bright green beauty any justice—it's an elegant pesto, fluffy, flamboyant, and fresh.

I only give the legumes a quick dip in boiling water, followed by a cold rinse to preserve their crunchy texture and crisp color, two essential qualities for the final result. Marjoram, garlic, lemon juice, and olive oil add a summery touch. The combination tastes so good that the recipe could stop there, and in fact, I sometimes use this vivid green pesto as a dip. Serve it with soft, spongy ciabatta and a glass of chilled white wine and the day could end happily. But when it comes to sandwiches, the rules change. Less-is-more turns into more, and I pair the pesto with salty, crunchy honey-caramelized bacon.

MAKES 4 SANDWICHES

FOR THE PESTO

9 ounces (260 g) fresh or frozen peas

2 cloves garlic, cut into quarters

3 tablespoons olive oil

1 to 2 teaspoons freshly squeezed lemon juice

1 to 2 teaspoons chopped fresh young marjoram leaves

Fine sea salt

Ground pepper

FOR THE SANDWICHES

Olive oil

8 slices bacon

1 teaspoon honey

4 whole-grain buns, cut in half

A few fresh young marjoram leaves

For the pesto, bring a small pot of salted water to a boil and blanch the peas and garlic for 1 minute. Drain the peas and garlic, reserving 3 tablespoons of the cooking water, then quickly rinse under cold water.

In a food processor or blender, combine the peas, garlic, 1 tablespoon of their cooking water, the olive oil, 1 teaspoon of the lemon juice, and 1 teaspoon of the marjoram. Purée until smooth. Add more cooking water if the pesto is too thick, and season to taste with salt, pepper, and additional lemon juice and marjoram. Transfer the pesto to a bowl and set aside.

In a large, heavy pan, heat a small splash of olive oil over medium-high heat and cook the bacon, turning occasionally, for a few minutes or until crispy and golden brown. Turn up the heat, add the honey, and caramelize the bacon, stirring occasionally, for about 1 minute. Take the pan off the heat.

Spread the pea pesto on the bottom of each bun. Layer each sandwich with bacon and drizzle with some of the honey-bacon juices. Sprinkle with a few marjoram leaves, add the top of each bun, and serve immediately.

lamb, moroccan lemon, and caper sandwich

The Mediterranean meets North Africa in this richly flavored sandwich, starring tender lamb, briny capers, and preserved lemon. I have a weak spot for lemons, so I complement the tart juices from the preserved fruit with citrus peel that's been roasted in olive oil. The fragrant oil is a delicious bonus to drizzle over the soft bread.

Moroccan preserved lemons can be found in the delicatessen section of bigger supermarkets or online, but I recommend giving the preparation a try in your own kitchen (*see page 239*). Tightly tucked in a jar, the fruit is preserved in sea salt for at least a month, giving it time to develop concentrated juices with biting intensity. The skin softens slowly during the process, which means the cook can use the entire lemon. Sliced thinly, it gives meat, cheese, or sautéed vegetables a bright boost of citrus. Some prefer to rinse off some of the salt, but it has such bold power that I don't like to waste it.

MAKES 4 SANDWICHES

6 long strips fresh lemon peel

Olive oil

10 ounces (280 g) lamb fillet

Fine sea salt

A few black peppercorns, crushed with a mortar and pestle

8 thick slices sourdough bread

1 small handful arugula leaves

¼ Moroccan preserved lemon, cut into very thin strips (*see page 239*)

1 heaping tablespoon capers, preferably preserved in salt, rinsed well and drained

Preheat the oven to 400°F (200°C).

In a small baking dish, toss the lemon peel with 3 tablespoons of olive oil. Roast for about 6 minutes or until the peel is crisp and golden brown—mind that it doesn't get dark. Let cool slightly then remove the peel from the oil and break it into pieces. Set the peel and the oil aside.

In a medium, heavy pan, heat a splash of olive oil over medium-high heat. Sear the lamb for 1½ to 2 minutes per side, or until evenly browned—it should stay pink on the inside. Take the pan off the heat and season the lamb to taste with salt and crushed peppercorns. Take the fillet out of the pan, wrap it in aluminum foil, and let the meat rest for a few minutes before cutting it into thin slices.

Drizzle a little lemon oil over the bread and layer 4 of the slices with arugula leaves and lamb. Drizzle with more lemon oil and sprinkle with preserved lemon, roasted lemon peel, capers, and crushed peppercorns. Top each sandwich with a second slice of bread and enjoy.

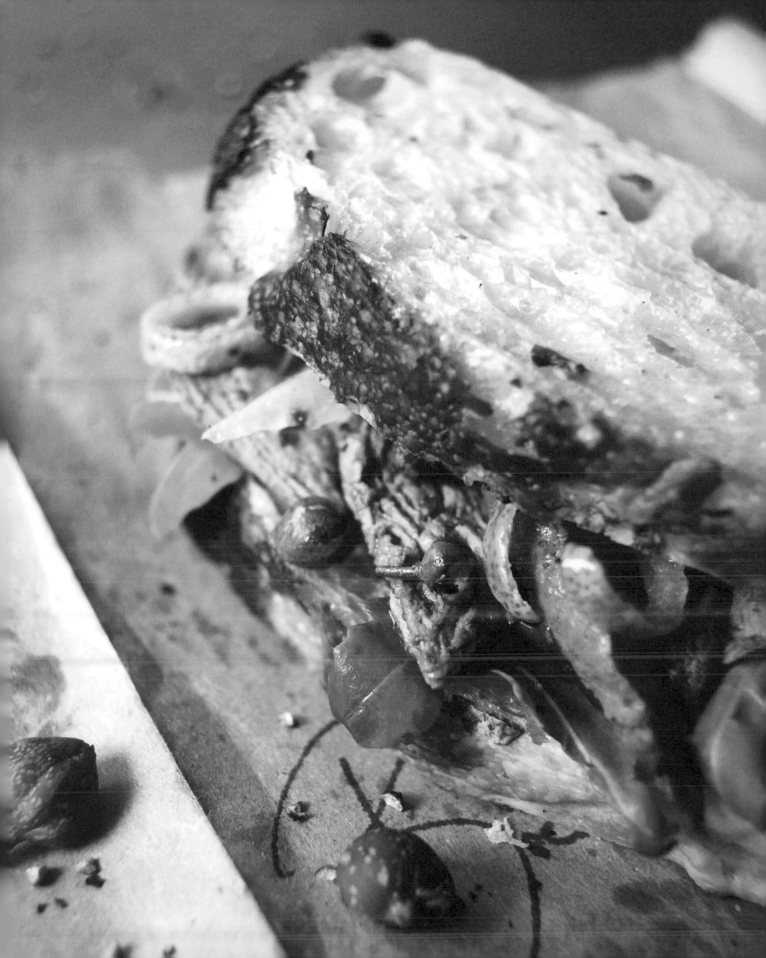

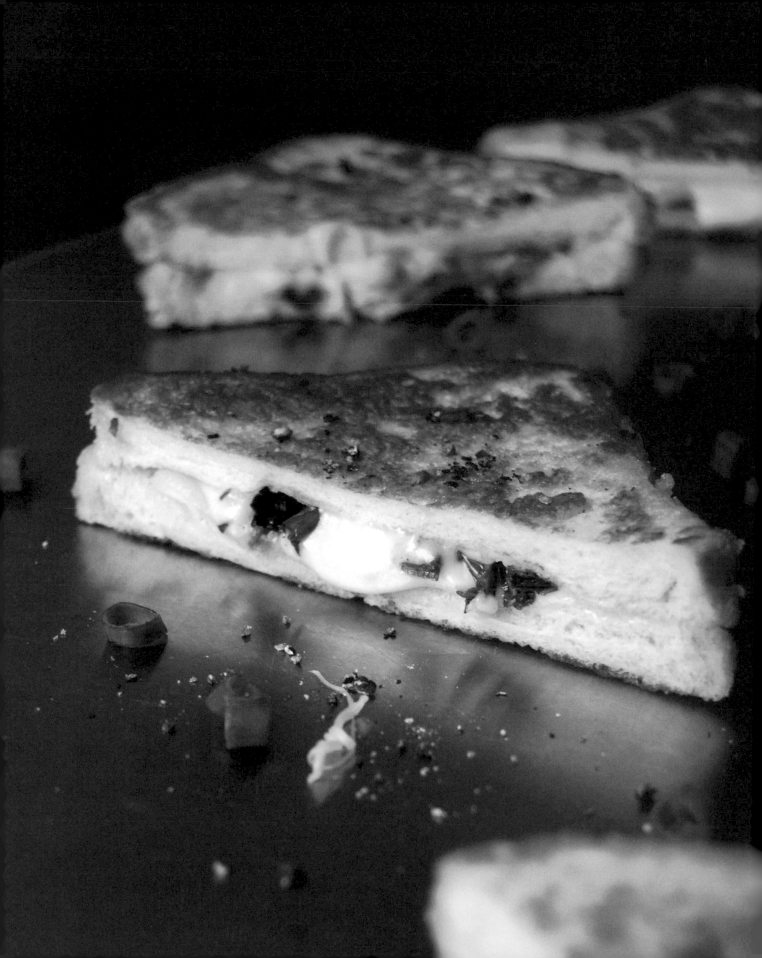

roasted spring onions and raclette in carrozza

I'm a big fan of Italian in *carrozza*, which translates to "in a carriage." This Neapolitan snack is eggy like French toast and wrapped in a golden crust. The most basic version features mozzarella and fresh basil melted between slices of soft bread and fried in sizzling butter. It's best fresh out of the pan, tender inside and slightly crisp on the outside. Don't spare on the filling: Soft cheese dripping lusciously when the bread is cut is an essential part of the experience.

An in carrozza sandwich goes well with just about anything that would please a pizza, but roasted spring onions and Raclette is exceptionally exciting. If you can't get hold of Raclette, use the strongest and most aromatic cheese you can find—it needs to have confident sharpness to stand up to the onions.

MAKES 3 SANDWICHES

4 small spring onions, cut in half lengthwise	2 large eggs	2 ounces (60 g) Raclette (or any aromatic cheese that melts well, such as Comté or Gruyère), cut into thick slices
1 tablespoon olive oil	4 tablespoons whole milk	
Coarse sea salt	Fine sea salt	
A few black peppercorns, crushed with a mortar and pestle	Ground pepper	6 slices soft white bread
	2 to 3 tablespoons all-purpose flour	About 1 tablespoon unsalted butter

Preheat the oven to 425°F (220°C).

In a baking dish, toss the spring onions with the olive oil and season to taste with coarse sea salt and crushed peppercorns. Roast, turning once, for about 15 to 20 minutes or until soft and golden brown.

In a shallow bowl, whisk together the eggs and milk. Season to taste with fine sea salt and ground pepper. Spread the flour on a flat plate.

Divide the onions and Raclette among 3 slices of bread, leaving a thin border around the edges. Top each with a second slice of bread and press the sandwiches together. Dip both sides of each sandwich in the flour until lightly coated. Carefully dip each sandwich in the egg-milk mixture, repeat until all the liquid is soaked up—mind that the filling stays inside.

In a large, heavy pan, heat the butter over medium heat and cook the sandwiches, turning and pressing down on them gently with a spatula, for a few minutes or until crisp and golden brown. Cut the sandwiches in half and serve immediately.

tajjeb

GRILLED EGGPLANT, RICOTTA, CHICKPEA, AND POACHED EGG TARTINE

My friend Guy introduced me to *sabih*. Meaning "beautiful" in Arabic, it's a delicious and lusciously filled sandwich, and very popular in Guy's home country of Israel. I was already familiar with the word—it means the same thing in Maltese—but the sandwich was completely new to me. The name sounds promising and the creation itself lives up to its title. Hummus thickly spread on a slice of soft white bread and topped with grilled eggplant and a hardboiled egg is divine, so much so that it's become a staple in my kitchen.

For a change, I combined sabih with another lovely dish, roasted eggplant rolls filled with ricotta. After a few adjustments, the two recipes merged into one, and became *tajjeb*, which translates to "good" in Maltese. I chose this simple name myself, and it's no exaggeration. Velvety balsamic and basil ricotta and whole chickpeas replace the hummus, and balance the eggplant's smokiness. A poached egg crowns the top and lends its warm and runny yellow juices—tajjeb!

MAKES 4 TARTINES

FOR THE BALSAMIC RICOTTA

6 ounces (170 g) fresh ricotta

1 tablespoon balsamic vinegar

10 fresh basil leaves, roughly chopped

Fine sea salt

Ground pepper

1 small eggplant, cut lengthwise into ¼-inch (7 mm) slices

Olive oil

Coarse sea salt

A few black peppercorns, crushed with a mortar and pestle

½ cup (85 g) drained and rinsed canned chickpeas

Fine sea salt

4 large eggs

4 thick slices soft white bread, such as ciabatta

FOR THE TOPPING

8 small fresh basil leaves

A few black peppercorns, crushed with a mortar and pestle

For the balsamic ricotta, whisk together the ricotta, vinegar, and basil. Season to taste with salt and pepper and set aside.

Set the oven to broil (quicker method) or preheat to 500°F (260°C).

Set a wire rack on a rimmed baking sheet and arrange the eggplant slices side by side on the rack. Brush both sides of the eggplant slices with olive oil and season to taste with coarse sea salt and crushed peppercorns. Broil, turning once, for about 5 to 7 minutes per side, or roast at 500°F (260°C) for 15 minutes then flip and continue roasting for another 6 minutes. The eggplant should be golden and partly brown, but not black. Watch it closely, as the very thin parts tend to burn quickly. Arrange the eggplant slices on top of each other on a plate—this will keep them moist—and set aside.

(continued)

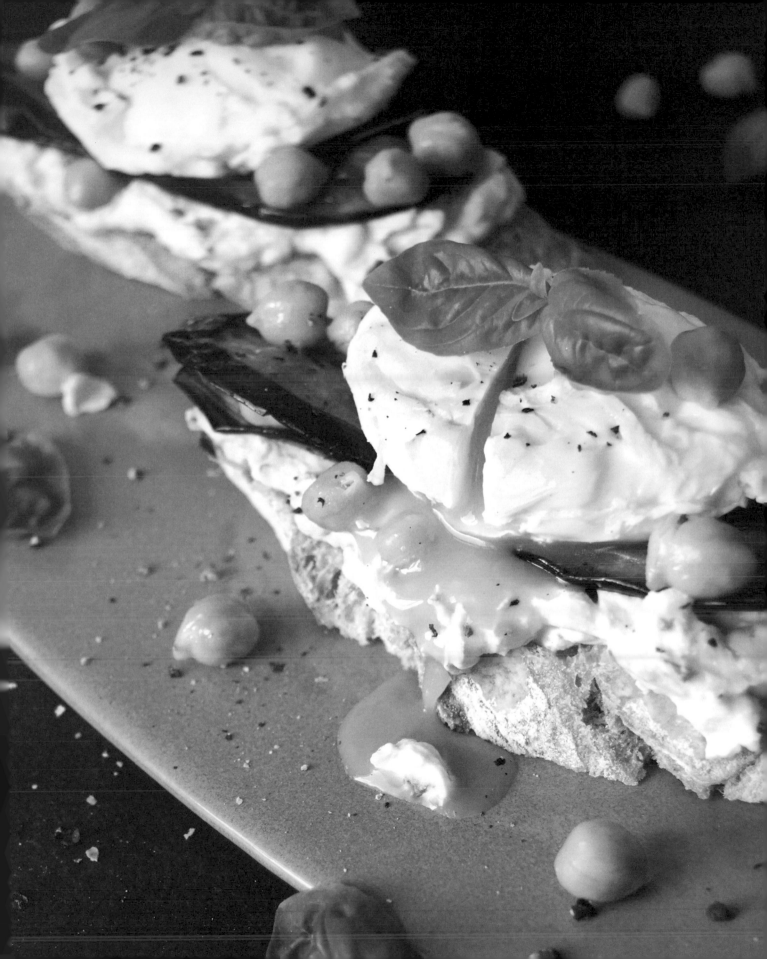

Mix the chickpeas with 1 teaspoon of olive oil, season to taste with a little fine sea salt, and set aside.

Bring a medium saucepan of water to a boil, add a little fine sea salt, and reduce the heat to a low simmer. Crack 1 egg into a small bowl. Hold a large spoon just over the surface of the simmering water and gently pour the egg onto the spoon. Lower the spoon into the water and hold for 3 minutes—use a second spoon to put the egg back into place if it slips. Lift up the spoon, let the excess water drip off, and carefully place the egg on a plate—you may have to gently scoop it off the spoon. Poach the remaining eggs the same way, adjusting the heat as needed to maintain a low simmer. It's best to poach 1 egg at a time, but you can cook 2 at once: Once the first egg cooks on the spoon for 1½ minutes, let it float in the water—mind that it doesn't stick to the bottom of the pan—and poach the second egg on a spoon. Take both eggs out once they've cooked for 3 minutes each.

Spread the balsamic ricotta generously on the bread and top with grilled eggplant and chickpeas. Arrange a poached egg on top, garnish with basil leaves and crushed peppercorns, and serve.

torta al testo with lemon-rosemary lentil burgers and mozzarella di bufala

Torta al testo is a traditional Umbrian flatbread that's been baked over hot coals on discs made of clay or stone—the *testo*—for centuries. Nowadays we can use a scorching hot cast iron skillet, which creates equally satisfying results. This bread is perfect for sandwiches. Filling it with mozzarella, arugula, and a light vinaigrette is an appealing idea, but I aimed for the next level. These lemon-rosemary lentil burgers turn this simple Italian snack into a proper lunch. The combination is so nutty, juicy, and creamy that you'll quickly forget about the meaty original.

This recipe takes some time, so I make big batches for a torta al testo feast.

MAKES 6 SANDWICHES

FOR THE FLATBREADS

2 cups (260 g) all-purpose flour

1½ teaspoons fast-acting yeast

¼ teaspoon fine sea salt

½ cup plus 2 tablespoons (145 ml) water, lukewarm

FOR THE LENTIL BURGERS

2 bay leaves

2 small sprigs fresh rosemary

½ cup (110 g) beluga lentils (no soaking required)

½ cup (110 g) small green or French Puy lentils (no soaking required)

1 small red onion, finely chopped

1 large clove garlic, crushed

3 large eggs

4 ounces (110 g) Parmesan, finely grated

½ cup (70 g) dry breadcrumbs

2 teaspoons finely chopped fresh rosemary

2 teaspoons freshly grated lemon zest

1¼ teaspoons fine sea salt

A generous amount ground pepper

Sunflower oil, to cook the burgers

FOR THE FILLING

2 large handfuls arugula leaves

9 ounces (250 g) mozzarella di bufala, torn into small pieces

Olive oil

White balsamic vinegar

Fine sea salt

Ground pepper

A few rosemary needles, roughly chopped

2 to 3 teaspoons freshly grated lemon zest

For the flatbread dough, combine the flour, yeast, and salt in a large bowl. Add the water and mix with the dough hooks of an electric mixer for a few minutes or until the dough is well combined and elastic. Continue kneading with your hands for a few minutes or until you have a soft, silky ball of dough. Put the dough back in the bowl, cover with a tea towel, and let rise in a warm place, or preferably in a 100°F (35°C) warm oven, for about 60 minutes or until almost doubled in size.

While the dough is rising, make the lentil burgers: Fill 2 large pots with water. Add 1 bay leaf and 1 sprig of rosemary to each pot. Add the beluga lentils to 1 pot and the green

(continued)

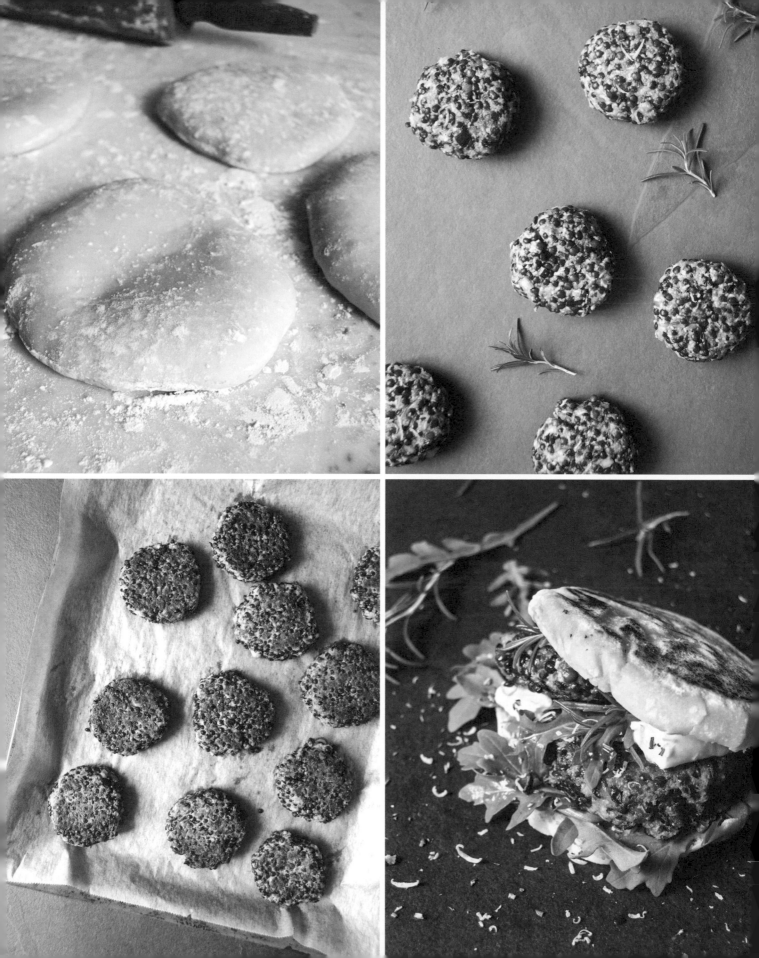

lentils to the other. Bring to a boil and cook, according to the package instructions, for about 20 minutes. The beluga lentils should have some bite; the green lentils can be a bit softer. Remove and discard the herbs, drain the lentils, and let cool completely.

In a large bowl, combine the beluga and green lentils with the red onion, garlic, eggs, Parmesan, breadcrumbs, chopped rosemary, lemon zest, salt, and pepper. Use your hands to gently mix until well combined. Wet your hands and form the mixture into 12 patties.

When the flatbread dough has almost doubled in size, punch it down, take it out of the bowl, and divide it into 6 pieces. On a well-floured table or countertop, use a rolling pin to roll each piece into a 4-inch (10 cm) disc. Cover the dough with a tea towel and let rise for 20 to 30 minutes or until puffy.

Preheat the oven to 400°F (200°C). Line a baking sheet with parchment paper.

While the dough is rising, cook the burgers: In a large, heavy pan, heat a generous splash of sunflower oil over medium heat. Working in batches, cook the burgers, flipping once, for 2 to 3 minutes per side or until golden brown. (Add a splash of oil between batches.) Transfer burgers to the lined baking sheet and bake for 9 minutes; keep warm.

Heat a dry large cast iron skillet over high heat. Once it is scorching hot, add 2 to 3 flatbread discs and cook, flipping once, for about 45 seconds to 2 minutes per side. The bread should be golden brown, black in small patches, and baked through—mind that it doesn't burn, which can happen in seconds. Cook the remaining flatbreads. Let them cool slightly before you make the sandwiches.

Cut each flatbread in half without cutting through it completely, so that you can stuff it like a pocket. Divide the arugula and mozzarella among the sandwiches, drizzle with a little olive oil and vinegar, and season to taste with salt and pepper. Divide the lentil burgers among the sandwiches, sprinkle with the fresh rosemary and lemon zest, and serve.

sausage and butter bean ciabatta sandwich with orange and thyme

A few years ago, my mother threw a pool party in her garden on one of the hottest days July has ever seen. It was a loud event, with lots of food, wine, and laughter—a proper family feast. To make her life easier, my mother decided against a seated lunch at the table and went for a long buffet instead. She treated us to scrumptious salads, cold roasts, gravlax, savory tarts, fruit, cheese, and cakes, all straight from her kitchen. It was a scene of almost Roman proportions. With glasses of wine in hand, we all went back and forth between the pool and the buffet, enjoying one delight after another. It was pure bliss.

Although I'm particularly obsessed with my mother's meat and seafood platters, one of her salads struck me the most that day. The combination of butter beans, spring onions, orange, and thyme was one to remember. This salad has been on our plates many times since that glorious feast, in its original form, as well as in variations. Adding sausage and stuffing it into a ciabatta sandwich is the most casual of them all.

MAKES 2 SANDWICHES

1 orange

Olive oil

3 teaspoons fresh thyme leaves

1¼ cups (250 g) drained and rinsed canned butter or cannellini beans

Fine sea salt

Ground pepper

1½ teaspoons unsalted butter

2 thick, coarse sausages

1 small ciabatta loaf, cut into 2 sandwich buns

1 small spring onion, green parts only, thinly sliced

Cut a strip of peel off the orange that is 2 inches long (5 cm) and ½ inch wide (1.25 cm) and cut it into very thin strips—mind that you only cut off the orange part of the peel and not the bitter white pith. Set aside.

Squeeze the juice from the orange and place 2 tablespoons in a large bowl. Add 2 tablespoons of olive oil and 2 teaspoons of the thyme; whisk to combine. Add the beans, stir, and season to taste with salt and pepper. Reserve 3 tablespoons of the beans and, in a food processor or blender, purée the remaining beans, along with the dressing, until smooth. Season to taste with salt, pepper, and more orange juice.

In a medium, heavy pan, heat a generous splash of olive oil and the butter over medium-high heat. Add the sausages, reduce the heat to medium, and cook, turning occasionally, for about 10 minutes or until golden brown and cooked through. Remove the sausages from the pan, reserving the pan juices, and cut them in half lengthwise.

Spread the bean purée on the bottom of each bun and top with sausage and some of the reserved beans. Feel free to drizzle some of the reserved pan juices over the meat. Sprinkle with the orange peel, spring onions, and the remaining thyme, then place the tops on each bun, and enjoy.

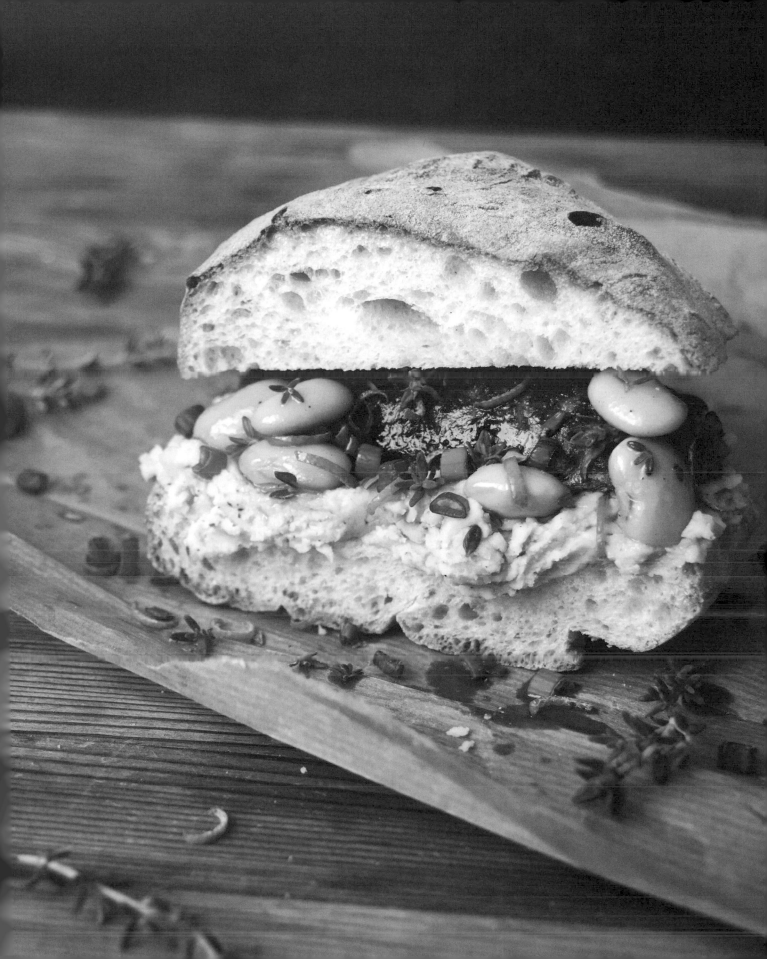

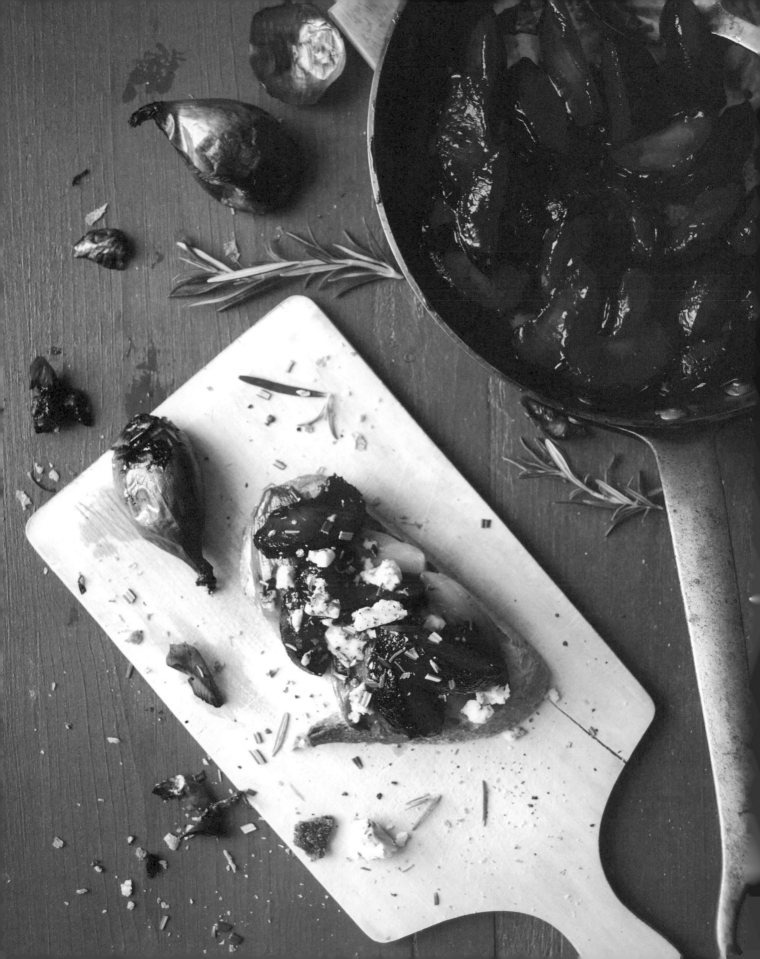

roasted shallot, caramelized plum, and stilton tartine with rosemary

I don't have a favorite sandwich, but the combination of plump fruit paired with the ripest cheese always gets my undivided attention. Give me a glass of dark Bordeaux to go with it, and I'm set for dinner. There is something magical about these two flavors—three, if you include the wine. It's a perfect match, and a reminder of simple kitchen pleasures.

When I prepare dinner, I like to have a little appetizer on hand, something small to nibble on while I chop and stir. Seasonal fruit, a piece of cheese, a baguette, and a glass of wine is more than enough to keep me happy and arouse my excitement for the meal to follow. But it's easy to turn this frugal treat into a precious little tartine. Packed with juicy, oven-roasted shallots, sticky caramelized plums, and sharp, spicy Stilton, this is one fragrant sandwich. Leave it on the chopping block, and you'll find that all of a sudden, you have a few more willing hands to help in the kitchen.

MAKES 3 TARTINES

9 small shallots, unpeeled

2 tablespoons olive oil

2 tablespoons granulated sugar

2 tablespoons water

3 large plums, cut into 8 wedges each

3 thick slices rustic white sourdough bread

2 ounces (60 g) Stilton (or any aromatic blue cheese), crumbled

2 teaspoons chopped fresh rosemary needles

A few black peppercorns, crushed with a mortar and pestle

Preheat the oven to 425°F (220°C).

In a baking dish, toss the shallots with 1 tablespoon of the olive oil. Roast for 15 minutes, then turn them over and roast for 15 minutes on the other side. If they feel soft when you push them down gently, they're done.

In a small, heavy pan, heat the sugar and water over medium-high heat until the sugar has melted and turns golden brown. Add the plums and cook, stirring occasionally, for about 8 minutes or until the plums are soft but still maintain their shape. Take the pan off the heat, cover, and keep warm.

Brush the bread with the remaining 1 tablespoon of the olive oil. Cut the ends off the shallots and squeeze them out of their skins and onto the bread slices. Lay the warm, caramelized plums on top and sprinkle with crumbled Stilton, rosemary, and crushed peppercorns. Serve warm.

crayfish with beet mousse on sourdough
A SWEDISH LOBSTER ROLL

My Swedish Lobster Roll is a Nordic adaptation of the American classic with pink crayfish—also known as freshwater lobster—silky beet mousse, freshly whipped mayonnaise, and dill. This scrumptious composition is a stunner, especially on Malin Elmlid's (*see page* 246) dramatic charcoal sourdough bread, but it tastes just as good on rustic white bread.

You can buy crayfish precooked or alive. The preparation demands strong nerves and boiling hot water, but I prefer cooking them myself.

MAKES 4 SANDWICHES

16 crayfish, precooked or alive

8 slices white sourdough bread (or 4 rolls)

1 small bunch dill, chopped

FOR THE BEET MOUSSE

1 medium beet, unpeeled, scrubbed

1 bay leaf

1 tablespoon olive oil

Fine sea salt

FOR THE MAYONNAISE

2 very fresh large egg yolks

¼ cup (60 ml) mild olive oil

1 tablespoon freshly squeezed lemon juice, plus more to taste

2 teaspoons sour cream or crème fraîche

Fine sea salt

If the crayfish are precooked, cut the meat into small chunks, and set aside.

If the crayfish are alive, wash them and keep in a deep bowl or bucket with cold water; discard any that don't move. Bring a large pot of water to a boil. Quickly drop the first crayfish into the boiling water. Wait a few seconds so the water can return to a boil, then add another crayfish. Continue like this until all the crayfish are in the pot and cook for another 1 to 2 minutes or until they all turn red. Use a slotted ladle or spoon to scoop the crayfish into a colander to drain. When they're cool enough to handle, pull the meat out of the shells, cut it into small chunks, and set aside.

For the beet mousse, bring a medium pot of salted water to a boil. Add the beet and bay leaf, reduce the heat, and simmer for 45 minutes or until the beet is tender. Drain the beet and rinse under cold water. When it's cool enough to handle, peel off the skin. In a food processor or blender, purée 4 ounces (110 g) of the beet until smooth. Whisk in the olive oil and season to taste with salt.

For the mayonnaise, drop the egg yolks into a bowl that's just large enough for an immersion blender. Start mixing and slowly pour in the olive oil. When it's thick and creamy, add the lemon juice and sour cream and stir to combine. Season to taste with salt, and additional lemon juice.

Spread the mayonnaise on half of the bread and top with generous dollops of the beet mousse. Divide the crayfish among the sandwiches. Sprinkle with the dill, top with a second slice of bread, and serve.

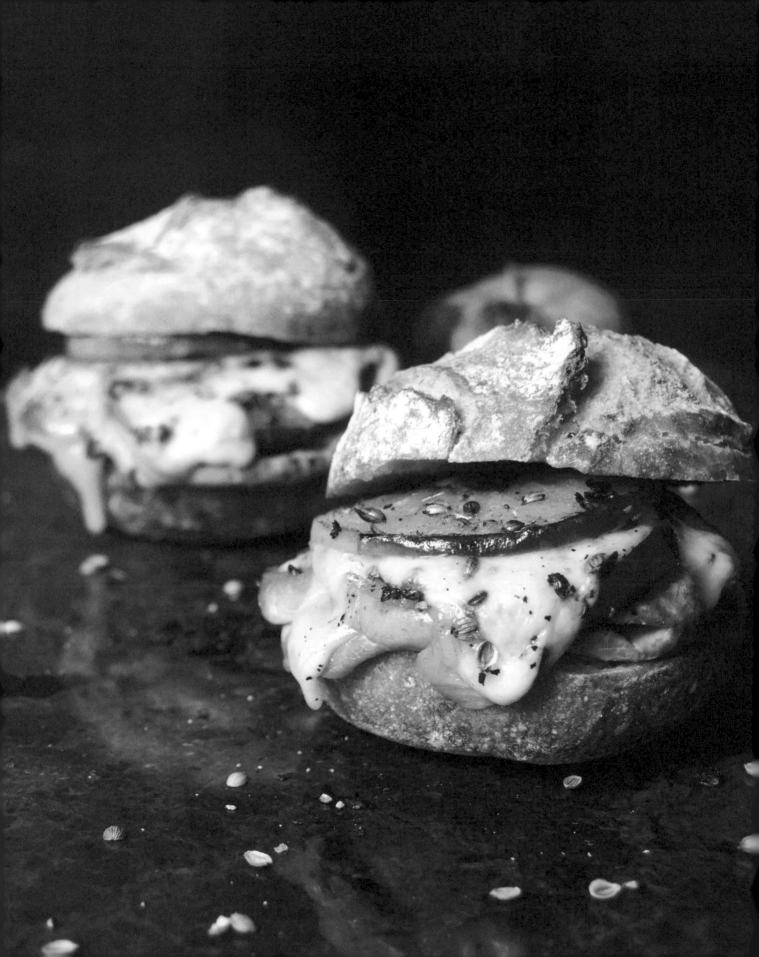

spiced apple, ham, and raclette sandwich

Imagine a cold gray morning in the early days of fall—the air silent and misty, a quiet chill hinting at the coming change of light and temperature. This is the moment when you realize that it's time for summery treats to make way for food that's more hearty and rich. A ham and cheese sandwich sounds just right.

It's not winter yet, and autumn apples shine in glowing gold, orange, and red. The flavors are sweet and saturated, almost overly ripe. All the fruit is now at its peak, and ready to show off what's been collecting under its skin for months.

For this sandwich, I prefer to use an old apple variety that's sour and juicy, like Belle de Boskoop. It's firm but softens slightly when sautéed in coriander-infused butter. The spiced fruit pairs so well with rustic ham, but we're not done yet. Aromatic grilled Raclette sinks into every bite and the whole thing is sandwiched on a crusty bun. Altogether, this seems like the best thing that could happen to ham and cheese.

MAKES 2 SANDWICHES

1½ tablespoons unsalted butter

1 teaspoon coriander seeds, crushed with a mortar and pestle

1 small bay leaf

1 firm tart baking apple, such as Belle de Boskoop, Granny Smith, or Braeburn, cored and cut into 6 slices

4 slices ham

2 rustic sandwich buns, cut in half

3 ounces (85 g) Raclette (or any aromatic cheese that melts well, such as Comté or Gruyère), cut into 4 thick slices

A few black peppercorns, crushed with a mortar and pestle

In a large, heavy pan, heat the butter over medium heat. Add the coriander and bay leaf and stir to coat them in butter. When the butter is hot and sizzling, arrange the apple slices next to each other in the pan and sauté for 1 to 1½ minutes per side or until golden brown—mind that the spices don't burn. Take the pan off the heat and set aside.

Set the oven to broil (quicker method) or preheat to 500°F (260°C).

Layer 2 slices of ham on the bottom half of each bun and top with 2 apple slices. Add 2 slices of Raclette and finish with the roasted coriander seeds from the pan and another slice of apple. Put the sandwiches under the broiler or roast at 500°F (260°C) for a few minutes or until the cheese starts to melt. Sprinkle with crushed peppercorns and place the top on each bun.

roasted garlic and tomato focaccia sandwich with rosemary oil

In my eyes, food is the best medicine. Apart from its nutritional value, eating something delicious instantly creates a good feeling. I strongly believe in the healing powers of nature's bounty, and a concentrated dose of garlic is one of my secret weapons when I feel my energy fading. I wouldn't chew on the raw bulb; I definitely prefer it cooked. Roasting garlic in its skin turns it into an aromatic spread and is the easiest way to eat a few healthy cloves in one go. It's about promoting health, so I use about 10 to 15 cloves for a single snack. Pair it with cherry tomatoes, rosemary-infused olive oil, and focaccia, and you have a sandwich with feel-good qualities.

The flavor of the spread depends on the quality of the garlic, so use the freshest bulbs you can find—French spring garlic is my favorite.

FOR 2 SANDWICHES

16 small cherry tomatoes, on the vine

20 large cloves garlic, preferably young, unpeeled

2 large focaccia buns, split

Flaky sea salt

FOR THE ROSEMARY OIL

3 tablespoons olive oil

Needles from 2 medium sprigs fresh rosemary

Preheat the oven to 425°F (220°C).

Spread the tomatoes and garlic cloves in a large baking dish and roast, turning the garlic occasionally, for about 25 minutes or until the garlic is soft enough to mash with a fork— mind that it doesn't burn. Take the garlic out of the oven. Continue roasting the tomatoes for another 10 to 20 minutes or until soft.

For the rosemary oil, in a small saucepan, heat the olive oil over medium-high heat. Add the rosemary and, as soon as it starts to sizzle, remove the pan from the heat. Cover and let the herb infuse the oil for at least 1 to 2 minutes.

Brush the bottom half of each bun with the rosemary oil. Peel the garlic, mash it with a fork, and spread it onto the oiled buns. Snip the tomatoes off the vine and arrange them on top of the garlic. Sprinkle with the crisp rosemary needles and season to taste with flaky sea salt. Place the top on each bun and enjoy warm.

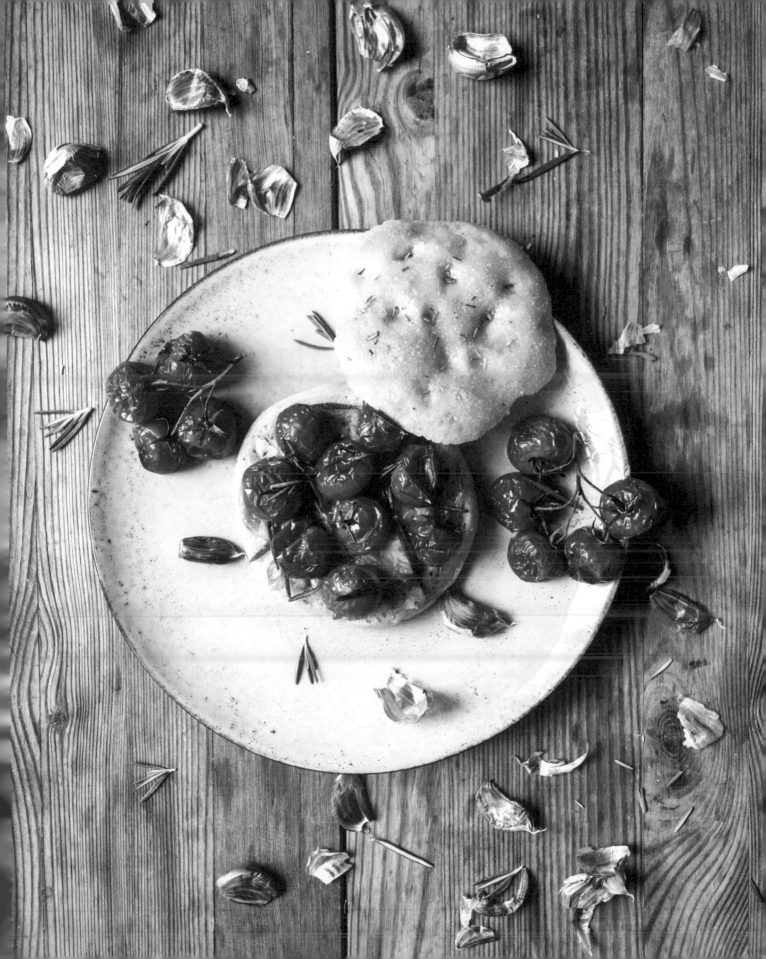

balsamic strawberry, chèvre, and pistachio tartine

When I visit my family in western Germany, I often take the train—I prefer to cross the country on the ground rather than in the air. Old fashioned, slow travel allows me to enjoy the different landscapes and cities passing by my window. To feel the distance in time and to observe the changing scenery turns a journey into a far more joyful experience.

My choice of transportation has another advantage. My train trip back home to Berlin always starts in Cologne, which is one of the country's oldest cities and was founded by the Romans in the first century. The train station is close to the famous Cologne Cathedral, the Kölner Dom, an imposing Gothic structure that seems to rise right into the sky. Opposite the Dom, is a charming grand hotel with a gorgeous bistro. This is the setting for a little tradition that my mother and I started years ago, our good-bye ceremony before I jump onto my train back home. We have a cappuccino, or more likely a glass of wine or Champagne, to celebrate the good times and dinners we had, and enjoy a small snack—a club sandwich for example. Most of the time we sit at one of the high windows, mesmerized by the view of the cathedral. Sometimes we prefer the old-fashioned red leather stools at the bar, where we're surrounded by strangers reading newspapers and drinking coffee served by waiters as elegant as the patrons. This place feels suspended in time and I love it for this reason. It's closed for renovations at the moment, and we're impatiently awaiting its reopening.

This fruity tartine, while not on the menu, would fit right in. Strawberries glazed with balsamic honey on top of creamy chèvre and sprinkled with crunchy pistachios makes quite an impressive appearance that's easily worthy of a grand hotel.

MAKES 4 TARTINES

5 ounces (140 g) soft, mild chèvre	1 tablespoon balsamic vinegar	5 ounces (140 g) hulled ripe strawberries, cut into quarters
4 thick slices ciabatta	1 tablespoon water	
1 tablespoon granulated sugar	1 teaspoon honey	2 tablespoons roughly chopped unsalted pistachios

Spread the chèvre generously on the bread.

In a small, heavy pan, bring the sugar, vinegar, water, and honey to a boil. Reduce the heat and simmer for 1 minute or until thick and syrupy. Take the pan off the heat, add the strawberries, and stir gently to coat the berries in the glaze. Arrange the strawberries on top of the chèvre, pour the syrupy juices on top, sprinkle with the pistachios, and enjoy.

seafood

TROUT AL CARTOCCIO WITH PROSCIUTTO, OLIVES, AND TOMATOES

BLOOD ORANGE MUSSELS WITH FENNEL, GINGER, AND TURMERIC

MALTESE STUFFED BELL PEPPERS WITH COD, TOMATOES, AND ZUCCHINI

PEPPER- AND SPICE-CRUSTED SALMON WITH VERMOUTH BUTTER

OVEN-ROASTED SEA BREAM WITH ZUCCHINI AND LIME

MALTESE TUNA AND SPINACH PIE

SWORDFISH WITH MINT, TOMATOES, AND LEMON-CAPER OIL

COD AL CARTOCCIO WITH RAMPS AND RED ONION

trout al cartoccio with prosciutto, olives, and tomatoes

I prefer to eat fish from the region where I live, fresh from the water and onto my plate. When I'm in Malta, I love going to the Marsaxlokk fish market on Sunday mornings, preferably after an early swim in the clear blue water of Wied il Zurrieq. The fishermen offer their latest catch, and it's so fresh that I don't even bother checking the eyes and gills. It doesn't get any better than this.

When I'm in Germany, I often visit the fishponds in the woods, especially in the Bergisches Land area in North Rhine-Westphalia, where my mother lives. Dense forest surrounds the shallow murky waters; the soil is rich and the air is heavy and moist. Here you can get the most delicious trout. Not everyone can appreciate the distinct earthy nuance of this freshwater fish, so I like to cook it with prosciutto, olives, tomatoes, and garlic. These vibrant flavors bring out the best in the trout, especially when it's cooked *al cartoccio*, that is, wrapped in a parchment paper bundle.

SERVES 1 TO 2

Parchment paper

Olive oil

1 medium tomato, thinly sliced

2 cloves garlic, thinly sliced

Fine sea salt

Ground pepper

1 whole trout, scaled, gutted, and cleaned, about 12 to 14 ounces (340 to 400 g)

2 bay leaves

10 thin slices Tyrolean prosciutto or prosciutto di Parma

10 black olives, preferably Kalamata

⅓ cup (75 ml) dry white wine

Preheat the oven to 350°F (180°C).

Cut 2 pieces of parchment paper large enough to wrap the fish like a package and lay them on top of each other. Brush the top sheet with olive oil. Spread the tomato and half of the garlic in the middle of the parchment and season to taste with salt and pepper.

Coat the trout with a little olive oil and season to taste with salt and pepper, inside and out. Stuff the trout with the remaining garlic and 1 bay leaf and carefully wrap the prosciutto around it. Place the fish on top of the tomato and lay the other bay leaf on top. Arrange the olives around the trout and lay the package in a baking dish. Fold the sides over and twist both ends of the parchment paper but leave a small opening on top of the fish. Pour the wine through the opening onto the fish then close the parchment package and fold the top twice to seal. Bake for 15 minutes. If the trout is cooked through and you can lift the fillets off the bones with a fork, it's done. If not, close the parchment again and continue baking for up to 5 minutes. The cooking time can vary depending on the size of the fish, but mind that you don't overcook it.

Divide the trout into 2 fillets. Arrange the fish, prosciutto, olives, and tomatoes on plates, and serve immediately.

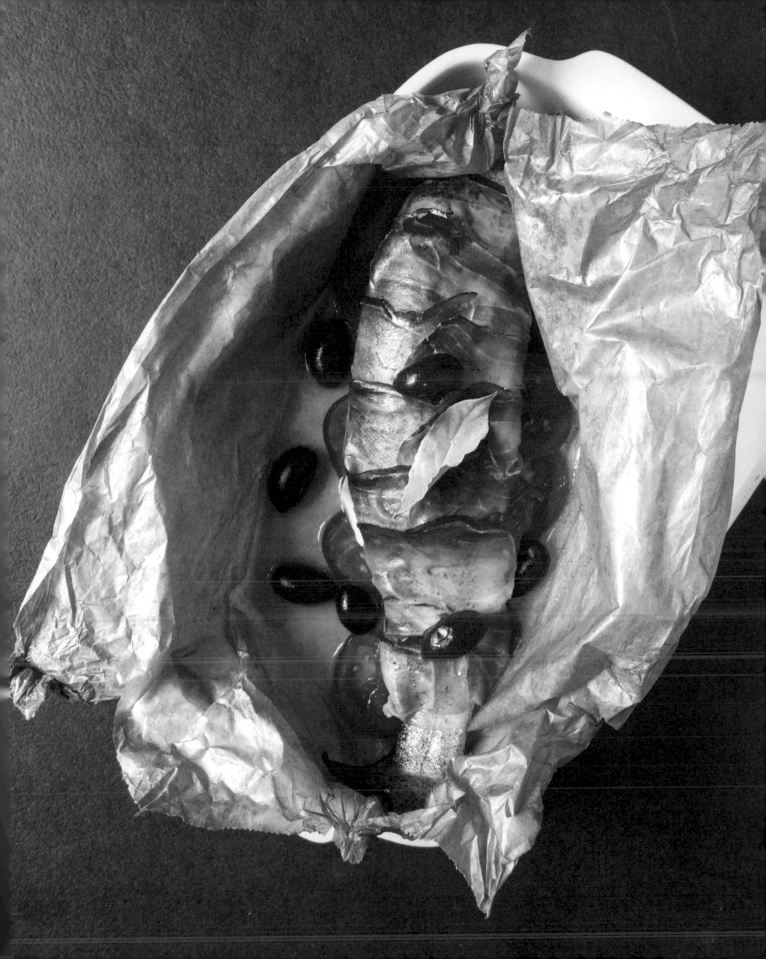

blood orange mussels
with fennel, ginger, and turmeric

My friend Essa once treated me to a scrumptious meal that opened my heart to mussels. The dinner was set in the most beautiful surroundings, and I think I could have fallen in love with almost any kind of food that night. Essa's little garden in Malta was lit up with countless candles, while stephanotis and plumbago flowers bloomed lusciously on the limestone walls, enchanting us with their sweet, hypnotizing perfume. It was one of those nights you can never forget, a memory to keep like a precious treasure.

I can't say that I didn't like mussels before, I just wasn't that fond of them. But Essa's generous addition of vibrant spices and fragrant herbs changed my perspective. Her recipe featured a confident and striking mix of lemongrass, ginger, cilantro, and spicy cayenne and it's been a great inspiration for me. Since then, my pots have seen various combinations. Whenever I'm in the mood for *moules*, I always aim for an aromatic broth to steam the sweet, tender seafood. Blood orange, fennel, ginger, and turmeric do a spectacular job.

SERVES 2 TO 3

2¼ pounds (1 kg) fresh mussels

1 cup (240 ml) dry white wine

¼ cup (60 ml) freshly squeezed blood orange juice

1 tablespoon freshly grated blood orange zest

1 small fennel bulb, cut into quarters and thinly sliced

1 (2-inch / 5-cm) piece fresh ginger, cut into short matchsticks

1 (2-inch / 5-cm) piece fresh turmeric, thinly sliced

1 bay leaf

½ teaspoon fine sea salt

FOR THE TOPPING

A few fennel fronds, chopped

Rinse and scrub the mussels under cold water and cut off the beards. Discard any broken mussels.

In a large pot, combine the wine, orange juice and zest, fennel, ginger, turmeric, bay leaf, and salt and bring to a boil. Add the mussels, reduce the heat to low, and cover and cook for 5 minutes or until the shells open. Shake the pot once or twice while the mussels are cooking or gently stir them with a slotted ladle or spoon. Discard any mussels that don't open.

Sprinkle the mussels with the fennel fronds and serve immediately, preferably with a baguette and a glass of chilled white wine.

maltese stuffed bell peppers
with cod, tomatoes, and zucchini

I can't imagine Maltese cuisine without stuffed, oven-roasted vegetables. Every family seems to have their own traditional formula, respectfully handed down to the next generation to keep this culinary tradition alive. I'm sure that many Maltese have a story about their nanna preparing this comforting dish in her kitchen. One of my favorites is green bell peppers filled with zucchini, tomato, and firm chunks of fish, and refined with a generous shot of vermouth.

SERVES 4

4 to 5 medium green bell peppers

Olive oil

1½ tablespoons butter

18 ounces (510 g) cod fillet (or any firm, white fish, such as monkfish or grouper), preferably 1 thick center piece

Fine sea salt

Ground pepper

1 medium onion, finely chopped

1 large clove garlic, crushed

12 ounces (340 g) zucchini, cut into very small cubes

¼ cup (60 ml) dry white vermouth, such as Noilly Prat, or dry white wine

1 medium tomato, cut into small cubes

3 tablespoons chopped flat-leaf parsley leaves, plus 1 to 2 tablespoons for garnish

Preheat the oven to 425°F (220°C).

Cut the tops off the peppers and reserve. Scrape out and discard the seeds and fibers, then rinse the peppers and set aside.

In a heavy pan, large enough to fit the fish, heat a generous splash of olive oil and the butter over medium-high heat. Sear the fish, turning once, for 1 to 3 minutes per side or until golden and flaky—mind that you don't overcook it. Remove from the heat, break the fish into chunks, and season to taste with salt and pepper.

In a large, heavy pan, heat a splash of olive oil over medium-high heat. Add the onion and sauté for 2 to 3 minutes or until soft and golden. Add the garlic and sauté for 1 minute. Pour in a little more olive oil, add the zucchini, and season to taste with salt and pepper. Sauté for about 4 minutes or until soft. Add the vermouth and cook, stirring and letting the alcohol burn off, for about 10 seconds. Take the pan off the heat, stir in the tomato and 3 tablespoons chopped parsley, and season to taste with salt and pepper.

To combine the filling, spread half the zucchini-tomato mixture on a large plate, lay the fish on top, and finish with the remaining vegetables. Adjust the seasoning if necessary.

Season the inside of the bell peppers with salt and pepper. Using a large spoon, generously stuff the peppers with the zucchini-cod mixture without pushing on the filling too much. If you have leftover filling, stuff the fifth bell pepper. Place the tops on the peppers and place them in a baking dish. Add a splash of water to cover the bottom of the dish and bake for about 25 minutes or until the bell peppers are al dente and the tops turn dark. Take the peppers out of the oven, sprinkle with more parsley, and serve warm.

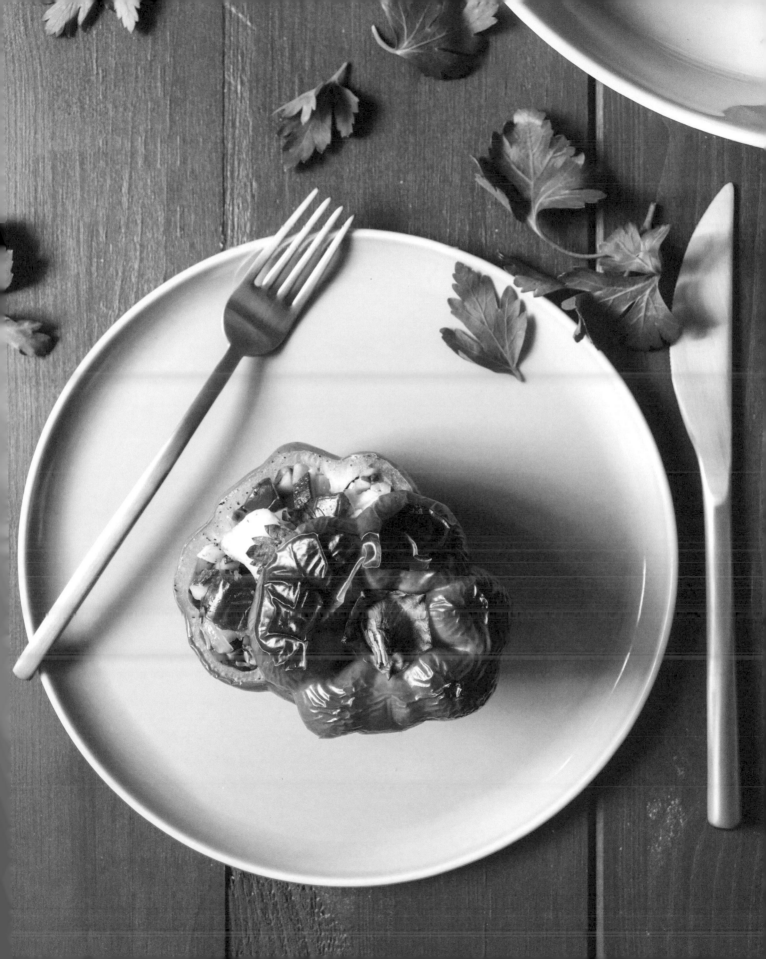

pepper- and spice-crusted salmon with vermouth butter

When silky salmon meets peppery spice, your taste buds are treated to the most aromatic—and pleasantly heated—flavors. This is not gentle seasoning. The sharpness of coriander and peppercorns presents a complex range of floral, fruit, and pepper notes. Each type of peppercorn has its very own unique taste, just as each comes with a different degree of spice. The white ones are the harshest of the trio. If you're sensitive, replace them with milder fennel seeds. The trick to getting the crushed mixture to stick to the salmon is a thin egg wash coating. It acts like edible glue, so the peppercorns and coriander can sizzle in the salmon's rich juices and turn into a crackling, crunchy crust.

A buttery vermouth sauce, smooth, thick, and winy, complements the spices and mellows the overall effect. It's so concentrated that you only need a drizzle. If you're looking for a side, try the Mediterranean Mashed Potatoes with Coriander Oil (*see page 66*).

SERVES 2

1 teaspoon coriander seeds, lightly crushed with a mortar and pestle

1 teaspoon green peppercorns, lightly crushed with a mortar and pestle

1 teaspoon pink peppercorns, lightly crushed with a mortar and pestle

1 teaspoon white peppercorns, lightly crushed with a mortar and pestle

1 (12-ounce / 340-g) salmon fillet with skin

1 large egg, beaten

Olive oil

Flaky sea salt

1 tablespoon unsalted butter

¼ cup (60 ml) dry white vermouth, such as Noilly Prat, or dry white wine

Mix the coriander seeds with the green, pink, and white peppercorns and spread them on a plate. Dip the skin-less side of the salmon in the egg wash then dip the same side into the spice mixture, pushing gently, so the spices stick to the fish.

In a medium, heavy pan, heat a splash of olive oil over medium-high heat. Add the salmon, skin-side down, and cook for about 5 minutes or until almost halfway cooked through. Carefully turn the salmon over—mind that the spices don't fall off—and add a little more oil to the pan if necessary. Reduce the heat to medium-low and cook the salmon for 2 to 3 more minutes, depending on its thickness, or until flaky but still pink inside. Lightly season with flaky sea salt, divide the fillet in half, and transfer to 2 plates.

Place the pan over high heat and add the butter. Once the butter starts to sizzle, add the vermouth and deglaze the pan, using a spatula to scrape any bits and pieces off the bottom. Let the sauce cook for a few seconds, while whisking, then pour it next to the salmon on each plate and serve immediately.

oven-roasted sea bream with zucchini and lime

Whole cooked fish always excites me. It reminds me of all those scrumptious holiday dinners near the sea, with fresh seafood spread out on wooden tables and the air sharp with saltiness—these are moments I'll never forget. Sometimes I buy the same wine we enjoyed on one of those special nights, just to smell the familiar bouquet and relive the whole precious memory.

My Mediterranean sea bream is covered with lime and lemon and roasts on a bed of fresh parsley and thinly sliced zucchini. Sweet and citrusy, it's as bright and fresh as can be. The whole fish cooks in the oven, absorbing the fragrant aroma, and baking to tenderness. Just looking at it brings to mind one sweet dinner after another.

SERVES 2

Olive oil

4 ounces (110 g) zucchini, very thinly sliced (use a mandoline or cheese slicer)

2 large cloves garlic, cut in half

1 medium bunch flat-leaf parsley

Fine sea salt

Ground pepper

1 (1-pound / 450-g) whole sea bream (porgy), scaled, gutted, and cleaned

1 lime, very thinly sliced

2 to 3 very thin slices lemon

⅓ cup (75 ml) dry white wine

Preheat the oven to 400°F (200°C).

Brush olive oil on the bottom of a baking dish large enough to fit the fish. Spread the zucchini, half the garlic, and half the parsley in the baking dish and season to taste with salt and pepper. Coat the fish with a little olive oil and season to taste inside and out with salt and pepper. Stuff the sea bream with the remaining parsley and garlic. Lay it on top of the vegetables and cover it completely with lime and lemon slices. Pour the wine into the baking dish and roast for 18 to 20 minutes or until the fish is cooked through. To see if the fish is done, cut along the middle line on its side, from gill to tail. If you can lift the fillet off the bones, it's done. If not, rearrange the citrus slices and continue roasting.

Divide the fish into 2 fillets, squeeze some of the juice from the roasted limes and lemons over the fish, and serve.

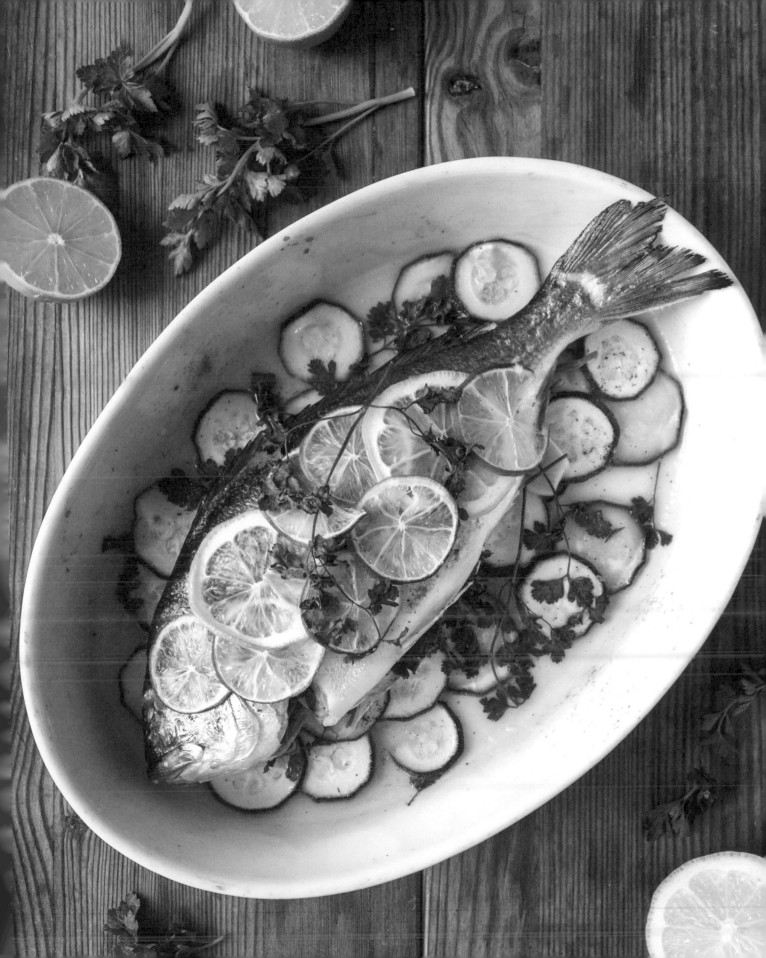

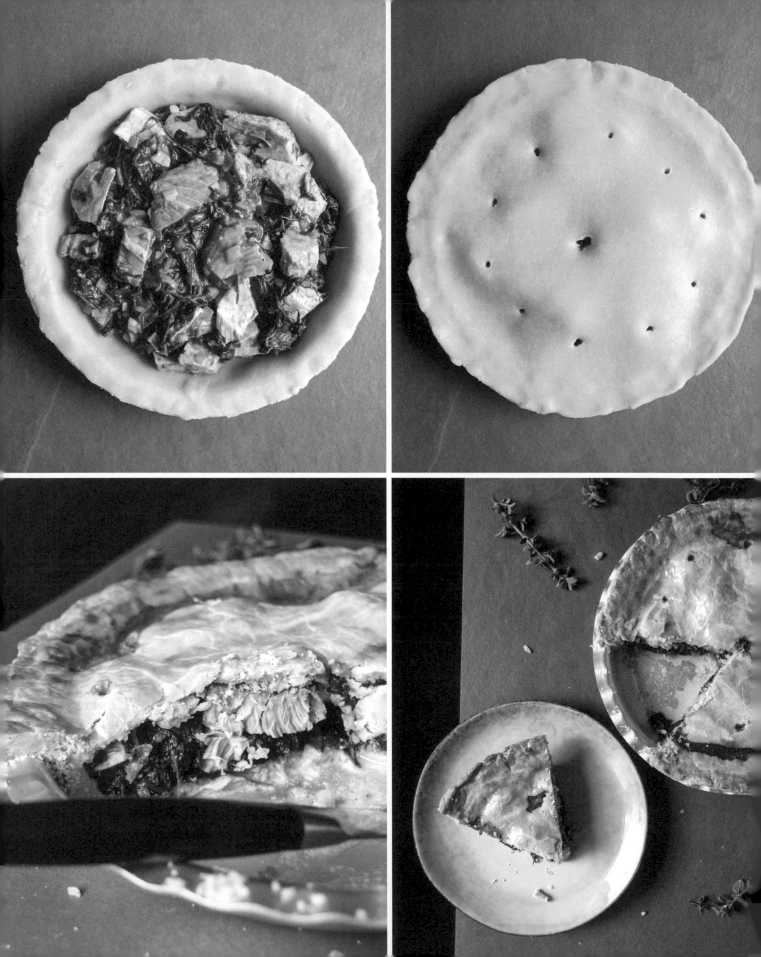

maltese tuna and spinach pie

Stuffat tal-fenek, or Maltese rabbit stew, is supposed to be Malta's national dish, but when I see how many pies *pastizzerias* sell each day, I wonder if those wouldn't have been a better choice. Filled with meat, fish, ricotta, mashed peas or spinach, these pies are either made with short crust (the bigger *qassatat*) or with flaky puff pastry (the smaller, fragile *pastizzi*). Both are extremely delicious and as tempting as they are filling. The traditional pies from the family-run pastizzeria, Crystal Palace Bar, in Rabat, are some of the best I've ever tried. Their secret recipes haven't changed in decades for good reason.

Once a year, between the end of August and November, *lampuki*, also known as dorado or mahi mahi, pass through Maltese waters, and bring a local specialty, lampuki pie, to the menu. I'm biased, but it's the best pie in the world. Lampuki has a strong taste and a meaty, chunky texture. It reminds me a little of tuna, which is what I use for my version, along with spinach and a buttery short crust. I recommend using fresh tuna for this recipe, as canned fish would give it a completely different taste and mushy texture.

SERVES 4 TO 6

FOR THE TUNA-SPINACH FILLING

Olive oil

1 medium onion, finely chopped

1 clove garlic, crushed

3 medium tomatoes, chopped

1 tablespoon tomato paste

1 tablespoon balsamic vinegar

14 ounces (400 g) baby spinach (or regular spinach leaves, chopped)

Fine sea salt

Ground pepper

14 ounces (400 g) fresh tuna steak

2 tablespoons dry white vermouth, such as Noilly Prat, or dry white wine

½ to 1 teaspoon chopped fresh oregano leaves, plus a few fresh leaves for the topping

FOR THE PASTRY

2⅓ cups (300 g) all-purpose flour

1 teaspoon fine sea salt

⅔ cup (150 g) unsalted butter, cold

2 large egg yolks

2 tablespoons water, cold

FOR THE GLAZE

1 large egg yolk

1 tablespoon whole milk

Pinch of fine sea salt

Use a 9-inch (23 cm) shallow pie dish or an 8-inch (20 cm) springform pan for this pie.

For the filling, in a large pot, heat a splash of olive oil over medium heat and sauté the onion and garlic for a few minutes or until soft and golden. Increase the heat to high, add the tomatoes and cook for about 3 minutes or until most of the liquid has evaporated. Stir in the tomato paste and vinegar and add the spinach leaves in batches. Season to taste with salt and pepper and stir well. Reduce the heat to medium and simmer for about 5 minutes or until the mixture is thick; if there is still a lot of liquid left in the pot, remove it with a ladle. Take the pot off the heat and set aside.

(continued)

In a medium, heavy pan, heat a splash of olive oil over medium-high heat. Sear the tuna, turning once, for 1½ to 2 minutes per side or until flaky and slightly pink inside. Season to taste with salt and pepper. Transfer the tuna to a plate and set aside. Place the pan over high heat, add the vermouth, and deglaze the pan, using a spatula to scrape any bits and pieces off the bottom. Pour this into the pot with the cooked spinach. Add ½ teaspoon of the chopped oregano, stir, and season to taste with salt and pepper. Break the tuna into bite-size pieces and gently fold it into the spinach. Add more oregano if necessary. You want to be able to taste the herb after the tuna is added, but it shouldn't be overpowering. Refrigerate the filling for 1 to 2 hours or until completely cool.

For the pastry, combine the flour and salt in a large bowl. Use a knife to cut the butter into the flour until there are only small pieces left. Continue with your fingers and quickly rub the butter into the flour. Add the egg yolks and water and mix with the dough hooks of an electric mixer until crumbly. Press the dough together and form a ball. Remove ⅓ of the dough and form it into a thick disc. Form the rest of the dough into a second disc. Wrap both discs in plastic wrap and freeze for 10 minutes.

Preheat the oven to 400°F (200°C).

For the glaze, whisk together the egg yolk, milk, and salt.

Take the dough out of the freezer and arrange each disc between two sheets of plastic wrap. Use a rolling pin to roll both discs into circles, the larger disc for the bottom and sides of the pie and the smaller disc to close the pie. Line the pie dish or springform pan with the larger disc of dough, spread the cooled filling inside—mind that there isn't too much liquid—and top with the smaller pastry disc. Use your fingers to gently press the edges of the pastry together to seal it. Use a skewer to make a few small holes in the top of the pie and brush the pastry with the egg glaze. Bake for 15 minutes then reduce the heat to 350°F (175°C). Bake for another 50 minutes or until the pie is golden and the pastry is baked through. Let the pie cool for at least 15 minutes before cutting into pieces. Serve sprinkled with fresh oregano leaves.

swordfish with mint, tomatoes, and lemon-caper oil

Cooking seafood used to drive me crazy, especially when it came to pan-frying thin fillets. I can't even remember how many meals I ruined by turning fragile fish into a soggy mess. After cooking my way through countless recipes, and learning with every failure and success, I realized that it's not minutes but seconds that count, not to mention using the right pan and the proper temperature. I still wouldn't call cooking fish completely stress-free, but as rules and experience soak in, it becomes more and more manageable.

Roasting fillets in the oven is a completely different story: It's as easy as pie. Once the fish, vegetables, and spices are piled into a baking dish, you can lean back and relax. I even find that it's possible to smell when the fish is done. A fine aroma starts to fill the kitchen, but I still check to see if I can easily flake the fish with a fork, which I think is the best way to be sure.

For this light Mediterranean recipe, I like the taste and texture of swordfish. Its flavor is strong enough to balance the mint, lemon, and capers. Plus, it's a forgiving fish, even if left in the oven for a little too long. The swordfish roasts on a bed of chopped tomatoes and as they cook, they release sweetness into the oily juices. If you want to keep dinner easy, enjoy this dish with warm, thick slices of soft ciabatta.

SERVES 2

Olive oil

1 clove garlic, cut into quarters

12 ounces (340 g) ripe tomatoes, cut into small cubes

15 fresh mint leaves

Fine sea salt

Ground pepper

1 tablespoon freshly squeezed lemon juice

1 heaping tablespoon capers, preferably preserved in salt, rinsed and drained

1 (9-ounce / 250-g) swordfish fillet, about 1 inch thick (2.5 cm)

A few black peppercorns, crushed with a mortar and pestle

Preheat the oven to 400°F (200°C) and brush the bottom of a medium baking dish with a little olive oil.

In a medium saucepan, heat a splash of olive oil over medium heat. Add the garlic and sauté for 1 minute or until golden. Add the tomatoes and 10 mint leaves, increase the heat to high, and cook, stirring, for 10 seconds. Take the pan off the heat and lightly season with salt and pepper. Spread the tomatoes in the middle of the oiled baking dish.

In a small bowl, whisk 3 tablespoons of olive oil with the lemon juice and capers. Dip the swordfish in the lemon-caper oil, making sure both sides are coated, then season to taste with salt and pepper. Lay the swordfish on top of the tomatoes and pour any remaining lemon-caper oil over the fish. Roast for about 16 minutes or until you can flake the fish with a fork. Sprinkle with the remaining mint leaves and crushed pepper and serve.

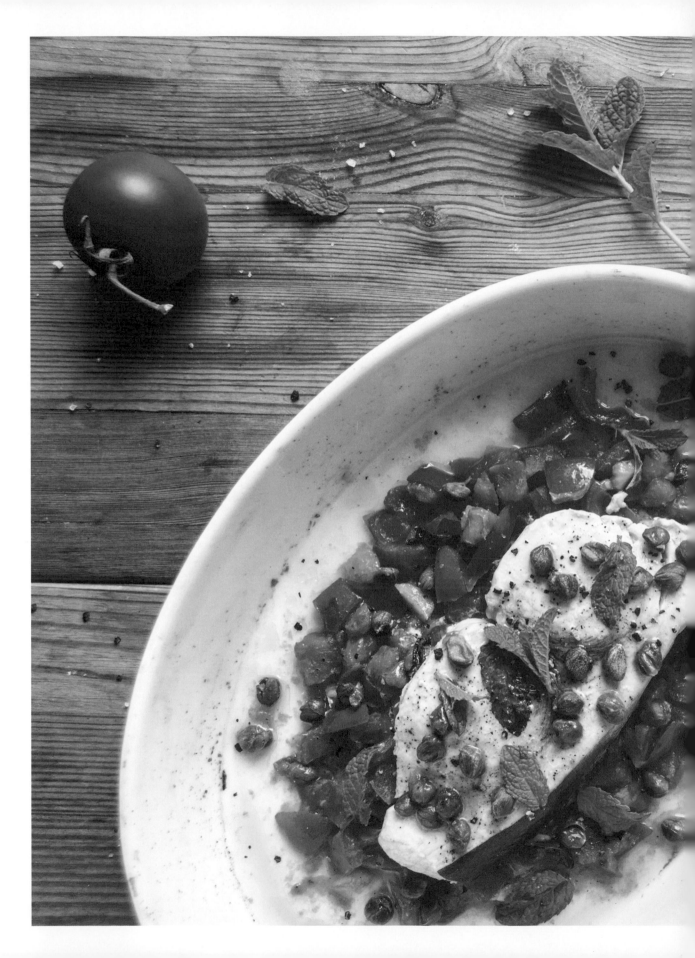

cod al cartoccio with ramps and red onion

As soon as the first ramps appear at the market, I jump on these delicate greens with elated enthusiasm. I don't just buy a couple bunches; I buy them in bulk. Waiting for their short season strains my patience, and makes me long for their garlicky green flavor even more. It feels like Christmas cookies, only healthier.

Red onions go very well with ramp's elegant leaves, and together they make a delicious bed for cod wrapped in parchment paper, or *al cartoccio*. Tucked in a sealed package, the fish cooks slowly to firm perfection, while being infused with flavor. You can use other mild, white-fleshed fish, such as monkfish or halibut, but the cooking time may need to be adjusted. If you can't find ramps at your market, there's no need to despair. A bunch of fresh flat-leaf parsley or basil will give this dish a different taste, but creates equally enjoyable results.

SERVES 2

Parchment paper

Olive oil

2 ounces (60 g) ramp or ramson leaves

1 (14-ounce / 400-g) cod fillet (or any firm, white fish, such as monkfish or halibut), about 1 inch thick (2.5 cm)

Flaky sea salt

Ground pepper

1 small red onion, cut in half and thinly sliced

2 tablespoons dry white wine

1 tablespoon freshly squeezed lemon juice

Preheat the oven to 400°F (200°C).

Cut 2 pieces of parchment paper large enough to wrap the fish like a package and lay them on top of each other. Brush the top sheet with olive oil, place all but 2 of the ramp leaves in the middle, and lay the cod on top. Season to taste with flaky sea salt and pepper. Put 1 ramp leaf on top of the cod and arrange the red onion around the fish. Whisk the wine with 2 tablespoons of olive oil and the lemon juice and pour over the fish. To close the package, fold the sides over, twist both ends of the parchment paper and fold the top twice so it's well sealed. Place the parchment package in a baking dish and bake for 10 minutes. If you can flake the fish gently with a fork, it's done. If not, close the parchment again and continue baking for up to 5 minutes. The cooking time can vary depending on the fillet's thickness, but mind that you don't overcook it.

Chop the remaining ramp leaf for the topping, sprinkle it over the fish, and serve.

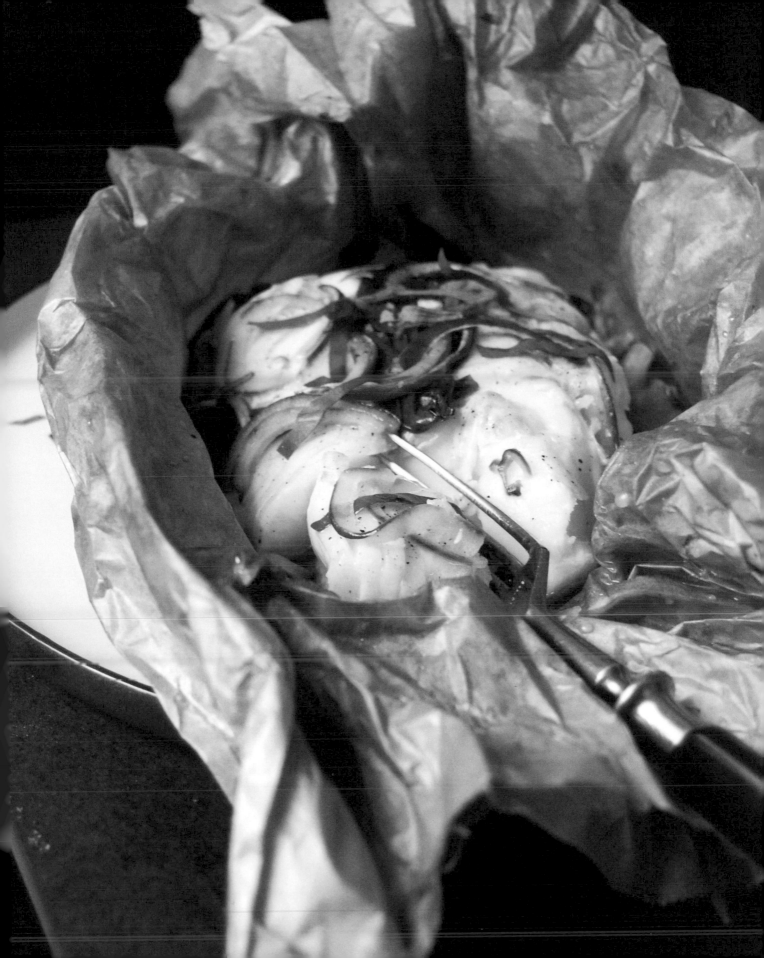

meat

SPICED BRAISED LAMB SHANKS WITH KUMQUAT, TOMATO, AND MINT

THE PERFECT SCHNITZEL WITH SWABIAN POTATO SALAD

BRUNGIEL MIMLI | MALTESE BOLOGNESE STUFFED EGGPLANT

BAVARIAN BEER–ROASTED PORK WITH SWEET POTATOES AND PARSNIPS

RIESLING AND ELDERFLOWER CHICKEN WITH APRICOTS

BEEF SHANK AND CAPONATA STEW

SLOW-ROASTED DUCK WITH GINGER, HONEY, AND ORANGE

RUSTIC MEATLOAF WITH LEEKS AND MOUNTAIN CHEESE

PORK LOIN WITH ORANGE-THYME CRUST AND BALSAMIC-ORANGE SAUCE

SALTIMBOCCA ALLA ROMANA WITH SAUTÉED APPLES

spiced braised lamb shanks
with kumquat, tomato, and mint

Meltingly tender braised lamb shanks cook slowly. They take their time—about two full hours—soaking up the dark juices of tomatoes and wine, and softening until the meat falls off the bone in succulent chunks. This is simple, rustic cooking, enhanced by a rich mixture of cardamom, cumin, coriander, and fennel seeds. Tiny sour-sweet kumquats are added for the last half hour of cooking, lending a bright citrus note to this aromatic feast. You can replace the kumquats with chunky orange wedges, and if you have the time, braise the meat a day ahead, as the flavors will deepen considerably.

SERVES 4

Olive oil

4 lamb shanks, about
2¼ pounds (1 kg) total

Fine sea salt

Ground pepper

2 teaspoons fennel seeds,
crushed with a mortar and
pestle

1 teaspoon coriander seeds,
crushed with a mortar and
pestle

1 teaspoon ground
cardamom

1 teaspoon ground cumin

1 medium onion, finely
chopped

4 cloves garlic, cut in half

1¾ cups (415 ml) dry white
wine

14 ounces (400 g) fresh
or canned whole peeled
tomatoes, chopped

4 long strips fresh orange
peel

2 bay leaves

8 kumquats (not cut)

FOR THE TOPPING

1 small handful fresh mint
leaves

Preheat the oven to 325°F (160°C).

In a Dutch oven with a tight-fitting lid, large enough to fit the meat, heat a splash of olive oil over high heat. Add the lamb shanks and sear, turning, for a few minutes or until browned on all sides. Season to taste with salt and pepper. Remove the meat from the pan and set it aside. Add a little more olive oil to the Dutch oven and place over medium-low heat. Add the fennel, coriander, cardamom, and cumin and sauté, stirring constantly, for 15 to 20 seconds or until fragrant. Add the onion and garlic and sauté for 1 to 2 minutes or until golden. Return the lamb to the Dutch oven and stir to mix it with the onion, garlic, and spices. Add the wine, tomatoes, orange peel, and bay leaves and season to taste with salt and pepper. Mix well and bring to a boil. Cover the Dutch oven with a tight-fitting lid and place it in the oven. Cook the lamb for 1½ hours then add the kumquats, cover, and cook for another 30 minutes or until the meat is tender and falling off the bone.

If you prefer a thicker sauce, transfer the meat and kumquats to a plate; cover and keep warm. Place the sauce on the stove and simmer until thickened. Remove and discard the orange peel and bay leaf and season to taste with salt and pepper. Sprinkle with fresh mint leaves, and serve with flatbread (see page 119) or boiled potatoes.

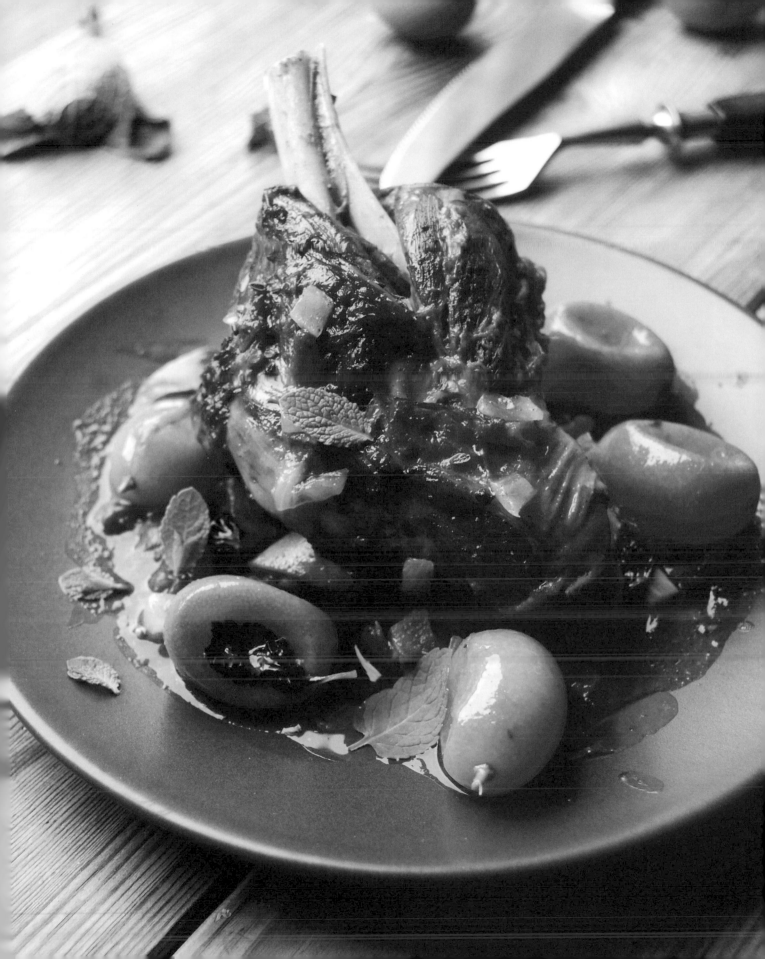

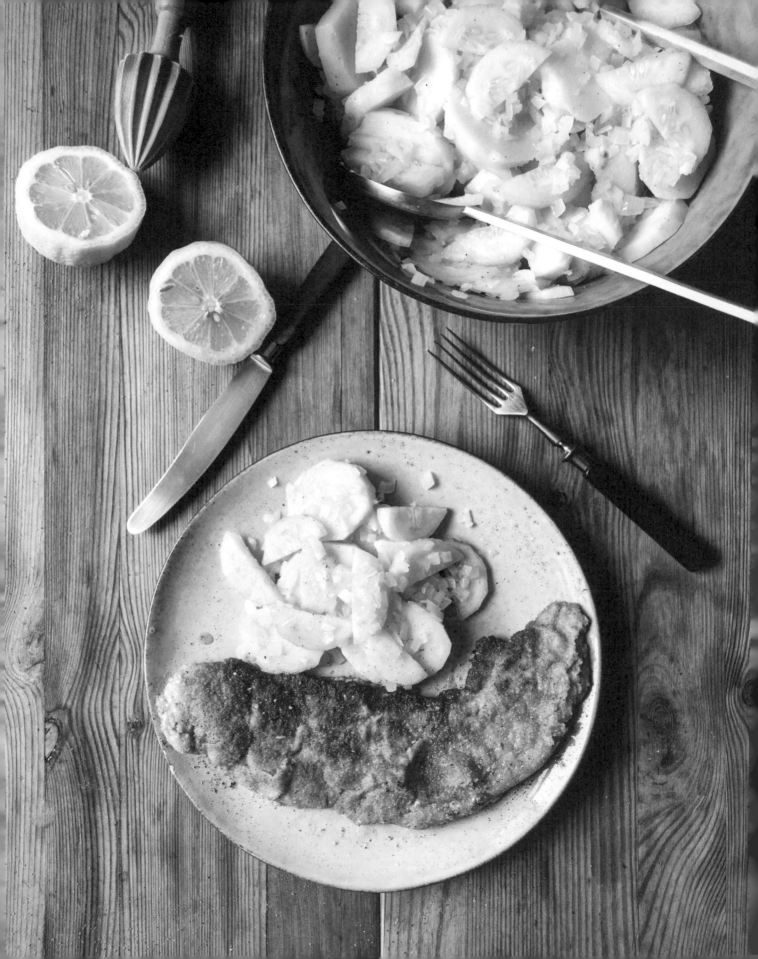

the perfect schnitzel with swabian potato salad

Perfect schnitzel is thin and juicy, with a golden crust that flakes off the meat in light, crispy waves. Whether you use veal or pork is up to you; veal is essential for traditional Wiener Schnitzel, but pork is cheaper and slightly heartier. Swabian potato salad makes an ideal companion for such simple, hearty fare. With sliced cucumbers and a sweet-sour dressing of onions cooked in white balsamic vinegar, it's a light, fruity counterpoint to the meat.

SERVES 4

FOR THE POTATO SALAD

½ cup (120 ml) white balsamic vinegar (or white wine vinegar), plus more to taste

½ cup (120 ml) water

6 ounces (170 g) onion, very finely chopped

2¼ pounds (1 kg) peeled waxy potatoes, boiled (warm or cold) and thickly sliced

15 ounces (420 g) peeled cucumber, cut in half lengthwise and thinly sliced

2 tablespoons olive oil, plus more to taste

Fine sea salt

Ground pepper

FOR THE SCHNITZEL

4 large, ¼-inch-thick (5 mm) veal or pork cutlets, about 21 ounces (600 g) total

Butter

Sunflower oil

About ¾ cup (100 g) all-purpose flour

2 to 3 large eggs, lightly beaten

About ¾ cup (110 g) dry breadcrumbs

Fine sea salt

Ground pepper

1 lemon, cut into wedges (optional)

For the potato salad, bring the vinegar, water, and onion to a boil in a small saucepan. Lower the heat and simmer for about 3 minutes or until the onion is tender. Remove from the heat, cover, and let sit for 5 minutes.

In a large bowl, toss together the potatoes, cucumber, olive oil, and the onion mixture. Season to taste with salt and pepper. If the salad is too dry, add more olive oil and vinegar.

On a table or countertop, arrange the veal or pork between 2 sheets of plastic wrap. Use a meat pounder or your fist to tenderize and slightly flatten the meat.

In a large, heavy pan, heat 2 tablespoons of butter and a generous splash of sunflower oil over high heat.

Place the flour, eggs, and breadcrumbs in 3 separate deep, wide plates.

Season the meat on both sides with salt and pepper. Lightly dredge the meat in the flour then dip it in the egg and dredge it in the breadcrumbs, making sure it's evenly coated. Only prepare as much as you can fit in your pan without overcrowding. Immediately place the meat in the hot pan. Lower the heat to medium-high and cook, turning, for 1 to 2 minutes per side or until golden brown and just cooked through. If the pan gets dry, add more oil. Transfer the schnitzel to a plate, season to taste with salt and pepper, cover, and keep warm. Add more oil and butter to the pan and cook any remaining meat.

Serve the schnitzel with a squeeze of lemon juice, if desired, and the potato salad.

brunġiel mimli

MALTESE BOLOGNESE STUFFED EGGPLANT

This is another take on Maltese stuffed vegetables, but far heartier than the Maltese Stuffed Bell Peppers from page 140. *Brunġiel mimli* is rich and fortifying like lasagna but without the heaviness of pasta. With beef, tomatoes, thyme, and rosemary mingling in the dark Bolognese, the fragrance from the oven is tantalizing, while the sweet and slowly softened flesh of the eggplant has the most divine texture. The results are more than delicious. This is feel-good food at its best.

SERVES 4

FOR THE BOLOGNESE SAUCE

Olive oil

1 medium onion, diced

1 medium carrot, peeled and diced

½ celery stalk, diced

1 large clove garlic, crushed

10 ounces (280 g) ground beef

1 tablespoon tomato paste

⅓ cup (75 ml) full-bodied red wine

14 ounces (400 g) canned whole peeled tomatoes, chopped

3 medium sprigs fresh thyme

1 medium sprig fresh rosemary

2 large fresh sage leaves

1 bay leaf

Fine sea salt

Ground pepper

FOR THE STUFFED EGGPLANTS

2 large eggplants, about 1½ pounds (680 g) total

Olive oil

1 tablespoon balsamic vinegar, plus more to taste

Fine sea salt

Ground pepper

1 large egg

4 ounces (110 g) young pecorino or Parmesan, freshly grated

4 small sprigs fresh thyme, plus a few thyme leaves for serving

4 small sprigs fresh rosemary, plus a few chopped rosemary needles for serving

For the Bolognese sauce, in a large, heavy pan, heat a generous splash of olive oil over medium heat. Add the onion, carrot, celery, and garlic and sauté, stirring constantly, for 3 minutes. Add the beef and a little more oil and cook, stirring to break up the meat, for a few minutes or until no more liquid comes out and the meat is browned. Add the tomato paste and cook, stirring, for 1 minute. Add the wine and deglaze the pan, using a spatula to scrape any bits and pieces off the bottom. Add the chopped tomatoes and their juices, along with the thyme, rosemary, sage, and bay leaf, and season to taste with salt and pepper. Bring to a boil, reduce the heat, and simmer, uncovered and stirring occasionally, for 20 minutes or until thick. If the sauce is too dry, add a little more wine. Take the pan off the heat, discard the herbs, and season to taste with salt and pepper. Set aside and let cool for a few minutes.

(continued)

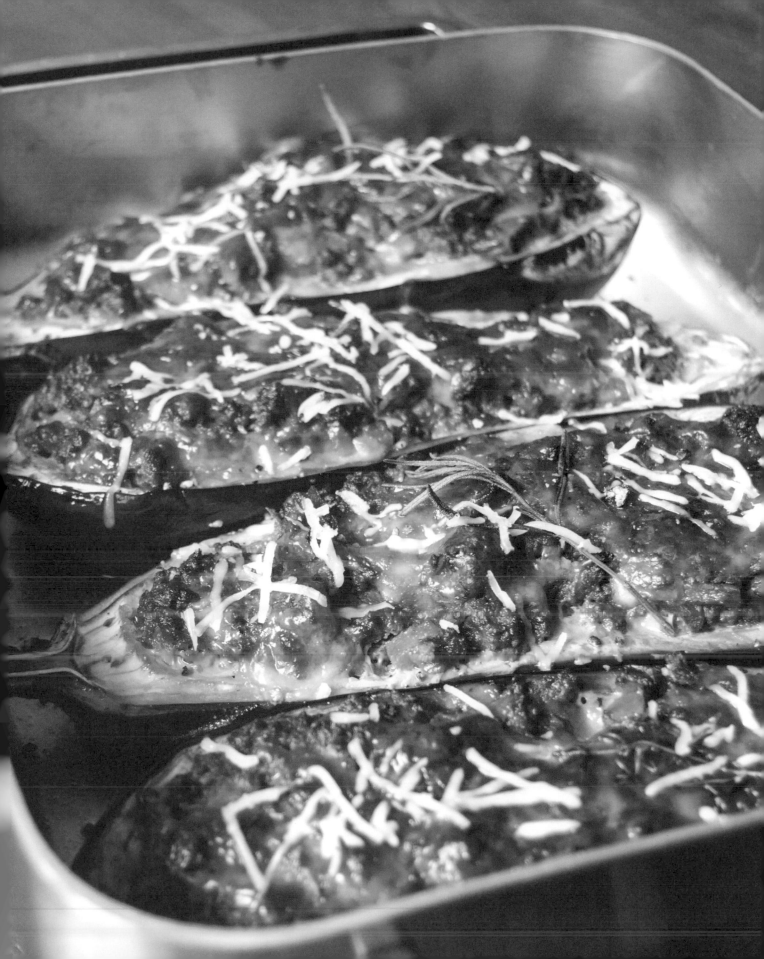

Preheat the oven to 400°F (200°C).

Cut the eggplants in half lengthwise and use a spoon to scrape out and reserve the pulp, but leave a ¼-inch (5 mm) border. Set the scraped eggplant halves aside. Measure and finely chop 9 ounces (250 g) of the pulp (use the remaining pulp for other recipes).

In a medium, heavy sauté pan, heat a splash of olive oil over medium-high heat. Add the chopped eggplant and sauté for about 2 to 3 minutes or until it resembles soft mashed bananas. Add the vinegar and deglaze the pan, using a spatula to scrape any bits and pieces off the bottom. Season to taste with salt and pepper. Add to the Bolognese sauce then season to taste with salt, pepper, and vinegar. Add the egg and stir until well combined.

Season the scraped eggplant halves with salt and pepper and arrange them in an oven-proof baking dish. Divide the Bolognese between the eggplant halves, sprinkle with ⅔ of the pecorino, and top each with a sprig of thyme and rosemary. Add ¼ inch (5 mm) of water to the baking dish. Bake for about 50 minutes or until the eggplant shells feel tender when you prick them with a skewer. Sprinkle with the remaining pecorino, the thyme leaves, and chopped rosemary, and serve.

bavarian beer-roasted pork
with sweet potatoes and parsnips

As autumn nears, I leave the buzz of the city and head to the suburbs to buy meat from a small local butcher near Müggelsee, Berlin's largest lake. It's become a tradition: My boyfriend and I place our order—whether for a roast, sausages, or both—at our trusted shop then go on a long walk through the dense woods that surround the picturesque lake. With fresh air in our lungs—and a few sweet treats from a nearby bakery in our bellies—we pick up the bags full of meaty delicacies and hop back on the train.

This really is the ultimate roast with perfect crackling, juices sweetened with elderflower or apricot jelly, and tender meat infused with beer, cloves, mustard, and cinnamon. It's pure comfort food.

SERVES 4 TO 6

1 tablespoon fine sea salt

12 whole cloves, finely crushed with a mortar and pestle

5½ pounds (2.5 kg) bone-in pork shoulder, with the fat scored (ask the butcher to do this or use a very sharp knife to create a diamond pattern)

2 cups (500 ml) beer

3 medium red onions, cut into quarters

2 large sweet potatoes, scrubbed or peeled and cut into cubes

4 large parsnips, scrubbed or peeled and cut lengthwise into quarters

1 cinnamon stick, broken

3 star anise pods

2 heaping tablespoons white mustard seeds

FOR THE SAUCE

½ to ¾ cup (120 to 180 ml) vegetable broth (*see page 239*)

1 tablespoon light, fruity jelly, such as elderflower or apricot

1 teaspoon Dijon mustard

Ground pepper

Preheat the oven to 350°F (180°C).

Combine the salt and cloves, sprinkle onto the scored surface of the pork and rub into the scores with your fingers. Place the meat, scored side up, in a deep roasting pan and roast for 1½ hours. Take the pan out of the oven, pour the beer over the meat, and arrange the red onions, sweet potatoes, parsnips, cinnamon, star anise, and mustard seeds around the meat. Roast for another 60 minutes, stirring the vegetables and spooning the juices from the pan over the meat every 20 minutes or so. Turn on the broiler for the last few minutes until most of the crackling is crisp—mind that it doesn't get too dark. Transfer the meat and vegetables to a large dish, cover with aluminum foil and set aside.

For the sauce, pour the juices from the roasting pan into a medium saucepan, discarding the cinnamon and star anise. Add ½ cup (120 ml) of the broth and bring to a boil. Whisk in the jelly and mustard and season to taste with pepper. Taste the sauce and if the beer flavor is too strong, add more broth. If you prefer the sauce more concentrated, let it cook down for a few minutes. Cut the pork roast into ½-inch (1.25 cm) slices and serve with the sauce and vegetables on the side.

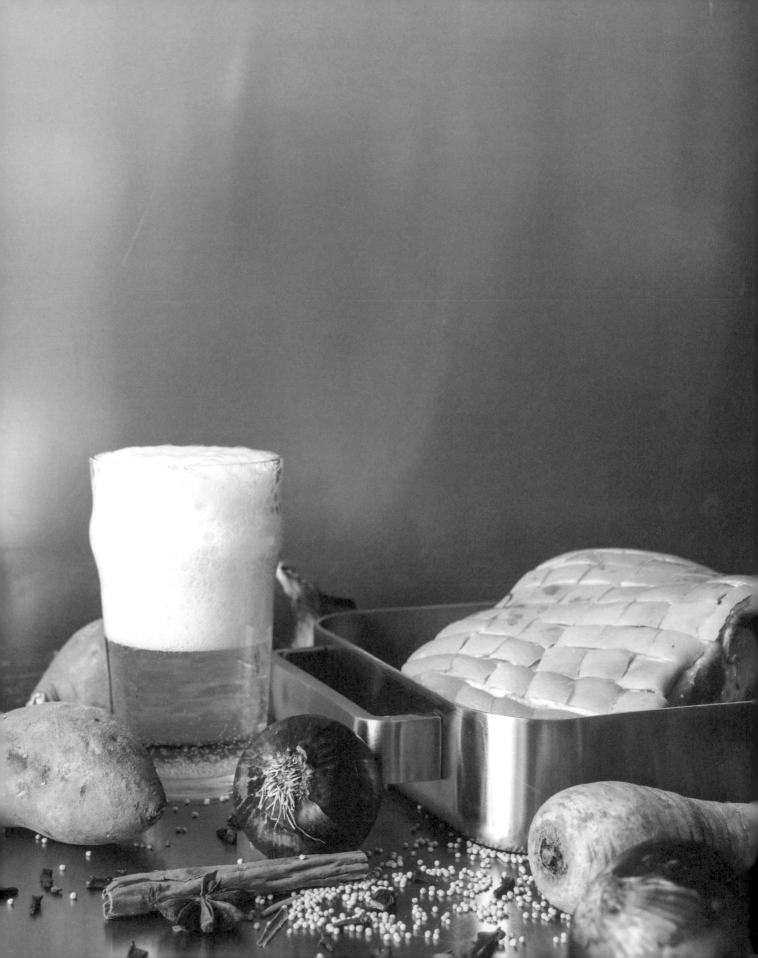

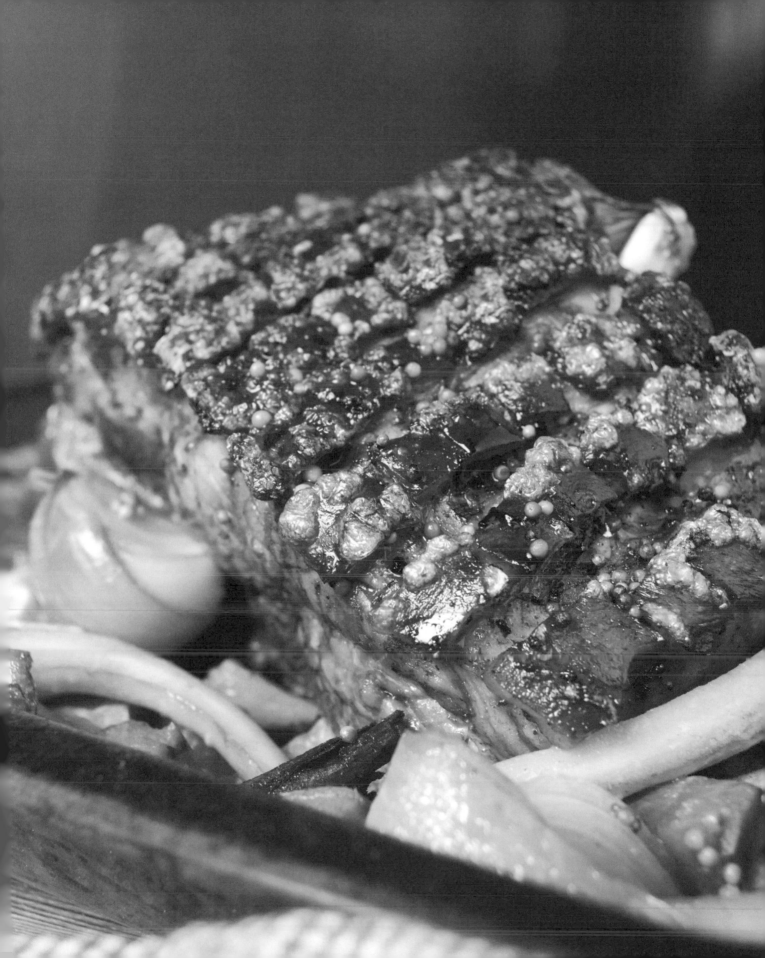

riesling and elderflower chicken with apricots

If you feel like eating meat, but time is tight, throw some chicken thighs in the oven. This is one of the quickest and easiest dishes to please a hungry crowd of family or friends, in which case just double the amounts below. And if there are fewer people at the table, add a little chutney (*see page* 238) and some arugula leaves to the cold leftovers, and stuff everything into a sandwich.

The chicken can marinate for several hours, which will make this dish even more flavorful. In the oven, the succulent meat roasts side by side with sweet, juicy apricots lusciously coated in Riesling and elderflower syrup (*see page* 238). You can replace the apricots with other fruit like peaches, plums, apples, or grapes. German Riesling is my favorite wine to use—it suits the acidic aroma of stone fruit perfectly—but feel free to use any fruity white, such as Italian Moscato.

This is light summer eating, perfect for an evening in the garden or on the balcony. Conveniently, the Riesling is already open, so make sure it's chilled and take it to the table.

SERVES 2 TO 4

4 bone-in, skin-on chicken thighs	4 tablespoons Riesling (or any fruity white wine)	Flaky sea salt
8 ripe apricots, cut in half and pitted	1 tablespoon olive oil	Needles from 10 medium sprigs fresh rosemary
5 tablespoons elderflower syrup (*see page 238*)	¼ teaspoon black peppercorns, crushed with a mortar and pestle, plus more to taste	

Preheat the oven to 425°F (220°C).

Cut off any large chunks of fat from the chicken thighs.

Place the chicken and apricots in a baking dish just large enough to fit them in. Whisk together the elderflower syrup, Riesling, and olive oil and pour it over the meat. Sprinkle with the crushed peppercorns. Using your fingers, rub the marinade and crushed peppercorns into the chicken skin until well coated. (If you have the time, cover the chicken and let it marinate in the refrigerator for 30 minutes or longer). Season to taste with flaky sea salt and sprinkle with ¾ of the rosemary needles. Bake, spooning the juices from the pan over the chicken every 10 minutes or so, for 25 to 30 minutes or until the juices run clear when you prick the thickest part of a chicken thigh with a skewer. Turn on the broiler for a few minutes until the chicken skin starts sizzling, but mind that the apricots don't burn. Take the baking dish out of the oven, sprinkle with the remaining rosemary, and season to taste with flaky sea salt and crushed peppercorns.

Serve immediately, with a glass of chilled Riesling, and use cold leftovers for sandwiches the next day.

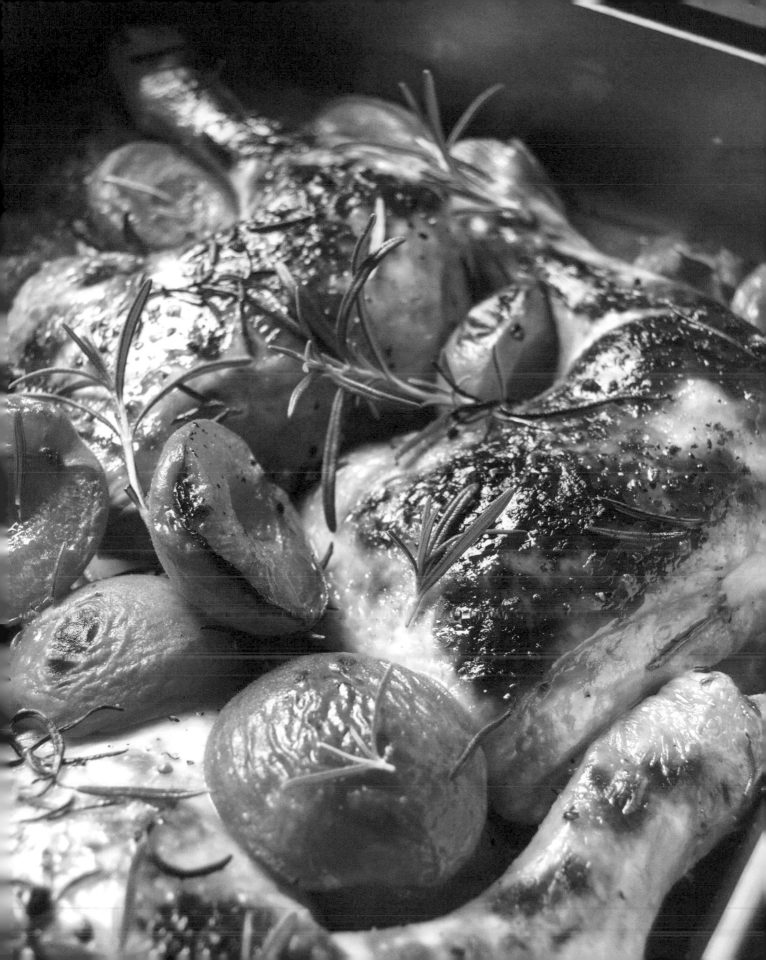

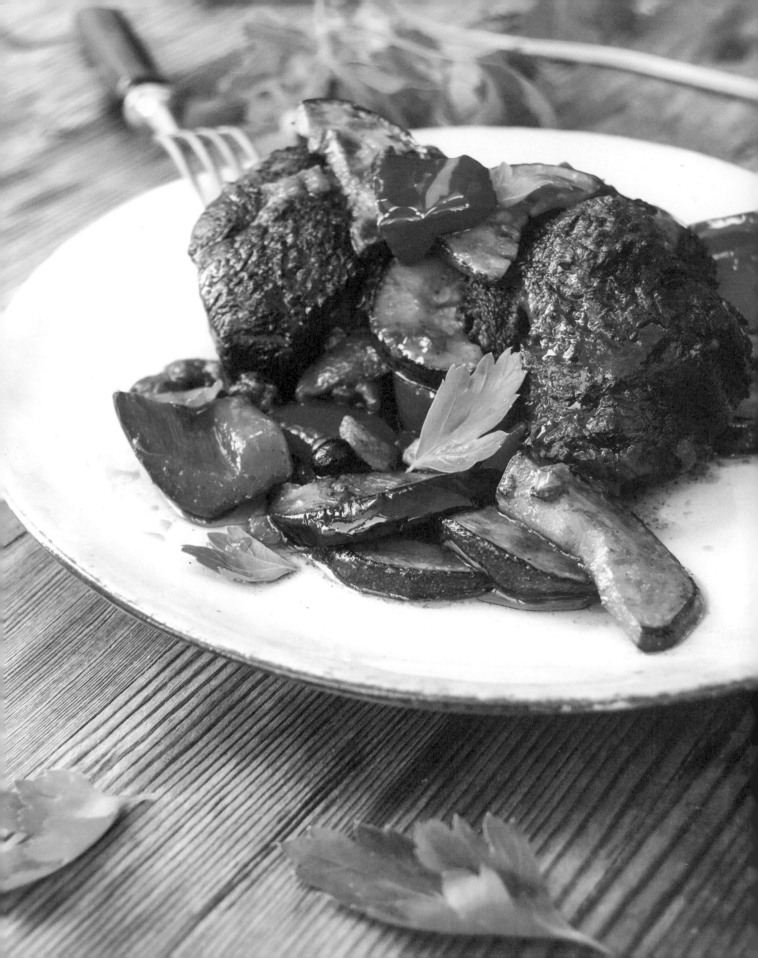

beef shank and caponata stew

My mother is the source of my cooking foundation. She taught me the essential techniques and how to trust my own taste and intuition, both of which are indispensible in the kitchen. A pasta can be thrown together spontaneously, but more complex dishes, meat and seafood especially, demand knowledge of the right cut, temperature, and cooking time, plus the confidence to experiment with flavors.

My mother continues to give me insight into her vast culinary expertise whenever we cook together. I'm happy with everything I've learned, but I'm particularly grateful that she taught me how to turn simple cuts of beef or lamb into the most aromatic and tender stews. Using a low temperature and cooking stews slowly is the secret to meat so soft and succulent that you can cut it with a fork. This requires patience, as you have to give the ingredients time to cook down and concentrate so they can release their juices and unfold their best qualities. My mother also uses lots of wine, various spices, and herbs from her own garden—some of the plants are older than me and produce the most fragrant thyme, rosemary, and sage I've ever tasted. I followed her nose to smell which herb and spice combinations work best, before I learned to trust myself more in the kitchen.

This beef shank and caponata stew combines my mother's traditional cooking with one of my favorite Maltese lunch dishes. I cook the meat and vegetables separately and combine them just before serving. The meat is soft and tender, the sauce is dark and strong, and the juicy vegetables maintain a slightly crunchy bite.

SERVES 4

FOR THE BEEF STEW

Olive oil

4 beef shanks, about 4 pounds (1.8 kg) total

Fine sea salt

Ground pepper

4 medium onions, finely chopped

4 cloves garlic, chopped

1 (750-ml) bottle full-bodied red wine

1¾ pounds (800 g) canned whole peeled tomatoes, chopped

1 small bunch flat-leaf parsley, tied with kitchen string

2 bay leaves

12 allspice berries

FOR THE CAPONATA

Olive oil

10 ounces (280 g) eggplant, quartered lengthwise and cut into ¼-inch (5 mm) slices

Fine sea salt

Ground pepper

10 ounces (280 g) zucchini, halved lengthwise and cut into ¼-inch (5 mm) slices

10 ounces (280 g) cored and seeded red bell pepper, cut into ½-inch (1.25 cm) cubes

1 tablespoon balsamic vinegar, plus more to taste

FOR THE TOPPING

1 small handful flat-leaf parsley leaves

(continued)

Preheat the oven to 350°F (180°C).

For the beef stew, in a Dutch oven with a tight-fitting lid, large enough to fit the meat, heat a splash of olive oil over high heat. Working in batches, sear the beef shanks for 1 to 2 minutes per side or until evenly browned. Season to taste with salt and pepper and transfer to a plate. Add a splash of olive oil, reduce the heat to medium, and sauté the onions and garlic for about 3 minutes or until soft and golden. Add a splash of red wine and deglaze the pan, using a spatula to scrape any bits and pieces off the bottom. Return the meat to the Dutch oven, add the tomatoes, parsley, bay leaves, allspice, and the remaining wine, stir, and season to taste with salt and pepper. Cover the Dutch oven and place it in the oven. After 45 minutes, lower the temperature to 275°F (140°C) and cook for about 4 hours, or until the meat is tender.

For the caponata, in a large, heavy pan over medium-high heat, heat a splash of olive oil. Add the eggplant and sauté, stirring constantly, for about 5 minutes or until it starts to soften—mind that it doesn't turn too dark. Season to taste with salt and pepper then transfer to a plate. Cook the zucchini and bell pepper the same way, one after the other, adding a splash of oil to the pan each time and sautéing for a few minutes or until al dente. Return all the vegetables to the pan and raise the heat to high. Add the vinegar and deglaze the pan, using a spatula to scrape any bits and pieces off the bottom. Take the pan off the heat and season to taste with salt, pepper, and more vinegar.

When the meat is done, remove the parsley and bay leaves and season to taste with salt and pepper. Stir in the caponata and serve with parsley leaves, and a fresh baguette or boiled potatoes.

slow-roasted duck
with ginger, honey, and orange

This is our Christmas duck—or I should say my Christmas duck. In Germany, we celebrate on December 24th. My boyfriend, however, celebrates on the 25th, according to the Maltese and American tradition. So, we have two Christmases and two festive meals and this tender slow-roasted duck is always the culinary gift on my holiday.

My basic formula for cooking duck never changes—about 3½ hours at a low temperature—because the results are just too good. But the seasoning depends on my mood. In this version, the bird is coated in a sticky glaze of honey, thyme, and ginger and set on a bed of sweet orange slices. Sometimes I fill the duck with more fruit and mixed herbs; other times I opt for a southern German liver stuffing I learned from my stepfather, Uli.

The sauce in this recipe is very concentrated, and not the kind that you would pour generously onto your plate. You won't need much, but take a spoonful and be sure to dip each bite of meat into the aromatic blend.

This recipe goes very well with Roasted Brussels Sprouts with Ginger and Lemon (*see page* 69) or the Warm Salad of Sautéed Carrots, Preserved Lemon and Mint on page 24.

SERVES 3 TO 4

FOR THE DUCK

1 large orange, thinly sliced

Olive oil

1 (5½-pound / 2.5-kg) duck, with neck and giblets reserved

Flaky sea salt

Ground pepper

1 small bunch fresh thyme

FOR THE GLAZE

2 tablespoons honey, preferably wild thyme honey

2 teaspoons freshly grated ginger

10 small sprigs fresh thyme

FOR THE SAUCE

Olive oil

⅓ cup (75 ml) brandy (or port), plus more to taste

¼ cup (60 ml) freshly squeezed orange juice

1 tablespoon light, fruity jelly, such as elderflower or apricot, plus more to taste

1½ teaspoons freshly grated ginger

1 teaspoon fresh thyme leaves

½ teaspoon honey, preferably wild thyme honey, plus more to taste

Fine sea salt

Ground pepper

Preheat the oven to 175°F (85°C).

Spread the orange slices in a roasting pan large enough to fit the duck.

For the duck, in a large, heavy pan, heat a splash of olive oil over high heat and sear the duck, turning, for a few minutes or until golden brown on all sides. Arrange the duck, breast-side up, on top of the orange slices and set the pan aside (you will need it for the sauce). Sprinkle the duck, inside and out, with flaky sea salt and pepper, and rub the seasoning into the skin. Stuff ⅓ of the thyme inside the duck and arrange the rest around it.

(continued)

For the glaze, in a small saucepan, heat the honey, ginger, and thyme over medium heat until just warm and liquefied. Pour the syrup over the duck and rub it into the skin. Roast, spooning some of the fat and juices from the pan over the duck every hour, for 3½ hours.

While the duck is roasting, make the sauce: In the pan used to sear the duck, heat a splash of olive oil over high heat. Add the neck and giblets and sear for 2 minutes. Add ½ of the brandy and deglaze the pan, using a spatula to scrape any bits and pieces off the bottom. Remove the neck and giblets, add the orange juice and the remaining brandy to the pan and bring to a boil. Add the jelly, ginger, thyme, and honey and cook for 1 minute then pour into a saucepan, cover, and set aside.

After 3½ hours, check to see if the duck is done by pricking the thickest part of the thighs with a skewer—the juices should run clear. Turn on the broiler for a few minutes until the skin is golden brown and partly crisp.

Remove the duck from the pan, cover, and let rest, while you finish the sauce. Skim the fat from the duck's juices, pour the juices into the reserved sauce, and bring to a boil. Lower the heat and simmer the sauce for 1 to 2 minutes. Season to taste with salt, pepper, brandy, jelly, and honey. Continue to simmer the sauce if you prefer a more concentrated flavor.

Carve the duck and serve the meat with the orange slices and the sauce.

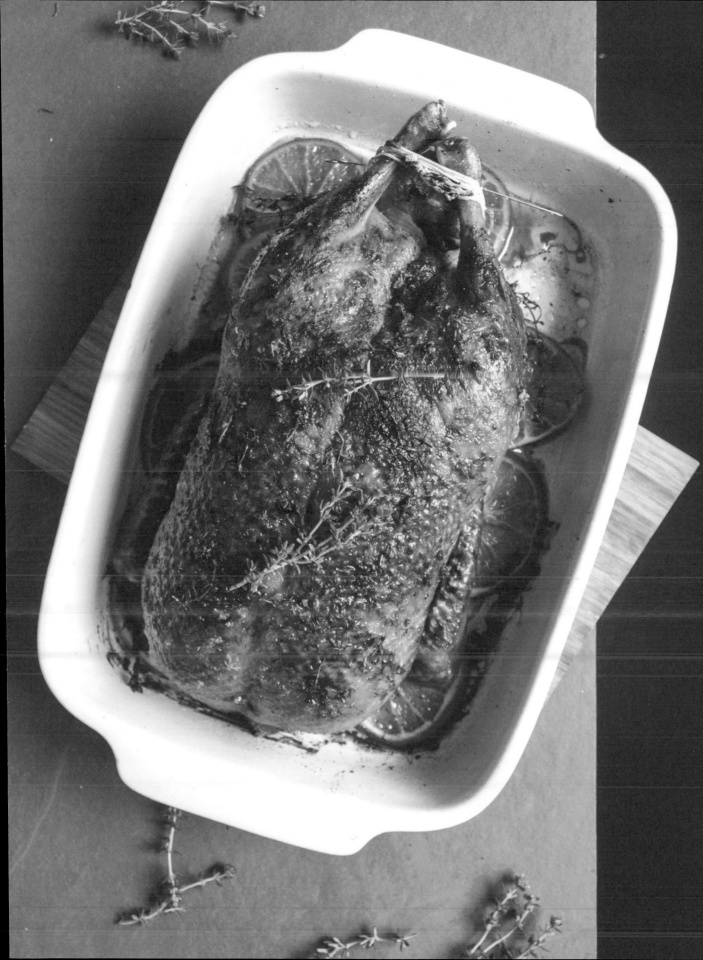

rustic meatloaf with leeks and mountain cheese

When I'm asked about my favorite food the answer is surprisingly simple: either white sourdough bread with olive oil or dark bread with butter. But ask me about my favorite meat dish, and I would have to say ground beef in all its variations—burgers, tiny polpettine in fruity sauces, and especially, juicy meatloaf, preferably cold the next day. Meatloaf is a child-hood memory. It often appears on my mother's kitchen table and I still fall for its honest, savory taste.

When I make meatloaf, I like to brighten the mixture with finely chopped vegetables like tomato, zucchini, or bell pepper, but for this recipe, I stir in lots of fresh herbs—thyme, rosemary, oregano—and leeks to add a rustic touch. A soft center of melted Gruyère leaves no doubt that it's a hearty treat, practically made for picnics, buffets, or casual dinner parties.

SERVES 6 TO 8

1½ cups plus 1 tablespoon (375 ml) whole milk

⅓ cup (50 g) dry breadcrumbs

2¼ pounds (1 kg) ground beef

10 ounces (280 g) leeks, cut in half and thinly sliced

2 large eggs

3 large cloves garlic, crushed

3 heaping tablespoons fresh thyme leaves, plus 3 small sprigs fresh thyme

2 heaping tablespoons finely chopped fresh rosemary needles, plus 3 small sprigs fresh rosemary

2 tablespoons fresh oregano leaves

3½ teaspoons fine sea salt

A generous amount ground pepper

4 ounces (110 g) Gruyère (or any aromatic hard cheese), thinly sliced

Preheat the oven to 350°F (180°C).

In a medium bowl, stir together the milk and breadcrumbs; let soak for 5 minutes.

In a large bowl, combine the beef, leeks, eggs, garlic, thyme leaves, chopped rosemary, oregano, salt, and pepper. Add the breadcrumb-milk mixture and mix together with your hands or the dough hooks of an electric mixer. Divide the mixture into 2 parts, place 1 part in a baking dish, and flatten to form a 10 x 5-inch (25 x 13 cm) shape. Arrange the sliced cheese on top, leaving a ¾-inch (2 cm) border. Place the remaining meat mixture on top and form a loaf, gently pressing to seal the edges. Arrange the sprigs of thyme and rosemary around and on top of the meat and bake for about 70 minutes or until golden brown.

Serve warm or cold, sprinkled with fresh herbs if desired.

pork loin with orange-thyme crust and balsamic-orange sauce

Roast pork loin is an easy way to impress at the dinner table, especially when the tender meat is crowned with a golden crust of orange, garlic, and thyme. It may seem like a difficult dish, but it's not at all complicated. The only challenge is making sure you don't overcook the pork.

Orange, thyme, and garlic are gentle on the meat, but enhance its flavor beautifully. And what works in the crust, can't be bad for the sauce. Refined with syrupy balsamic vinegar, the luxurious mixture is so good you'll want to mop up every last drop.

SERVES 3 TO 4

3 tablespoons (40 g) unsalted butter, cold

2 tablespoons (20 g) dry breadcrumbs

1 clove garlic, crushed

2 tablespoons fresh thyme leaves

2 teaspoons freshly grated orange zest

1 teaspoon freshly squeezed orange juice

Fine sea salt

Ground pepper

Olive oil

1 (1⅓-pound/ 600-g) pork loin

FOR THE SAUCE

6 long strips fresh orange peel

⅓ cup (75 ml) freshly squeezed orange juice

1 tablespoon balsamic vinegar, plus more to taste

3 small sprigs fresh thyme

Fine sea salt

Ground pepper

FOR THE TOPPING

1 teaspoon fresh thyme leaves

1 teaspoon freshly grated orange zest

Preheat the oven to 400°F (200°C).

In a food processor or blender, pulse together the butter, breadcrumbs, garlic, thyme, orange zest, and orange juice. Season to taste with salt and pepper. If the mixture is very soft, refrigerate it until you can cut it with a knife.

On a table or countertop, arrange the butter mixture between 2 sheets of plastic wrap. Use a rolling pin to roll it into roughly the shape of the top of the pork loin. Leave the butter mixture wrapped in the plastic wrap and refrigerate until ready to use.

In a large, heavy pan, heat a splash of olive oil over high heat and sear the pork, turning, for 1 to 2 minutes or until golden brown on all sides. Transfer the meat to a baking dish, season with salt and pepper, and set the pan aside (you will need it for the sauce). Quickly lay the butter mixture on top of the pork and gently press it into the meat. Roast for 12 minutes—the meat should still be pink inside. Turn on the broiler and let the crust brown for another 2 to 3 minutes. Take the meat out of the oven, cover loosely with aluminum foil, and set aside.

For the sauce, place the pan used to sear the pork over high heat. Add the orange peel, orange juice, vinegar, and thyme and bring to a boil. Reduce the heat and simmer for about 2 minutes or until the sauce is thick. Season to taste with salt, pepper, and vinegar.

Cut the pork into thick slices, drizzle with the balsamic-orange sauce, sprinkle with fresh thyme and orange zest, and serve.

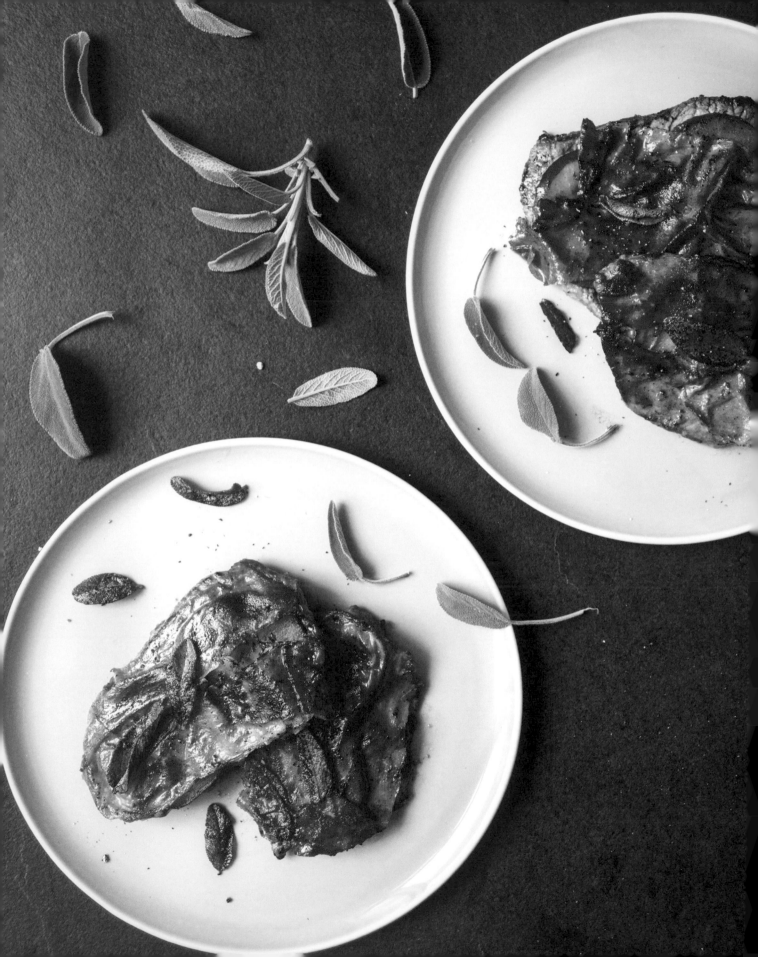

saltimbocca alla romana with sautéed apples

Saltimbocca is a Roman schnitzel, which obviously appeals to me as a German—we seem to have an inborn affection for this meaty dish. The name derives from "*salt' im bocca!*" a Roman expression meaning "jump in the mouth!" Some like to roll the pounded scaloppine, others fold it or leave it flat, like German schnitzel, and that's what I do. I sneak a thin slice of apple between the layers of sage and prosciutto and find the bitter herb and dry-cured ham welcome a little fruitiness with open arms. This dish is hearty, but still elegant, and makes a scrumptious dinner for two.

SERVES 2

Unsalted butter

1 to 2 tart baking apples, cored and cut into ¼-inch (5 mm) round slices (about 2 slices for each cutlet)

12 ounces (340 g) thin veal cutlets (4 small scallopine or 2 large, cut in half)

Fine sea salt

Ground pepper

About 2 heaping tablespoons all-purpose flour

24 fresh sage leaves

4 thin slices prosciutto di Parma (or Tyrolean prosciutto or coppa di Parma)

Olive oil

¼ cup (60 ml) Marsala wine

FOR THE TOPPING

A few black peppercorns, crushed with a mortar and pestle

In a large, heavy pan, heat 1½ tablespoons of butter over medium-high heat. Sauté the apples for 1 minute per side or until golden brown but not soft—the apples should still have some bite. Transfer the apples to a plate and set the pan aside (you will need it for the saltimbocca).

On a table or countertop, arrange the veal between 2 sheets of plastic wrap. Use a meat pounder or your fist to pound the meat until it's about ¼ inch thick (5 mm). Season to taste on both sides with salt and pepper and dust 1 side with flour. Flip the veal over and top each piece with 4 sage leaves and 2 slices of apple (or enough to cover the meat). Arrange slices of prosciutto on top and gently press the toppings into the meat.

In the pan you sautéed the apples in, heat 2 tablespoons of butter and a generous splash of olive oil over medium-high heat. Add the saltimbocca, prosciutto-side down, and sear for 1 minute then carefully flip the saltimbocca over, add the remaining sage, and cook for 1 minute or until golden brown and just done. Transfer the saltimbocca and sage to a plate, but leave the pan over the heat. Add the Marsala and deglaze the pan, using a spatula to scrape any bits and pieces off the bottom.

Divide the saltimbocca and sage between the plates, season to taste with salt and sprinkle with the crushed peppercorns. Drizzle with the juices from the pan and serve.

savory baking

CHEESY MOUNTAIN BUNS

GOZITAN PIZZA WITH POTATOES, EGGPLANT, CHÈVRE, AND FENNEL OIL

GERMAN PRETZEL BUNS

SFINCIONE | SICILIAN PIZZA WITH TAPENADE

PEAR AND BLUE CHEESE TART WITH ROSEMARY

cheesy mountain buns

On a cold winter's morning, I decided to create mountain buns—neither the name nor the recipe existed in my head until then. While lost in daydreams about the skiing holidays I used to spend in the mountains of northern Italy as a young child, the region's hearty food came to mind. We used to stay in the picturesque Val Badia, which is famous for rustic South Tyrolean treats, including rich soups and stews, dumplings, and strudel. We took countless breaks from our sporting activities to refuel in the kitchens of wooden huts covered in snow, high up, where the mountains are just rocks and silence. I used to be particularly fond of a crunchy traditional bread called *Schüttelbrot*, which translates to "shaken bread" and is a reference to how it's prepared. By shaking and turning the dough on a baking sheet, it gets its typical round, flat shape. Its other defining characteristic is that it's spiced with lots of aniseed, fennel seeds, and coriander seeds, making it a proper mountain bread.

Thinking about the warm aroma of those spices, but wanting to make bread with a much softer texture, I landed on these mountain buns. When I first wrote about them on my blog, people assumed these buns had been around for a long time and weren't just a fantasy in my head. Now, they're a staple in my kitchen and I make a few variations, including this one with strong mountain cheese and rhubarb chutney (*see page 238*) for dipping.

MAKES 12 BUNS

4¼ cups (550 g) flour (preferably white spelt or unbleached wheat)

1 (¼-ounce / 7-g) envelope fast-acting yeast

2 teaspoons coriander seeds, lightly crushed with a mortar and pestle

1½ teaspoons aniseed, lightly crushed with a mortar and pestle

1½ teaspoons fine sea salt

1 teaspoon granulated sugar

1¼ cups (300 ml) whole milk, lukewarm

4 tablespoons (55 g) unsalted butter, melted and cooled

1 large egg

3 ounces (85 g) Appenzeller (or any aromatic hard cheese, such as Raclette or Gruyère), coarsely grated

FOR THE TOPPING

1 teaspoon coriander seeds, lightly crushed with a mortar and pestle

½ teaspoon aniseed, lightly crushed with a mortar and pestle

Combine the flour, yeast, coriander, aniseed, salt, and sugar in a large bowl.

In a medium bowl, whisk together the milk, butter, and egg—the mixture should be lukewarm. Add to the flour-spice mixture and mix with the dough hooks of an electric mixer for a few minutes or until well combined. Transfer the dough to a table or countertop and continue kneading it with your hands for a few minutes or until you have a smooth and elastic ball of dough. Place the dough back in the bowl, cover with a tea towel, and let rise in a warm place, or preferably in a 100°F (35°C) warm oven, for 70 minutes or until doubled in size.

(continued)

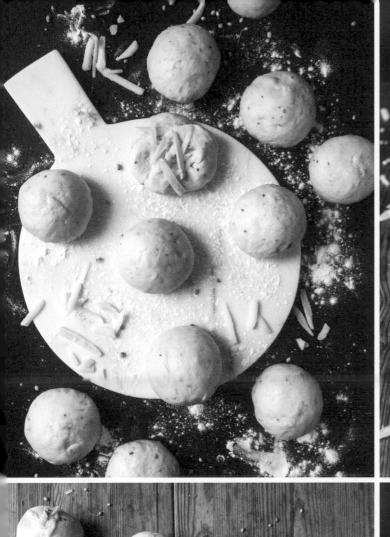
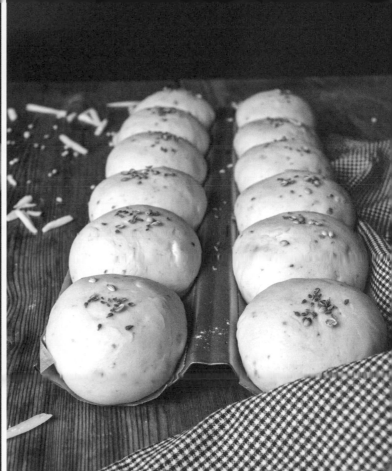
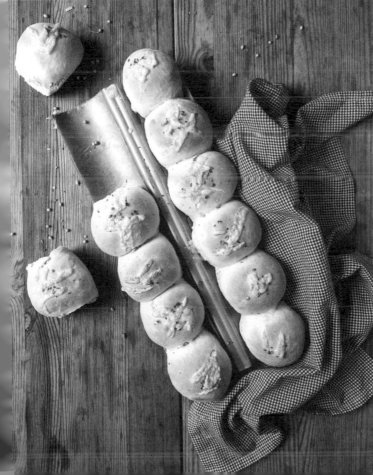
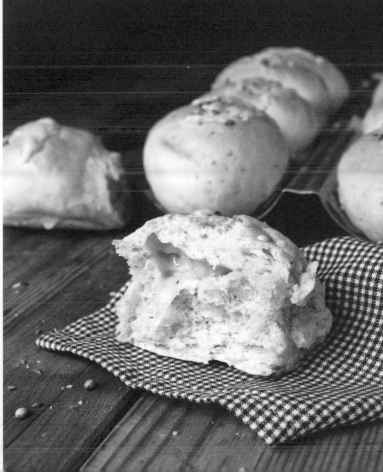

Divide the cheese into 14 equal portions. Line 1 baking sheet with parchment paper.

When the dough has doubled in size, punch it down, take it out of the bowl, and knead for about 30 seconds. Divide the dough into 12 equal (roughly 3-ounce / 85-g) portions. Place a portion in one hand and shape it into a thick disc. Place 1 portion of cheese in the middle of the disc, fold the dough over, and use 2 fingers to squeeze the edges and seal the cheese inside. Use both hands to gently roll the bun into a round ball. Use the remaining dough and 11 portions of the cheese to make 11 more buns. Arrange the buns close to each other on the lined baking sheet and sprinkle with the crushed coriander and aniseed, pressing gently into the spices so they stick to the dough. Cover the buns with a tea towel and let rise for about 20 minutes or until puffy.

Preheat the oven to 425°F (220°C).

Sprinkle the buns with the remaining cheese and bake for about 13 minutes or until golden. Knock on the bottom of a bun—it should sound hollow when it's done. Let the buns cool for a few minutes before serving and enjoy pure or with chutney.

gozitan pizza with potatoes, eggplant, chèvre, and fennel oil

Many, many dinners ago, my boyfriend and I had a great idea to start a new weekly tradition. Every Sunday we bake pizza from scratch, and enjoy a cozy night on the sofa, usually accompanied by a nice bottle of red wine and a couple classic movies.

Kneading the oily dough and turning it into a smooth ball of silkiness is my job and it's pure relaxation. I've learned that the dough rises best when I prepare it in Malta, a rather hot country. So when I'm in Berlin, I trick the dough by letting it rise in a warm oven, which changes the results drastically.

We always chop up various toppings according to our mood. Sometimes we add French sardines preserved in lemon oil from the Belle Île, an island off the coast of Brittany. Other times, it's Italian prosciutto or fennel salami. Or we keep it light, and go vegetarian. No matter how many pizzas I've pulled from my oven, it never ceases to amaze me how different they taste. And each one is satisfying in its own way.

The Maxokk Bakery in Nadur, on Malta's sister island Gozo, is famous for its local ftira pizzas. They're shaped like open galettes, with the edge of the dough folded over a thin layer of potatoes for a rich and savory treat. This was my inspiration but I top the dough with sweet tomato sauce, super-thin slices of eggplant, mozzarella, and Sainte-Maure de Touraine chèvre, plus potatoes, fragrant fennel oil, and fresh oregano.

MAKES 2 (11-INCH / 28-CM) PIZZAS

FOR THE DOUGH

2⅔ cups (350 g) all-purpose flour

1 (¼-ounce / 7-g) envelope fast-acting yeast

1 teaspoon fine sea salt

¾ cup (180 ml) water, lukewarm

4 tablespoons olive oil

FOR THE TOMATO SAUCE

14 ounces (400 g) canned whole peeled tomatoes, chopped

Fresh or dried oregano

Fine sea salt

Ground pepper

FOR THE TOPPING

6 tablespoons olive oil

2 teaspoons fennel seeds, lightly crushed with a mortar and pestle

1⅓ pounds (600 g) peeled waxy potatoes, boiled and sliced

4½ ounces (125 g) mozzarella, cut into small cubes

4 ounces (110 g) semi-ripe chèvre, preferably Sainte-Maure de Touraine or Maltese Ġbejna, very thinly sliced

1 small eggplant or zucchini, very thinly sliced (use a mandoline or cheese slicer)

1 small handful fresh oregano sprigs, leaves only

A few black peppercorns, crushed with a mortar and pestle

(continued)

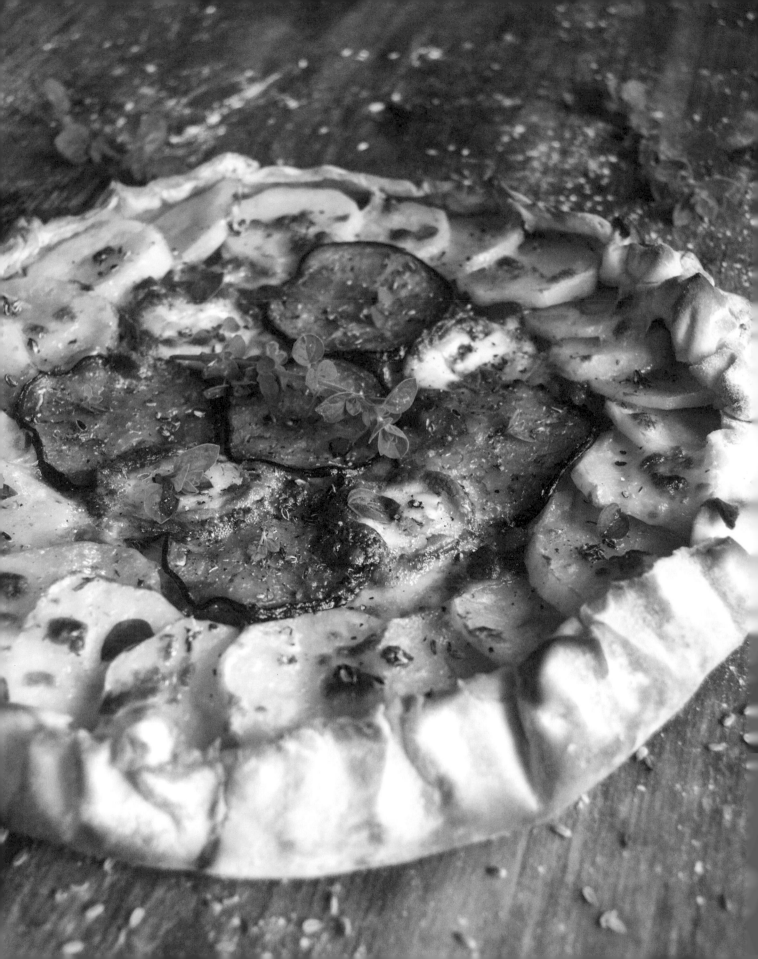

Start the preparations about 2 hours before you want to sit down to eat. I bake my pizza on a baking sheet that's been heated on the bottom of the oven; like a hot pizza stone would, it helps create a crunchy crust.

For the dough, combine the flour, yeast, and salt in a large bowl. Add the lukewarm water and olive oil and mix with the dough hooks of an electric mixer for a few minutes or until well combined. If the dough is too sticky, add more flour. Transfer the dough to a table or countertop and continue kneading and punching it down with your hands for a few minutes until you have a smooth and elastic ball of dough. Place the dough back in the bowl, cover with a tea towel, and let rise in a warm place, or preferably in a 100°F (35°C) warm oven, for 50 to 60 minutes or until doubled in size.

While the dough is rising, make the sauce: Place the tomatoes with their juices in a medium saucepan and season to taste with oregano, salt, and pepper. Cook over medium-high heat, stirring occasionally, for about 10 minutes or until thick. Remove from the heat, season to taste with salt and pepper, and set aside.

For the topping, in a small saucepan, heat the olive oil over medium heat. Add the fennel seeds and cook for 1 to 2 minutes or until fragrant—mind that the seeds don't turn dark. Take the pan off the heat and set aside.

When the dough has doubled in size, punch it down, take it out of the bowl, and divide into 2 parts. On a well-floured work surface or pizza peel, stretch and roll each piece of dough into a 13-inch (33 cm) disc. Cover with a tea towel and let rise for 15 to 20 minutes or until puffy.

Place a baking sheet (or pizza stone) on the bottom of the oven and preheat the oven to the highest temperature, 500°F (260°C) or higher.

Once the baking sheet is hot, carefully take it out of the oven, flip it over, and place it on a trivet or other heat-safe surface. Arrange 1 of the risen dough discs on the baking sheet and spread half the tomato sauce on top, leaving a 1½-inch (4 cm) border. Working quickly, arrange half of the potato slices in an overlapping outer circle on top of the tomato sauce then fold up the edge of the dough and gently press it onto the potatoes. Sprinkle the tomatoes with half of the mozzarella then top with half of the chèvre, and finish with half of the eggplant slices. Spoon a little fennel oil (but not the seeds; you will use those later) over the eggplant and bake on the bottom of the oven for about 9 minutes or until the crust is golden brown and crisp and the cheese is bubbling. Sprinkle with the reserved fennel seeds, fresh oregano leaves, and crushed peppercorns. Repeat to make the second pizza and serve hot.

german pretzel buns

These buns are soft and spongy inside, with a thin brown crust that's sprinkled with coarse sea salt. I love to use the salt harvested by the Cini family at the Xwejni Salt Pans in Gozo (*see page 244*). The secret to these buns is giving them a quick bath in a boiling alkaline solution before popping them in the oven—this is what gives them their distinctive flavor and color. I use baking soda to give the water a high pH level. The mixture isn't as strong as the lye used in professional bakeries, but it's safer, and still creates that irresistible pretzel look and taste.

MAKES 10 PRETZEL BUNS

3¾ cups plus 1 tablespoon (500 g) flour (preferably white spelt or unbleached wheat)

1 (¼-ounce / 7-g) envelope fast-acting yeast

2 teaspoons fine sea salt

1¼ cups (300 ml) water, lukewarm

3 tablespoons (40 g) unsalted butter, melted and cooled

3 tablespoons baking soda, for the alkaline solution

Coarse sea salt

Combine the flour, yeast, and salt in a large bowl.

In a medium bowl, whisk together the water and butter—the mixture should be luke-warm. Add to the flour mixture and mix with the dough hooks of an electric mixer for a few minutes or until well combined. If the dough is too sticky, add more flour. Transfer the dough to a work surface and continue kneading and punching it down with your hands for a few minutes until you have a smooth and elastic ball of dough. Place the dough back in the bowl, cover with a tea towel, and let rise in a warm place, or preferably in a 100°F (35°C) warm oven, for 60 minutes or until doubled in size.

When the dough has doubled in size, punch it down, take it out of the bowl, and knead for about 30 seconds. Divide the dough into 10 equal (roughly 3-ounce / 85-g) portions. Dust your hands with flour, lay a portion of dough on the palm of one hand, and with the other hand forming a dome over the dough, roll it for about 10 seconds until its top is round and firm. This process creates surface tension and prevents the buns from becoming flat. Continue with the remaining dough then cover with a tea towel, and let rise in a warm place for about 20 minutes or until puffy.

Preheat the oven to 425°F (220°C) and line 2 baking sheets with parchment paper.

In a large pot, wide enough to fit 2 buns at once, bring 4¼ cups (1 l) of water and the baking soda to a boil. Watch the pot; the baking soda-water mixture will foam up. With a slotted ladle or spoon, slip two buns gently into the boiling water and cook for 30 seconds, turn them over, and cook for another 30 seconds. The buns don't need to be completely covered with the solution, but mind that they don't stick to the bottom. Transfer the buns to the lined baking sheets, score a cross on the buns, and sprinkle with coarse sea salt. Cook the remaining buns in the same manner then bake, 1 sheet at a time, for about 16 minutes or until golden brown. Enjoy warm with unsalted butter.

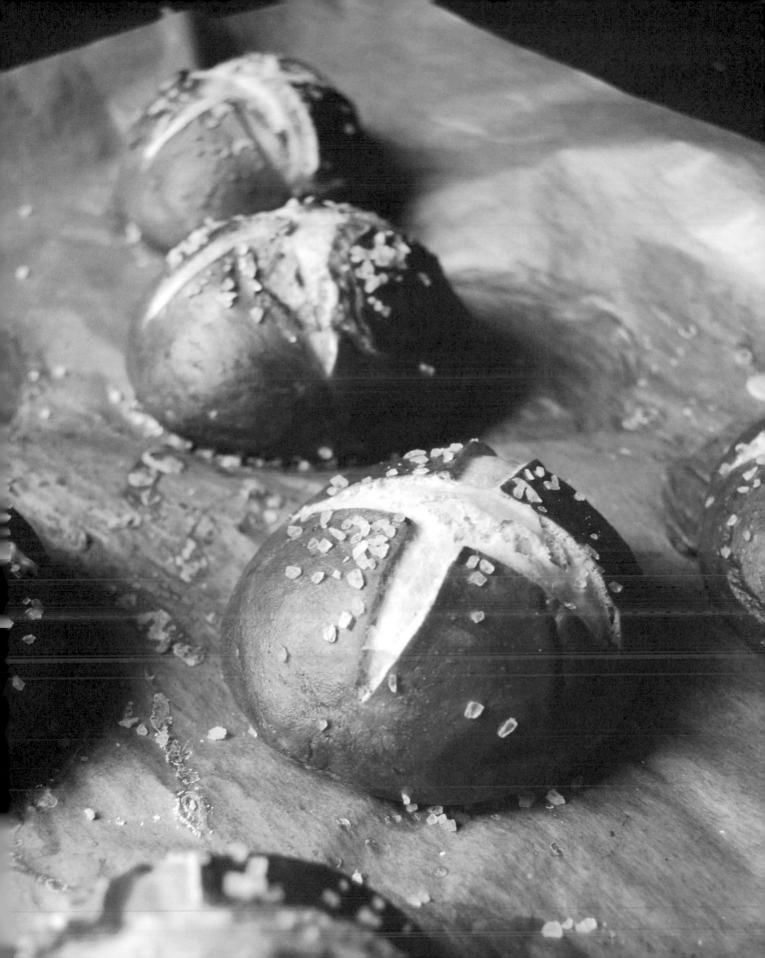

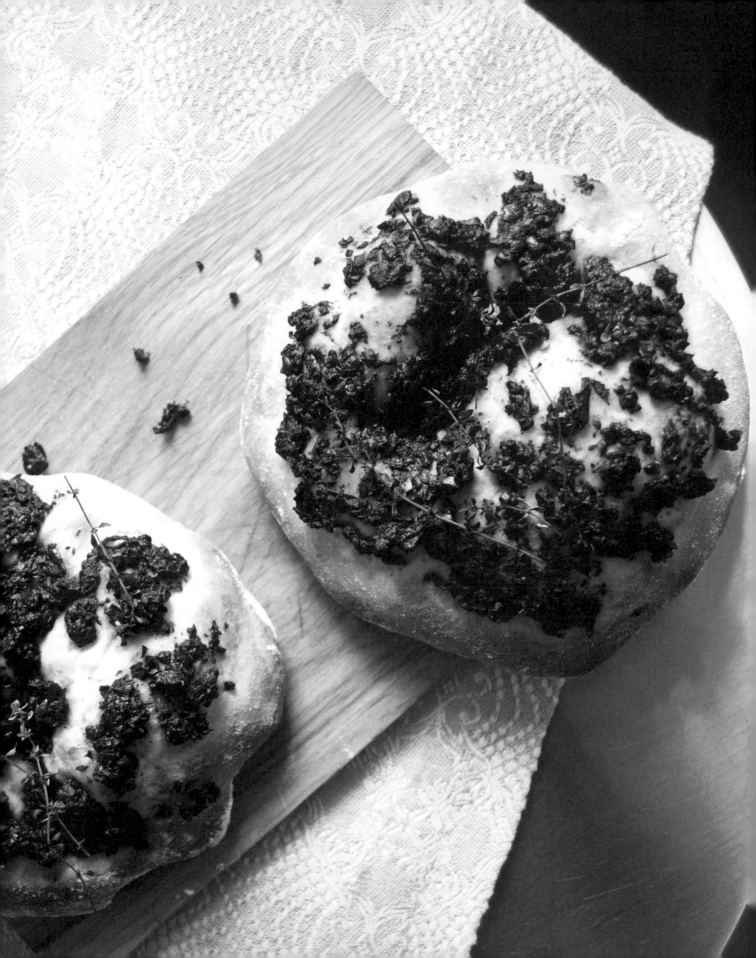

sfincione SICILIAN PIZZA WITH TAPENADE

Thin and crisp makes way for thick and juicy in Sicilian *sfincione*, which is somewhere between pizza and focaccia. The origins of this dish date to the late Baroque period when aristocratic Sicilian families employed French chefs to glamorize their dining rooms, and improve their social status. These chefs, known as *monzu*, derived from the French "monsieur," guaranteed luscious pleasures at the table and gossip in the piazza. When it comes to toppings, I go for a dark Provençal tapenade, made with black olives, capers, and anchovies. The strong summery flavors are the perfect contrast to the mild, almost sweet, yeasted dough. It makes a great treat for picnics.

MAKES 4 SFINCIONE

FOR THE DOUGH

3¾ cups plus 1 tablespoon (500 g) all-purpose flour

1 (¼-ounce / 7-g) envelope fast-acting yeast

½ teaspoon fine sea salt

1 cup (240 ml) whole milk, lukewarm

1 large egg

FOR THE TAPENADE

6 ounces (170 g) pitted black olives, preferably Kalamata

2 tablespoons capers, preferably preserved in salt, rinsed and dried

2 anchovy fillets, rinsed and dried

2 tablespoons olive oil

2 tablespoons brandy (or cognac)

2 tablespoons freshly squeezed lemon juice

1 teaspoon Dijon mustard

Ground pepper

FOR THE TOPPING

16 small sprigs fresh thyme

1 tablespoon roughly chopped fresh rosemary

Olive oil

For the dough, combine the flour, yeast, and salt in a large bowl.

In a medium bowl, whisk together the milk and egg. Add to the flour mixture and mix with the dough hooks of an electric mixer for a few minutes or until well combined. Transfer the dough to a table or countertop and continue kneading and punching it down with your hands for a few minutes or until you have a smooth and elastic ball of dough. Place the dough back in the bowl, cover with a tea towel, and let rise in a warm place, or preferably in a 100°F (35°C) warm oven, for 60 minutes or until almost doubled in size.

Line 1 baking sheet with parchment paper.

When the dough has almost doubled in size, punch it down, and divide it into 4 equal pieces. Stretch each piece into a 6-inch (15 cm) disc and arrange on the lined baking sheet. Cover with a tea towel and let rise for about 20 minutes or until puffy.

Preheat the oven to 475°F (250°C).

For the tapenade, in a food processor, purée the olives, capers, anchovies, olive oil, brandy, lemon juice, and mustard until smooth. Season to taste with pepper.

When the dough is puffy, spread the tapenade evenly on top of the discs of dough. Top with the sprigs of thyme and the chopped rosemary, and bake for about 10 to 12 minutes or until golden brown. Drizzle the sfincione with a little olive oil, and serve warm or cold.

pear and blue cheese tart with rosemary

There are two recipes that I call my very best friends. Both have been with me for many years and created countless moments of utter bliss. The first is the Most Perfect Cinnamon Fruit Crumble Cake (*see page 196*) and the other is this tart with the most buttery, flaky crust. It's as versatile as pizza, so you can use different vegetable and cheese combinations. Filling the pastry with pear wedges, crumbled blue cheese, and rosemary is a minimal take on the recipe. It's an elegant savory tart, great for picnics, brunches, or as a starter for dinner.

I always blind bake my crust, though I have to admit, I often skip the recommended step of lining the dough with dried legumes. Instead, I just prick the dough with a fork to keep it from bubbling up, but the choice is yours.

SERVES 4 TO 8

FOR THE PASTRY

2 cups (260 g) all-purpose flour

1 teaspoon fine sea salt

½ cup plus 1 tablespoon (130 g) unsalted butter, cold

1 large egg

FOR THE TOPPING

2 large, firm pears, cored and cut into thin wedges

3 ounces (85 g) aromatic blue cheese, such as Stilton, Roquefort, Fourme d'Ambert or Gorgonzola, crumbled

3 medium sprigs fresh rosemary, needles only

3 tablespoons olive oil

Flaky sea salt

A few black peppercorns, crushed with a mortar and pestle

For the pastry, combine the flour and salt in a large bowl. Add the butter and use a knife to cut it into the flour until there are just small pieces left. Quickly rub the butter into the flour with your fingers until combined. Add the egg and mix with the dough hooks of an electric mixer until crumbly. Form the dough into a thick disc, wrap it in plastic wrap, and freeze for 10 minutes.

Preheat the oven to 400°F (200°C).

On a table or countertop, place the dough between 2 sheets of plastic wrap and use a rolling pin to roll out into a disc large enough to line the bottom and sides of a 12-inch (30 cm) quiche dish. Fit the dough into the quiche dish, pushing it into the dish, especially along the edges. Let the dough hang over the rim a little or trim with a knife. Use a fork to prick the dough all over. Bake for 15 to 18 minutes or until golden. If the dough bubbles up, push it down with a fork. (If you blind bake the pastry under parchment paper and dried legumes, remove the paper and legumes after 15 minutes and bake uncovered for a few more minutes until golden.)

Arrange the pear wedges in overlapping circles on top of the warm, pre-baked pastry, sprinkle with the cheese and most of the rosemary, drizzle with the olive oil, and season to taste with flaky sea salt and crushed peppercorns. Bake for 15 minutes or until the cheese has melted and the pastry is crisp. Sprinkle with the remaining rosemary and enjoy warm or cold.

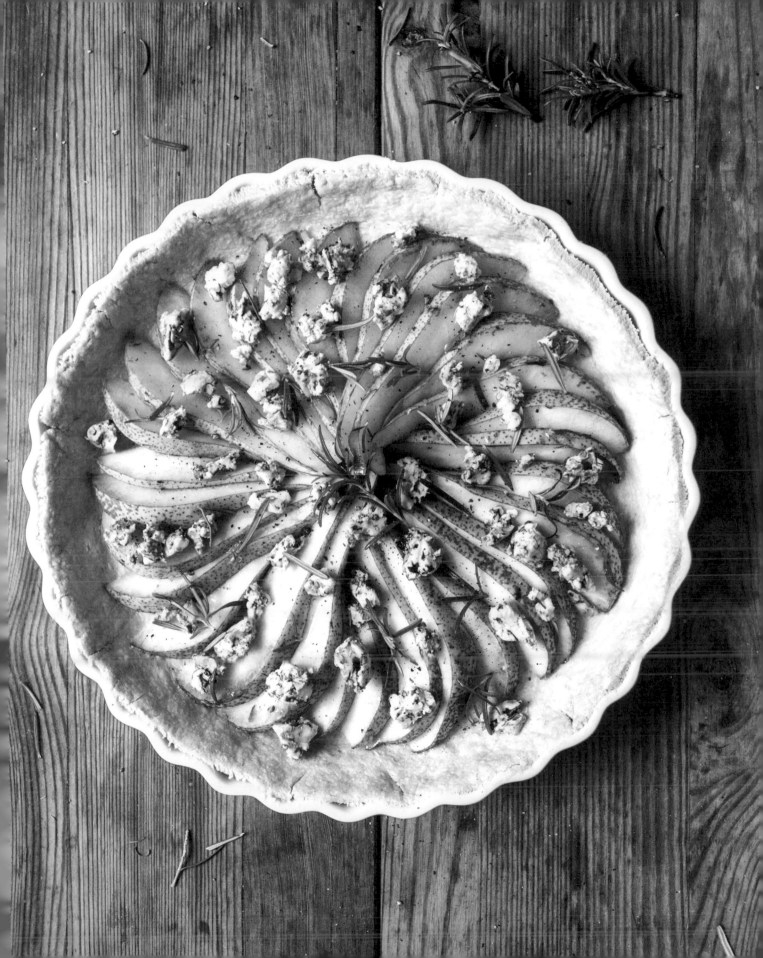

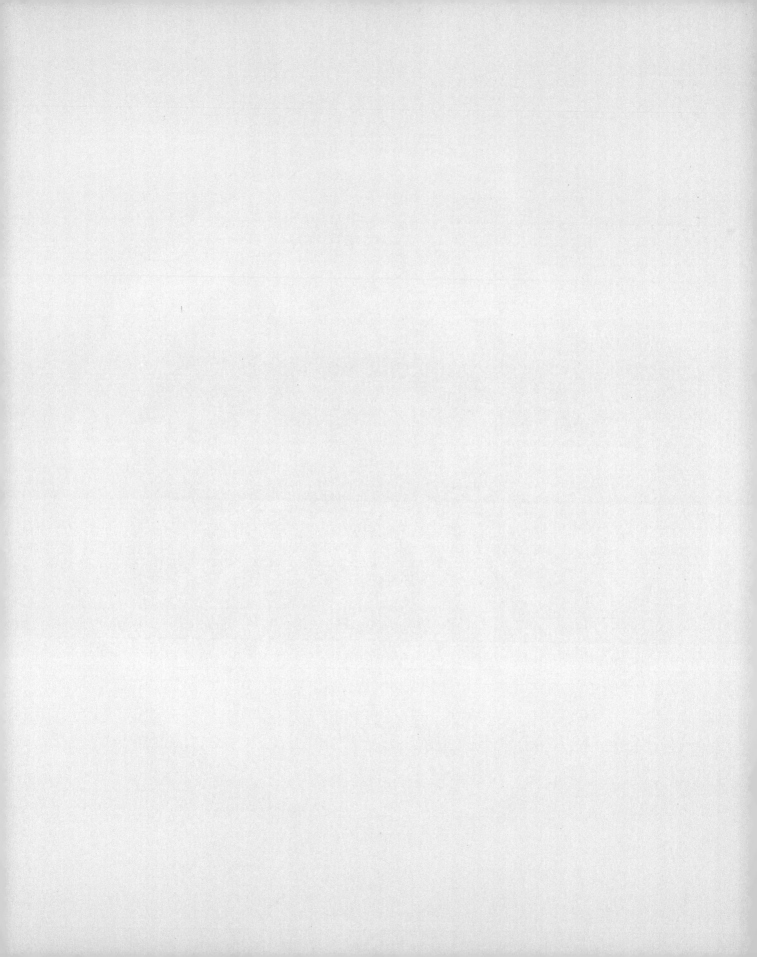

sweets

THE MOST PERFECT CINNAMON
FRUIT CRUMBLE CAKE

LEMON RICOTTA CANNOLI

DONAUWELLE | MARBLED CHERRY
CAKE WITH VANILLA BUTTERCREAM
AND CHOCOLATE

BUTTER BUCHTEL BUNS WITH
CHERRIES AND VANILLA CUSTARD

POLENTA-ALMOND CAKE
WITH ROSEWATER-VANILLA SYRUP

LIME-BUTTERMILK CAKE WITH PISTACHIOS
AND ORANGE BLOSSOM YOGURT

STRAWBERRY AND
RICOTTA OLIVE OIL MUFFINS

FRANKFURTER KRANZ | FRANKFURT
CROWN CAKE

RASPBERRY AND BLUEBERRY TART
WITH BAVARIAN CREAM

LEMON CARDAMOM CRESCENT
MILK ROLLS WITH POPPY SEEDS

BITTERSWEET CHOCOLATE–OLIVE OIL
BUNDT CAKE WITH CANDIED ORANGE PEEL

CARDAMOM KIPFERL CHRISTMAS COOKIES

BLUEBERRY, BUCKWHEAT,
AND HAZELNUT MUFFINS

ELDERFLOWER PANNA COTTA

PUDDINA | JOANNA'S MALTESE
BREAD PUDDING

RIESLING AND RHUBARB CAKE

OTTIJIET | MALTESE SESAME SEED,
CLOVE, AND ANISEED COOKIES

STRAWBERRY-RICOTTA CHEESECAKE
WITH OAT COOKIE CRUST

the most perfect cinnamon fruit crumble cake

I simply adore this cake based on a trusted family recipe. It's a buttery, spongy cake topped with a juicy layer of fruit—I like to use plums, rhubarb, or apples—lying under a delicious finish of cinnamon crumble. This heavenly trilogy has everything—sweet softness, vivid fruit flavor, and crunch—all in one cake.

SERVES 8 TO 12

FOR THE CAKE BASE

½ cup plus 1 tablespoon (125 g) unsalted butter, at room temperature

⅔ cup (125 g) granulated sugar

¼ vanilla bean, split and scraped

3 large eggs

2 cups (260 g) all-purpose flour

2 teaspoons baking powder

⅛ teaspoon fine sea salt

CHOOSE ONE OF THE FRUIT FILLINGS

2¼ pounds (1 kg) pitted plums, cut in half

or 1¾ pounds (800 g) trimmed rhubarb, cut into 1½-inch (4 cm) pieces

or 5 large tart baking apples, peeled, cut in half, and cored, the outside of each apple half-scored lengthwise (5 times)

FOR THE CRUMBLE

1½ cups (200 g) all-purpose flour, plus more as needed

⅔ cup (125 g) granulated sugar

¼ vanilla bean, split and scraped

2 teaspoons ground cinnamon

½ cup plus 1 tablespoon (125 g) unsalted butter, melted, plus more as needed

FOR THE TOPPING

2 teaspoons granulated sugar

⅛ teaspoon ground cinnamon

Preheat the oven to 350°F / 180°C (preferably convection setting). Butter a 10-inch (25.5 cm) springform pan.

For the cake base, in a large bowl, use an electric mixer to beat the butter, sugar, and vanilla seeds for a few minutes or until light and fluffy. Add the eggs, 1 at a time, incorporating each egg before adding the next one, and beat for 2 to 3 minutes or until creamy.

In a medium bowl, whisk together the flour, baking powder, and salt. Add to the butter-sugar mixture and mix with an electric mixer for 1 minute or until well combined. Scrape the batter into the buttered springform pan and arrange the fruit of your choice on top. Plums and rhubarb work best arranged vertically; apples should be arranged scored-side up. Push the fruit gently into the batter.

For the crumble, whisk together the flour, sugar, vanilla seeds, and cinnamon in a large bowl. Add the melted butter and use the dough hooks of an electric mixer to mix just until it forms crumbles. If the crumbles are too moist and sticky, add more flour; if they're too small and don't form large crumbles, add more melted butter. Immediately spread over the fruit, using your fingers to separate any large crumbles.

For the topping, in a small bowl, whisk together the sugar and cinnamon and sprinkle over the crumbles. Bake for about 50 to 60 minutes (slightly longer if using a conventional oven) or until golden on top. If you insert a skewer in the center, it should come out almost clean. Let the cake cool for at least 15 minutes before taking it out of the pan.

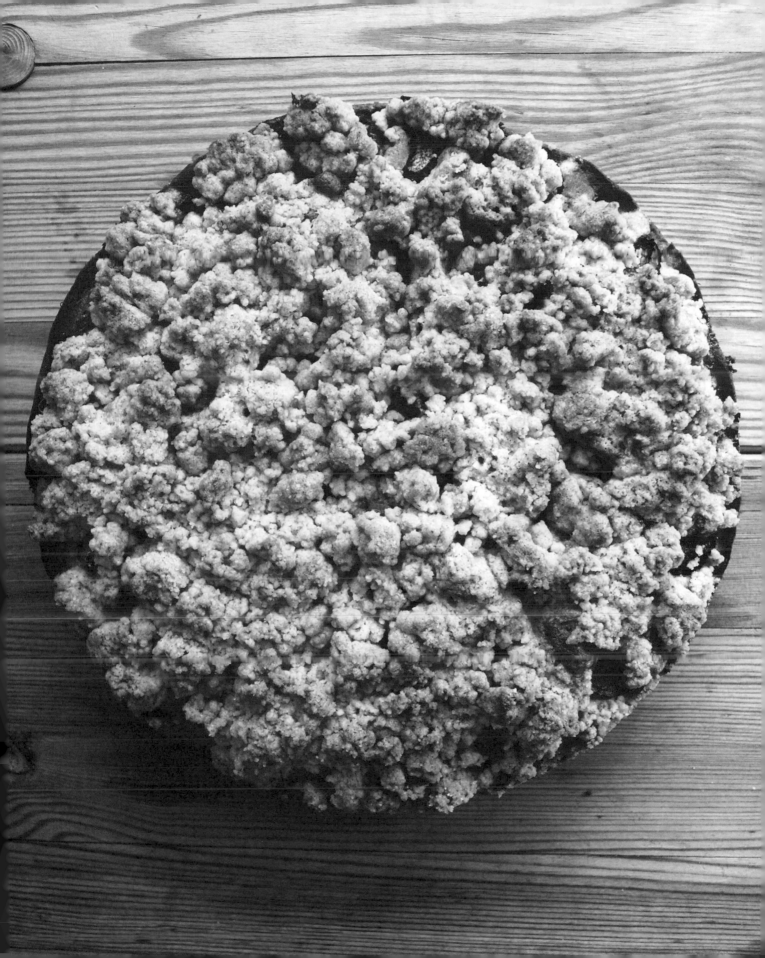

lemon ricotta cannoli

Many of Malta's tempting delicacies are made with ricotta; local bakers use it in buttery, flaky *pastizzi*, hearty *qassatat*, elegant cassata Siciliana, and in cannoli, which becomes *kannoli* on the islands. I love all of them with a huge passion and an even greater appetite. My cannoli are golden crisp, and refined with cinnamon and sweet Moscato wine instead of the usual Marsala. You could buy the cannoli shells ready-made, but it's far more satisfying to fry your own. The stainless steel forms necessary to shape cannoli are easy to find online.

MAKES 20 CANNOLI

FOR THE FILLING

2 ¾ pounds (1.25 kg) fresh ricotta, drained

¾ cup plus 1 tablespoon (160 g) granulated sugar, plus more to taste

1 tablespoon freshly grated lemon zest, plus more to taste

9 ounces (250 g) hazelnuts, chopped

FOR THE CANNOLI HORNS

2½ cups (325 g) all-purpose flour

⅓ cup (65 g) granulated sugar

1½ teaspoons Dutch-process or natural unsweetened cocoa powder

½ teaspoon fine sea salt

¼ teaspoon ground cinnamon

2 tablespoons (30 g) unsalted butter, at room temperature

1 large egg yolk

⅓ cup (75 ml) Moscato (or Marsala or fruity white wine)

⅓ cup (75 ml) water

About 4¼ cups (1 l) sunflower oil, for frying

1 to 2 large egg whites, lightly beaten, to seal the cannoli horns

Use stainless steel cannoli forms to fry the pastry.

For the filling, in a large bowl, whisk together the ricotta, sugar, and lemon zest until fluffy. Add more sugar and lemon zest to taste, cover, and refrigerate.

For the cannoli horns, in a large bowl, whisk together the flour, sugar, cocoa powder, salt, and cinnamon. Add the butter, egg yolk, wine, and water to the flour mixture and use the dough hooks of an electric mixer to mix until soft and elastic—it will be quite sticky. Wrap the dough in plastic wrap and let rest for 30 minutes.

To fry the cannoli, heat the oil in a large, heavy pot over medium-high heat. Use the handle of a wooden spoon to check if the oil is hot enough; bubbles will rise when the temperature is right.

On a well-floured table or countertop, use a rolling pin to roll out the dough very thinly. Use a round cookie cutter or teacup to cut out 20 (5-inch / 13-cm) discs and cover with plastic wrap. Wrap each disc around a cannoli form and lightly brush the overlapping edges with egg wash. Push the edges together. When the oil is hot, carefully place 2 to 3 cannoli horns and their metal tubes in the oil and fry, occasionally turning them with a slotted ladle or spoon, for 1 to 2 minutes or until golden brown. Transfer to paper towels to drain, and let cool for 1 to 2 minutes before removing the metal tubes. Repeat with the remaining dough.

Let the pastry cool completely before filling generously with lemon ricotta. Dip the ends into the chopped hazelnuts and serve immediately.

donauwelle

MARBLED CHERRY CAKE WITH VANILLA BUTTERCREAM AND CHOCOLATE

Food is like music—it preserves memories for the rest of our lives, so that we can recall them at any time. This sweet recollection was brought to life by my granny Lisa, one of the most inspiring women I've ever met. She sparked my deep love for the kitchen and the many magical creations that come from this marvelous space.

Lisa used to make my young childish heart so happy when she baked *Donauwelle*, a sheet cake with marbling that resembles the waves of the Danube River. With a spongy texture, rich vanilla buttercream, juicy cherries, and bittersweet chocolate, this classic German cake is nothing short of heavenly and it's a reminder of where it all started, in the hands and kitchens of our grannies.

SERVES 8 TO 12

FOR THE CAKE

1¼ cups (280 g) unsalted butter, at room temperature

1⅓ cups plus 1 tablespoon (280 g) granulated sugar

½ vanilla bean, split and scraped

4 large eggs

3 cups plus 1 tablespoon (400 g) all-purpose flour

4 teaspoons baking powder

⅛ teaspoon fine sea salt

¾ cup (175 ml) whole milk

2 heaping tablespoons Dutch-process or natural unsweetened cocoa powder

10 ounces (280 g) pitted preserved or fresh cherries

FOR THE BUTTERCREAM

2 cups plus 2 tablespoons (500 ml) whole milk

4 large egg yolks

⅔ cup (125 g) granulated sugar

½ cup (60 g) cornstarch

⅛ teaspoon fine sea salt

1 vanilla bean, split lengthwise

½ cup plus 1 tablespoon (125 g) unsalted butter, at room temperature

FOR THE CHOCOLATE GLAZE

4 ounces (110 g) bittersweet chocolate

1 tablespoon unsalted butter

Preheat the oven to 350°F / 180°C (preferably convection setting). Line a 9 x 11-inch (23 x 28 cm) cake pan with parchment paper.

For the cake, combine the butter, sugar, and vanilla seeds in a large bowl and beat with an electric mixer for a few minutes or until light and fluffy. Add the eggs, 1 at a time, incorporating each egg before adding the next one, and beat for a few minutes or until thick, creamy, and light yellow.

In a separate large bowl, whisk together the flour, baking powder, and salt. With a wooden spoon, fold about ⅓ of the flour mixture gently into the butter-sugar mixture, followed by ⅓ of the milk. Repeat with the remaining flour mixture and milk, folding until just combined. Divide the batter equally between 2 bowls, add the cocoa powder to the batter in 1 bowl, and stir well to combine.

(continued)

Scrape the plain batter into the lined cake pan, spreading it evenly. Pour the cocoa batter on top and spread it evenly. Sprinkle the cherries across the top of the cake and push them gently into the batter. Bake for about 40 to 45 minutes (slightly longer if using a conventional oven) or until a skewer comes out clean when you insert it in the center of the cake. Transfer the cake to a rack and let cool completely.

For the buttercream, in a small bowl, whisk 4 tablespoons of the milk with the egg yolks, sugar, cornstarch, and salt until well combined. In a medium saucepan, bring the remaining milk and the vanilla bean halves to a boil. Take the vanilla out and scrape the seeds from the pod into the milk. Whisking constantly, add the egg yolk mixture to the hot milk and bring to a boil. Take the saucepan off the heat; continue whisking for 2 minutes. Pour into a bowl, place plastic wrap directly on the surface of the pudding, and let cool to room temperature.

In a large bowl, use an electric mixer to beat the butter for 5 minutes or until soft, white, and fluffy.

To make the buttercream, the pudding and the butter both have to be at room temperature. Press the pudding through a fine-mesh sieve into a large bowl. Working in batches, fold the pudding into the butter, mixing well between batches, then use the electric mixer to beat for a few seconds or until creamy and well combined.

For the glaze, melt the chocolate and butter in a saucepan over low heat, whisking until smooth. Let cool while you spread the buttercream evenly over the cake. Drizzle with melted chocolate. When the chocolate glaze is set, cut the cake into squares.

Serve the cake at room temperature, but keep it in the refrigerator—it's best on the first or second day.

butter buchtel buns
with cherries and vanilla custard

A recipe that suits breakfast, lunch, teatime, and dessert—maybe even dinner—is a good recipe in my eyes. And when it comes to sweet and cozy comfort treats, traditional German *Buchteln*, also known as *Ofennudeln* or *Rohrnudeln*, are at the top of my list. In my version, these fragrant and buttery yeast rolls are enriched with dark red cherries and topped decadently with thick vanilla custard.

MAKES 8 BUNS

FOR THE BUCHTELN

3 cups plus 1 tablespoon (400 g) all-purpose flour

⅓ cup (60 g) granulated sugar

1 (¼-ounce / 7-g) envelope fast-acting yeast

¼ vanilla bean, split and scraped

1 teaspoon freshly grated orange zest

¼ teaspoon fine sea salt

½ cup (120 ml) whole milk, lukewarm

¾ cup (170 g) unsalted butter, melted and cooled

2 large eggs

16 to 24 pitted preserved or fresh cherries

4 to 6 sugar cubes, cut into quarters

FOR THE VANILLA CUSTARD

2 cups plus 2 tablespoons (500 ml) whole milk

4 large egg yolks

½ cup (100 g) granulated sugar

¼ cup (30 g) cornstarch

⅛ teaspoon fine sea salt

1 vanilla bean, split lengthwise

FOR THE TOPPING

1 tablespoon unsalted butter

Confectioners' sugar

For the buchteln, in a large bowl, whisk together the flour, sugar, yeast, vanilla seeds, orange zest, and salt.

In a medium bowl, whisk together the milk, half the melted butter, and the eggs—the mixture should be lukewarm. Add the milk-butter mixture to the dry mixture and mix with the dough hooks of an electric mixer for a few minutes or until well combined. Transfer the dough to a table or countertop and continue kneading with your hands for a few minutes or until you have a soft and silky ball of dough. Place the dough back in the bowl, cover with a tea towel, and let rise in a warm place, or preferably in a 100°F (35°C) warm oven, for 70 minutes or until doubled in size.

When the dough has doubled in size, punch it down, take it out of the bowl, and knead for about 30 seconds. Divide the dough into 8 equal portions and use your hands to roll each one into a smooth ball.

Fill each cherry with a quarter of a sugar cube. Use your thumb to make a hole in each ball of dough and stuff 2 to 3 cherries inside. Use your fingers to squeeze the dough together to close the bun and seal the cherries tightly inside.

(continued)

Brush a 7 x 2½-inch (18 x 6 cm) round baking dish with 3 tablespoons of the melted butter. Turn the buns in the remaining melted butter and tuck them, fold-side facing down, next to each other in the baking dish. If there is any melted butter left, pour it over the buns, cover with a tea towel, and let rise in a warm place for 15 to 20 minutes or until puffy.

Preheat the oven to 350°F / 180°C (preferably convection setting).

Bake the buns for about 30 minutes (slightly longer if using a conventional oven) or until golden brown. If you insert a skewer in the buns, it should come out clean.

While the buns are baking, make the custard: In a small bowl, whisk 4 tablespoons of the milk with the egg yolks, sugar, cornstarch, and salt until well combined. In a medium saucepan, bring the remaining milk and the vanilla bean halves to a boil. Take the vanilla out and scrape the seeds from the pod into the milk. Whisking constantly, add the egg yolk mixture to the hot milk and bring to a boil. Take the saucepan off the heat; continue whisking for 2 minutes.

For the topping, rub the warm buns with the butter, let cool for a few minutes, then dust with confectioners' sugar, and serve with the warm vanilla custard.

polenta-almond cake with rosewater-vanilla syrup

Sugared roses turn this innocent-looking cake into a flamboyant beauty. I'm not a big cake decorator—I'm normally more of a plain cake kind of girl—but here, the roses struck me. This polenta-almond cake, richly soaked with rosewater-vanilla syrup, doesn't need to be dressed extravagantly like a dramatic diva. It's quite a simple cake, delicious as a nibble for breakfast, a little snack at tea time, and of course, as a fragrant dessert.

SERVES 6 TO 8

FOR THE SUGARED ROSES

2 to 3 edible roses

1 very fresh large egg white, beaten

2 to 3 tablespoons granulated sugar

FOR THE SYRUP

⅓ cup plus 2 tablespoons (110 ml) freshly squeezed orange juice

2½ tablespoons honey

¼ vanilla bean, split lengthwise

1 to 3 teaspoons high-quality rosewater, preferably organic

FOR THE CAKE

2 cups plus 2 tablespoons (250 g) ground skin-on almonds

¾ cup (120 g) fine polenta

2½ teaspoons baking powder

⅛ teaspoon fine sea salt

¾ cup plus 2 tablespoons (200 g) unsalted butter, at room temperature

1 cup (200 g) granulated sugar

1 tablespoon freshly grated orange zest

1 tablespoon high-quality rosewater, preferably organic

4 large eggs, lightly beaten

For the sugared roses, pull the petals off 1 to 2 roses (reserve 1 flower for decoration) and brush the top of each petal with a thin layer of beaten egg white. Sprinkle with sugar and let dry on a wire rack for at least 2 hours or overnight.

For the syrup, in a small saucepan, bring the orange juice, honey, and vanilla bean halves to a boil. Reduce the heat to medium-high and cook, uncovered, for 5 minutes. Take the vanilla bean out and scrape the seeds from the pod into the juice mixture. Add 1 teaspoon of the rosewater, stir, and add more to taste; set aside.

Preheat the oven to 350°F / 180°C (preferably convection setting). Butter an 8-inch (20 cm) springform pan.

In a medium bowl, whisk together the ground almonds, polenta, baking powder, and salt.

In a large bowl, use an electric mixer to beat the butter, sugar, orange zest, and rosewater for a few minutes or until light and fluffy. Use an electric mixer to beat about ⅓ of the almond-polenta mixture into the butter mixture, followed by ⅓ of the beaten eggs, mixing well in between. Repeat with the remaining almond-polenta mixture and the eggs, mixing until well combined. Spread the batter evenly in the prepared pan and bake for about 45 minutes (slightly longer if using a conventional oven) or until golden brown and firm on top. If you insert a skewer in the center of the cake, it should come out almost clean. While the cake is still warm, prick the top all over with a skewer. Pour the syrup over the warm cake, let cool for 10 minutes, then take it out of the pan. Decorate the cooled cake with the sugared petals and the reserved rose just before serving.

lime-buttermilk cake with pistachios and orange blossom yogurt

When a simple buttermilk loaf meets crunchy pistachios and yogurt whipped with honey and orange blossom water, it tastes like sweet perfection. This cake is refined with a soft hint of flowery lime and offers a burst of juicy citrus in a soft sponge. It's a bite of bliss and goes beyond a simple breakfast treat. With its fine aromas, it would, by no means, be out of place on the Sunday coffee table.

SERVES 4 TO 6

FOR THE CAKE

1½ cups plus 2 tablespoons (210 g) all-purpose flour

½ cup plus 2 tablespoons (70 g) cornstarch

1 tablespoon baking powder

¼ teaspoon fine sea salt

¾ cup plus 1 tablespoon (180 g) unsalted butter, at room temperature

¾ cup plus 2 tablespoons (180 g) granulated sugar

3 large eggs

1½ teaspoons freshly grated lime zest

2 tablespoons freshly grated lemon zest

3 tablespoons freshly squeezed lemon juice

⅓ cup plus 1 tablespoon (90 ml) buttermilk

FOR THE TOPPING

3 tablespoons freshly squeezed lemon juice

2 tablespoons confectioners' sugar

1 small handful unsalted pistachios, chopped

FOR THE ORANGE BLOSSOM YOGURT

7 ounces (200 g) Greek yogurt

1 tablespoon honey, plus more to taste

2 teaspoons high-quality orange blossom water, preferably organic

Preheat the oven to 325°F / 160°C (preferably convection setting). Butter a 9 x 4-inch (23 x 10 cm) loaf pan.

For the cake, in a large bowl, whisk together the flour, cornstarch, baking powder, and salt. In a second large bowl, use an electric mixer to beat the butter and sugar for a few minutes or until light and fluffy. Add the eggs, 1 at a time, incorporating each egg before adding the next one, and beat for 2 to 3 minutes or until light and creamy. Add the lime zest, lemon zest, and lemon juice and beat for 1 minute. With a wooden spoon, fold about ⅓ of the flour mixture gently into the batter, followed by ⅓ of the buttermilk. Repeat with the remaining flour mixture and buttermilk, folding just until combined. Pour the batter into the prepared pan and bake for about 50 minutes (slightly longer if using a conventional oven) or until golden on top. If you insert a skewer in the center of the cake, it should come out clean. Let the cake cool in the pan for a few minutes before turning it out onto a wire rack.

For the topping, whisk together the lemon juice and confectioners' sugar until combined. Prick the warm cake all over with a skewer and slowly pour the lemon syrup over the top. Sprinkle with the pistachios.

For the orange blossom yogurt, whisk together the yogurt, honey, and 1 teaspoon of the orange blossom water. Add more orange blossom water and honey to taste and serve with the warm cake.

strawberry and ricotta olive oil muffins

The flowery sweetness of strawberries deserves a special muffin, a Mediterranean mélange of creamy ricotta, mild olive oil, and freshly squeezed orange juice. Blackberries or blueberries would also fit, or a mix of all three. Imagine all the glowing shades of red and blue, from dark purple to light pink, stirred into the muffins' fair fluffiness. But we can also keep it simple: The elegant flavor of honey-sweet, ripe strawberries makes these muffins irresistible. It's the pure taste of summer, treated respectfully with a modest use of sugar.

This is a perfect Sunday morning muffin, broken into warm, fragrant chunks and spread with a little butter to slowly melt into the tender sponge. Not very cake-like, these muffins are more on the rustic side. They're just right for breakfast and definitely a good start to the day.

MAKES 12 MUFFINS

2½ cups (320 g) all-purpose flour

½ cup plus 1 heaping tablespoon (115 g) granulated sugar

1 tablespoon baking powder

½ teaspoon baking soda

¼ teaspoon fine sea salt

7 ounces (200 g) hulled ripe strawberries, cut into chunks

9 ounces (250 g) fresh ricotta

2 large eggs

⅓ cup plus 2 tablespoons (100 ml) mild olive oil

2 tablespoons freshly squeezed orange juice

FOR THE TOPPING

Honey or granulated sugar

12 paper muffin pan liners

Preheat the oven to 375°F / 190°C (preferably convection setting). Line a 12-cup muffin pan with paper liners.

In a large bowl, whisk together the flour, sugar, baking powder, baking soda, and salt. Take 1 heaping tablespoon of the flour mixture and toss it gently with the strawberries.

In a second large bowl, whisk together the ricotta, eggs, olive oil, and orange juice until light and fluffy. Add to the flour mixture and stir with a wooden spoon until the batter is lumpy with a few bits of flour here and there. Gently fold in the floured strawberries—mind that if you mix too much, the muffins will lose their light texture.

Spoon the batter into the muffin cups and drizzle a little honey over the tops or sprinkle with sugar. Bake for about 18 minutes (slightly longer if using a conventional oven) or until golden and baked through—mind that the strawberries will make the muffins very juicy. Take the muffins out of the pan and let them cool on a wire rack for 2 minutes before serving.

frankfurter kranz FRANKFURT CROWN CAKE

The famous German Frankfurt Crown Cake, also known as *Frankfurter Kranz*, is the queen of German buttercream cakes and my grandmother Annie was a master at baking it. This four-layer sponge cake is voluptuously filled with buttercream enriched with vanilla pudding. Sprinkled with caramelized hazelnuts, this luxurious delicacy combines smooth creaminess with nutty bittersweet crunch. It may be hard to believe, but the cake is best on the third day.

SERVES 12

FOR THE SPONGE CAKE

Dry breadcrumbs, for sprinkling the Bundt pan

¾ cup plus 2 tablespoons (200 g) unsalted butter, at room temperature

1 cup plus 2 tablespoons (225 g) granulated sugar

¼ vanilla bean, split and scraped

6 large eggs

1½ cups (200 g) all-purpose flour, sifted

¾ cup plus 1 tablespoon (100 g) cornstarch

1 tablespoon baking powder

⅛ teaspoon fine sea salt

FOR THE BUTTERCREAM

2 cups plus 2 tablespoons (500 ml) whole milk

4 large egg yolks

⅔ cup (125 g) granulated sugar

½ cup (60 g) cornstarch

⅛ teaspoon fine sea salt

1 vanilla bean, split lengthwise

1 cup plus 2 tablespoons (250 g) unsalted butter, at room temperature

FOR THE CARAMELIZED HAZELNUTS

7 ounces (200 g) hazelnuts, finely chopped

½ cup (100 g) granulated sugar

2 tablespoons (30 g) unsalted butter

Preheat the oven to 350°F (180°C). Butter a 10-cup (2.4 l) Bundt pan and sprinkle generously with breadcrumbs.

For the sponge cake, use an electric mixer to beat the butter, sugar, and vanilla seeds in a large bowl until fluffy. Add the eggs, 1 at a time, incorporating each egg before adding the next one, and continue beating for a few minutes or until thick, creamy, and light yellow.

In a second large bowl, whisk together the flour, cornstarch, baking powder, and salt. Working in batches, add to the butter-sugar mixture and fold gently with a wooden spoon until combined. Scrape the batter into the prepared Bundt pan and bake for about 45 minutes or until golden. If you insert a skewer in the middle of the cake it should come out clean. Let the cake cool for 10 minutes before turning out onto a wire rack to cool completely. When the cake has cooled off, slice it horizontally 3 times, into 4 layers.

For the buttercream, in a small bowl, whisk 4 tablespoons of the milk with the egg yolks, sugar, cornstarch, and salt until well combined. In a medium saucepan, bring the remaining milk and the vanilla bean halves to a boil. Take the vanilla out and scrape the seeds from the pod into the milk. Whisking constantly, add the egg yolk mixture to the hot milk and bring to a boil. Take the saucepan off the heat; continue whisking for 2 minutes. Pour into a bowl, place plastic wrap directly on the surface of the pudding, and let cool to room temperature.

(continued)

In a large bowl, use an electric mixer to beat the butter for 5 minutes or until soft, white, and fluffy.

To make the buttercream, the pudding and the butter both have to be at room temperature. Press the pudding through a fine-mesh sieve into a large bowl. Working in batches, fold the pudding into the butter, mixing well in between, then use the electric mixer to beat for a few seconds or until creamy and well combined.

For the nut topping, in a large, heavy pan, combine the hazelnuts, sugar, and butter over medium-high heat and cook, stirring constantly, for about 5 minutes or until the nuts are golden brown and caramelized—mind that they don't burn. Take the pan off the heat, spread the nuts on a sheet of parchment paper, and let cool completely then break into small crumbles.

To assemble the Frankfurter Kranz, reserve a little more than ⅓ of the buttercream and set it aside. Spread ⅓ of the remaining buttercream on the bottom cake layer. Repeat to make 2 more layers then top with the remaining cake layer. Spread the reserved buttercream all over the top and sides of the cake and sprinkle with the caramelized nuts on all sides. Serve the cake at room temperature, but keep it in the refrigerator—it's best on the second or third day.

raspberry and blueberry tart with bavarian cream

A picnic in the soft hills of southern France—imagine a blossoming picture book-like scene of roses, jasmine, and lavender behind ancient stone walls—was the inspiration for this gorgeous little tart. On a family holiday in Grasse, with my aunt and uncle, I encountered the prettiest fruit tart baked by a lovely French lady. I've never let go of the image in my mind of colorful berries artfully arranged on thin pastry. This vivid memory called for a remake. My version features a delicate short-crust pastry, layered with fluffy, vanilla-scented Bavarian cream, and with sweet raspberries and blueberries lying gracefully on top.

SERVES 12 TO 16 (MAKES 2 TARTS)

FOR THE BAVARIAN CREAM

1 large egg plus 2 large egg yolks

⅓ cup plus 1 tablespoon (80 g) granulated sugar

⅛ teaspoon fine sea salt

2 (3 x 4-inch / 7 x 11-cm) gelatin sheets (or 2 teaspoons powdered gelatin)

1 cup (240 ml) whole milk

½ vanilla bean, split lengthwise

1 cup (240 ml) heavy cream, whipped (stiff peaks)

FOR THE PASTRY

3 cups (390 g) all-purpose flour

½ cup (100 g) granulated sugar

¼ teaspoon fine sea salt

¾ cup plus 2 tablespoons (200 g) unsalted butter, cold

3 large egg yolks

2 tablespoons water, cold

FOR THE TOPPING

7 ounces (200 g) fresh blueberries

4 ounces (110 g) fresh raspberries

For the Bavarian cream, use an electric mixer to beat the egg, egg yolks, sugar, and salt in a large bowl for a few minutes or until thick and creamy.

Soak the gelatin sheets in cold water for 5 minutes.

In a large saucepan, bring the milk and vanilla bean halves to a boil. Take the pan off the heat, remove the vanilla, and scrape the seeds from the pod into the milk. Gradually whisk about half of the hot milk into the egg mixture then gradually pour the mixture back into the saucepan, whisking constantly. Place the pan over medium-low heat and cook, whisking constantly, for about 5 to 7 minutes or until thick enough to coat the back of a spoon. Transfer to a large bowl.

Squeeze the excess water from the soaked gelatin sheets, crumble into the warm custard, and whisk thoroughly. Let the custard cool to room temperature, whisking occasionally, then gently fold in the whipped cream. Cover and refrigerate for at least 1 hour or until the Bavarian cream is almost set.

For the pastry, combine the flour, sugar, and salt in a large bowl. Add the butter and use a knife to cut it into the flour until there are just small pieces left. Quickly rub the butter into the flour with your fingers until combined. Add the egg yolks and water and mix with the

(continued)

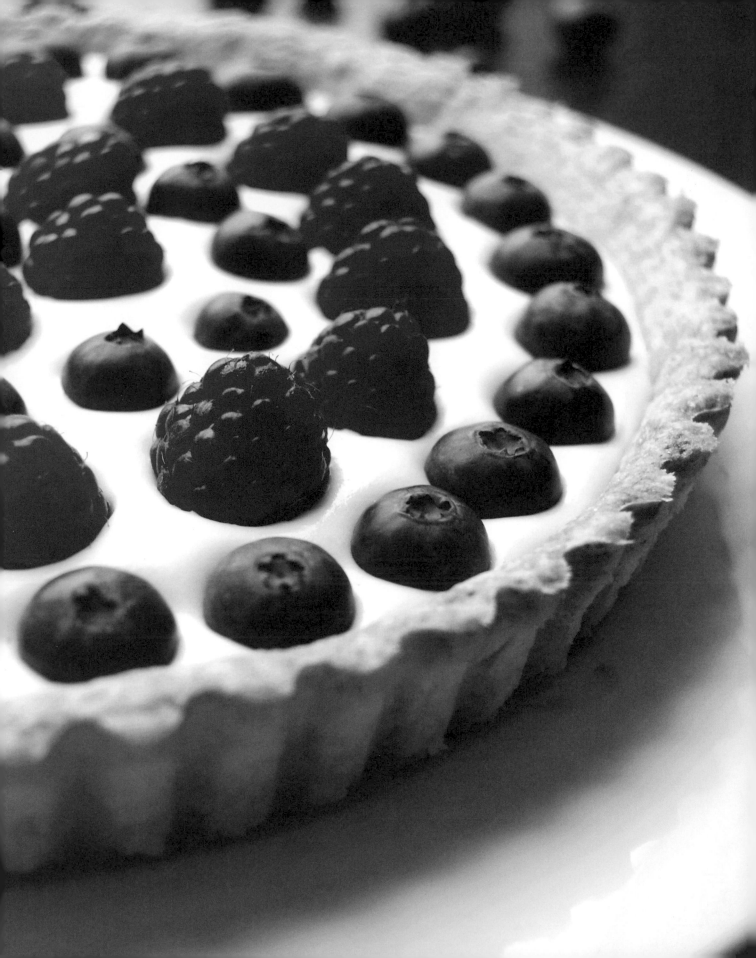

dough hooks of an electric mixer until crumbly. Form the dough into 2 thick discs, wrap in plastic wrap, and freeze for 20 minutes.

Preheat the oven to 400°F (200°C).

On a table or countertop, place 1 disc of dough between 2 sheets of plastic wrap and use a rolling pin to roll out into a disc, large enough to line the bottom and sides of a 9-inch / 22.5 cm (preferably loose-bottom) tart pan. Fit the dough into the tart pan, pushing it into the pan, especially along the edges. Trim any excess dough off the rim with a knife then prick the dough in the pan all over with a fork. Repeat with the other disc of dough and a second tart pan. Bake for about 20 minutes or until crisp and golden. If the pastry bubbles up, push it down with a fork. (If you blind-bake the pastry under parchment paper and dried legumes, remove the paper and legumes after 20 minutes and bake uncovered for a few more minutes until golden.) Let the tart shells cool completely then carefully take them out of their pans.

To assemble the tarts, divide the Bavarian cream between the pastry shells and spread it out evenly. Arrange the berries in concentric circles on top and serve immediately. The tart tastes and looks best when freshly assembled. The pastry shells can be made ahead and kept in an airtight container for 1 to 2 days; the cream can be prepared and kept in the refrigerator for 1 day until you're ready to assemble the tarts.

lemon cardamom crescent milk rolls with poppy seeds

As soon as these puffy golden yeast rolls leave the oven, they fill the kitchen with the sweetest smell of butter, cardamom, and citrus. Soft crescent milk rolls are a classic German breakfast treat, made even more tempting with sweet lemon-cardamom butter.

MAKES 10 CRESCENT ROLLS

FOR THE DOUGH

3¾ cups plus 1 tablespoon (500 g) all-purpose flour

3 tablespoons granulated sugar

1 (¼-ounce / 7-g) envelope fast-acting yeast

1 teaspoon fine sea salt

¾ cup plus 3 tablespoons (220 ml) whole milk, lukewarm

3 tablespoons (40 g) unsalted butter, melted and cooled

1 large egg

FOR THE FILLING

½ cup plus 1 tablespoon (125 g) unsalted butter, at room temperature

2 tablespoons freshly grated lemon zest

1 tablespoon granulated sugar

1 teaspoon ground cardamom

FOR THE TOPPING

1 large egg yolk

1 tablespoon water

2 to 3 tablespoons poppy seeds

For the dough, in a large bowl, whisk together the flour, sugar, yeast, and salt. In a medium bowl, whisk together the milk, butter, and egg—the mixture should be lukewarm. Add to the flour mixture and use the dough hooks of an electric mixer to mix for a few minutes or until well combined. Transfer the dough to a work surface and continue kneading it with your hands for a few minutes or until you have a soft and silky ball of dough. Place the dough back in the bowl, cover with a tea towel, and let rise in a warm place, or preferably in a 100°F (35°C) warm oven, for 70 minutes or until doubled in size.

For the filling, in a large bowl, use an electric mixer to beat the butter, lemon zest, sugar, and cardamom until fluffy. Line 2 baking sheets with parchment paper.

When the dough has doubled in size, punch it down, take it out of the bowl, and knead for about 30 seconds. Divide the dough into 10 equal (roughly 3-ounce / 85-g) portions and use your hands to roll each portion into a smooth ball. Lightly flour a work surface and use a rolling pin to roll out each portion into an 8-inch-long (20 cm) triangle shape, about 4 inches wide (10 cm) at the base. Spread a thin layer of the lemon-cardamom butter onto each triangle then, starting at the base, roll each triangle up toward its tip. Bend the rolls into crescent shapes; make sure the pointy tip of the triangle is tucked underneath, so the rolls don't open while baking. Arrange the rolls on the lined baking sheets, cover with a tea towel, and let rise in a warm place for 20 minutes. Reserve the remaining cardamom butter for serving.

Preheat the oven to 425°F (220°C). For the topping, whisk together the egg yolk and water and brush onto the tops of the crescent milk rolls. Sprinkle generously with poppy seeds and bake, 1 sheet at a time, for about 11 minutes or until golden. Serve with the reserved butter. The rolls taste best on the first day.

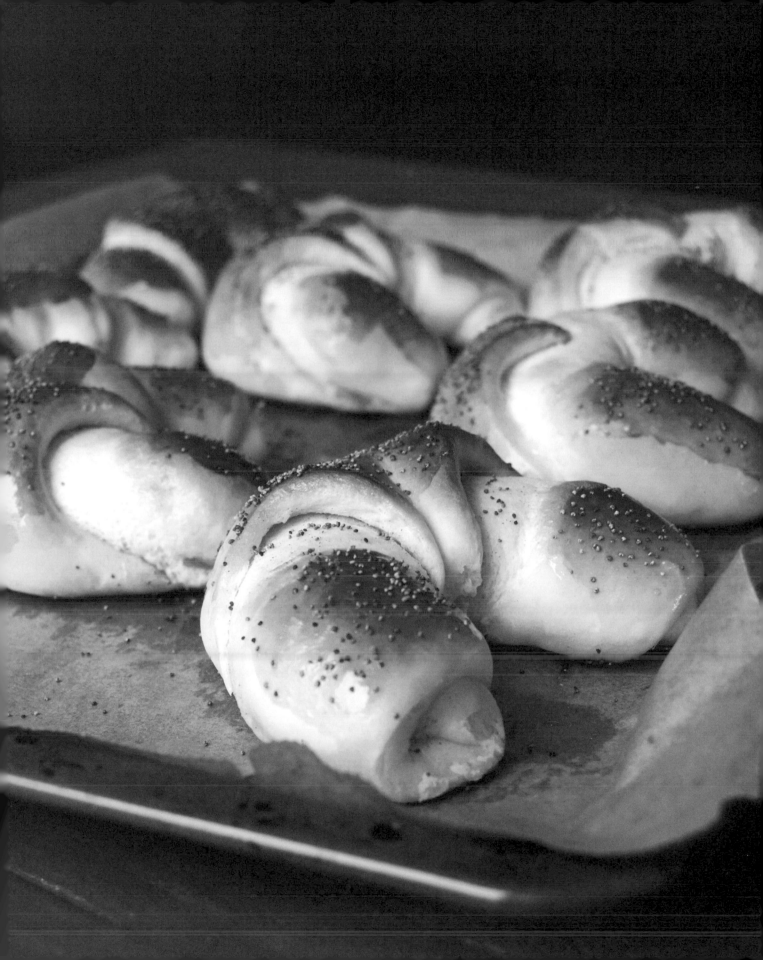

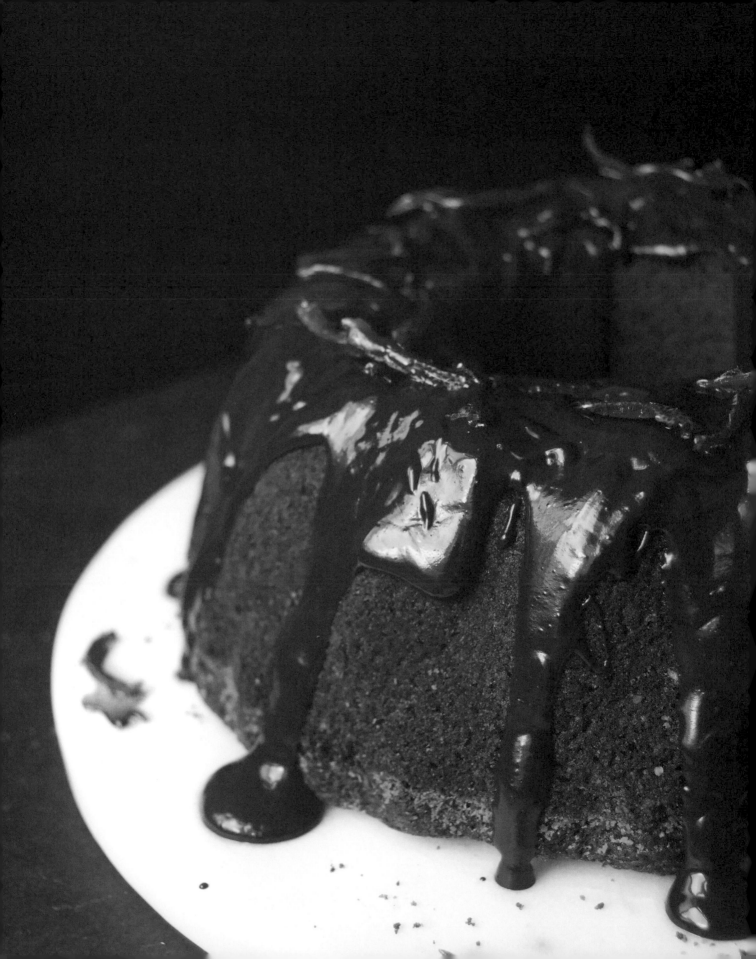

bittersweet chocolate–olive oil bundt cake with candied orange peel

I wouldn't call myself a chocolate addict, but every once in a while, I need a cake with deep bittersweet flavor. This one isn't particularly fudgy, but it has the sponginess of a Bundt cake and that's what catches my attention. Olive oil instead of butter makes this cake fragrant and moist, while candied orange peel brings fruity notes. A dark and voluptuously thick glaze slowly running down the sides satisfies the most serious chocolate cravings.

SERVES 8 TO 12

Dry breadcrumbs, for sprinkling the Bundt pan

2 cups (260 g) all-purpose flour

1 cup (200 g) granulated sugar

1 tablespoon baking powder

1 teaspoon baking soda

⅛ teaspoon fine sea salt

5 ounces (140 g) bittersweet chocolate

⅔ cup (155 ml) olive oil

5 large eggs

3½ tablespoons (50 ml) whole milk

1 tablespoon freshly grated orange zest

3½ tablespoons (50 ml) freshly squeezed orange juice

FOR THE CHOCOLATE GLAZE

5 ounces (140 g) bittersweet chocolate

1 tablespoon (15 g) unsalted butter

1 to 2 teaspoons sunflower oil

FOR THE CANDIED ORANGE PEEL

¼ cup (50 g) granulated sugar

2 tablespoons water

1 small handful very thin strips of fresh orange peel

Preheat the oven to 350°F / 180°C (preferably convection setting). Butter a 7½-cup (1.75 l) Bundt pan and sprinkle generously with breadcrumbs.

In a large bowl, whisk together the flour, sugar, baking powder, baking soda, and salt.

In a large heat-proof bowl set over a saucepan of barely simmering water, melt the chocolate. Let cool for a few minutes then add the olive oil, eggs, milk, orange zest, and orange juice, and beat with an electric mixer for 2 minutes or until smooth. Add to the flour mixture and quickly mix with an electric mixer for 1 minute or until well combined. Pour the batter into the prepared Bundt pan and bake for about 35 to 40 minutes (slightly longer if using a conventional oven) or until golden brown and firm on top. If you insert a skewer into the cake, it should come out clean. Let cool for a few minutes then shake the Bundt pan a little and turn the cake out onto a plate. Let cool completely. Trim the bottom of the cake to even it out.

For the chocolate glaze, melt the chocolate and butter in a saucepan over low heat. Add 1 to 2 teaspoons of vegetable oil and whisk until smooth. Pour the glaze over the cooled cake, evening it out with a knife or leaving it in voluptuous drops.

For the candied orange peel, in a small saucepan, bring the sugar and water to a boil. When it starts to caramelize add the orange peel. Reduce the heat to medium and cook for 3 to 4 minutes or until the peel is golden and soft—mind that it doesn't burn. While the caramel is still liquid, quickly transfer the candied peel to a piece of parchment paper. Let cool for 1 minute then peel it off the paper and decorate the cake while the glaze is soft.

cardamom kipferl christmas cookies

This promise is easy to keep: Your kitchen will smell like a bakery at Christmas as soon as you take the first batch of these light and crumbly crescents out of the oven. Kipferl are traditional southern German Christmas cookies. The classic version is made with vanilla, but I use aromatic cardamom instead. They make a pretty appearance on a festive teatime table if they make it there—I tend to nibble them by the dozen right off the baking sheet.

MAKES ABOUT 55 KIPFERL

2 cups plus 2 tablespoons (275 g) all-purpose flour

1 cup (110 g) ground hazelnuts (or almonds)

⅓ cup (65 g) granulated sugar

⅛ teaspoon fine sea salt

¾ cup plus 2 tablespoons (200 g) unsalted butter, cold

1 cup (100 g) confectioners' sugar, for dusting

About 2 teaspoons ground cardamom, for dusting

In a large bowl, whisk together the flour, hazelnuts, granulated sugar, and salt. Add the butter and use a knife to cut it into the flour until there are just small pieces left. Quickly rub the butter into the flour with your fingers until combined then mix with the dough hooks of an electric mixer until crumbly. Form the dough into a 1¼-inch-thick (3 cm) disc, wrap in plastic wrap, and refrigerate for at least 40 minutes, or freeze for 10 minutes.

Preheat the oven to 350°F / 180°C (preferably convection setting). Line 3 baking sheets with parchment paper.

Sift the confectioners' sugar with 1 to 2 teaspoons of the cardamom. Add more cardamom to taste. Sift about ⅓ of the mixture onto a large plate or serving platter. Reserve the rest.

Take the dough out of the refrigerator and cut off a 1-inch-thick (2.5 cm) slice. Place the remaining dough back in the refrigerator. Cut the slice into ½-inch (1.25 cm) pieces. Use your hands to quickly roll each piece into a ball then shape it into a 3½-inch-long (9 cm) kipferl, bending it slightly into a crescent. If the ends are too thin and pointy, they'll burn in the oven, so cut them off. Continue shaping the remaining dough, arranging the kipferl generously spaced on the lined baking sheets. Bake, 1 sheet at a time, for about 11 to 12 minutes (slightly longer if using a conventional oven) or until golden. Let the cookies cool on the baking sheet for 1 to 2 minutes. When they are still warm but firm enough to be moved, carefully place them on the plate with the cardamom sugar. Sift a generous amount of cardamom sugar over the cookies—they should be covered on all sides. Repeat with the remaining kipferl. If you want each kipferl to look perfect, arrange them in a single layer for dusting and storage. Otherwise, lay the kipferl on top of each other and dust with cardamom sugar.

Once the kipferl are completely cool, store in airtight containers for up to 1 week.

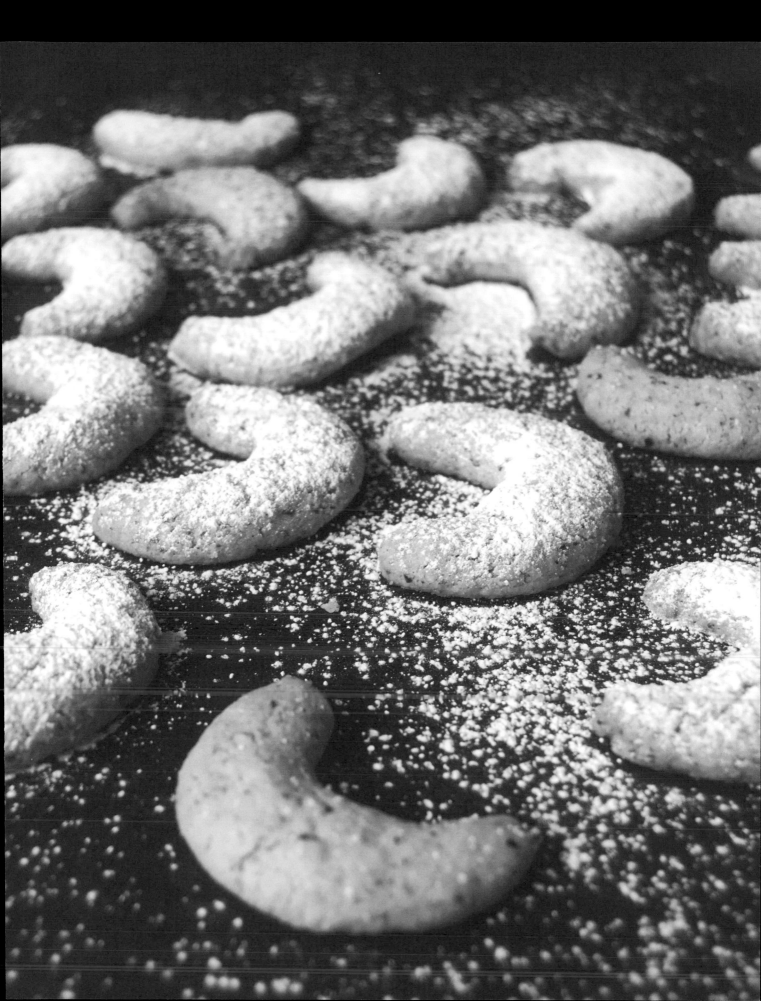

blueberry, buckwheat, and hazelnut muffins

Ground hazelnuts and nutty buckwheat replace wheat flour in this recipe, and turn these muffins into a gluten-free treat. The warmth of cinnamon merged with sweet juicy blueberries creates the most beautiful and tempting aroma from the oven.

Baking with buckwheat leads to pastries with a heartier flavor than those made with wheat or spelt flour. They're less dainty, more rustic but still cakey. I never regret a muffin, no matter what flour I use, but in this case, I tend to eat a few extra—it's nuts, fruit, and buckwheat after all. I learned about this combination in the mountains of South Tyrol, where on cold winter days, I've often enjoyed the fantastic *Schwarzplentene* torte in one of the area's many cozy wooden huts. This sweet Tyrolean classic features buckwheat and hazelnut sponge cake sandwiched with a red jam filling. It's wonderfully pleasing to enjoy, while sitting next to a warm fire and watching icy snowflakes fall in front of the window.

You can replace the hazelnuts with almonds, use blackberries, sliced apples, or pears instead of the blueberries, and if you're in an experimental mood, try adding a little orange zest.

MAKES 12 MUFFINS

1⅓ cups (200 g) buckwheat flour

1½ cups (170 g) ground hazelnuts

½ cup (100 g) granulated sugar, plus more for topping

1 tablespoon baking powder

½ teaspoon baking soda

1 teaspoon ground cinnamon

¼ teaspoon fine sea salt

1 cup (240 ml) whole milk

2 large eggs

½ cup plus 1 tablespoon (125 g) unsalted butter, melted and cooled

8 ounces (225 g) fresh blueberries

12 paper muffin pan liners

Preheat the oven to 375°F / 190°C (preferably convection setting). Line a 12-cup muffin pan with paper liners.

In a large bowl, whisk together the buckwheat flour, hazelnuts, sugar, baking powder, baking soda, cinnamon, and salt.

In a medium bowl, whisk together the milk, eggs, and butter. Add to the flour mixture and stir with a wooden spoon just until a lumpy batter forms. Gently fold in the blueberries. Mind that if you mix the batter too much, the muffins will lose their light texture.

Spoon the batter into the muffin cups, sprinkle the tops with a little sugar, and bake for about 16 minutes (slightly longer if using a conventional oven) or until golden. Take the muffins out of the pan and let them cool on a wire rack for 2 minutes before serving.

elderflower panna cotta

Making your own elderflower syrup (*see page 238*) is a very relaxing kitchen project. It takes a few days and a bit of patience, but the results are more than worth it. Mixing the syrup with chilled white wine, lemon peel, and mint to create a Hugo cocktail is just one way to use it. Stirring its flowery sweetness into panna cotta is a creamy pleasure.

For a multicourse dinner I would plan for one portion per guest, but that doesn't mean it's impossible to empty two or three of them in one go. It's actually quite likely, as this dessert tastes so heavenly. Keep in mind that the custard has to set for several hours before it can go on the table. However, because of my impatient nature, I came up with an idea to speed up the process by refrigerating the panna cotta for an hour, followed by twenty minutes in the freezer. It works perfectly: The panna cotta is slightly chilled and ready to be enjoyed.

If you can't find elderflowers where you live, you can buy elderflower syrup online.

SERVES 2 TO 4

2½ (3 x 4-inch / 7 x 11-cm) gelatin sheets (or 2½ tea-spoons powdered gelatin)

1 cup (240 ml) heavy cream

½ cup (120 ml) whole milk

¼ cup (60 ml) elderflower syrup (*see page 238*)

1 tablespoon granulated sugar

⅛ teaspoon fine sea salt

1 elderflower cluster for decoration (optional)

Soak the gelatin sheets in cold water for about 5 minutes.

In a small saucepan, bring the cream, milk, elderflower syrup, sugar, and salt to a boil. As soon as the mixture is bubbling, take the pan off the heat. Squeeze the excess water from the soaked gelatin sheets and crumble them into the warm cream mixture; whisk thoroughly. Let the mixture cool in the pan, whisking occasionally.

Once the cream mixture is at room temperature—it will still be liquid—divide it between 4 (4-ounce / 120-ml) ramekins. Cover them with plastic wrap and refrigerate for 1 hour. Transfer the ramekins to the freezer and chill for about 25 minutes or until set but not frozen. Alternatively, leave the ramekins in the refrigerator for 2 to 3 hours or overnight.

If you have access to fresh elderflowers, snip a few flowers off an elderflower cluster and decorate the panna cotta just before serving. Enjoy plain or with strawberries on the side.

puddina JOANNA'S MALTESE BREAD PUDDING

Joanna Bonnici is a true Maltese mama and one of the most kind and humble women I've ever met. She was introduced to the wonders of cooking and baking by the female cooks in her family, so her culinary education is based on the knowledge of generations of strong, food-loving ladies and traditional recipes handed down from one child to the next until they reached Joanna. When we met for the first time, at her house in Malta, she treated me to so many amazing dishes that I never wanted to leave. One was Maltese bread pudding—the famous *puddina*—which is a masterpiece in Joanna's hands. It's fudgy and slightly chocolaty, with strong hints of orange and tangerine, and as moist as good bread pudding should be.

SERVES 8 TO 12

18 ounces (510 g) 2-day-old stale white bread or buns with crust*

9 ounces (250 g) mixed dried fruit

4 ounces (110 g) pitted dates, chopped

3 tablespoons desiccated coconut

2 tablespoons freshly grated orange zest

1 heaping teaspoon freshly grated tangerine zest

3 heaping tablespoons granulated sugar

2 tablespoons Dutch-process or natural unsweetened cocoa powder

Pinch of nutmeg, preferably freshly grated

½ teaspoon ground cinnamon

4¼ cups (1 l) whole milk

½ cup (120 ml) freshly squeezed orange juice

2 heaping tablespoons orange or tangerine marmalade

2 tablespoons Amaretto di Saronno or whiskey

½ vanilla bean, split and scraped

FOR THE TOPPING (OPTIONAL)

Confectioners' sugar

A few thin strips fresh orange peel

Tear the bread into bite-size chunks and place in a large baking dish. Add the dried fruit, dates, coconut, orange zest, tangerine zest, granulated sugar, cocoa powder, nutmeg, and cinnamon and toss to combine.

In a large bowl, whisk together the milk, orange juice, marmalade, amaretto, and vanilla seeds. Add to the bread mixture and use your hands to mix well. Cover and let soak for 1 hour at room temperature. After an hour, tear large chunks of the bread into smaller pieces—it should have a mushy texture.

Preheat the oven to 350°F / 180°C (preferably convection setting). Line a 9 x 11 x 2-inch (23 x 28 x 5 cm) baking dish with parchment paper.

Spread the pudding mixture evenly in the lined baking dish and bake for about 65 to 75 minutes (slightly longer if using a conventional oven), or until the top is firm and springy. If you insert a skewer in the middle, it should come out almost clean. Turn off the oven and leave the pudding inside, with the door closed, for 30 minutes. Take the pudding out of the oven and let cool for about 30 minutes before cutting and sprinkling with confectioners' sugar. Decorate with orange peel. It's best on the second day.

* If using fresh bread, mind that it will lose weight while drying out.

riesling and rhubarb cake

The Alsace region, in northeastern France, has always been one of my favorite places to indulge in the sweet French lifestyle for an extended weekend. Driving down the beautiful Route des Vins, between the Rhine River and the Vosges Mountains, takes you to the picturesque villages of Orschwiller, Ribeauvillé, and Hunawihr. The butchers, bakeries, cheese shops, and farmers' markets spoil travelers with such amazing treats that it's not necessary to visit a single one of the region's excellent restaurants, which I still recommend, as they are just as good. Alsace combines the best of hearty northern comfort food with the finesse of classic French cuisine.

Life is good in Alsace, and the list of tempting specialties is long. *Choucroute garnie* (sauerkraut with various sausages and meats), *tarte flambée*, pâtés, and sweet *gugelhupf* make it easy to understand the German expression, "Leben wie Gott in Frankreich," which means "to live like God in France." Alsatian *gâteau au vin blanc* is a sponge cake made with Riesling and olive oil; it's moist, fragrant, and light. Folding in chopped rhubarb makes it fruitier, and apples work just as well.

SERVES 6 TO 8

2 cups plus 2 tablespoons (280 g) all-purpose flour

1 tablespoon baking powder

1 teaspoon ground cinnamon

4 large eggs, separated

¼ teaspoon fine sea salt

1 cup (200 g) granulated sugar, plus more for sprinkling

¾ cup (180 ml) Riesling (or any fruity white wine)

¾ cup (180 ml) mild olive oil

10 ounces (280 g) trimmed rhubarb, cut into ¾-inch (2 cm) cubes

Whipped cream for serving (optional)

Preheat the oven to 350°F / 180°C (preferably convection setting). Butter an 8-inch (20 cm) springform pan.

Sift the flour, baking powder, and cinnamon into a medium bowl.

In a large bowl, use an electric mixer to beat the egg whites, salt, and 1 heaping tablespoon of the sugar for about 20 seconds or until the whites start to foam and thicken—it shouldn't form peaks yet.

In a second large bowl, use an electric mixer to whisk together the egg yolks, the remaining sugar, and 1 heaping tablespoon of the egg whites until light and fluffy. Whisk together the wine and olive oil, add to the yolk-sugar mixture, and continue whisking until combined. With a wooden spoon, fold about ⅓ of the egg white mixture gently into the yolk mixture, followed by ⅓ of the flour mixture. Repeat with the remaining egg white and flour mixtures, folding until just combined. Gently fold in the rhubarb, pour the batter into the prepared pan and bake for about 55 minutes (slightly longer if using a conventional oven) or until golden. If you insert a skewer into the center of the cake, it should come out clean. Sprinkle the warm cake with ½ teaspoon of sugar and let cool in the pan for about 10 minutes before transferring it to a large plate. Enjoy plain or with whipped cream.

ottijiet MALTESE SESAME SEED, CLOVE, AND ANISEED COOKIES

Maltese *ottijiet*, which translates to "figure-of-eights," have a rather rustic look. They're perfectly crumbly cookies and wonderfully rich. With a heavy dose of orange and lemon, they possess such vibrant citrus flavors that they seem almost ripened under the Mediterranean sun. They're honest and simple, not very sweet, and refined with aniseed, cloves, and nutty sesame seeds. The British brought the fantastic tradition of teatime to Malta's vivid culture. While it doesn't always happen at 5 o'clock—we're in the Mediterranean after all—it's a sacred afternoon ritual for our family to meet and chat in the kitchen with a cup of tea and some ottijiet. My Maltese loved ones dip the cookies into the blackest of tea, however this is not for me; I prefer them crunchy.

MAKES 22 COOKIES

2 ⅓ cups (300 g) all-purpose flour

½ cup (100 g) granulated sugar

2 teaspoons baking powder

1 tablespoon aniseed, finely ground with a mortar and pestle

20 whole cloves, finely ground with a mortar and pestle

½ vanilla bean, split and scraped

1 teaspoon freshly grated orange zest

1 teaspoon freshly grated lemon zest

⅛ teaspoon fine sea salt

⅓ cup plus 2 tablespoons (100 g) unsalted butter, cold

1 large egg

1 tablespoon freshly squeezed orange juice

1 tablespoon freshly squeezed lemon juice

1 tablespoon water, cold

5 tablespoons white sesame seeds

In a large bowl, whisk together the flour, sugar, baking powder, aniseed, cloves, vanilla seeds, orange zest, lemon zest, and salt. Add the butter and use a knife to cut it into the flour until there are just small pieces left. Quickly rub the butter into the flour with your fingers until combined. Add the egg, orange juice, lemon juice, and water and mix with the dough hooks of an electric mixer until crumbly. Form the dough into a thick disc, wrap in plastic wrap, and refrigerate for 1 hour, or freeze for 15 minutes.

Preheat the oven to 400°F / 200°C (preferably convection setting). Line 2 baking sheets with parchment paper.

Spread the sesame seeds on a large plate.

Break off 1½-inch (4 cm) chunks of dough and use your hands to quickly roll them into balls. On a table or countertop, roll the balls into 10-inch-long (25.5 cm) sausage shapes then bend them into rings and seal the ends. Carefully twist each ring to form the shape of an 8. Dip the cookies in the sesame seeds and arrange them, generously spaced, on the lined baking sheets. Bake, 1 sheet at a time, for about 11 minutes (slightly longer if using a conventional oven) or until golden brown. Let the cookies cool for a few minutes before transferring to a wire rack to cool completely.

Once the cookies are completely cool, store them in airtight containers for up to 1 week.

strawberry-ricotta cheesecake with oat cookie crust

Imagine a velvety, orange-scented cheesecake, made with light ricotta and rich cream cheese, and crowned with sweet, ripe summer strawberries. You could easily use store-bought cookies for the base, but homemade tastes so much better. You'll only need about half the cookies to make the cake, but they're so delicious that I like to make an extra large batch. I often nibble on so many while making the base that I have to stop myself to make sure I have enough for the cheesecake.

I recommend baking the cookies a day ahead, as they have to be dry and crunchy. If it's hard to find sweet strawberries you can replace them with blueberries.

SERVES 6 TO 8

FOR THE OAT COOKIES

Scant 1 cup (90 g) rolled oats

1 cup plus 1 tablespoon (110 g) oat flour

½ cup plus 1 tablespoon (120 g) Demerara sugar

½ teaspoon baking soda

¼ teaspoon ground cinnamon

⅛ teaspoon fine sea salt

⅓ cup (75 g) unsalted butter, melted and cooled

1 large egg

Preheat the oven to 350°F / 180°C (preferably convection setting). Line 2 baking sheets with parchment paper.

In a large bowl, whisk together the oats, oat flour, Demerara sugar, baking soda, cinnamon, and salt. Add the melted butter and the egg and use the dough hooks of an electric mixer to mix until combined—the mixture will be crumbly.

Fill a small bowl with water to wet your hands. Shovel 2 generous teaspoons of the dough into one hand, squeezing lightly to form a ball. Use the other hand to squeeze and flatten the ball. Continue with the rest of the dough to form about 24 cookies and spread them on the lined baking sheets. Bake, 1 sheet at a time, for 5 minutes then use a fork to flatten the cookies. Continue baking for about 9 more minutes (slightly longer if using a conventional oven) or until golden and crunchy. Transfer the cookies to a rack to cool and dry out for at least a few hours, but preferably overnight. To dry out the cookies more quickly, break them into chunks.

(continued)

FOR THE CHEESECAKE

FOR THE BASE

7½ ounces (210 g) dried oat cookies *(see recipe on page 234)*

¼ cup (60 g) unsalted butter, melted and cooled

FOR THE FILLING

11 ounces (310 g) cream cheese, at room temperature

9 ounces (250 g) fresh ricotta, at room temperature

½ cup (100 g) granulated sugar

¼ vanilla bean, split and scraped

3 large eggs

1 heaping teaspoon cornstarch

1 heaping teaspoon freshly grated orange zest

3 tablespoons freshly squeezed orange juice

⅛ teaspoon fine sea salt

FOR THE TOPPING

2 tablespoons apricot jam

2 tablespoons water

7 ounces (200 g) hulled ripe strawberries, cut in half (reserve 3 whole strawberries for decoration)

Confectioners' sugar, to dust the cake

For the base, grind the cookies in a food processor or blender until finely ground. Transfer to a large bowl, add the melted butter, and stir until well combined. Spread the cookie mixture in an 8-inch (20 cm) springform pan, using the back of a metal tablespoon to press it firmly and evenly into the pan, especially along the edges. Freeze for 20 minutes.

Place a deep roasting pan, large enough to fit the cake pan comfortably, on the lowest rack of the oven. Preheat the oven to 325°F (160°C). Fill a kettle with water and bring to a boil.

For the filling, in a large bowl, use an electric mixer to beat the cream cheese, ricotta, sugar, vanilla seeds, eggs, cornstarch, orange zest, orange juice, and salt until well combined.

Take the springform pan out of the freezer and wrap it in 2 layers of 18-inch wide (45 cm) aluminium foil—mind that the bottom and sides are completely covered to protect the cheesecake from the water while it's baking.

Pour the cheesecake batter into the springform pan and carefully place the pan into the roasting pan in the oven. Slowly pour the boiling water into the roasting pan until it comes about halfway up the sides of the springform pan. Bake for about 50 minutes or until the filling is just set but still slightly wobbly in the center. Turn off the oven, quickly and carefully remove the cheesecake from the roasting pan, and remove the foil. Take the water-filled roasting pan out of the oven and place the cheesecake back in the oven on the lowest rack. Leave the oven door slightly open and let the cheesecake cool for 15 minutes, then take the cheesecake out of the oven and let cool to room temperature. Once cool, the cheesecake can be refrigerated for 2 to 3 days. Or, you can add the topping and serve it right away. (Don't refrigerate the cheesecake when it's still warm, or the base will turn soggy.)

For the topping, in a small saucepan, bring the jam and water to a boil. Lower the heat and simmer for about 30 seconds or until it starts to thicken. Push the glaze through a fine-mesh sieve into a bowl. Remove the sides of the springform pan and gently brush the glaze over the top of the cheesecake. Arrange the halved strawberries in concentric circles on top of the cheesecake and place the whole berries in the middle. Sprinkle with confectioners' sugar just before serving.

elderflower syrup MAKES ABOUT 1 QUART (1 L)

4¼ cups (1 l) water

5 cups (1 kg) granulated sugar

1 ounce (30 g) citric acid

25 blossoming elderflower clusters, briefly rinsed, thick green stems cut off

1 lemon, thinly sliced

80-proof (40%) spirit, to sterilize the bottles

In a large pot, bring the water to a boil. Add the sugar and citric acid, remove from the heat, and stir until dissolved. Put the elderflower clusters in a large heat-resistant ceramic or glass (not metal) bowl, add the hot water, and place the lemon slices on top. Cover with a tea towel and let it sit for 5 to 6 days at room temperature, stirring once a day.

When ready to bottle the syrup, sterilize one 1-quart (1 l) or two ½-quart (500 ml) glass bottles and their screw tops for 5 minutes in boiling water then rinse them out with the 80-proof (40%) spirit.

Strain the syrup through a fine cotton or linen towel into a large pot and bring to a boil. Strain through a towel again and divide between the sterilized bottles. Close tightly and keep in the pantry for up to 1 year. Once opened, the bottles should be stored in the refrigerator.

spicy rhubarb chutney MAKES 3 MEDIUM JARS

FOR THE SPICE MIXTURE

⅛ teaspoon ground turmeric

½ teaspoon ground cinnamon

½ teaspoon fennel seeds, finely ground with a mortar and pestle

12 whole cloves, finely ground with a mortar and pestle

2 star anise pods, finely ground with a mortar and pestle

2 small dried chiles, finely ground with a mortar and pestle

FOR THE CHUTNEY

1¼ pounds (560 g) trimmed rhubarb, thickly sliced

5 ounces (140 g) peeled and cored tart baking apple, roughly chopped

1 medium red onion, roughly chopped

1 cup (240 ml) cider vinegar

¾ cup (150 g) granulated sugar

½ fresh red chile, seeds removed, finely chopped

1 large clove garlic, finely chopped

1 heaping teaspoon freshly grated ginger

80-proof (40%) spirit, to sterilize the jars

For the spice mixture, mix the spices together in a small bowl.

For the chutney, in a large pot, combine 1½ teaspoons of the spice mixture with the rest of the ingredients and bring to a boil. Reduce the heat to medium and simmer, uncovered, for about 1 hour or until thickened. Season to taste with the spice mixture.

Sterilize the jars and their lids for 5 minutes in boiling water then rinse the rims and lids with the 80-proof (40%) spirit. Divide the chutney among the jars, fill them to the top, and immediately close tightly. Let the chutney sit for at least 3 weeks. It stays fresh for up to 1 year and can be kept in the pantry, but once opened, the jars should be stored in the refrigerator.

moroccan preserved lemons MAKES 5 PRESERVED LEMONS

5 small lemons, preferably thin-skinned, rinsed and scrubbed

⅓ cup (70 g) coarse sea salt

Juice of 2 to 4 large lemons, plus more as needed

80-proof (40%) spirit, to sterilize the jar

Sterilize 1 (3½-cup / 830-ml) preserving jar and its lid for 5 minutes in boiling water then rinse with the 80-proof (40%) spirit.

Cut both ends off the lemons and quarter the fruit lengthwise, cutting only ⅔ through the fruits. Rub a heaping teaspoon of the coarse sea salt into each lemon then push them into the sterilized jar, compressing the fruit as needed. Add the remaining salt and enough lemon juice to fill the jar. Push the lemons down firmly; they should be completely submerged in juice. Close the jar tightly and keep in a dark place.

For the first 3 days, once a day, press down on the lemons with a spoon to release their juices. If the fruit isn't completely submerged, add additional freshly squeezed lemon juice. Keep the jar in the refrigerator, occasionally pushing down on the lemons and adding more lemon juice as needed. The lemons will be soft and ready to use after about 4 weeks.

Either rinse the lemons quickly before you use them or leave them covered in their salty juices. Thinly sliced, they're a delicious addition to sautéed vegetables (*see carrots page 24*), meat stews, sandwiches (*see page 112*), and seafood.

vegetable broth MAKES ABOUT 12 CUPS (3 L) BROTH

Using a colorful variety of vegetables is the best way to create a fragrant broth. I favor leeks, spring onions, carrots, celery, celeriac, tomatoes, fennel, and zucchini. I don't use cabbage, as it tends to be too overpowering. If you're looking for a spicy broth, try adding some dried chiles.

1 large onion, cut in half

2¼ pounds (1 kg) mixed vegetables, preferably including 1 to 2 medium tomatoes, roughly chopped

About 12 cups (3 l) water, cold

1 small bunch flat-leaf parsley

1 bay leaf

8 black peppercorns

5 allspice berries

2 whole cloves

Place the onion, cut-side down, in a large dry pot over high heat and cook for 1 to 2 minutes or until the onion is roasted and dark brown. Add the remaining vegetables and cook, stirring occasionally, for 1 minute. Add the water, parsley, bay leaf, peppercorns, allspice berries, and cloves; cover and bring to a boil. Reduce the heat and simmer for 1 hour. Remove from the heat and let cool then pour the broth through a fine-mesh sieve into airtight containers. Refrigerate for up to 3 days or freeze for up to 6 months.

Yossy Arefi

A deep love of food inspired Yossy to work in restaurant kitchens long before she started sharing her marvelous recipes on her blog, *Apt. 2B Baking Co.*, and in her cookbook, *Sweeter Off the Vine*. Yossy's natural sense for tasty combinations and the way she plays with balance and contrast, make her creations outstanding. And then there are the visuals: Yossy is an amazing photographer. | *www.apt2bbakingco.com*

What sparked your interest in working in the food world?

I grew up in a very food-focused family where celebrations were always accompanied by feasts, so to me, food represents family and gathering. I have always felt totally at ease in the kitchen, and making that my job is a total dream.

How do your Iranian roots inspire your cooking and baking?

I love the balance of flavors in Iranian cooking. Meat stews are served with fragrant rice, cool yogurt, and pickles; bitter tea is served with dates or little bits of saffron candy. Iranians aren't big on baked desserts, but every Iranian household always has a big bowl of fruit to snack on, which sparked my love of fruit desserts. I also use a lot of traditional Middle Eastern flavors in my desserts: Cardamom, saffron, orange flower water, rose water, and pomegranate molasses all have a place in my baking pantry.

Who is your biggest inspiration in the kitchen?
My family.

You're well known for your gorgeous fruit pies and tarts. What do you love about the combination of fruit and pie crust?

I try to reflect seasonality in my cooking and baking, and fruit pies are a great way to do that. They are also exceptionally beautiful, and well balanced in flavor—sweet, tart, and buttery. Top a slice with vanilla ice cream and you have something much greater than the sum of its parts.

You also work as a photographer and often shoot analog. Where does your fascination for film come from?

I love the way that film captures light and color. I also like that it forces me to slow down a bit, and consider my composition carefully, before firing the shutter. When I am photographing something on film, I usually only take about ten to fifteen frames, but if I am shooting digitally I would double that at least. Sometimes the process can be frustratingly slow, because I have to take my film to a lab, and wait a couple of days before I can share the photos, but nothing beats picking up a fresh batch of prints from the lab.

What was your favorite food as a child? What is it now?

I've never been able to turn down a good slice of pizza.

Do you prefer to cook on your own or with others?

On my own. I get really focused and like to just zone out when I am cooking.

yossy arefi's raspberry-rose frozen yogurt

MAKES ABOUT 1 PINT (500 ML)

12 ounces (340 g) fresh raspberries

1 cup (200 g) granulated sugar

1½ cups (340 g) full-fat plain Greek yogurt

½ cup (120 ml) heavy cream

1 vanilla bean, split and scraped

1 to 3 teaspoons high-quality rose water, preferably organic

⅛ teaspoon fine sea salt

In a blender or food processor, purée the raspberries and sugar until smooth. Strain the purée through a fine-mesh strainer or food mill into a large bowl. Add the yogurt, heavy cream, vanilla seeds, 1 teaspoon of the rose water, and salt and whisk until smooth. Add more rose water to taste.

Chill the mixture thoroughly, for at least 1 hour, then churn it in an ice cream machine, according to manufacturer's instructions. Eat immediately as soft serve, or transfer to a freezer-safe container, cover, and freeze for a few hours or until firm.

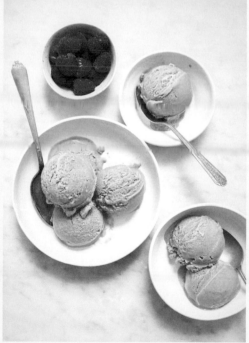

Cynthia Barcomi

New York / Berlin

Cynthia is one of Berlin's early food pioneers. She left New York in 1985, and established two gems, Barcomi's Café & Kaffeerösterei and Barcomi's Deli, which has been my favorite refuge in this vibrant city for decades. In addition to being a fantastic baker, Cynthia is also a coffee roaster, cookbook writer, and television host, and she built her flourishing food business while also raising four children. Cynthia is an endless source of energy and positivity—she's truly inspirational. | www.cynthiabarcomi.com

You opened your first Barcomi's in 1994. How would you describe Berlin's café scene in those days?
In 1994, and up until a few years ago, there was really no alternative to industrially roasted coffee beans and industrially produced pastries in Berlin, except Barcomi's. Everything tasted the same—and bad! Bad food and coffee corrupts the palate, so that at some point, people no longer know how "real" food and coffee should taste. I have always seen my work as an alternative to the industry—be it feeding our guests or writing books, so that people can bake and cook successfully themselves.

How much of the New Yorker is still in you?
New York is a magical—and tough—city. It is an extremely competitive and fast-moving city, and if you live there, you have to keep up! Living and going to school there taught me not to be afraid of competition by always doing my best and remaining true to my ideas and beliefs.

Where do you find inspiration for new recipes?
Inspiration is everywhere: ingredients, shapes, colors, occasions, dreams, and sense memories just to name a few. Inspiration is always the starting point for a new recipe, and without it, I cannot create. A baking recipe begins as an intellectual theory of a bunch of ingredients. The magic happens when I synthesize theory with practice—baking. This involves all of my senses and is partially an intuitive process. When a pastry finally comes out of the oven, theory and practice have united—I love it!

How much family is there in Barcomi's?
There is a lot of family in Barcomi's. My husband and son love to do the store deliveries on Sundays. My youngest daughter is a great helper and baker in the kitchen. Barcomi's is my family's existence, as well as the existence of many coworkers of mine.

You're going to have ten friends over for a spontaneous dinner. What will be on the table?
It is one of my favorite things to do—open my cupboards and simply throw a meal together—often in less than thirty minutes! As my husband would say, I have done some of my best "work" in the least amount of time. I love the flow of improvising in the kitchen. It would be my dream TV show to go to someone's home, open up the kitchen cupboards, and cook an amazing meal!

cynthia barcomi's peanut butter brownies

MAKES ABOUT 16 LARGE BROWNIES

½ cup plus 3 tablespoons (155 g) unsalted butter

7 ounces (200 g) bittersweet chocolate, broken into pieces

¾ cup (150 g) granulated sugar

1 tablespoon plus 1 teaspoon vanilla extract

¾ cup (90 g) all-purpose flour

3 tablespoons Dutch processed or natural unsweetened cocoa powder

¾ teaspoon fine sea salt

½ teaspoon baking soda

¾ cup (200 g) creamy peanut butter

¼ cup (25 g) confectioners' sugar, sifted

3 large eggs

Preheat the oven to 350°F (180°C) and butter a 9-inch (23 cm) square baking pan.

In a small saucepan, over medium-low heat, heat ½ cup plus 1 tablespoon (125 g) of the butter, add the chocolate, and stir until combined. Pour the melted chocolate into a large bowl, add the granulated sugar and 1 tablespoon of the vanilla, and stir to combine. Set aside and let cool for about 15 minutes.

Sift together the flour, cocoa powder, ½ teaspoon of the salt, and the baking soda.

In a medium bowl, use an electric mixer to beat the peanut butter and confectioners' sugar with the remaining 2 tablespoons of butter, 1 teaspoon vanilla, and ¼ teaspoon salt until creamy and well combined.

Whisk the eggs into the cooled chocolate mixture until creamy then gently fold in the flour-cocoa mixture. Scrape the batter into the baking pan and spread evenly. Place dollops of the peanut butter mixture on top of the brownie batter and swirl it a little with a toothpick—it should be marbled, but most of the peanut butter should stay on top. Bake for about 23 minutes or until just firm on top, but not overbaked. Let cool on a wire rack.

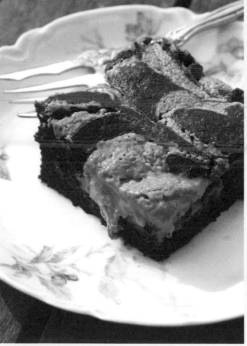

The Cini Family

The Cini family has been harvesting sea salt in Xwejni Bay for generations. Their salt pans are on the northern coast of Gozo, one of three inhabited islands in Malta's archipelago. Emmanuel, his wife Rose, their daughter Josephine, and her husband David, work hard for their "white gold" from the sea. They're preserving an old tradition and I get to stock my pantry with the best salt I've ever tasted.

Emmanuel, your wife's family has been working at the salt pans for five generations. When did you join the business and how did it change your life?

The salt pans have been in the family since 1860. We took over in 1969 and we have been tending them lovingly ever since then. My wife taught me the trade and together we have continued to cultivate the salt pans with lots of dedication. Over the years we have been through very difficult moments, but the salt we managed to harvest made us stronger.

Salt harvesting is done during the summer period, starting from May up until the end of August or September, depending on Mother Nature—the wind, the sun, and the sea. As summer is approaching, we're always eager to go down to the salt pans to harvest the salt. We collect about a ton of salt every week, with June and July being the peak months. A good season will yield about twenty-five tons of genuine sea salt. Nowadays, as we are getting older, my daughter helps out, along with her family. Our harvest day starts very early, at about five in the morning, to avoid the heat of the sun. We sweep the salt and carry the buckets of salt into a big heap on a flat surface to dry for a few hours. Then it is bagged into 66-pound (30 kg) sacks ready to be stored for packing and distribution. Finally, the pans are refilled with seawater.

What makes Gozo salt so special?

Our salt is unique because of the rocks, the clean seawater, the climate, and the craftsmanship. It is the perfect salt for cooking and preserving, as it does not contain any chemicals or additives.

Do you have the perfect job?

I have been working the salt pans and harvesting salt with my wife, Rose, for nearly half a century. It's definitely one of the best jobs in the world, in one of the best places on earth. Whatever job one does in life, it is important to do it lovingly and with dedication—this is the ideal formula. We have silently worked together and have been an inspiration to artists, photographers, writers, and many more. It's been a great opportunity to meet a lot of people. It is extremely satisfying to work with nature and our environment, which nowadays struggles to survive. It is a miracle of nature to see the salt of the earth being produced in front of our eyes. The simple and genuine things are the most extraordinary in life. I look forward to working at the salt pans for many years to come!

Where can we find you and buy your salt?

We can be found selling salt on the side of the road right at the Xwejni Salt Pans, and it is sold in some local shops on the island of Gozo.

rose cini's sun-dried tomatoes

To dry tomatoes in the sun, you need a hot climate and no rain for four to six days.

Medium, ripe tomatoes

Coarse sea salt, about 1 heaping teaspoon per tomato half

Set a wire rack on a baking sheet. Cut the tomatoes in half crosswise, spread them, cut-side up, on the rack, and generously sprinkle each tomato half with coarse sea salt.

Leave the tomatoes out in the sun for 4 to 6 days, covered with a mosquito net by day and with a plastic sheet by night to protect them from humidity.

When the tomatoes are dry and wrinkled, rinse them and place back under the sun for 1 hour or until completely dry. Place the tomatoes in sterilized jars, add a handful of coarse sea salt (for a medium jar), and seal the jars. Store in the pantry for up to 1 year.

You can also preserve the dried tomatoes in olive oil by filling the jar with oil instead of sea salt.

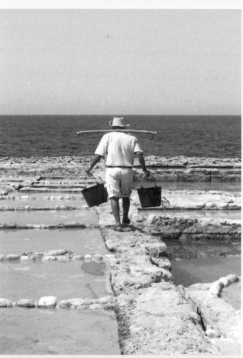

Malin Elmlid

Malin started The Bread Exchange in 2008. She's a self-taught baker, and makes Berlin's best sourdough bread. But you can't buy it—you can only trade for it. With more than 1,400 loaves baked and traded all over the world, Malin's been rewarded with fascinating stories, memories, and recipes—all collected on her blog and in her book, *The Bread Exchange*. | *www.thebreadexchange.com*

What fascinates you about sourdough and what led you to start your bread-trading project?
About ten years ago, I had a hard time finding quality bread in Berlin. Everything seemed to be baked with commercial yeast. Sourdough is so much healthier, but it's time consuming, and time is money. Therefore, I started to bake my own bread. Sourdough is a beautiful thing. It keeps you in tune with your senses. It's like an art in itself, like meditation. And in the end, you get an even better product than anything you could have bought in a store. That makes it very rewarding and my friends love it. It's good for you, but you can also share it with the ones you love.

What is the biggest gift you received from The Bread Exchange?
It's the lesson that if you start giving, without the intention of getting anything in return, you will become a way richer person. Maybe not right away, but in the long run.

What are your memories connected to *bullar*, Sweden's yeast snails?
When I grew up in the Swedish countryside, we used to judge someone's mother by her cinnamon buns, the *kanelbullar*. On this scale, my mother got a pretty low rating, since she would never stick to one recipe, but rather made freestyle versions of the classic. Sometimes she filled her bullar with marzipan, sometimes with hazelnut cream. I was devastated. Looking back, I am proud of her creativity and

I know that my grade as a classic bullar-mother would rate just as low. My version of the buns is lightly salty, which works perfectly with a sweet cardamom filling.

malin elmlid's salted cardamom bullar

MAKES ABOUT 20 BULLAR

FOR THE PRE-DOUGH
1⅓ cups plus 1 tablespoon (325 ml) whole milk, cold

3 cups (390 g) all-purpose flour

1½ ounces (42 g) fresh yeast

FOR THE DOUGH
6 tablespoons (90 g) unsalted butter, at room temperature

⅓ cup (75 g) light brown sugar

½ tablespoon fine sea salt

2 small eggs

¼ vanilla bean, split and scraped

2 cups plus 2 tablespoons (275 g) all-purpose flour

FOR THE FILLING
⅓ cup plus 2 tablespoons (100 g) salted butter, at room temperature

¾ cup plus 2 tablespoons (185 g) light brown sugar

⅓ cup (45 g) all-purpose flour

1 teaspoon fine sea salt

1½ teaspoons ground cardamom (or the seeds from the pods, ground with a mortar and pestle)

1 vanilla bean, split and scraped

FOR THE TOPPING

1 large egg, lightly beaten

2 tablespoons unsalted butter, melted

Light brown sugar, mixed with a pinch of vanilla seeds from a pod

For the pre-dough, mix the ingredients together in a large bowl and let rise for 3 hours at 70°F (20°C) or for 12 hours at 55°F (12°C). Bullar stay fresh longer when the dough rises slowly at a lower temperature.

For the dough, add the dough ingredients to the pre-dough and knead with the dough hooks of an electric mixer for 7 to 10 minutes or until well combined and elastic. Form the dough into a sausage shape, transfer to a plate and cover with plastic wrap. Place in the refrigerator to rest for 1 hour.

For the filling, mix the ingredients together until creamy and set aside. Line 2 baking sheets with parchment paper.

On a lightly floured large table or countertop, use a rolling pin to roll out the dough into a 16 x 40-inch (40 x 100 cm) rectangle. Working lengthwise, spread the filling onto one half of the dough, covering an 8 x 40-inch (20 x 100 cm) rectangle. Fold the plain half over the filling and cut the dough into 1-inch (2.5 cm) wide strips. Quickly twist each strip of dough into a long spiral and close in a loose knot. Transfer the bullar to the lined baking sheets, cover with warm, damp tea towels (use 120°F / 50°C warm water) and let rise for 30 minutes.

Preheat the oven to 450°F (230°C).

Brush the tops of the bullar with the beaten egg and bake for 7 to 10 minutes or until golden brown. Brush the warm bullar with the melted butter and sprinkle with vanilla-sugar.

Jasmine + Melissa Hemsley

The Hemsley sisters are a true force of nature. Charming and gorgeous, they took over the food world with recipes that are completely free of gluten, grain, and refined sugar, but are still packed with creativity and pure deliciousness. Their cookbooks, *The Art of Eating Well* and *Good + Simple*, are fun to cook with and the food will nourish your body. *www.hemsleyandhemsley.com*

What moved you to start your family business, Hemsley + Hemsley in 2010?

MELISSA: We didn't intentionally "launch" the business—it came about organically. As people reached out to us for help with their digestion and relationship with food, we suddenly found ourselves working as wellness coaches and private chefs. Providing a bespoke service for these clients, we'd clear out their cupboards, fill up their fridges and freezers, and show them how to cook our recipes. The results were so positive. Our clients felt better—happier, healthier, and more energized. Back then we didn't have a name, so our clients called us their "food fairies" and from the first week, we had a waiting list, as everybody recommended us to their friends, families, and colleagues.

What are the advantages of working so closely with your sister?

JASMINE: We always said it would be great to have a family business, making the food we all want to eat—food that keeps us happy and energized—and be able to share it with everybody. The business has evolved naturally and we now work in areas that we each love the most. When it comes to recipes, my sweet tooth means I usually mastermind the puddings and desserts, while Mel is the queen of knock-out curries and one-pot dishes. My partner, Nick, is the third wheel to Hemsley + Hemsley, the man behind the scenes, taking all the photos and running the back end of the business.

Who is your biggest inspiration in the kitchen? What are your culinary roots?

We've both always loved good home-cooked food thanks to our Filipina mum being wonderful and inspiring in the kitchen. She would make use of everything we had— that's definitely where our frugal streak comes from—and each meal was made with great care and attention.

If you could choose one person to cook a meal for you, who would it be and what would be on the table?

JASMINE: Keith Floyd, cooking up a bouillabaisse in the South of France, and enjoying it with plenty of wine in the sunshine. I bet it'd be an afternoon to remember!

MELISSA: Rather than have her cook for me, I'd want to cook for the legendary Madhur Jaffrey—probably something like our Chicken Curry and Cauliflower Rice, so that she could critique it!

hemsley + hemsley's beet spaghetti with pesto and goat cheese

Use a spiralizer to give the beets a spaghetti shape. You can also julienne the beets with a knife or use a vegetable peeler to create pasta-like shapes. An even faster option would be cutting the beets into chunks and roasting them in butter, ghee, or animal fats until tender.

To make this dish dairy free, replace the goat cheese with a generous sprinkle of toasted pumpkin seeds, sesame seeds, and extra brazil nuts, and for a nut-free version, simply leave out the brazil nuts. SERVES 4

FOR THE SPAGHETTI

4 large beets, unpeeled

7 ounces (200 g) goat cheese, crumbled

Olive oil

Chili flakes (optional)

FOR THE PESTO

10 brazil nuts

4 ounces (110 g) fresh basil leaves

2 ounces (60 g) fresh watercress, leaves and stalks

1 large clove garlic

½ cup (120 ml) olive oil

2 tablespoons freshly squeezed lemon juice

Fine sea salt

Ground pepper

Cayenne pepper (optional)

For the spaghetti, wash the beets, top and tail them, and spiralize each one using the small noodle blade. Snip any longer strands into shorter lengths for easier eating. Leave them raw, or sauté or steam them in a pan, with a few tablespoons of water, until just tender. Place in a large bowl and set aside.

For the pesto, combine the brazil nuts, basil, watercress, garlic, olive oil, and lemon juice in a food processor or blender and purée until smooth. Season to taste with salt, pepper, and a tiny pinch of cayenne, if using.

Add the pesto to the beet spaghetti and gently toss to combine. Divide the spaghetti among bowls and scatter the goat cheese on top. Drizzle with olive oil, sprinkle with a pinch of chili flakes or a grind of black pepper, and serve.

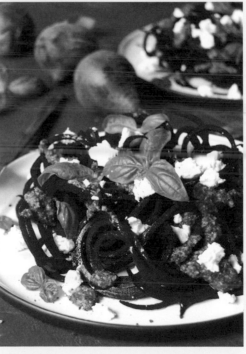

Molly Yeh

The voice behind the blog *My Name Is Yeh*, inspires readers with playful words and unique recipes. Molly moved from New York City to North Dakota to be with the love of her life, and now she's happily settled into farm life. Her gingerbread farm, a replica of the farm where she lives, made me fall for this girl and it's why I wanted to meet her in her kitchen immediately. | *www.mynameisyeh.com*

What do you miss the most about city life and what do you prefer about your life now?
I miss the food, my friends, and the music scene, but the quality of life on the farm is what's going to keep me from ever moving back. It's so energizing that I feel like I can get every piece of work done that I want to, and the small town community here is really wonderful. If I had moved here in an age when we didn't have the Internet—to FaceTime with my friends, live-stream concerts, and look up copycat recipes for my favorite dishes from New York restaurants—it might have been a slightly different story. Just slightly.

How did living on a farm change your kitchen activities?
I have a much bigger kitchen now, and more time, so I just do a lot more, and we live outside of the range for delivery, so there's a lot more planning in advance. We also have a garden, a rhubarb patch, an apple tree, chickens, and all that jazz.

What do you like about bringing Jewish and Chinese cooking together in your pots and pans?
They go really well together! Both cuisines pack a lot of carbs and comfort, and I grew up on both of them equally, so there's a lot of nostalgia mixed in as well.

How did your partner's Norwegian roots influence your cooking?
It's so fascinating! There are so many Norwegian and Upper Midwest dishes that I'm learning about that are so great. *Lefse* is one of them. Hotdish is another. A lot of the new dishes that I'm learning are hearty, comforting meals that are perfect for the long winters here, and that type of food has always been my favorite. There is not a single unit of spiciness in sight, so my tolerance for spicy food has plummeted, but other than that, I'm so excited to be learning about all of these new dishes. And I love putting my spins on them, whether it's adding flavors inspired by my roots or subbing in newer, trendier ingredients like kale and ramps.

Who is your biggest inspiration in the kitchen?
My mom! Also: all of my blogger friends.

What was your favorite food as a child and what is it now?
Mac and cheese.

You're going to have ten friends over for a spontaneous dinner. What will be on the table?
Mac and cheese.

molly yeh's ricotta, bacon, and egg sandwich

MAKES 1 SANDWICH

2 slices thick-cut bacon
1 large egg
Butter
2 thick slices fresh whole-grain bread
Coarse sea salt
Ground pepper
Fresh ricotta

In a small skillet set over medium-high heat, cook the bacon until crispy. Remove the bacon but leave the fat in the pan and keep it over medium heat. Crack the egg into the skillet and cook to the desired doneness. Remove the egg from the pan but leave the fat in the skillet.

If the skillet is too dry, add a little butter. Add the bread and toast until crispy. Season to taste with coarse sea salt and pepper and remove it from the heat.

Spread ricotta on one slice of bread, season to taste with coarse sea salt and pepper, and top with the bacon. Place the egg on top of the bacon and season lightly with coarse sea salt and pepper. Close the sandwich with the other slice of bread and enjoy.

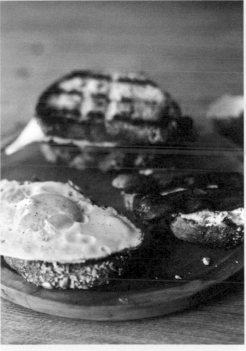

index